Postmodern Picturebooks

Routledge Research in Education

1. Learning Communities
in Education
Edited by John Retallick, Barry Cocklin
and Kennece Coombe

2. Teachers and the State
International Perspectives
Mike Bottery and Nigel Wright

3. Education and Psychology
in Interaction
Working with Uncertainty in
Inter-Connected Fields
Brahm Norwich

4. Education, Social Justice and
Inter-Agency Working
Joined up or Fractured Policy?
Sheila Riddell and Lyn Tett

5. Markets for Schooling
An Economic Analysis
Nick Adnett and Peter Davies

6. The Future of Physical Education
Building a New Pedagogy
Edited by Anthony Laker

7. Migration, Education and Change
Edited by Sigrid Luchtenberg

8. Manufacturing Citizenship
Education and Nationalism in Europe,
South Asia and China
Edited by Véronique Bénéï

9. Spatial Theories of Education
Policy and Geography Matters
Edited by Kalervo N. Gulson and
Colin Symes

10. Balancing Dilemmas in
Assessment and Learning in
Contemporary Education
Edited by Anton Havnes and
Liz McDowell

11. Policy Discourses, Gender, and
Education
Constructing Women's Status
Elizabeth J. Allan

12. Improving Teacher Education
through Action Research
Edited by Ming-Fai Hui and
David L. Grossman

13. The Politics of Structural
Education Reform
Keith A. Nitta

14. Political Approaches to
Educational Administration and
Leadership
Edited by Eugenie A. Samier with
Adam G. Stanley

15. Structure and Agency in the
Neoliberal University
Edited by Joyce E. Canaan and
Wesley Shumar

16. Postmodern Picturebooks
Play, Parody, and Self-Referentiality
Edited by Lawrence R. Sipe and
Sylvia Pantaleo

Postmodern Picturebooks

Play, Parody, and Self-Referentiality

Edited by
Lawrence R. Sipe
and Sylvia Pantaleo

Routledge
Taylor & Francis Group
New York London

First published 2008
by Routledge
711 Third Avenue, New York, NY 10017

Simultaneously published in the UK
by Routledge
2 Park Square, Milton Park, Abingdon, Oxfordshire OX14 4RN

Routledge is an imprint of the Taylor & Francis Group, an informa business

First issued in paperback 2012

Typeset in Sabon by IBT Global

Library of Congress Cataloging in Publication Data
 Postmodern picturebooks : play, parody, and self-referentiality / edited by Lawrence R. Sipe and Sylvia Pantaleo.
 p. cm.— (Routledge research in education ; 16)
Includes index.
 1. Picture books for children. I. Sipe, Lawrence R. II. Pantaleo, Sylvia Joyce.
 PN1009.A1P625 2008
 741.6'42--dc22
 2007047875

ISBN13: 978-0-415-96210-0 (hbk)
ISBN13: 978-0-415-54305-7 (pbk)
ISBN13: 978-0-203-92697-0 (ebk)

To Janet Hickman, friend and mentor
-Larry-

To Paul, the love of my life
- Sylvia -

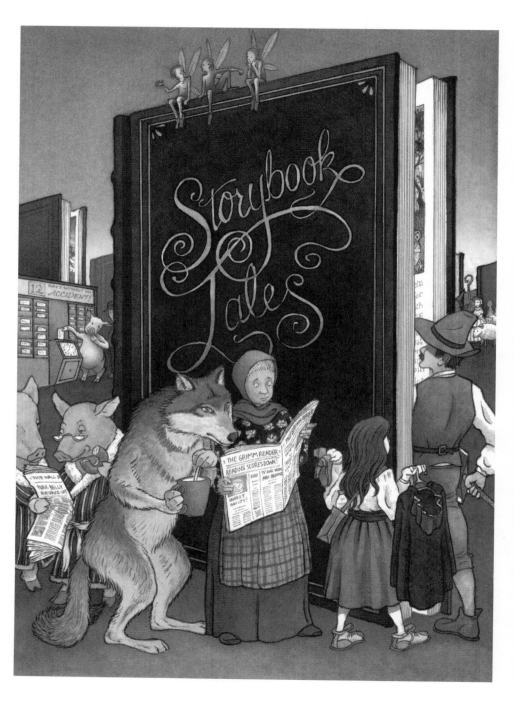

In this image, David Wiesner alludes to several features of postmodern picturebooks.

Contents

List of Figures and Tables ix

Acknowledgments xi

Introduction: Postmodernism and Picturebooks 1
SYLVIA PANTALEO AND LAWRENCE R. SIPE

1 What is a Picturebook, Anyway?: The Evolution of Form and
 Substance Through the Postmodern Era and Beyond 9
 BARBARA KIEFER

2 The Artist and the Postmodern Picturebook 22
 MARTIN SALISBURY

3 Radical Change Theory, Postmodernism, and Contemporary
 Picturebooks 41
 ELIZA T. DRESANG

4 Play and Playfulness in Postmodern Picturebooks 55
 MARIA NIKOLAJEVA

5 Postmodern Picturebooks and the Transmodern Self 75
 KAREN COATS

6 "They are Always Surprised at What People Throw Away":
 Glocal Postmodernism in Australian Picturebooks 89
 JOHN STEPHENS

7 Postmodern Picturebooks and the Material Conditions
 of Reading 103
 MARGARET MACKEY

8 The Paradox of Space in Postmodern Picturebooks 117
 BETTE GOLDSTONE

9 Imagination and Multimodality: Reading, Picturebooks, and
 Anxieties About Childhood 130
 CHRISTINE HALL

10 Postmodern Picturebook as Artefact: Developing Tools for an
 Archaeological Dig 147
 MICHÈLE ANSTEY

11 Lauren Child: Utterly and Absolutely Exceptionordinarily 164
 SUSAN S. LEHR

12 Would I Lie to You?: Metalepsis and Modal Disruption in Some
 "True" Fairy Tales 180
 ROBYN McCALLUM

13 "It Doesn't Say How?": Third Graders' Collaborative Sense-
 Making from Postmodern Picturebooks 193
 CAROLINE McGUIRE, MONICA BELFATTI, AND MARIA GHISO

14 The Voices Behind the Pictures: Children Responding to
 Postmodern Picturebooks 207
 EVELYN ARIZPE AND MORAG STYLES WITH KATE COWAN, LOUIZA MALLOURI
 AND MARY ANNE WOLPERT

15 First Graders Interpret David Wiesner's *The Three Pigs*:
 A Case Study 223
 LAWRENCE R. SIPE

16 Ed Vere's *The Getaway*: Starring a Postmodern Cheese Thief 238
 SYLVIA PANTALEO

Contributors 257
Index 261

List of Figures and Tables

FIGURES

2.1 Double-page spread from *Garmanns Sommer* by Stian Hole. 27

2.2 Double-page spread from *Garmanns Sommer* by Stian Hole. 28

2.3 Image from *Den Gamle Mannen og Hvalen* by Stian Hole. 29

2.4 Final double-page spread from *Garmanns Sommer* by Stian
 Hole. 31

2.5 Front cover of *Little Louie Takes Off* by Toby Morison. 34

2.6 Double-page spread from *Little Louie Takes Off* by Toby
 Morison. 35

2.7 Image from *Little Louie Takes Off* by Toby Morison. 39

4.1 Image from *Bak Mumme bor Moni* by Svein Nyhus. 57

4.2 Image from *Ispigen*, illustrated by Dorte Karrebaek. 58

4.3 Image from *Den nye leger* by Dorte Karrebaek. 61

4.4 Double-page spread from *Den nye leger* by Dorte Karrebaek. 62

4.5 Image from *Pigen der var go' til mange ting* by
 Dorte Karrebaek. 65

4.6 Image from *När Åkes mamma glömde bort* by
 Pija Lindenbaum. 69

4.7 Image from *Historien*, illustrated by Lilian Brøgger. 70

4.8 Image from *Historien*, illustrated by Lilian Brøgger. 71

6.1 Image from *The Great Escape from City Zoo* by Tohby Riddle. 99

x *List of Figures and Tables*

8.1 Final image from *Black and White* by David Macaulay. 121

9.1 Image from *Crispin The Pig Who Had It All* by Ted Dewan. 133

9.2 Double-page spread from *Traction Man is Here* by Mini Grey. 138

9.3 Double-page spread from *Wolves* by Emily Gravett. 142

10.1 Double-page spread from *The Short and Incredibly Happy Life of Riley* by Colin Thompson. 148

11.1 Double-page spread from *Clarice Bean, That's Me* by Lauren Child. 170

11.2 Double-page spread from *Clarice Bean, That's Me* by Lauren Child. 172

16.1 Front and back cover from *The Getaway* by Ed Vere. 242

16.2 Double-page spread from *The Getaway* by Ed Vere. 244

TABLES

3.1 Comparison of Literary Changes Identified by Radical Change and Metafictive Devices and Techniques Identified by Postmodernism 43

10.1 Identification of Postmodern Picturebook Characteristics in *The Short and Incredibly Happy Life of Riley* 150

Acknowledgments

Our sincere appreciation to David Wiesner for the intriguing frontispiece.

Introduction
Postmodernism and Picturebooks

Sylvia Pantaleo and Lawrence R. Sipe

Historically, children's literature has reflected societal values, attitudes, and knowledge. Indeed, Bader described a picturebook as a "social, cultural, historical document" (1). Bakhtin's term, chronotope, is useful for understanding how literature reflects the time and space relationships in our world. Chronotopes can be used "as a means for studying the relation between any text and its times, and thus a fundamental tool for a broader social and historical analysis" (Holquist 113). Although not writing specifically about picturebooks, Kristeva emphasized that "texts cannot be separated from the larger cultural or social textuality out of which they are constructed" (Allen 36). Lewis also noted that throughout its history, social and cultural changes have impacted the ecology of the picturebook.

Various conceptual and theoretical frameworks have been proposed to explain the changes evident in contemporary children's literature. For example, Eliza Dresang's Radical Change theory recognizes how temporal and spatial relationships in society "have resulted in historically manifested narrative forms" in literature (Holquist 109), and she proposes that, "connectivity, interactivity and access in the digital world explain the fundamental changes taking place" in current children's and young-adult literature (Dresang 14). Other individuals have noted how the changes in contemporary literature for children and young adults reflect the broader historical, social, and cultural movement referred to as postmodernism (Coles and Hall; Goldstone, "Ordering the Chaos," "Whaz Up"; Lewis; McCallum; Yearwood).

Postmodernism is often used as a general term to describe the changes, tendencies and/or developments that have occurred in philosophy, literature, art, architecture, and music during the last half of the twentieth century. Flieger, and Coles and Hall, among others, have written about the confusion, vagueness, and lack of consensus that surround a definition of postmodernism. According to Hutcheon, postmodernism is "a critical revisiting, and ironic dialogue with the past" (4). Writing specifically about literature, Watson described postmodernism as "more of an extension of modernism than a reaction against it" (55). Flieger explained that differences in opinion on postmodernism originate from different views on modernism. He described four positions on postmodernism, "as reaction,

as denial, as residue, or as intensification of modernism" (28), and stated that these positions share five common beliefs about the characteristics of postmodernism. Two of these joint views relate to the discussion of most of the picturebooks in this book: "a questioning of the concept of originality, with an emphasis on citation, iterability, borrowings, intertextuality; [and] a ludic, ironic, or parodic quality corresponding in part to the uneasiness about legitimate or authoritative values" (29).

Hassan created a chart with contrasting terms to distinguish modernism from postmodernism. Several of the features or concepts associated with postmodernism are applicable to discussions about postmodern picturebooks: play, chance, anarchy, text/intertext, process/performance/happening, participation, combination, scriptable (writerly), and indeterminacy (99–100). Lewis also identified several key features that characterize living in the postmodern world: indeterminacy, fragmentation, decanonization, irony, hybridization, and performance and participation (88–91). Grieve wrote that, "ontological plurality or instability is the governing dynamic of postmodernism" (15). Similarly, Coles and Hall stated that one undisputed feature of postmodernism is its "rejection of unity, homogeneity, totality and closure" (114). Consistent with the spirit or tendency of postmodernism itself, many of the features identified above are synergistic and interrelated in nature.

Because writers and illustrators have been exposed to "the same postmodernizing influences as everyone else it would be reasonable to suppose that such influences might find their way into books" (Lewis 99). Indeed, two of the postmodern characteristics identified by Goldstone, "greater power given to the reader/viewer encouraging cocreation with the author or artist" and "nonlinearity" ("Whaz Up" 363), are most evident in the picturebooks discussed in this book. Postmodern fiction is "interested in the nature of fiction and the processes of storytelling, and it employs metafictive devices. for undermining expectations or for exposing the fictional nature of fictions" (Lewis 94). Waugh has identified various techniques authors use to create metafictional texts. Lewis described five strategies or devices evident in postmodern picturebooks (and novels): boundary breaking, excess, indeterminacy, parody, and performance (94–98). To Anstey and Bull, contemporary postmodern picturebooks exhibit the following characteristics: "variations in design and layout," "variations in the grammar of the author and illustrator," indeterminacy, contesting discourses, intertextuality, and multiple meanings and audiences (336–338).

Coles and Hall wrote about the breaking down of barriers, the playfulness and the "self-conscious, self-referential posture and style of postmodernism" (112). They explained how the "playfulness, parody, pastiche, and irony, as well as doubling, intertextuality and other metafictive devices" evident in postmodern texts are also exhibited in children's "cultural diet" of movies, television shows, computer and video games (112). Grieve also wrote about the innovative play of postmodern devices in postmodern picturebooks: "the use of metafiction; the manipulation of the whole physical space of a book;

parody and intertextuality" (16). Nikolajeva stated that many selections of contemporary children's literature are "exhibiting the most prominent features of postmodernism, such as genre eclecticism, disintegration of traditional narrative structures, polyphony, intersubjectivity and metafiction" (222).

The features of contemporary postmodern picturebooks identified by Watson are similar to those listed above. According to Watson, postmodernism literature

> extends the techniques of modernism: not only do we find multiple viewpoints, intertextuality, indeterminacy, breaking of genre boundaries, eclecticism, collage, but in postmodern works there is also a deliberate revealing of their constructedness (metafictive techniques) and a delight in games (in postmodernism criticism 'ludism' and 'ludic'). Postmodern discourses make great use of parody, pastiche, and surrealism, and there is a pervasive use of metafiction. (55)

To Watson, postmodern picturebooks "provide the most accessible examples of postmodern eclecticism: the breaking of boundaries, the abandonment of linear chronology, the emphasis on the constructedness of texts, the intermingling and parodying of genres" (55–56). McCallum also wrote about how metafiction writing has thrived within postmodernism and stated that common features of both postmodernism and metafiction include "narrative fragmentation and discontinuity, disorder and chaos, code mixing and absurdity" as well as openness, playfulness and parody (400).

Finally, synthesizing the work of several theorists, Sipe and McGuire identified six characteristics of postmodern picturebooks:

1. blurring the distinctions between popular and "high" culture, the categories of traditional literary genres, and the boundaries among author, narrator, and reader
2. subversion of literary traditions and conventions and undermining the traditional distinction between the story and the outside "real" world
3. intertextuality (present in all texts) is made explicit and manifold, often taking the form of pastiche, a wry, layered blend of texts from many sources
4. multiplicity of meanings, so that there are multiple pathways through the narrative, a high degree of ambiguity, and nonresolution or open-ended endings
5. playfulness, in which readers are invited to treat the text as a semiotic playground
6. self-referentiality, which refuses to allow readers to have a vicarious lived-through experience, offering instead a metafictive stance by drawing attention to the text *as a text* rather than as a secondary world (Benton)

As is evident by the above review of the literature, there is much overlap and commonality amongst those theorists and researchers who have written about the particular features or characteristics of postmodern picturebooks. Further, some of the postmodern characteristics described above are more encompassing (e.g., metafiction, blurring) and could subsume some of the specific postmodern attributes (e.g., parody).

With all of these varying (though related) perspectives, it is difficult to say with certainty the specific characteristics that are necessary in order for a picturebook to be classified as postmodern. However, if we did so, we would be creating a binary (postmodern—not postmodern) that is actually antithetical to the spirit of postmodernism itself. Therefore, we propose that, given the multiplicity of characteristics we discussed above, it makes more sense to think of picturebooks as located along a continuum of postmodernism. If a book exhibits one or two of the characteristics or qualities, we could say it expresses a few attributes of the postmodern picturebook. If a selection of literature has many of the characteristics or qualities, we would be more likely to classify it as truly postmodern. For example, in our view, a book that expresses virtually all of the qualities discussed above is *The Stinky Cheese Man and Other Fairly Stupid Tales* (Scieszka). Indeed, it is commonly considered to be one of the quintessential postmodern picturebooks (Stevenson 32). One the other hand, a book that is a parody of a traditional fairytale, such as *The Paper Bag Princess* (Munsch) exhibits only a few characteristics identified as postmodern and so would be located towards the opposite end of the continuum from *The Stinky Cheese Man*. Thus, we could use Scieszka's well-known book as a touchstone when considering the extent to which other picturebooks exhibit postmodern attributes.

In Margaret Meek's words, if "texts teach what [and how] readers learn," (3) we should expect that new types of texts would afford different opportunities for reading in new ways. Postmodern picturebooks are not, of course, the only new types of texts that have arisen in that past fifteen to twenty years. In today's society, most readers are familiar with hypertext, comfortable with all manner of digital formats, and understand the Internet as a multiplicity of (sometimes contradictory) texts that layer onto each other. In his study of the effects of popular culture, Johnson noted that, "multiple threading is the most acclaimed structural convention of modern television programming" (65). He stated that this increased narrative complexity of television shows and films requires viewers to hold multiple threads in their consciousness like a "kind of mental calisthenics" (129). These "new literacies" (Anstey) have contributed significantly to the changed nature of contemporary readers, who are now much more tolerant of the fruitful ambiguities of postmodern picturebooks. Readers are invited to generate multiple, often contradictory interpretations and to become coauthors in ways that traditional picturebooks do not offer, at least to the degree and intensity of postmodern picturebooks. Many of the contributors to this volume write cogently of the characteristics of these new readers, as well

as of the new conceptions of "self" that postmodernism engenders; and several authors report on how children of various ages react to postmodern picturebooks—with surprise, confusion, and ultimately, delight. All in all, these new books encourage a critical, active stance that celebrates a diversity of response rather than univocal interpretation.

David Wiesner's brilliant frontispiece for this book includes a line of fairytale characters "punching in" a time clock for their shifts. The three pigs read newspapers; a wolf holds a steaming beverage, following Grandmother, Red Riding Hood, and the Woodsman, as they await their turns to enter their stories and go to work. Red Riding Hood wears sneakers, but carries her "work shoes" in one hand and her signature cloak in the other. The newspaper headlines make ironic and trenchant comments about both our world and the world of fairy tales. Just visible along the right edge of the slightly opened book is a subtle intertextual reference to another character in Wiesner's own books: a frog from *Tuesday*. We believe that this visual image captures a great deal of what we have just described as the features of postmodern picturebooks: the blurring between story and real life; the playfulness, parody, and intertextuality that are so often present in postmodern texts; and the constructed artifice and the metafictive, self-referential qualities that are perhaps the most salient hallmarks of these unique types of picturebooks. Wiesner also gestures to the ambiguity, multiplicity of meanings, and open-ended nature of postmodern picturebooks, by prompting us to speculate on the "other lives" of storybook characters when they are not laboring to amuse, delight, and enlighten us in their tales. The tables are turned on us as readers: rather than identifying ourselves as "real" and stories as products of human creativity, the frontispiece prompts us to imagine the story characters as the truly real entities, while we desultorily while away our hours in casual reading.

OVERVIEW OF THE BOOK

Barbara Kiefer begins the book with an appropriate historical contextualization of picturebooks, tracing the development of postmodern characteristics and speculating on what lies ahead in the development of this protean and ever-changing art form.

As an illustrator of children's books, Martin Salisbury provides a unique perspective, suggesting that labels such as "postmodern" are less important considerations to artists than the work itself. He argues that many derivative picturebooks often result from truly innovative work; that the whole concept of postmodern picturebooks deserves critical examination; and wonders if the postmodern picturebook has a long and rich future, or whether it will disappear into an artistic void.

Eliza Dresang discusses how Radical Change theory and postmodernism identify many of the same elements in contemporary picturebooks, but

each offers different explanations for the changes in children's books that are evident since the early 1990s.

Using Scandinavian postmodern picturebooks, Maria Nikolajeva explores the essential playfulness of these texts, with their embodiments of forms that gesture toward conventions even as they subvert them, and the pleasure of puzzling through multiple layers of meaning and ambiguity.

Karen Coats's chapter intriguingly develops the idea of the "transmodern," distinguishing it from the postmodern, and argues that postmodern picturebooks are better theorized by this construct than by ideas of the postmodern, which always carry with them a nihilistic and oppressive element.

Through an examination of five Australian picturebooks, which in some sense can be described as postmodern, John Stephens explores how the dialogue between internationalism and local concerns has produced a glocal version of postmodernism, what he calls a postmodern hybridization.

As well as discussing the postmodern qualities of six picturebooks that play with and interrogate their own conditions of existence, Margaret Mackey explores the potential of these texts to teach children about reading in postmodern times.

In her chapter, Bette Goldstone reflects on the reconceptualization of the concept of space in postmodern picturebooks, concluding that they experiment with, expand, and question our fundamental notions of what constitutes real and imagined realities.

Christine Hall contrasts picturebooks that she does not consider to be postmodern with others that do have postmodern characteristics, and argues that postmodern picturebooks have the potential to stimulate children's imaginations in new ways that are sorely needed in a time when concerns have been expressed about the seeming sterility of children's creative energies.

In her chapter, Michèle Anstey discusses heuristics for exploring postmodern picturebooks from an ethnographic perspective. She presents tools for readers to use as they engage in an "archaeological dig" of postmodern picturebooks as historical artefacts.

Susan Lehr's chapter focuses on one author/illustrator—Lauren Child—to analyze the postmodern elements in Child's work, ranging from the nature of her bricolage/collage illustrations to her metafictive and intertextual plot devices.

Through a discussion of several metafictive fairy tale picturebooks, Robyn McCallum discusses the interrelationships among four postmodern strategies that draw attention to the fictional nature of a picturebook: overt intertextuality; inversion of the narrative voice; metaleptic disruptions to the diegetic level of narration; and modal contrasts and disruptions within the pictorial discourse.

The final four chapters of the book focus on children's responses to postmodern picturebooks; a number of these books have been analyzed in previous chapters. Caroline McGuire, Monica Belfatti, and Maria Ghiso

report on third graders (eight-year-olds) puzzling their way through the intricacies and ambiguities of *Bad Day at Riverbend* (Van Allsburg), *Shortcut* (Macaulay), and *Voices in the Park* (Browne) with minimal scaffolding from the teacher. Evelyn Arizpe, Morag Styles, and three graduate students share some of the findings from their research that explored readers' reactions to selected postmodern picturebooks. In particular, they focus on the many forms of playfulness within the metafictive texts themselves, as well as the behavior of the children (ranging in age from five- to eleven-years-old), including their performative physical responses and their articulation of intertextual references. Lawrence R. Sipe's chapter is a case study of a class of first graders (six-year-olds) attempting to fit David Wiesner's *The Three Pigs* into their well-developed schema for this tale; their realization that their preconceived notions of how the story should proceed are not working; and their eventual radical expansion of their idea of a *Three Pigs* story in the light of Wiesner's postmodern text. Finally, Sylvia Pantaleo's chapter focuses on *The Getaway* by Ed Vere. As well as describing the metafictional character of this postmodern picturebook, she discusses third and fourth grade (eight- and nine-year-old) students' responses to and interpretations of this text, noting how Vere's playful text contributed to the children's literary understanding and appreciation.

WORKS CITED

Allen, Graham. *Intertextuality*. New York: Routledge, 2000.

Anstey, Michèle. "'It's Not All Black and White': Postmodern Picturebooks and New Literacies." *Journal of Adolescent and Adult Literacy* 45.6 (2002): 444–457.

Anstey, Michèle, and Geoff Bull. "The Picture Book: Modern and Postmodern." *International Companion Encyclopedia of Children's Literature: Volume 1*. 2nd ed. Edited by Peter Hunt. New York: Routledge, 2004. 328–339.

Bader, Barbara. *American Picturebooks from "Noah's Ark" to "The Beast Within."* New York: Macmillan, 1976.

Bakhtin, Mikhail. *The Dialogic Imagination*. Translated by Caryl Emerson and Michael Holoquist. Austin, TX: University of Texas Press, 1981.

Benton, Michael. *Secondary Worlds: Literature Teaching and the Visual Arts*. Buckingham, UK: Open University Press, 2002.

Coles, Martin, and Christine Hall. "Breaking the Line: New Literacies, Postmodernism and the Teaching of Printed Texts." *Reading: Literacy and Language* 35.3 (2001): 111–114.

Dresang, Eliza. *Radical Change: Books for Youth in a Digital Age*. New York: The H.W. Wilson Company, 1999.

Flieger, Jerry. *The Purloined Punch Line: Freud's Comic Theory and the Postmodern Text*. Baltimore, MD: The John Hopkins University Press, 1991.

Goldstone, Bette. "Ordering the Chaos: Teaching Metafictive Characteristics of Children's Books." *Journal of Children's Literature* 24.2 (1998): 48–55.

———. "Whaz Up With Our Books? Changing Picture Book Codes and Teaching Implications." *The Reading Teacher* 55.4 (2001/2002): 362–370.

Grieve, Ann. "Postmodernism in Picturebooks." *Papers: Explorations into Children's Literature* 4.3 (1993): 15–25.

Hassan, Ihab. "Toward a Concept of Postmodernism." *Revolutions of the Word: Intellectual Contexts for the Study of Modern Literature.* Edited by Patricia Waugh. New York: Arnold, 1997. 95–101.

Holquist, Michael. *Dialogism: Bakhtin and his World.* New York: Routledge, 1990.

Hutcheon, Linda. *A Poetics of Postmodernism: History, Theory, Fiction.* New York: Routledge, 1988.

Johnson, Steve. *Everything Bad is Good for You: How Today's Popular Culture is Actually Making us Smarter.* New York: Riverhead Books, 2005.

Lewis, David. *Reading Contemporary Picturebooks: Picturing Text.* New York: RoutledgeFalmer, 2001.

McCallum, Robyn. "Metafictions and Experimental Work." *International Companion Encyclopedia of Children's Literature.* Edited by Peter Hunt. New York: Routledge, 1996. 397–409.

Meek, Margaret. *How Texts Teach What Readers Learn.* Stroud, UK: Thimble Press, 1988.

Nikolajeva, Maria. "Exit Children's Literature?" *The Lion and the Unicorn* 22.2 (1988): 221–236.

Sipe, Lawrence R., and Caroline E. McGuire. "*The Stinky Cheese Man* and Other Fairly Postmodern Tales for Children." *Shattering the Looking Glass: Challenge, Risk, and Controversy in Children's Literature.* Edited by Susan Lehr. Norwood, MA: Christopher-Gordon Publishers, forthcoming.

Stevenson, Deborah. "'If you read this sentence, it won't tell you anything': Postmodernism, Self-referentiality, and *The Stinky Cheese Man.*" *Children's Literature Association Quarterly* 19.1 (1994): 32–34.

Watson, Ken. "The Postmodern Picture Book in the Secondary Classroom." *English in Australia* 140 (2004): 55–57.

Waugh, Patricia. *Metafiction: The Theory and Practice of Self-conscious Fiction.* New York: Methuen, 1984.

Yearwood, Stephenie. "Popular Postmodernism for Young Adult Readers: *Walk Two Moons, Holes* and *Monster.*" *The ALAN Review* 29.3 (2002): 50–53.

CHILDREN'S LITERATURE CITED

Browne, Anthony. *Voices in the Park.* London: Picture Corgi Books, 1998.

Macaulay, David. *Shortcut.* Boston, MA: Houghton Mifflin, 1995.

Munsch, Robert. *The Paperbag Princess.* Toronto: Annick Press, 1980.

Scieszka, Jon. *The Stinky Cheese Man and Other Fairly Stupid Tales.* New York: Viking, 1992.

Van Allsburg, Chris. *Bad Day at Riverbend.* Boston: Houghton Mifflin, 1995.

Vere, Ed. *The Getaway.* London, UK: Puffin Books, 2006.

Wiesner, David. *Tuesday.* Boston: Houghton Mifflin, 1991.

Wiesner, David. *The Three Pigs.* New York: Clarion Books, 2001.

1 What is a Picturebook, Anyway?
The Evolution of Form and Substance Through the Postmodern Era and Beyond

Barbara Kiefer

So, what *is* a picturebook? For much of the twentieth century a picture-book was an artifact of culture that contained visual images and often words. Pictures and words were printed on paper and bound between hard board covers. Picturebooks most generally consisted of thirty-two pages of story, poem, or concept but they included endpapers, information about the book, author, artist, and publisher as well. For most of the century the picturebook was created for the enjoyment of an audience of young children with the object of engaging them in a pleasurable experience. The picturebook's material content reflected societal norms and its physical form was the result of the printing technology available to produce and sell it.

Various scholars have explored the essence of the modern picturebook. In her historical study of American children's picturebooks that focused mainly on the twentieth century, Barbara Bader provided an expansive definition:

> A picturebook is text, illustrations, total design; an item of manu-facture and a commercial product; a social, cultural, historical docu-ment; and foremost an experience for a child.
>
> As an art form it hinges on the interdependence of pictures and words, on the simultaneous display of two facing pages, and on the drama of the turning page. (1)

Many others have built upon or extended Bader's definition. Nodelman and Reimer classify picturebooks as forms of literature and provided a thoroughly developed scheme for how pictures provide information about stories. "Pictures can help people of all ages to understand words" (277). Nodelman also suggests that the relationship between pictures and text is always an ironic one; that is, "the words tell us what the pictures do not show, and the pictures show us what the words do not tell us" (222). Nikolajeva and Scott underscore the dual quality of images and words when they state, "The unique character of picturebooks as an art form is based on a combination of two levels of communication, the visual and the verbal" (1).

Illustrator Uri Shulevitz emphasizes the primacy of the visual art in picturebooks. He argues "A true picturebook tells a story mainly or entirely with pictures. When words are used they have an auxiliary role" (15). Marantz sees the picturebook as unique art form and argues, "picturebooks are not literature, that is, word dominated things, but rather a form of visual art. The picturebook must be experienced as a visual/ verbal entity if its potential values are to be realized" (151).

Sipe describes the relationship between text and pictures as "synergistic." He analyzes the interplay that occurs between pictures and words in picturebooks and shows how that transaction becomes more complex as we read through the book: "Each new page opening presents us with a new set of words and new illustrations to factor into our construction of meaning" (106). Sipe also argues that "visual texts are on an equal footing with verbal texts" in this process (107).

Many of these scholarly analyses seem to imply that in picturebooks words and pictures are always present in the service of a story. If we accept Bader's definition then we must also acknowledge many other categories of books that are generally found on shelves along with picture storybooks. These include alphabet and counting books, "toy" books, concept books, information books, and, of course, wordless books. Most important, however, is the agreement among all these scholars that images and words work in tandem and the emphasis that the picturebook is an art form rather than a teaching tool. The use of this term "art form" then leads to a second question.

WHAT IS AN ART FORM?

All these definitions seem to recognize the picturebook as an art form or object rather than utilitarian object. Suzanne Langer has argued that the arts—literature, music, drama, dance, pictorial art—evolved out of their unique potential to express meaning that discursive language is not capable of on its own. Each art form relies on symbols and structures that create meaning in different ways. To utter the statement, "War is terrible," cannot adequately express the range of human experience of war or help us comprehend its scope. However, listening to Brahms's *A German Requiem*, viewing Picasso's *Guernica*, or reading Toshi Maruki's picturebook *Hiroshima No Pika,* can give each of us an opportunity to know more deeply and feel more intuitively what war has meant to humanity over the centuries. Each of these art forms use different symbol systems, organized in unique ways. Picasso's work exists on a single two- dimensional picture plane, while Brahms's and Maruki's works are built as we experience them over time. Our individual experience with Brahms or Picasso or Maruki's work is unique, something magical and personal, one that will change with each encounter, "each time a little different as metaphors grow richer" (Marantz 151).

I would agree with all those cited above, that the picturebook is first and foremost an art object. Most broadly it is the combination of image and idea presented in sequence whose creation is grounded in three ways. An artist creates the art object for an audience. Over our human history the artist, the audience, and the object have been influenced by society, culture and technology. What has stayed constant is that an aesthetic experience arises from images and ideas combined in some complete form when an audience brings to it intellectual and emotional understandings.

THE FIRST PICTUREBOOKS

If we accept this idea of the picturebook as one in which participants engage both intellectual and emotional resources with a visual/verbal art form, I believe we can trace the first picturebooks back thousands of years. Rock paintings in the Chauvet Pont de Arc caves in southern France date back at least thirty thousand years, and similar paintings have been found throughout the world. Although the cave paintings do not resemble today's picturebook, they may represent a similar aesthetic process. Using the products of technology available (there was of course no paper, no written alphabet, no printing presses or book binderies), an artist created a visual form that was probably shared with an audience in some ritualistic way, accompanied by a story told or by chants sung.

The paintings were possibly a result of a cultural need—the need to represent through image and myth the basic aspects of survival of the individual and the race. The rituals surrounding the cave paintings were probably social (Campbell 311). Campbell speculates that the paintings were not experienced in solitary but as part of a group ceremony and interaction. There is reason to believe that these "stories" were retold again and again, for, in places, the images are painted on top of earlier images indicating a repeated "reading" or reexperiencing of the art form. Thus, these technological, cultural and social underpinnings provide the basis throughout history for the individual's response to image and idea now found in the picturebook.

FROM CAVE WALLS TO PAPYRUS SCROLLS

As a result of the development of written systems around 4100–3800 BCE, we begin to find objects that more closely resemble today's picturebooks and we can understand their form, function, and audience more precisely. The first objects that had the attributes associated with a modern picturebook emerged in Egypt around 2700 BCE. Around this time people of the Mesopotamian region were using marks pressed into wet clay, and the Chinese were writing on long strips of bamboo or wood. In Egypt, the

development of papyrus, made from stems of a plant that grew along the Nile River, provided a technological advance that gave the Egyptians an advantage over other Middle and Far Eastern societies. The papyrus scrolls were much more easily transported and stored than the unwieldy wood or clay tablets, and were nonperishable in the dry desert climate. The availability of papyrus scrolls, and cultural tradition of Egyptian visual art, led to an art form that combined written language with pictorial images.

These papyruses, especially those referred to as the *Book of the Dead*, combined pictorial image and verbal story. On many of these scrolls, the pictorial images are predominant while the words are part of the overall composition and are pleasingly balanced and integrated with the images. The scrolls are meant to be read in a sequence rather than viewed as a single entity thus allowing, just as with modern picturebooks, for an aesthetic experience that evolved in sequence over time. The placement of pictures and words is remarkably similar to what we see in today's picturebooks. Often what appears to be a decorative border accompanies the central scene, anticipating the beautifully designed borders of the illuminated books of the Middle Ages or the modern-day picturebooks of artists such as Jan Brett or Trina Schart Hyman. The subjects of these scrolls were often religious; they were meant as a guide into the world after death. However, enough material has survived the great fires in the library at Alexandria to suggest that animal fables, astronomy, magic, satire, and erotica also provided the content for papyrus scrolls.

A NEW BOOK FORM

Around the first century CE a new technological invention, the codex, changed the picturebook into the form we still have today. Based on the multi-leaved clay tablets used in Greece and Rome at the time, this technique allowed bookmakers to cut pieces of papyrus or parchment into sheets, which were folded and sewn together in the fold, then bound with thin pieces of wood covered with leather. The codex was much easier to use than scrolls. It allowed both sides of the page to be used thus saving space. It also made it easier for the readers to find specific places in a text more quickly. Moreover, the codex changed layout and design in books. A full-page, framed illustration—sometimes alone, sometimes facing a page of printed text—was the result of this form. The invention of the codex, according to Harthan, "affected book production as profoundly and permanently as did the invention of printing in the mid-fifteenth century" (12).

The codex also allowed a wider range of style and media to be used in the illustrations. Since layers of paint would crack when rolled and unrolled, rolled scrolls were executed mostly with line drawings. In addition, papyrus rapidly disintegrated in the Mediterranean climate beyond Egypt. As

the new codex form moved north and west papyrus was replaced by parchment or vellum, made of animal skins. The codex form and the parchment page made possible the use of rich colors, including gold, for illustrations.

It should be noted that following the development of the codex, today's picturebooks evolved out of the European traditions. However, the combination of image and idea developed in other cultures as well, from China to South America to the Middle East. As it did in Europe, the book form became central to Islam. However, religious strictures of Islam led to the development of the art of calligraphy and decoration rather than of imagery. Therefore, although the decorative forms of Islamic art might influence Western traditions, the art of pictorial story telling was nurtured by societal and cultural norms of European cultures.

In the West, as the Roman Empire drew to a close, the picturebook form survived due to the needs and husbandry of the Christian Church which preserved the book form through the Dark Ages. One of the Church's purposes was to further the spread of Christianity and to convert pagans by spreading the Christian message. Because each book was created by hand, the Church became responsible for creating copies of the religious documents that could be sent through the developing Christian world. Visual imagery in these manuscripts was important for several reasons. The vast majority of new converts were illiterate. Visual images in sacred books allowed a universal reading of the Christian message. In addition, these books were meant to inspire religious awe among new converts. Thus, the combination of image and word became an essential form of art in the Christian world.

For some time styles of book illustration developed in two major European centers. In the Byzantine Empire, books relied on Greco-Roman style, which gradually merged into the stylistic, uniform pictorial symbols of early Christian art. During this same time, book illustration in England and Ireland evolved in an independent school, called insular. These insular manuscripts reflected styles and motifs of Celtic art that survived in the British Isles through the first millennium. The illustrations in these manuscripts were predominately ornamental and included interlacing, beast ribbon designs, and spiral patterns such as those found in the *Book of Kells* (800 CE) or the *Lindisfarne Gospels* (690 CE). In these books a visual story was sublimated to visual decoration; very few portraits or landscapes appear aside from stylized portraits of saints. Gradually these two artistic styles began to intermingle and change as Charlemagne sought to unify his empire in the latter part of the ninth century. As a result, the artistic traditions in the Irish and English manuscripts began to merge with classical forms from the East. By the tenth century Western illustration was becoming more individualized and dynamic as well as more elaborate.

It was common in the Middle Ages to put the Old and New Testaments into separate sections. Thus, the types of manuscripts that developed for use in religious services included Gospels, Psalters, Lectionaries, and Graduals.

Specific iconography and patterns of composition were found in each of these different forms. By the twelfth century the content of illuminated manuscripts, while still sacred, expanded into books popular with lay populations. Books of Hours began to be used for private devotions of the wealthy. Along with biblical passages and devotions, these books always included calendars to mark important religious days throughout the year. It became a tradition to divide the calendar into the twelve months of the year and to illustrate each month with a scene of secular life. Pictures of the patrons who commissioned these books were often included in Books of Hours thus freeing the illustrator to move beyond previously prescribed styles and subject matters. Illustrated versions of the Apocalypse also became popular and gave even more freedom to the imagination of the artist.

Beginning in the thirteenth century several forms were developed that are visually similar to today's picturebooks in their page design and balance of image and word. These include the Bible Moralise, Bible Pauperum, and Bible Histoire. These often had short biblical passages and commentaries with allegorical lessons and emphasized the connections between the Old and New Testaments. The British Library owns a Bible Pauperum that is remarkably similar to a picturebook of today. The book is unusual first for its presentation. Rather than the typical vertical orientation of medieval manuscripts which resulted from the folded gatherings of parchment, the Kings V is horizontal, the result of gluing three pieces of parchment together. Only the right-hand half of each double-page spread is illustrated as if to focus viewer's attention on a single message. The central section holds the largest painting, a depiction of a major scene from the life of Christ. Taking up about two-thirds of the central section, the picture is framed by a rectangular, decorated border. Flowing banners on three sides carry important ideas pertaining to the picture, accompanied by smaller faces of important saints. Underneath the paintings a paragraph of explication is printed in three different colors. The left and right sections of the page also contain brief colored paragraphs of text and bordered biblical scenes. These depict stories from the Old Testament that presage the New Testament event. Like the Egyptian *Book of the Dead* or a modern picturebook, the Kings V is a notable integration of image and text.

During the early Middle Ages, although the work of bookmaking centered in the Church on religious texts, church scribes also preserved and illustrated secular works. In the thirteenth century, as forms of religious texts were developing and expanding, the picturebook began to move beyond monastery walls into the province of the secular world. Universities and a more widely literate populace increased the demand for books. This trend led to the illustration of many more secular texts—histories, epic poems, and romances—and to the expansion of book production to a secular commercial enterprise.

Harthan argues that "after the long near monopoly of religious subjects, illustration was at last becoming popular, instructional, and recreational in a manner we can recognize as anticipating modern attitudes"(48). With this shift of focus, the illustrations in books began to reflect the real world of the time along with more realistic portrayals.

The Middle Ages can be said to represent a golden age for the picture-book as an art object. This golden age reached its zenith in the first half of the thirteenth century. At this time the picturebook and its interplay of image and word was truly an art object of great significance to society. The artists who created the images began to be named and known, often traveling from place to place to create the most elaborate of the images that appeared. Working under contract, they were supported by a publishing "industry" that included parchment makers, book binders, and other artists who prepared the lesser decoration. Because they were created by hand, picturebooks reached a small adult audience of the clergy and upper classes who could afford to commission and purchase them. Children would not be part of that audience for another two hundred years.

A NEW TECHNOLOGY

Several major technological advances took place during the Middle Ages that affected book availability and production. The first was the development of paper, which may have spread to Europe from China through Islamic countries. This material was not as strong as parchment but it was much cheaper and by the thirteenth century methods of paper production were being perfected by such firms as Fabriano in Italy. At about the same time, inks the proper consistency for woodblock printing were developed, as was a method of printing in which letters and pictures were cut into a single block. The great revolution in book production, however, came with the invention of the printing press with movable type during the 1450s. This invention signaled the end of the hand-illuminated book and the beginning of picturebook making as a commercial rather than a purely aesthetic process. In fact, the early printers were probably not as much concerned with the beauty of the finished product as they were with making a profit.

The advent of a method by which books could be mass-produced quickly, on fairly inexpensive paper for a wider, less privileged audience, further supports the argument that the nature and audience of the picturebook changes as a result of social, cultural, and technological changes. This period in history, which saw the rise of the middle class as well as a more even distribution of wealth and power, was reflected by the turn toward secular subject matter. Among the titles of these first mass-produced books are Boccaccio's *Decameron* and Aesop's fables.

The illuminated book did not, of course, disappear overnight; it coexisted for many years with typeset forms. Initially, too, the mass-produced

picturebook searched for an identity of its own and perhaps for an audience. The plates printed on the presses were often cast to resemble handwritten books. Other mechanically printed books were illustrated by hand even though the woodblock was widely known and ideally suited to the typeset text. At other times, the wood-block was used for illustrations, but only to produce the simplest of outlines, which were then colored in by hand. Eventually the standards of beauty set by the illuminated manuscripts were set aside for the expediency of print making. Caxton's *Mirrour of the World*, an illustrated encyclopedia, was printed in 1481. Its simple woodcut pictures set within the longer printed text is typical of book design and illustration that followed the advent of movable type for many years.

PICTUREBOOKS FOR CHILDREN

We have seen that prior to the sixteenth or seventeenth century picturebooks were created for an adult audience. Although children of the upper classes may have seen illuminated manuscripts and enjoyed their beauty they were not considered a group apart, separate from adults in entertainments or other artifacts of culture as they are today. Aries for example, explains that the artists of "the tenth and eleventh centuries did not dwell on the image of childhood, and that that image had neither interest nor even reality to them" (34). Aries speculates that this may have been due to the terrible toll taken by disease in these dark ages. However as the infant mortality rate began to improve and as the middle classes began to own books, the interest in educating children grew. Books began to be created specifically for their use—alphabet books, catechisms, and so on. Because these were books of instruction they included many pictures.

Although alphabet books created to teach children Hebrew had been found in Egypt and date from a much earlier time, the first children's picturebook is generally accepted to be the *Orbis Pictus*, an alphabet book intended to "entice witty children." Published in 1658, by John Amos Comenius as *Orbis Sensualium Pictus, (The Visible World in Pictures)*, it might more accurately be called the first basal reader because Comenius's aim was to teach, not to entertain. The *Orbis Pictus* became a popular model for other books for children. Each page contained one or two black-and-white woodcut prints, with brief text accompanying it. Often the text described the content of the picture rather than working with it a "synergistic" way (Sipe). Chapbooks, cheaply made and sold, were the only access children of the time had to picturebooks that provided entertainment. Although they often contained popular tales like "Jack the Giant Killer" and "Robin Hood," these were generally created for an audience of adults.

By the 1700s, however, ideas of the Age of Enlightenment and of philosophers such as John Locke began to influence the types of picturebooks that were created for children. Locke believed that once children were taught to

read they should read for pleasure. The changing view of childhood and the continuing success of chapbooks and collections of fairy tales and fables convinced British publisher John Newbery to print books for children, solely for their amusement. His *A Little Pretty Pocket Book*, published in 1744, opened the way for today's literature for children—picturebooks and other books that were aesthetic objects rather than educational ones.

As book publishing for children became a thriving industry, advances in printing techniques allowed a wider range of illustration and began to attract a great many accomplished artists. Until the late 1700s illustrations in books were created with woodcuts or wood engravings, or etchings on metal plates. The somewhat delicate nature of this media, especially wood, made it difficult to produce thousands of copies of books needed for sale to a mass audience. Simple line drawings meant that new blocks of original art could be engraved to replace those worn with use. Although very fine black-and-white prints were created using these processes, the most accomplished print artists rarely created illustrations in books for children.

Variations on engraving or etching techniques were used in picturebooks well into the 1800s until lithography was developed by Aloys Senefelder in 1798. In this process, a design is drawn or painted onto a smooth stone with a waxy substance, much like drawing on paper with a crayon. Lithography made possible the printing of a much more painterly style of illustration and signaled the development of ever more refined and efficient modes of reproduction.

As printing techniques improved, illustrated newspapers and magazines became popular and began to attract talented artists such as Edward Lear, John Tenniel, Richard Doyle, and Habblot "Phiz" Brown. Magazines such as *Punch,* which first appeared in 1849, were meant to provide satirical and political comment and in turn allowed the artists to be playful rather than formal in depiction. Tenniel, Doyle, Brown, and others were commissioned to provide illustrations for children's books and raised the bar on excellence in illustration for children.

Through the end of the nineteenth century the subject matter children's picturebooks continued to center on were nursery rhymes, folktales, and songs. The illustrations, although delightful, were accompaniments to the texts, not integral to the picturebook as an art object. However during this time we can notice more attention being paid to the holistic nature of book design. For example, illustrator Richard Doyle created twenty-two engravings for John Ruskin's fifty-eight-page *The King of the Golden River or The Black Brothers: A Legend of Stiria*, first published in 1851. In addition to the illustrations, Doyle created a remarkable title page to reflect the book's content and theme. Here a landscape of the book's characters in their mountain setting is framed on three sides by a tree limb border that gives way to flowing branches at the top of the page. Below these curling branches, the words *The King of the Golden River* are hand lettered to resemble bare tree branches and the other words of the title are also hand

drawn. This hand-drawn lettering device is worked into the illustrations and first word for subsequent chapter's opening illustrations. This attention to the integrated nature of the design of the total book was certainly prelude to book design of the twentieth century.

For much of the nineteenth century the search for effective and inexpensive color reproduction was paramount. Aside from studio experiments like the colored etchings of William Blake, color had to be added to prints by hand, using brush or stencil. The credit for achieving color reproduction for a large market must go to publisher Edmund Evans. By the 1860s, Evans, an artist himself, made a real effort to refine the process of color printing. Alderson suggests:

> There is no gainsaying the care which Edmund Evans gave to the early print-runs of his picturebooks, if not always the later ones. The "clever artist" in him recognized the need for printing techniques to match the illustrator's work as closely as possible and he was one of the pioneers in applying photographic processes to the preparation of woodblocks. He was also sensitive to colour-values and how they could be mingled through the overprinting of tints, and he exercised great care in his choice of pigments for his inks. (75)

With this attention to detail, Evans enlisted accomplished artists like Walter Crane and Kate Greenaway to create works especially for children. In their books, often collections of nursery rhymes or songs, we see a real interaction between pictures and words in addition to pleasing color reproduction and total book design. In 1878 Randolph Caldecott worked with Evans to create *The Diverting History of John Gilpin,* the first of his many popular books for children. Of the three illustrators, Caldecott's lively and humorous art raised his status above Crane's highly decorative and Greenaway's preciousness, so that he is considered by many to be the father of the modern picturebook.

Thanks to Evans's techniques in England, the field of illustration for children would go on to attract now-legendary figures that included Beatrix Potter, Arthur Rackham, Leslie Brooke, and Ernest Shepard, while America would give us Howard Pyle, N.C. Wyeth, and Jessie Wilcox Smith. In 1927, *Clever Bill* was written and illustrated by English artist William Nicholson and was followed in 1928 by American illustrator Wanda Gag's *Millions of Cats.* These stories were told with very little text and relied heavily on the illustrations to convey meaning, a format that predominates in children's picturebooks through much of the twentieth century. Their publication marked a new era of picturebook publishing.

By the early 1900s techniques such as offset printing, in which an image was transferred to the printing plate by photographic negative, had replaced hand-colored engravings as the method for translating original art to the printed page. For a full-color book, even the streamlined processes of offset

printing often required many tedious hours of color pre-separation on the part of the artist, and full color was still expensive to reproduce. For this reason, many books were done in black and white or in only two or three colors well into midcentury. Even so, illustrators like Virginia Lee Burton, Wanda Gag, Clement Hurd, Robert McCloskey, Esphyr Slobodkina, Lyn Ward, and Leonard Weisgard produced picturebooks that are still in print today, and serve as examples of innovative techniques and vibrant imagination.

For the greater part of the twentieth century the content of picturebooks was shaped by societal beliefs about the needs of an audience of young children. Simple stories that reflected notions of child development were created for this (mostly white) audience along with alphabet and counting books, concept books, and traditional tales. This focus on young children began to change in the 1960s as the Vietnam War opened up previously taboo topics and as the civil rights movement called for an expansion of cultural experiences depicted in picturebooks. Artists such as Raymond Briggs and Maurice Sendak began to manipulate format and to push content beyond the protective walls of childhood innocence. In addition, new techniques in laser printing streamlined the process of book production and allowed the picturebook to continue to develop as an art form. Now, almost any original medium can be reproduced in the pages of picturebooks. This simplification of process seems to have attracted more and more artists who have discovered the picturebook as a challenging medium for their talents and who seem to be more interested in the possibilities of visual storytelling rather than in providing entertainment to an audience of young children. Thus changing technology, societal, and cultural norms have brought us into a new century and a postmodern era.

CONCLUSION

My purpose in writing this chapter has not been to detail the history of children's picturebooks in the twentieth century or to provide a scheme for analyzing the visual/verbal interactions inherent in the picturebook as an art object. Others, including myself, have undertaken that task in other venues.[1] Instead, in looking at picturebooks in a historical context I have sought to provide a context for understanding picturebooks in the postmodern era.

The picturebook has changed over time due to social, cultural, and technological factors. The greatest changes have occurred in the physical makeup of the art object that is the picturebook and in the type of audience that responds to this form. The aesthetic interaction between image and idea has changed in form from cave wall to papyrus scroll to illuminated manuscript to printed book. We should not be surprised that new forms continue to emerge. Sylvia Pantaleo and Lawrence R. Sipe have discussed various theoretical perspectives on postmodern picturebooks in the Introduction to this

book. Other authors will explore these perspectives in more depth in subsequent chapters.

Through the centuries, the artist's role has been to understand the needs of society and, using the technology at hand, to convey some meaning through the pages of a picturebook. Throughout the years the creators of picturebooks have been people who had some inner need to tell about their world through pictures, to respond to societal needs but also to push the boundaries of visual depiction. Play, a sense of irony, subversion of convention and other aspects of the postmodern picturebook can be found in many eras. A papyrus scroll in the British Museum dates from approximately 1295 BCE. In wordless format a group of animals with clearly humorous aspects engage in human behaviors such as making music and playing board games. A Book of Hours owned by the Morgan Library includes a border showing an upstanding rabbit doctor holding a urine sample and preparing for a visit from two dogs on crutches (Wilson 27). Indeed, the margins of sacred manuscripts of the Middle Ages contain images of imps, monsters, monkeys, and humans engaged in activities of a very earthy sort. They "play within and against the most elevated and transcendent forms" (Camille 55), just as today's picturebook artists play with and against tradition.

What seems clear is that picturebooks will continue to evolve and change, but that the powerful partnership of image and idea will continue to delight human audiences of all ages and to attract artists to explore the human condition. The graphic novel format, for example, has allowed artists and authors to move beyond traditional boundaries of both the comic strip and the picturebook. In 2007 Shaun Tan used the strip format in a 128-page wordless book, *The Arrival*, and Brian Selznick integrated images into *The Invention of Hugo Cabret* in an entirely new format—images separated from words yet essential to our aesthetic experience of the text. I believe we can expect similar blurring between forms and formats in the future. The picturebook has remained a vital art object that speaks to our imagination. We will continue to respond to it, in what ever future form it takes, "with the deepest reaches of our emotions as well as our intellect" (Kiefer 70).

NOTES

1. See, for example, Alderson, Bader, Kiefer, McCloud, Moebius, Nodelman, Sipe, and others.

WORKS CITED

Alderson, Brian. *Sing a Song of Sixpence: The English Picture Book Tradition and Randolph Caldecott*. Cambridge, UK: Cambridge University Press, 1986.
Ariès, Philippe. *Centuries of Childhood: A Social History of Family Life*. Translated by Robert Baldick. New York: Knopf, 1962.

Bader, Barbara. *American Picturebooks: From "Noah's Ark" to "The Beast Within."* New York: Macmillan, 1976.

Camille, Michael. *Image on the Edge: The Margins of Medieval Art.* Cambridge, MA: Harvard University Press, 1992.

Campbell, Joseph. *The Masks of God: Primitive Mythology.* New York: Viking Penguin, 1986.

Harthan, John. *The History of the Illustrated Book: The Western Tradition.* New York: Thames and Hudson, 1981.

Kiefer, Barbara. *The Potential of Picturebooks: From Visual Literacy to Aesthetic Understanding.* Columbus, OH: Merrill, 1995.

Langer, Suzanne K. *Feeling and Form.* New York: Charles Scribner & Sons, 1953.

———. *Philosophy in a New Key.* Cambridge, MA: Harvard University Press, 1942.

McCloud, Scott. *Understanding Comics: The Invisible Art.* New York: Harper-Collins, 1993.

Marantz, Kenneth. "The Picture Book as Art Object: A Call for Balanced Reviewing." In *Signposts to Criticism of Children's Literature*, edited by R. Bator, 152–155. Chicago: American Library Association, 1983.

Moebius, William. "Introduction to Picturebook Codes." *Word & Image* 2.2 (1986): 141–152.

Nikolajeva, Maria, and Carole Scott. *How Picturebooks Work.* New York: Garland, 2001.

Nodelman, Perry. *Words about Pictures: The Narrative Art of Children's Books.* Athens, GA: The University of Georgia Press, 1988.

Nodelman, Perry, and Mavis Reimer. *The Pleasures of Children's Literature.* Boston: Allyn and Bacon, 2003.

Shulevitz, Uri. *Writing with Pictures: How to Write and Illustrate Children's Books.* New York: Watson-Guptill, 1985.

Sipe, Lawrence R. "How Picturebooks Work: A Semiotically Framed Theory of Text-Picture Relationships." *Children's Literature in Education* 29 (1998): 97–108.

Wilson, Elizabeth B. *Bibles and Bestiaries: A Guide to Illuminated Manuscripts.* New York: Farrar Straus & Giroux, 1994.

2 The Artist and the Postmodern Picturebook

Martin Salisbury

A few years ago, the American editorial illustrator Brad Holland contributed a wonderfully subjective, ironic chapter to Steven Heller and Marshall Arisman's edited book, *The Education of an Illustrator*, in which he roared through the history of art by means of a "glossary of terms" that covered not only all of the major movements in Art and Design, but some basic terms for the layman. Holland's helpful explanation of the oft heard expression, "That's not Art, that's Illustration" is in the form of a splendid rant:

> Everybody is an artist these days. Rock and roll singers are artists. So are movie directors, performance artists, make-up artists, tattoo artists, con artists, and rap artists. Movie stars are artists. Madonna is an artist, because she explores her own sexuality. Snoop Doggy Dog is an artist because he explores other people's sexuality. Victims who express their pain are artists. So are guys in prison who express themselves on shirt cardboard. Even consumers are artists when they express themselves in their selection of commodities. The only people left in America who seem not to be artists are illustrators. (16)

The title of Holland's short chapter was "Express Yourself—It's Later Than You Think." As well as conforming to our glorious tradition within the world of illustration of paranoia, inferiority complex, and navel-gazing, it was in many ways a prophetic statement of the need for illustrators to break out of the subservient stereotype that had prevailed for so long.

As a fellow, albeit considerably less gifted, illustrator (though I like to think I could run him a close second in ranting), I empathise closely with Holland's observations. As an illustration educator, I am familiar with the struggle of aspiring illustrators to explain and "justify" what they do in the context of the broader visual arts arena. I am also very conscious of the gulf between the perceptions of the commentators and academics and those of the artists themselves when it comes to issues such as postmodernism. This chapter sets out to examine the process of developing as an illustrator, with

special attention to the artist's (and the student artists') perspective on the postmodern picturebook.

Illustration has never sat comfortably within a particular grouping of the arts. Rather like one of those awkward illustrated books for older readers that booksellers find hard to "place" on their shelves, the subject of illustration has been endlessly shunted around the departments of art schools and universities. Here it falls under Graphic Design. There it falls within the Fine Arts. More recently we have seen an endlessly inventive stream of titles to try to accommodate it: Graphic Fine Art, Communication Design, Visual Communication, Communication Art & Design, Narrative and Sequential Design anything to avoid that awkward word, "illustration." One recent attempt to relabel the activity introduced the term "made image" (I am not sure what an "unmade" image would be). "Commercial artist" won't do any more because the world of Fine Art has long since taken over ownership of that concept. At my own institution, Anglia Ruskin University in Cambridge in the UK, we have retained both the term "Art School" (we are "Cambridge School of Art" and have been for over 150 years) and the term "illustration." Our award titles include BA (Hons.) Illustration, BA (Hons.) Illustration and Animation and MA Children's Book Illustration. Cambridge School of Art was originally opened by the Victorian artist and philosopher, John Ruskin, in the centre of the city in the 1850s. This was at a time when a number of regional art schools were opening with a mission to make art more relevant to industry. Ruskin was the ideal man to promote such ideals and the university into which we are now absorbed has adopted his name. Unusually, the subject of illustration has played a lead role throughout the art school's history, with graduates including the great graphic artist, Ronald Searle, "Luck and Flaw" (otherwise known as Roger Law and Peter Fluck, creators of the worldwide TV satire, *Spitting Image*), the influential designer, illustrator, and painter Edward Bawden, as well as the many successful children's book author-illustrators who have emerged in recent years.

Of course Illustration is a hybrid art. It has to sit close to Graphic Design, existing as it does, primarily (still) on the designed, printed page, and usually in close company with the printed word. We use the term "Art & Design" to cover all areas of art education, but it is probably illustration that is best summed up by the coming together of those two concepts. Illustration is increasingly breaking out of its role as graphic designers' plaything, as "authorstrators" (I borrow the term from one of my PhD students, Sarah McConnell) of children's books and graphic novels create their own content, content that is often primarily conveyed visually, and where frequently the visual content *is* the content. The relentless drift of fine art toward the purely conceptual has created a vacuum that I would argue is increasingly being filled by sequential artists working for mass publication. The increasing proportion of picturebooks that are "authorstrated" reflects, I think, the unique nature of the picturebook and especially the

postmodern picturebook. The union of words and pictures and the blurring of boundaries between the two are surely more effectively achieved when the composer is one person (notwithstanding Lane Smith and Jon Scieszka's telepathic understanding—the exception that proves the rule). The intimacy of this medium is an attractive prospect for any artist.

The American artist/illustrator, Marshall Arisman, founder of the MFA programme, Illustration as Visual Essay at the School of Visual Arts in New York City, quotes the sculptor David Smith's definition of commercial art as "art that meets the minds and needs of other people," and his definition of fine art as "art that meets the mind and needs of the artist" (Heller and Arisman 3). Arisman himself goes on to suggest "it is possible to be a figurative artist and see illustration as simply one outlet for 'work done to meet the mind and needs of the artist' if the artistic vocabulary remains the same in both the illustration and fine art areas" (Heller and Arisman 3).

Since founding the Masters programme in Children's Book Illustration at Anglia Ruskin University in Cambridge, it has been interesting for me to see the increasing number of Fine Arts graduates applying to the programme. "Fine art refugees" we are often tempted to call them. Like many applicants, they will have observed the extraordinary range of beautiful, dark, uplifting, enigmatic, and challenging visual art now being offered to children around the world through the medium of the picturebook. Having so often been required to detach themselves from childhood (and drawing) during their undergraduate studies, these fine arts graduates tend to be hungry to express themselves in, ironically, a more personal way.

I was honoured to be invited to act as one of the judges at the 2007 Bologna Ragazzi Awards, a task that involved two days spent looking at just under a thousand recently published illustrated books for children. This was a chance to gorge on some of the finest visual, graphic art from around the world, to experience the rich variety of graphic traditions across cultures, and to see how relevant or otherwise the strict division between fine and "applied" art is internationally. It was certainly apparent that in some cultures, a deeply personal artistic voice is not seen as an impediment to a successful career working within illustration for the mass-produced children's book. It could perhaps be argued that the countries that have had the least exposure to Western culture are often those whose books exhibit the best art in picturebooks, and whose output contains the lowest level of self-referential postmodernism. I suspect that I am making a very subjective point here, but I am inclined to feel that the "innocent eye," unburdened by postmodern references, can be the most powerful asset in communicating visual narratives in a truly personal, artistic way.

My interest in these tensions between "art" and "illustration" (or whatever we now call it), stems very much from a perspective of *practice*, from my own background as a practicing illustrator, and from the extremely enjoyable activity of working with talented student practitioners and leading publishers of children's books. The relationship between research and

practice, within art schools that are increasingly under pressure to "academicise," is still a matter for much debate (the polite word). Traditionally, the activity of illustration has been taught by practicing illustrators, but with pressures to reduce part-time, hourly-paid teaching staff and growing pressure to employ staff educated to PhD level, this situation, at least in the UK, is under threat. My own response to this has been to encourage practice-led doctoral research in illustration. This takes the form of reflective practice taken to the highest level, retaining focus on research *through* practice rather than research *into* practice.

In general, the academic study of children's picturebooks has been approached from the educational perspective, from those interested in the picturebook as a tool for the educational development of the child. This involves looking at the picturebook in its final form as a finished artefact—looking at it from the outside in, so to speak. The concept of research of this nature is, it appears to me as a relative outsider, well established. In this context the voice of the illustrator tends to be heard primarily through interviews and, of course, through the work itself.

While I am not sure that many authorstrators would be conscious of, or interested in, labels such as "postmodern picturebook," it is nevertheless inevitable that such terms will be applied to works that contain playful layering of meanings. The published picturebook is the outcome of a lengthy process of research and development for the artist and its final form, postmodern or otherwise, is likely to be informed by the artist's educational experience. Postmodern ideas may form part of the backdrop to this experience, but for many the preoccupation will be simply with learning to draw and to control media and processes.

At art school (sorry, that's the *Faculty of Communication Design and Made Images*), unlike most Fine Art programmes, courses in illustration are often still rooted in the discipline of observational drawing. This is seen as a means to an end, a way of opening a "window on the world" (in the words of one of my own former tutors). The activity of looking, of learning to see through drawing, feeds and informs a visual vocabulary that gradually asserts its own unique identity within each individual artist. Use of a range of preferred media and processes, traditional or digital, will also emerge gradually. It is important to understand that this visual identity is something entirely different from the concept of "style," a reductive term that implies facile mannerism. For our students, the sketchbook is at the heart of this process. This is the place where everything ferments: personal preoccupations, random thoughts, ideas, obsessions, observations, doodles, shopping lists, and plenty more besides. With the advent of software such as Adobe Photoshop, with its potential for all-singing, all-dancing effects and the consequent temptation to believe that it will do the thinking and creating for you, the sketchbook is more important than ever.

In my experience the illustrator is a shy, retiring creature, rarely emerging from his burrow, but given to quietly observing the strange activities of his

species from a safe distance, and processing these observations visually, creatively, in narrative form. With the explosion in the sheer volume of imagery that the average person is now exposed to, it has become extremely important for the illustrator to have an authorial voice. Visual text is becoming visual literature. So it is vital that illustration students, particularly at the masters level, are encouraged to create content as well as to "decorate" (I hasten to add that decorative illustration is no less noble an art). The choice of Chris Ware's *Jimmy Corrigan: The Smartest Kid on Earth* as winner of the Guardian First Book Award here in the UK a few years back was an important event in this context. It caused many a raised eyebrow in the literary world. Normally awarded to a traditional novel, the selection of a graphic novel was met with astonishment in some quarters. But Ware's brilliant, relentlessly bleak classic and the universal acclaim that it gathered was further evidence of a growing awareness of the ability of the sequential image to speak for itself.

Looking at the range of picturebooks submitted at the Bologna Children's Book Fair from around the world, one cannot fail to be struck by the sheer breadth of approaches to image making and by the continued improvement in standards of design and production. The picturebook that we judges awarded first prize was *Garmanns Sommer* by Stian Hole, published by Cappelen in Norway. Hole is one of thirty or so picturebook authorstrators with whom I made contact and featured in my new book, *Play Pen: New Children's Book Illustration* (Salisbury, 2007). Like almost all of the artists, he made it clear that he did not consciously consider the age of the reader when composing a picturebook:

> So far, I have not spent much energy on thinking about the reader, and his or her age. I try to tell the story right. Right for me. Right for my editor, Ellen Seip, who is experienced and patient. That is good enough for me. (personal communication)

This proved to be a familiar refrain from most of those I spoke to. It is clear that, despite the applied nature of the art, the creation of a picturebook is, or can be, a deeply personal artistic statement. Hole explained that the visual "feeling and atmosphere" of *Garmanns Sommer* (Garmann's Summer) was inspired by a journey he made to Cape Cod in the United States, "and also by my favourite painter, Edward Hopper. And by Holden Caulfield in *The Catcher in the Rye* of course." He wanted to create a feeling of autumnal melancholy throughout the book, through colour and mood. The story tells of a boy's anxiety about returning to school after the summer holidays, and in particular his concern that he will be the only child whose new teeth have not yet come through. The book's postmodern characteristics can be seen in the abundance of intertextual references to art, design, philosophy, and cinema.

Hole's previous book, *Den Gamle Mannen og Hvalen* (The Old Man and the Whale) was equally rooted in a sense of place; this time the deeply Nordic imagery emerged from a period spent living in the far north of

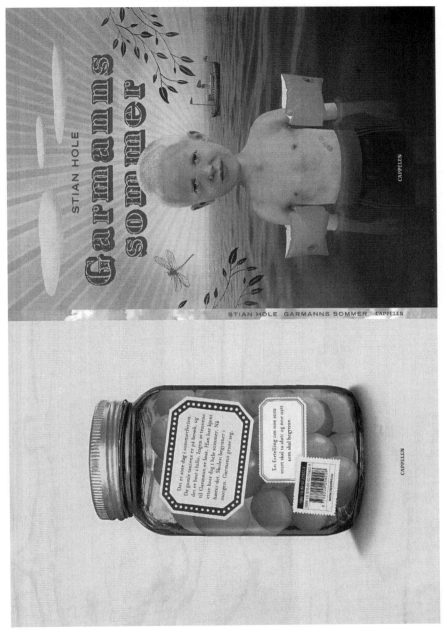

Figure 2.1 Garmanns Sommer by Stian Hole is created entirely in Adobe Photoshop, allowing the author to import visual motifs and references with a vast range of cultural origins. Image courtesy of Stian Hole.

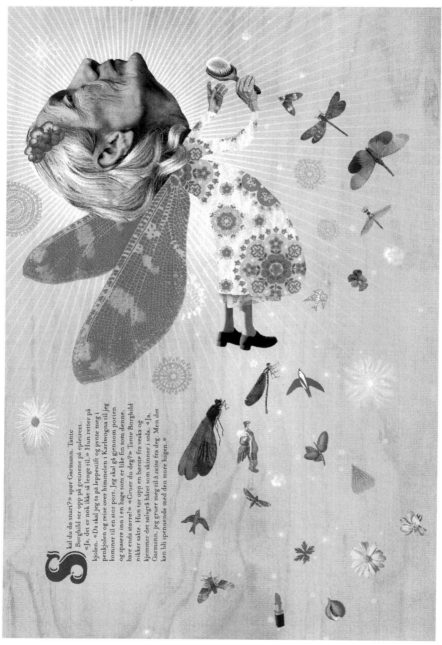

Figure 2.2 In this spread, Garmann asks his grandmother whether she is going to die soon. She replies, 'probably' and explains that she is going to 'put on lipstick and fly through the constellations.' Image courtesy of Stian Hole.

Norway, where his wife was studying medicine. "The illustrations, which I guess are influenced by the wonderful northern landscape, came first, then the text," he told me. From this artist's point of view, it seems that any consideration of audience age is incidental and retrospective. Hole says, "You don't have to explain everything. Anyway, I think kids are far more used to and experienced in visual reading than before. Don't underestimate them! And many of these books are read together with an adult. I always feel happy as a reader when there are messages in a children's book that speak to me, and my experiences as a grown-up also."

He also quotes the Swedish writer, Max Lundgren, who summarised the three most important functions of the picturebook in the following way: "1. Child meets image and art. 2. Child meets literature. 3. Child meets parents. I personally consider the third function that the picturebook performs to be the most important."

As artists, we tend to resist the idea of labels and movements, being happier for others to busy themselves with identifying and analysing tendencies. But Stian Hole's books could be described as both postmodern and Romantic, characteristics that are not normally seen as natural bedfellows. The romantic element, in terms of traditional definitions of romanticism in the visual arts, reveals itself through the celebration of landscape and place-specific ephemera in both of the books mentioned above (both books draw

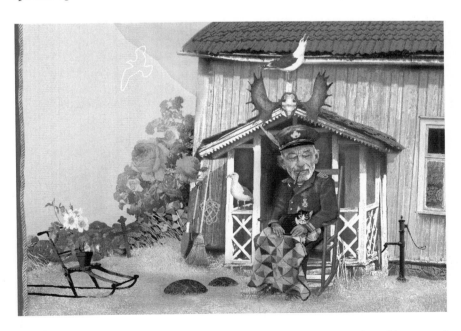

Figure 2.3 In this image from *Den Gamle Mannen og Hvalen (The Old Man and the Whale)*, Hole's painterly use of digital media creates a strong sense of place. Image courtesy of Stian Hole.

upon specific places of importance to the author: *Garmanns Sommer* is set in Hole's own garden). Eric Newton suggested that the unmistakable symptom of romanticism could be found in what he called the "autobiographical" tone of voice of the artist who is more anxious to explain his reactions than to describe the experience to which he reacts. Hole's picturebooks have a hauntingly evocative, nostalgic visual tone, but at the same time make playful postmodern references to a range of visual idioms including mid-twentieth-century consumer advertising and "Bollywood meets David Lynch" colour arrangements. These digitally imported elements somehow successfully coexist despite hugely diverse cultural and stylistic origins. There are Art Nouveau swirls, 1950s American comics, and Victorian line engravings, all held together by the artist's powerful overall vision, sense of light and, most importantly, control of the medium.

Hole spoke to me about these references. I asked him to what extent he felt children consciously picked up some of these more "adult" postmodern visual references. He told me:

> That's an interesting question. On the one hand, I don't expect children to pick up any of these references and quotations. Hopefully they don't have to do that to enjoy the book. On the other hand, I don't have the key to know precisely how children of different ages interpret the images and the text. Children and adults will always bring different baggage to the book. I believe some children probably read some of these "hidden messages" differently from grown-ups, but that doesn't necessarily mean that they are wrong or that they "miss" something. On the contrary, I often find it liberating how children are more open and straightforward in their confrontation with images and literature than adults. Children are not afraid of what they don't understand. (personal communication)

An experienced Norwegian critic, who is quite sceptical towards modern Norwegian picturebooks, told me that she always checks whether her children laugh at the same places as she does when reading picturebooks. I don't understand why she has to do that. Why should children and adults have to laugh at the same places?

Of course, it is impossible to discuss such phenomena without reference to the increasing role of Adobe Photoshop (the universal medium for digital collage) in the creation of illustrative imagery and in particular, its role in the postmodern picturebook. The ease with which found imagery can be imported and recycled now means that ironic and playful visual references are more easily achieved. When Photoshop first arrived on the scene as an artist's tool, the initial infatuation led to a period of indistinguishable, characterless imagery with graphic designers convincing themselves that the day of the illustrator was over. Suddenly, it seemed that by simply importing, rearranging and layering photographic imagery, anyone could make illustration. It wasn't long before the novelty wore off. A craving for a return to the

Figure 2.4. In this final image from *Garmanns Sommer*, laden with Nordic melancholy and painterly, filmic references, the author leaves the child to decide for herself whether Garmann's dread of school is justified. Image courtesy of Stian Hole.

intimacy of the hand-drawn line soon led to the Photoshop aesthetic looking dated. But in the hands of an artist such as Hole, the medium is transcended by a powerful sense of vision. Only now it seems are we beginning to see artists with such strong vision making Photoshop work for them, rather than the other way round. Hole takes a cautious, balanced view:

> It took me some years of experimenting and practice to find out how to use this tool, how to use Photoshop without making the illustrations look too influenced by the tool (which is nonsense of course, I guess they will look just like Photoshop montages in ten years from now, just like airbrushed illustrations from the early 80s very much look like they are made with airbrush today you will always be able to trace the tool in the illustrations). But, like my teacher Bernard Blatch always said, 'Thinking comes first.' For me, Photoshop is a very practical and useful tool, no more, no less. (personal communication)

Perhaps Hole's books could be described as "postmodern with soul." He makes use of the tool that has been instrumental in facilitating the postmodern picturebook, but takes it that bit further by truly painting with it rather than merely assembling disparate elements and references cleverly.

It could be argued that the exceptional, highly sophisticated visual quality of picturebooks from a small country such as Norway is due to a rather artificial situation in terms of commercial publishing. With a population of only four million or so, most children's books are imported and translated; but with a high tax economy, the government funds arts projects well and provides subsidy for a number of indigenous picturebooks each year. This means that these books are not subject to the same kind of commercial pressures as, for example, in the UK (where the need to sell coeditions invariably drives down standards), and the publishers can focus on quality. There is also a far less rigid distinction here between the idea of a children's book and a book for adults. These books are bought by and for all ages. Perhaps we can dare to hope that the postmodern picturebook is leading a revival of illustration in books for adults, with growing awareness of the intellectual demands that narrative pictures can make. Adults are increasingly buying picturebooks for their own consumption. Publishers and authors have long been resistant to illustration in adult fiction, seeing it as an intrusion on the ownership of the reader's visual imagination. But the picturebook that contains an abundance of references in primarily visual form, and which speaks to adult and child reader simultaneously in interchangeable layers, is indeed a wonderful vehicle for "child meets art—literature—parent" and may be educating the parent as a by-product.

Another of the artists that I featured in *Play Pen*, Toby Morison, could be said to exhibit a great deal of postmodernism in his first book for children, *Little Louie Takes Off*. Morison is best known for his editorial and advertising illustration and has recently relocated from the United Kingdom to

Brooklyn, New York. *Little Louie* is the story of a fledgling swallow who fails to learn to fly, and who consequently migrates by airplane. Images of the little bird nestled on his window seat, with earphones, water and peanuts are executed with great charm. Embedded in Morison's graphic work is a consummate visual literacy. *Visual literacy*: now there's a term that I have a problem with (if I may be permitted to digress). Like the word *drawing*, it suffers from being bandied about promiscuously by a wide range of people who are all happily ascribing different meanings to it, secure in the belief that we are all talking about the same thing. It does seem to me that the term has been hijacked by areas of academia that are not primarily visually oriented (you don't often hear the term used in art schools), using it to describe a perceived form of visual code breaking. In other words, *visual literacy* is used to describe a form of understanding of pictures that is based on a series of acquired connection-making skills that allows the picture reader to draw out literal meaning from the various signs and signals.

We come across the term most often in relation to the "reading" of those few picturebook artists who favour the use of visual metaphor as a medium for communication (as distinct from the field of editorial illustration where the use of visual metaphor is pretty much essential and universal). The champion of this minority field is of course the excellent Anthony Browne, hence his popularity as a subject for academic analysis. For me though, visual literacy is a skill that is, or should be, demonstrable through visual means. Toby Morison's postmodern *Little Louie Takes Off* can be seen to evolve from, and exhibit knowledge gained from, the following sample list of qualities (among many others):

- a fascination for the linear representation of three-dimensional form

- a keen interest in and knowledge of the British graphic tradition as practiced by, in particular, Ben Nicholson, Edward Bawden and Eric Ravilious

- an ongoing commitment to drawing from direct observation

- a keen interest in and knowledge of the history of reprographic processes, as evidenced by playful visual references to the sometimes approximate nature of line and colour registration in mid-twentieth-century printing technology

- a keen interest in and knowledge of mass-market advertising with particular reference to the "Golden Age" of travel posters

Of course, it is hardly essential for the reader to be acquainted with such references in order to be able to appreciate the book on the simplest

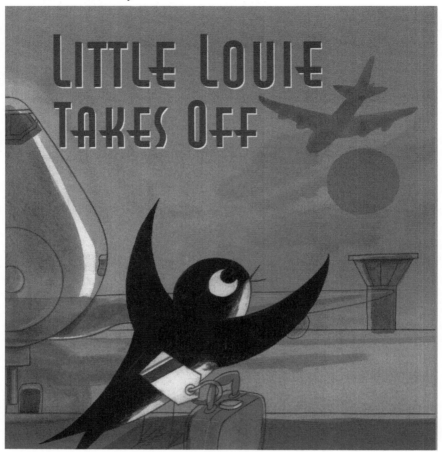

Figure 2.5 Toby Morison's cover design gently references graphic traditions of the 1920s and 1930s. Image courtesy of Toby Morison.

level, but many of the references to "low culture," advertising and print technology could be said to be postmodern in their use, and an understanding of them inevitably enhances the reading process, which includes visual literacy.

Morison's visual literacy comes from a lengthy and thorough artistic training, culminating in an MA award from the Royal College of Art in London, and from a passion for drawing, a key characteristic of the illustrator that I touched on earlier. His sketchbooks still form the foundation of his visual language and he will regularly take time out from commissioned work to make a drawing trip to, for example, India in order to feed and refresh his visual vocabulary.

I have interviewed candidates for undergraduate study in Illustration for many years. In recent years I have noticed an odd phenomenon, namely an

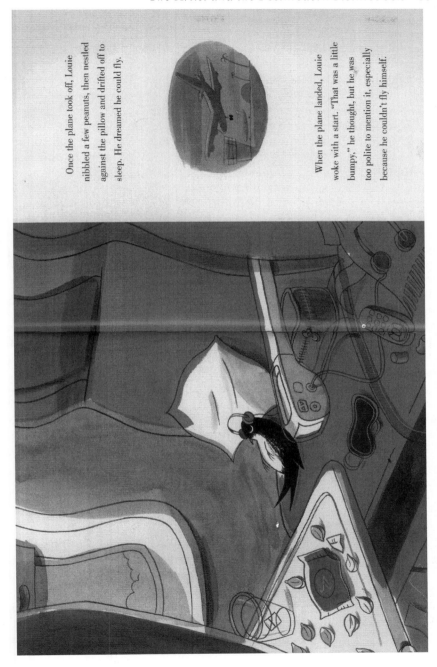

Once the plane took off, Louie nibbled a few peanuts, then nestled against the pillow and drifted off to sleep. He dreamed he could fly.

When the plane landed, Louie woke with a start. "That was a little bumpy," he thought, but he was too polite to mention it, especially because he couldn't fly himself.

Figure 2.6 The irony of a flightless bird being served in-flight peanuts and water is not lost on children of picturebook age who are increasingly familiar with air travel (from *Little Louie Takes Off*). Image courtesy of Toby Morison.

increasing number of students with portfolios full, not of their own draw-
ings, but of projects "about" artists. These students have been encouraged
to research the work of various well-known artists, make copies of their
artworks, visit galleries to see their artworks (usually in Barcelona, where
art students must outnumber residents) and generally immerse themselves
in the work of these artists. In fact they seem to be encouraged to do any-
thing other than make a drawing directly from the world around them and
are being led to believe that this is a substitute for learning to draw (or
rather, learning to see by learning to draw). The generally agreed definition
of the word *literacy* is "the ability to read and write." But *visual literacy*
seems to be used only with reference to the "reading" bit about pictures. I
would argue that the "writing with pictures" element (to borrow the title of
Uri Shulevitz's excellent book) is a key component of true visual literacy. I
recall some time ago hearing the British pop artist, Peter Blake, talk about
his art school education in the 1950s, and how at the age of around sev-
enteen he had been drawing every day for three years without having any
knowledge of art history. This may be an opposite extreme, but Blake was,
to my mind, far better equipped to understand and appreciate the paintings
of others (and to absorb influences in a subtle rather than slavish, imita-
tive way) as a result of coming to the work of others so much later, and
after a sustained period of practice. Blake's work, which could certainly be
described as postmodern, was then able to demonstrate a genuine visual
literacy. My point is that collage and assembled artwork, so characteristic
of many postmodern picturebooks, is no substitute for drawing.

If schools can begin to understand the importance of drawing in terms
of intellectual development we may see a visual literacy emerge which
goes a little deeper than acquired decoding skills. Learning to draw
means learning to see. This might in turn lead to a higher incidence of
quality postmodern picturebooks such as those by Stian Hole and Toby
Morison.

With so many contemporary picturebooks falling easily under the
postmodern label, and with most people in the publishing industry agree-
ing that there have been far too many mediocre picturebooks published
recently, it seems to me that there is a need for distinctions to be drawn
between the picturebook as amusing throwaway postmodernism, and the
picturebook as art, if I may use that frightening word. It is my delibera-
tion on the extent to which these two concepts are compatible that has led
me to examine the books of Stian Hole and Toby Morison. These books
seem to me to be examples of "sustainable postmodernism." I come back
to the role of the image in the picturebook as something more than a con-
veyor of word meaning. The fact that so few of the leading artists with
whom I have spoken profess to take a conscious interest in the age of their
audience is not an accident. It is something of a cliché that artists speak to
"the child within." But it seems to me that if an artist is saying something
important to himself, the outcome is likely to have more intrinsic value

and meaning than if the preoccupation is with perceptions of audience need, audience expectation, or audience decoding skills.

There is inevitably a wide range of visual quality evident in today's published picturebooks, postmodern or otherwise. Since the work of the brilliant Lane Smith and Jon Scieszka first came to prominence we have seen a plethora of pale imitations and endless inverted and subverted folk tales. The page as stage has been explored and exploited in what would appear to be every conceivable manner. Is it possible, I wonder, that it is in the nature of postmodernism that it inevitably eventually disappears up its own orifice artistically? Its very "knowingness" and self-referentiality could be said to be incompatible with the childlike eye of the true artist. Once we get into the world of "knowingness about knowingness" we can be sure that things are starting to become tiresome. It is hard to know what can follow postmodernism. Post ironic sincerity? Somehow, I don't think so. For the most blunt assessment, I have to go back to Brad Holland's glossary, this time in the context of his definition of "Craftsmanship":

> In traditional art, craftsmen worked within certain conventions. Occasionally, those conventions were redefined by acts of genius. In modern art, everybody has to redefine art all the time. This might have made our era another Renaissance, if suddenly there had been an explosion of geniuses in the world. But since ego is more common than genius, post-Modern art is destined to be narcissistic. (18)

I think there is a good deal of truth in Holland's acerbic analysis, but among the arrivals on the children's book scene in the postmodern era have been a number of highly original artists whose work seemingly finds its natural home in this arena, while often being seen as controversial in some quarters. Shaun Tan is an interesting example. The Australian is another whose work attracts academic investigation and theory, primarily because he is happy to leave unanswered questions and ambiguous endings in his work—irresistible to the theorists! Tan's work combines traditional craftskills with a postmodern tone, including references to surrealism and other movements, and clear evidence of his interest in the comic book format. Unusually for an authorstrator, Tan is comfortable speaking and writing about his work and his website (www.shauntan.net) is full of insights into his working process. It also inadvertently highlights what can be major disparities between the levels on which "word people" and "picture people" (excuse the crass generalisation) experience and process information. It is often assumed that a book first emerges as a narrative idea that requires illustrating, but many picturebooks evolve from random visual musings that are somehow threaded together to make a kind of visual, sequential sense. The words will then follow as a sort of scaffolding. "Being an artist," he says "is not about manipulating objects or an audience so much as

constantly assessing a series of often accidental and mysterious ideas."
This accords with the definition provided by the English artist/illustrator
of the mid-twentieth-century, John Minton who described his own work-
ing process as "a matter of the successful steering of accident; making
the particular quality of the medium have in itself a formal significance"
(Rothenstein 52).

Tan explains that his enigmatic postmodern visual texts, *The Red Tree*
and *The Lost Thing,* grew from apparently random sketchbook doodles
that somehow repeatedly asserted themselves and "seemed significant in a
sea of other small drawings." Another authorstrator who has spoken of a
similar working process is Emma Chichester Clark, who, when looking for
a new book, will doodle endless characters—animal or human—until one
of them "speaks" back to her more insistently than the others.

Answering his own question, "who do you write and illustrate for?"
Tan replies, in familiar fashion, "It's a little difficult to answer, as it's not
something I think about much when I'm working alone in a small studio,
quite removed from any audience at all. In fact, few things could be more
distracting in trying to express an idea well enough to myself than having
to consider how readers might react!"

On that slippery old concept of visual literacy he opines that the most
basic kind is

> one restricted to the recognition of familiar things. This is a
> literacy based on fixed definitions, control, order and efficiency, the
> kind of 'reading' that takes place when we observe street signs, look at
> maps or watch the nightly news a passive decoding that allows us
> to manage our daily lives, particularly as responsible adults, to recog-
> nise things and events as efficiently as possible. However, this kind of
> 'closed reading' can go too far to the extent that it can make alterna-
> tives invisible, and anything unfamiliar is dismissed as foreign, useless
> and unwelcome. (www.Shauntan.net)

Tan is perhaps articulating the frustration that artists often experience
when faced with the rather literal reading of their work. Pictures speak in
ways which often cannot be decoded into words, any more than a musical
symphony can. In postmodern picturebooks, the neat, clear distinctions
between words and visual images often break down.

In a spirit of developing greater understanding between the wordies and
the picies, here in Cambridge, Morag Styles and I have been experimenting
with a series of research seminars shared by our respective MEd students
(Morag's students at the Faculty of Education, University of Cambridge)
and my own MA Children's Book Illustration students at Cambridge School
of Art, Anglia Ruskin University. We have been running these seminars for
two years now, the students crossing campuses to sit in on each other's
classes and "crits," attend exhibitions, presentations from top artists and

writers (including Quentin Blake and Martin Waddell) as well as from researchers, practice-based and theory-based at each university. It has been a stimulating experience with much learned on both sides. Initially, the practitioners have tended to be bemused by the theorists' interpretations (I well remember one of my student's comments at the end of a fascinating lecture from Morag Styles: "but Morag, don't you think you're reading too much into it?"). Similarly, the education students have sometimes been surprised by the artists' lack of concern for, or awareness of "message" in the

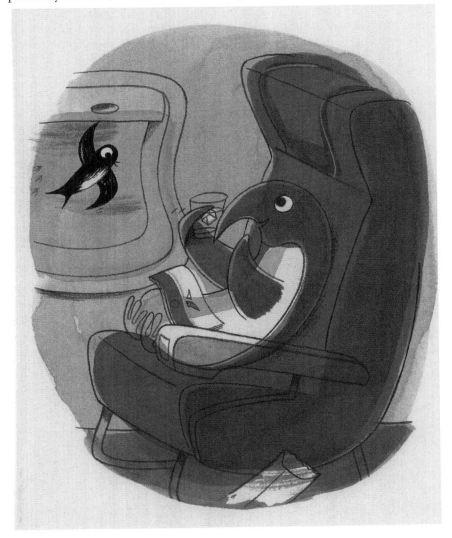

Figure 2.7 The elegance and economy of Toby Morison's line has charm and wit but is grounded in acute observation. Image courtesy of Toby Morison.

literal sense, or of the presence of obviously postmodern elements within their work. A lecture from Helen Bromley examined the postmodern characteristics of Mini Grey's *Traction Man is Here*, drawing on Bromley's extensive experience of sharing this book with children. One of our own PhD students, illustrator Katherina Manolessou, spoke about her practice-led research into the use and role of animal characters in picturebooks, demonstrating the nonlinear, often intuitive processes that lead to new discoveries in creative practice. It has been exciting to observe a mutually beneficial growth of understanding between the two groups. Dare I say it, even some of my own prejudices are being broken down. Plans are now evolving for the next steps in attempting to bring these hitherto alien species closer together, and the natural blurring of words and visual images in postmodern picturebooks may be an important part of this process.

WORKS CITED

Arisman, Marshall. "Is There a Fine Art to Illustration?" In *The Education of an Illustrator*, edited by Steven Heller and Marshall Arisman, 3–4. New York: Allworth Press, 2000.
Holland, Brad. "Express Yourself—It's Later Than You Think." In *The Education of an Illustrator*, edited by Steven Heller and Marshall Arisman, 14–20. New York: Allworth Press, 2000.
Newton, Eric. *The Romantic Rebellion*. London: Longmans, 1962.
Rothenstein, Michael. *Looking at Paintings*. London: George Routledge & Sons, 1947.
Salisbury, Martin. *Play Pen: New Children's Book Illustration*. London: Laurence King, 2007.
Shulevitz, Uri. *Writing with Pictures*. New York: Watson-Guptill, 1985.

CHILDREN'S LITERATURE CITED

Grey, Mini. *Traction Man is Here*. London: Random House, 2005.
Hole, Stian. *Garmanns Sommer*. Oslo: Cappelen, 2006.
———. *Den Gamle Mannen og Hvalen*. Oslo: Cappelen, 2005.
Morison, Toby. *Little Louie Takes Off*. London: Simon and Schuster, 2007.
Tan, Shaun. *The Red Tree*. Thomas C. Lothian Pty Ltd, 2001.
Ware, Chris. *Jimmy Corrigan, the Smartest Kid on Earth*. New York: Pantheon, 2000.

3 Radical Change Theory, Postmodernism, and Contemporary Picturebooks

Eliza T. Dresang

Radical Change theory can be utilized to examine and clarify a number of aspects of contemporary society (Dresang, "Intellectual Freedom;" "Radical Change"). It grew out of a need to explain apparent changes in youth, their behaviors, and their books in a digital environment; therefore, it has most frequently been applied to explain texts and situations related to youth. As with all theories, it provides explanatory power for something that might otherwise either be misunderstood or understood from a different perspective.

Radical Change was proposed in the early 1990s. It is based on the digital age principles of interactivity, connectivity, and access. Digital refers not only to the media themselves but also to the interactive, connective, easily altered qualities they possess and encourage, which have permeated much of society. Interactivity refers to dynamic, user-controlled, nonlinear, nonsequential, complex information behavior and representation in or related to books and other media. Connectivity refers to the sense of community or construction of social worlds that emerge from changing perspectives and to expanded associations in the real world or in books and other resources. Access refers to the breaking of long-standing information barriers, bringing entrée to a wide diversity of formerly inaccessible opinion and opportunity. Looking around, we can see the effect of these principles on everyone whether at work or at play, whether using technology or not.

When applied to literature for youth, Radical Change consistently identifies three types of changes that can be explained by these digital age principles, i.e., changing forms and formats, changing perspectives, and changing boundaries (Dresang "Radical Change," 17–28). Any radical-change book can contain one or more of these types of changes. When Radical Change theory is applied to the behavior of digital age youth, changes in how they think and learn, changes in their perspectives, and changes in the ideas and information to which they have access and the communities in which they participate are made clear (52–80). The end purpose of Radical Change as discussed here is to provide an overarching, congruent explanation of the changes in contemporary children's books and behaviors.

Postmodernism is also an historically based explanatory concept that emerged some three decades before Radical Change, although it was not applied frequently to literature for youth in published literary analyses until near the end of the twentieth century. Even though postmodernism here is applied specifically to picturebooks, it is "most fruitfully viewed as a variety of perspectives on our contemporary situation" (Ward 6). In a broad sense, postmodernism questions meaning, communication, human identity, progress, and interpretations of history. Yet it is clearly influenced by the social, political, economic, art, and other cultural contexts in which it exists. When applied to literature, particularly children's literature, postmodernism becomes more focused: it promotes "skepticism about the claims of any kind of overall, totalizing explanation" (Butler 15). Lyotard defines postmodernism as a lack of belief in metanarratives; he proposes a world in which decisions are "made on the basis of local conditions and are applicable only in that limited context" (xxiv). Furthermore, according to McGowan, postmodernism "highlights the multiplication of voices, questions, and conflicts" without providing a resolution to this cacophony (587). When applied to literature for youth, postmodernism is often described in terms of metafictive devices and techniques.

SIMILARITIES AND DIFFERENCES

Radical Change and postmodernism identify many of the same elements in contemporary picturebooks. However, the elements are described with different terminology, and not all Radical Change characteristics have parallels in the commonly referred to metafictive devices described by postmodernism. Both Radical Change and postmodernism, when applied to picturebooks, assume a semiotic system that denotes a synergistic relationship between words and pictures, if both exist. Therefore, it is natural that the greatest correspondence in terms will come in what is described by Radical Change as changing forms and formats. The most common associations (or the lack thereof) between terminologies used when the two theories are applied to children's literature are found in Table 3.1.

Some of the terms associated with either Radical Change or postmodernism have specific connotations when applied to literature. For Radical Change, *handheld hyptertext* refers to books that reflect nonlinear (as opposed to only one way progression), nonsequential (as opposed to a predictable sequence) characteristics of digital media. *Digital design* describes the presentation of picture and text in a juxtaposition that requires, or at least promotes, a hypertextual approach to thinking and reading. For both concepts, *intertextuality* refers to elements of another text (e.g., a book, film, movie, etc.) that incorporate references to or imitation of a preexisting content in another context, often in subtle ways. Even within the literary realm, a great deal of disagreement exists among scholars about the mean-

Table 3.1 Comparison of Literary Changes Identified by Radical Change and Metafictive Devices and Techniques Identified by Postmodernism

Literary Changes Identified by Radical Change	Metafictive Devices and Techniques Identified by Postmodernism
Changing Forms and Formats	
• graphics in new forms and formats, including *handheld hypertext and digital design*	• typographic experimentation (McCallum) • new and unusual design and layouts (Anstey) • "a pastiche of illustrative styles" (Anstey 447)
• words and pictures reaching new levels of synergy	• illustrative framing [. . .] (i.e., a text-visual or verbal-buried within another text) Nikolajeva and Scott
• nonlinear and nonsequential organization and format	• disruption of traditional time and space relationships (Goldstone "Ordering the Chaos")
• multiple layers of meaning	• "availability of multiple readings and meanings for a variety of audiences" (Anstey 447)
• interactive formats (with text, between text and reader, and between texts)	• overly obtrusive narrators who directly address readers and comment on their own narrations (McCallum) • intertextuality (Anstey) • parodic appropriations of other texts, genres, and discourses (McCallum) • "Mixing of genres, discourse styles, mode of narration and speech representation" (McCallum 397) • description of the creative process (Goldstone "Ordering the Chaos")
Changing Perspectives	
• multiple perspectives, visual and verbal	• multiple narrators; multiple narratives (Goldstone "Ordering the Chaos")
• previously unheard voices	
• youth who speak for themselves	
Changing Boundaries	
• subjects previously forbidden	
• settings previously overlooked	
• characters portrayed in new, complex ways	
• new types of communities	
• unresolved endings	• "indeterminacy in written or illustrative text, plot, character or setting" (Anstey 447)

Sources: "Literary Changes Identified by Radical Change" (Dresang, Radical Change 19, 24, 26. The digital age principles of interactivity, connectivity, and access upon which Radical Change is based occur across all listed categories); "Metafictive Devices and Techniques Identified by Postmodernism" (Adapted from Pantaleo ,"The Long, Long Way" 3–4. Pantaleo characterizes her even more extensive list as neither exhaustive nor definitive, but rather representative of some of the more salient metafictive features. Where a blank exists in this table, no characteristic parallel to that listed for Radical Change was identified.).

ing of various postmodern concepts, including intertextuality. Pastiche is generally regarded as a bringing together of disparate elements or styles, and parody is a gentle mockery (Hutcheon). Boundary breaking is a term often applied to the more general postmodern manifestations in children's literature, while changing boundaries, as can be seen in Table 3.1, has a more specific connotation for Radical Change.

Radical Change and postmodernism as applied to children's literature are distinct in origin yet were postulated with the same end purpose in mind. Both stem from a visible and widely recognized change in children's books that became evident in the early 1990s and that scholars sought to explain. Therefore, both postmodernism and Radical Change can be viewed as parallel theoretical approaches to explicate many of the same observed changes, each surfacing from a different historical and societal perspective.

However, the explanatory power offered, the 'why' behind the 'what,' is often quite dissimilar. So although both theories call attention to many of the same elements in a literary work, the interpretation of the meaning may differ. Postmodernism in picturebooks emphasizes pastiche and parody, bricolage, irony, and playfulness that are related to the ambiguity and fragmentation of postmodernism in society. Radical Change in picturebooks emphasizes handheld hyptertext and digital design that are related to the interactivity, connectivity, and access of the digital environment. Latham demonstrates how these digital age principles work in his radical-change based analysis of five of Peter Sis's picturebooks.

From its inception Radical Change has focused on both text and reader. It has always seen ambiguity and fragmentation as positive elements that liberate the reader to make her/his own connections and to form her/his own meaning. Pantaleo's research has demonstrated that "Radical Change texts [. . .] can provide the kinds of reading experiences that develop readers' abilities to critically analyze, construct, and deconstruct an array of texts and representational forms" ("The Long, Long Way" 17).

IT ALL STARTED WITH MACAULAY'S *BLACK AND WHITE*

Radical Change theory grew out of a puzzle. After serving as a member of the 1991 Caldecott Award Committee that chose *Black and White* as the most distinguished picturebook of the year, I noticed it appealed strongly to children but often not to adults. Admittedly *Black and White* is not a traditional picturebook with its title page warning that "this book appears to contain a number of stories that do not necessarily occur at the same time. Then it may contain only one story." I discovered that other recently published books evoked this same sort of mixed response. I wondered why. McClelland, also on the Caldecott Committee, and I set out to solve this puzzle. Along the way we described changes we had observed in *Black and White*:

We have come to realize that *Black and White* is a prototype. On the one hand, a prototype of the picturebook; on the other hand, the prototype of literature for a young person of the electronic age. It is the embodiment of profound and unalterable change in literature for young people. Understanding *Black and White* is a journey toward understanding literature in relation to how children . . . are thinking and perceiving. (704)

This revelation laid the foundation for articulating Radical Change theory. I found it was impossible to ponder the changes in children's literature without thinking about the concomitant changes in readers and linking them both to the interactivity, connectivity, and access of the digital environment.

Black and White also served as a milestone for the recognition of postmodernism in picturebooks. The postmodernist characteristics of *Black and White* have been discussed by a number of scholars (Anstey; Coles and Hall; Kaplan; Trites).

Sometimes both postmodernism and Radical Change are applied in the same research on Macaulay's award-winning book. In one study in which forty-five readers ages seven, ten, and twelve were asked to read *Black and White*, both Radical Change and postmodern theory were used to describe the 'radical' elements of the picturebook (McClay). The researcher refers to the concepts of Radical Change in explicating the results of the students' reading. Her conclusions are related to the attributes of digital age readers identified by Radical Change, e.g., greater interactivity with *handheld hypertext* (although the term is implied not used) and improved understanding through connectivity with other students.

A 2007 study using *Black and White* demonstrates how postmodernism and Radical Change can each strengthen and reinforce the other (Pantaleo, "Everything Comes from Seeing Things"). This research focused on fifty-eight Grade 5 students reading playful postmodern, radical-change picturebooks (and one novel), culminating with *Black and White* because of its complexity. Students responded verbally and in writing to the literature they read. The pragmatic and easily understood nature of Radical Change emerges in this study, as Jenny, one of the students, recognizing the potential symbolism of blending the four stories into one, observed that "'another RC thing is words become pictures and pictures become words—it happens when they throw the newspaper [pieces] around'" (8).

RADICAL CHANGE APPLIED TO CONTEMPORARY PICTUREBOOKS

The remainder of this chapter focuses on several contemporary picturebooks that exhibit elements of both postmodernism and Radical Change.

In this particular discussion, the picturebooks will be analyzed from the point of view of Radical Change.

The discussion is organized by the Radical Change principles of inter-activity, connectivity, and access, which are not mutually exclusive; so all picturebooks highlighted could be explained by any of these principles. Likewise all three principles can identify changing forms and formats, changing perspectives, and changing boundaries in picturebooks. However, because these are also postmodern picturebooks, the emphasis is on where the theoretical congruence is greatest: changing forms and formats characteristics. The books discussed are, of course, only examples of the types of books that demonstrate the three Radical Change principles.

Interactivity: The Reader in the Driver's Seat

One of the changes that Radical Change identifies about digital age youth is that they are, much more than any previous generation, in the driver's seat. The Internet and other digital devices have given them the opportunity to make choices they did not previously have, and they have grown accustomed to making many of their own decisions at a very young age. Scholars analyzing contemporary picturebooks with Radical Change theory will recognize that this heightened control that permeates society provides an explanation for why digital age youth are so responsive to the changing forms and formats in their handheld books.

Young readers willingly testify to the importance of these interactive formats. In an unpublished pilot study, a doctoral student and I observed two sixth-grade students' reactions to digitally designed picturebooks on several occasions. When queried afterward, one of the students, on behalf of both, said "I am so accustomed to making choices [. . .] I would not have pursued reading in another more traditional format." As Pantaleo noted in a research project with first-grade children using books identified by the Radical Change theory, "the Radical Change characteristics [. . .] require readers to have heightened involvement in the creation of meaning ("Grade 1 Students" 81).

Many contemporary picturebooks are designed to give the reader a sense of control. In one of these, *Don't Let the Pigeon Drive the Bus!*, Willems, a four-time Emmy Award winner and writer for Sesame Street and the Cartoon network, produced a highly interactive picturebook with graphics in new forms and formats. The words and pictures reach new levels of synergy, i.e., words become pictures and pictures become words. First the bus driver, in a 'retro' cartoon bubble, tells the readers that he has to leave for a little while and is putting them in charge. And, almost as an afterthought, he admonishes, "Don't let the pigeon drive the bus!" Enter the pigeon, who in its best begging, pleading, bargaining preschool-like voice, tries to get the readers to give it permission to drive the bus. Although the audience never caves to the pigeon's wheedling, all is not lost, and the final endpa-

pers, a peritextual element essential to meaning in many contemporary picturebooks (Sipe and McGuire, "Picturebook Endpapers"), show the pigeon dreaming of driving a red semi truck. Willems, who has years of experience with involving preschoolers in media, brings the young readers directly into an interactive decision-making role in the carefully crafted telling of the tale as he hands off authority for them to react to the pigeon's pleas.

An immensely popular interactive picturebook is Scieszka's and Lane's *The Stinky Cheese Man and Other Fairly Stupid Tales*. Jack talks to the audience, giving them instructions about what to do and what not to do. As with Willems' book, the reader must make choices about whether or not to 'obey' the voice of the obstreperous book character. Jack engages readers in a multilayered skirmish complete with nonlinear, pasted-on word-pictures that set the fairy tale elements askew and require a high level of cognitive involvement from the reader.

In Kanninen's and Reed's *A Story with Pictures*, the author, who becomes a character, carries on an ongoing discussion with readers and a dialogue with a busy-body duck, desperately soliciting solutions for reining in the out-of-control illustrator. The unseen illustrator turns a deaf ear, producing wildly inappropriate and enormously funny pictures without the author's story. On every page opportunities for readers to point out problems and suggest solutions appear. Color, size, and shape of fonts change rapidly, quite natural to children accustomed to composing daily on the screen and adept at hot links, word art, and multiple fonts.

Connectivity: Connections in Unexpected Places

When Radical Change was conceived, the concept of Web 2.0 or Library 2.0, the social networking level of online communication with Second Life, MySpace, Facebook, and YouTube did not exist nor did voluminous text messaging and instant messaging. However, what now seem relatively primitive forms of digital age connectivity, such as online discussions of various sorts, did and continue to flourish. The online connectivity has exploded for both adults and children, e.g., youth around the world developed "a Web-based 'school newspaper' for the fictional Hogwarts" (Jenkins 171); and so has the connectivity in picturebooks for youth. As part of a research study conducted in the Saint Louis Public Library from 2001 to 2003, a faculty colleague and I held focus groups with library users ages nine to thirteen. Students of both genders and all grade levels wanted informal situations in which they could exchange knowledge about things they know, e.g., they named good books (book reading and discussion), CDs, DVDs and websites. A fifth-grade boy put it this way: "I think they [the library] should have clubs where you can get together and talk." The connectivity of the digital environment extends far beyond the online networking into the creation of communities on and offline.

Pantaleo documented the experiences of fifth-grade students who read and responded to two wordless picturebooks with Radical Change characteristics ("How Could That Be?"). She concluded that

> The [Radical Change] principles of connectivity and interactivity are most germane when considering both Banyai's wordless picturebooks. . . . With respect to connectivity the Grade 5 students' responses [. . .] reflected how they generated connections to their personal experiences, as well as connections among the various rectos and the multiple perspectives and layers of meaning in the books. Further connections were articulated during both the peer-led small group and whole-class discussions. The written responses indicated a high degree of interactivity as students actively constructed meaning during their reading transactions. (232)

Referring to Radical Change in other research, Pantaleo observed that "connectivity also refers to the increased sense of community created by these books because the forms, formats, and subjects encourage sharing among readers ("What Do Four Voices" 9).

Contemporary picturebooks demonstrate the need or desire of children for connections. Wiesner's *Flotsam* is a twenty-first-century wordless picturebook that provides a highly interactive reading experience, teasing the reader to create his or her own story. It includes nonlinear organization and format, and contains multiple layers of meaning from a variety of perspectives. One of the most salient features is explained by the connectivity it promotes.

In *Flotsam,* after a few pages of foreshadowing, the central flotsam, an old-fashioned camera, washes up in a major wave, and the visual adventure begins. A variety of panels contain the action narrative where the boy explores the camera, finds a roll of film, and runs to the store to get it developed. He receives a series of photos that show magical underwater life, and then the most magical of all, a photo within a photo of a girl holding a photo of a boy holding a photo, going backward through many smaller and smaller photos. Using his magnifying glass and then his microscope the protagonist enlarges the embedded photos as he discovers a series of children from various geographic locations and earlier and earlier historical times. The story ends for him when he takes a picture of himself holding the multilayered pictures and returns the camera to the ocean, but the reader follows it until, assisted by various sea creatures, it finds the next child.

Even a cursory look at *Flotsam* brings to light the many kinds of connections that can be drawn out and related to the life of the child reader. There are connections with other children around the world, in different cultures, in different circumstances, and the opportunity for developing additional perspectives by doing so. The camera in *Flotsam* is antique, and

yet it suggests the potentiality of an across-time-and-space connection. The potential for digital age connectivity outside the book is embedded in the story.

Wordless picturebooks are certainly not the only venues of connectivity. However, Lehman's *The Red Book* and *Rainstorm*, other contemporary wordless picturebooks that are highly interactive and thought provoking with multiple layers of meaning, are aptly understood as examples of connectivity for young digital age readers when examined through the lens of Radical Change.

Like the camera in *Flotsam*, the red book of the title presents itself to the child protagonist. But this magic is 'live-action.' The big-city girl opens the book to find an island boy looking back at her through his own red book. Magically, balloons she buys carry her to his beach, although on the way she drops her red book, soon to be picked up by yet another child who will create yet another adventure.

Lehman's *Rainstorm* opens with a clearly bored boy, dressed to the nines in necktie and shirt, in a mansion filled with late-nineteenth to early-twentieth-century type toys; he discovers a key, which opens a trunk in which a ladder leads to a cellar, away from a rainstorm, and the magic begins. The boy goes through doors, up marvelously drawn spiral stairs, and emerges at the top of a lighthouse on a small island—from all appearances years later in time than where he began. Awaiting him are three children and a dog ready to play. Night falls and the boy returns through his magical route to his servant-served dinner. Later, he starts back to the island, encounters his friends and brings them to his home—but the astute reader notices that out his window, the island is in full view. Was it a fantasy after all? The gaps in time and space leave much for the young reader to ponder. Thus, *Rainstorm, The Red Book,* and *Flotsam* provide connectivity for children to other children in completely different times and places.

Access: Real and Imaginary Monsters

Children reading contemporary picturebooks live in a digital environment saturated with information on a huge diversity of topics. The Internet Archive, which archives all publicly accessible Web pages, contains two petabytes of data, more than the largest print libraries. As one youth says, "I think the Internet has made me smarter because it has given me a broader knowledge of things" (Tapscott 99). Looking at picturebooks using Radical Change theory brings to light previously forbidden topics, characters, settings, and issues and explains them as a natural part of the increased access of the digital environment.

Among the topics surfacing in contemporary picturebooks are monsters, some real, some metaphors for deep-seated emotions. These books represent changing boundaries identified by Radical Change. They all also

exhibit a high-level synergy of words and pictures, various graphic forms and formats, multiple layers of meaning, and highly interactive formats.

Sendak's, Yorinks,' and Reinhart's expertly paper-engineered picturebook *Mommy?* is a twenty-first-century version of Sendak's *Where the Wild Things Are* (1963). The main character of both books is a little boy who confronts and controls imaginary and figurative monsters. But the 2006 story has radical-change characteristics that its predecessor does not. For example, the linear and sequential home-away-home traditional plot structure employed in *Wild Things* has been abandoned in *Mommy?* The reader does not know where this contemporary toddler has been; he simply cheerfully walks into the 'monster mash' of the mad scientist's lab, entering from a graveyard to hunt for his Mommy. He is not naughty nor is he banished like Max of *Wild Things*. Intertextuality, another type of connectivity, with its multiple meanings abounds: the monsters, including Mommy, who is the Bride of Frankenstein, are all from books or films. And is the little boy really Mickey from *In the Night Kitchen*?

Mommy? breaks barriers and changes boundaries in picturebooks as its predecessor did forty years ago. In a 2006 interview Sendak alludes to his own personal lifelong quest for a mother who loves him, unlike his own mother who was possibly mentally ill and an embarrassment to him (Zarin). This information would suggest that *Mommy?* is only on the surface a parody of *Wild Things* but underneath a quite serious contemporary version of the same small child quest. It is the expression of how a digital age child might go about searching for his Mommy (or his Mommy's love), not the traditional Mommy of the *Wild Things*, but more realistically a Mommy who is herself part monster. Radical Change reveals this Mommy as a character "portrayed in new, complex ways." She is more honestly the object of the child's longing, a child who seems completely oblivious to the other monsters all chasing him at the end, indicating that even a Mommy who is a monster represents some sort of wish fulfillment and safety.

The second contemporary monster book is Gaiman's and McKean's *The Wolves in the Walls*. A young girl is ridiculed by her family when she hears wolves in the walls—that is until they actually arrive and take over the house! The radical-change characteristics of words and pictures reaching new levels of synergy, e.g., words that *become* pictures with increased size representing crescendos of sound (the wolves sneaking, creeping, crumpling, nibbling, squabbling) immediately catch the eye reflecting digital design.

Finally the family decides 'enough is enough' and frightens the wolves who flee to the Arctic Circle or Sahara Desert or . . . and all is well, that is, until Lucy hears elephants in the walls. Another barrier in children's picturebooks is broken—rather than happily ever after, an unresolved ending.

Gaiman, too, is portraying the fears of a child in a picturebook for children that pushes boundaries, but with even more potential layers of meaning and more complex characters. The parents are there but ineffectual, distant beings. Do the parents seem oddly reminiscent of the problem parents in

Black and White? They are both simplistic and multifaceted as are the wolves who move in and take over. Intertextuality exists, but what does it mean? This picturebook presents the type of ambiguity that occurs daily in the life of the digital age child who has both the freedom of greater access and the dilemma of trying to reach resolution.

If Gaiman's book frightens, the third monster book, Wild's and Spudvilas's *Woolvs in the Sitee,* terrifies. The odd phonetic spelling, the sinister colors, shadows, and sounds that surround the orphaned boy, living in an inner city, create an atmosphere of intense fear. The boy and the reader are sure that the 'woolvs' are ready to tear him to pieces. When he feels he must hunt for Missus Radinski who appears to be a victim also, he turns to the reader with an impossible to resist look-in-the-eye and says longingly, "Joyn me." This picturebook, also, leaves the reader with no conclusion about what further danger awaits as the story ends.

Access to the levels of terror in these picturebooks is highly unusual, even for older-than-usual-readers, but it may well provide a catalyst for some young reader to gain courage to face his or her terrors. These books provide access to other atypical picturebook features, e.g. ineffectual parents, abandoned children, and unresolved endings.

IMPLICATIONS FOR LITERACY

The digital age calls for rethinking literacy both on and offline (Burnett and Dresang; Coiro; Sutherland-Smith). Pantaleo and other researchers have demonstrated that young children readily understand postmodern or radical-change texts. In several of her research studies with young children, Pantaleo has used Radical Change principles to explain what she has observed about their reading. "The multiplicity in picturebooks . . . increases students' interaction with the texts. . . . Readers made choices as they read, and, as is evident in the transcript excerpts, transact with the verbal and visual texts in various nonsequential ways" ("Young Children" 186). Sipe and McGuire enumerate the virtues of postmodern reading experiences for youth, both for the process of learning to read and for reading pleasure ("The Stinky Cheese Man"). A number of researchers are hoping to change the ways of teaching literacy to incorporate nonlinear and nonsequential text; one such scholar has suggested ways to integrate Radical Change principles and books by teaching children to take advantage of handheld hypertext (Hammerberg; Hassett "Reading Hypertextually").[1] She has also suggested how current reading and writing practices are inadequate for early literacy (Hassett "Signs of the Times"), and how best practices might be developed with what we now know about the value for children of handheld hypertext and children's positive responses to nonlinear text (Hassett "Technological Difficulties").

Pantaleo has also extended her research into writing. For example, she has explored how elementary students incorporate Radical Change characteristics into their own texts after they have read radical-change literature. Both she and the children have identified and described in detail the Radical Change features included in the students' writing. Fifth-grader Alyssa, for example, identified synergy, nonlinearity, and nonsequentiality, a variety of colors and sizes of fonts, multiple texts, and multiple visual perspectives as radical-change elements in her complex story ("Writing Texts with Radical Change" 22–24). Each page in Alyssa's book was divided into four quadrants, telling simultaneously occurring parallel stories, similar to Macaulay's design in *Black and White*.

PARTING THOUGHTS

Clearly postmodernism and Radical Change identify many of the same features in contemporary picturebooks—yet use different terminology to describe them. But because postmodernism and Radical Change emerged from different roots and because they tend to interpret the features upon which they agree from somewhat different perspectives, each has the potential of adding value to the other. In a study that employed both metafictive and Radical Change perspectives, Pantaleo noted a supportive relationship between the two theories. "The metafictive devices . . . illustrate both the connectivity and interactivity described in Dresang's Radical Change theory [. . . .] ("What Do Four Voices" 9).

If this chapter were rewritten from the point of view of postmodernism using the same picturebooks and even the same features of each, it is sure that additional insights would be gained. The same could be said about applying Radical Change theory to analyses conducted with postmodernism. They are similar, yet different and scholarship benefits from both.

NOTES

1. Dawnene D. Hassett formerly wrote as Dawnene D. Hammerberg

WORKS CITED

Anstey, Michèle. "'It's Not All Black and White': Postmodern Picturebooks and New Literacies." *Journal of Adolescent & Adult Literacy* 45 (2002): 444–57.
Burnett, Kathleen, and Eliza T. Dresang. "Rhizomorphic Reading." *Library Quarterly* 69 (1999): 421–425.
Butler, Christopher. *Postmodernism: A Very Short Introduction*. New York: Oxford University Press, 2002.

Coiro, Julie. "Exploring Literacy on the Internet." *The Reading Teacher* 56 (2003): 458–466.

Coles, Martin, and Christine Hall. "Breaking the Line: New Literacies, Postmodernism and the Teaching of Printed Texts." *Reading: Literacy and Language* 35 (2001): 111–114.

Dresang, Eliza T. "The Information-Seeking Behavior of Youth in the Digital Environment." *Library Trends* 54 (2005): 78–96.

———. "Intellectual Freedom and Libraries: Complexity and Change in the Twenty-First-Century Digital Environment." *The Library Quarterly* 76 (2006): 169–92.

———. *Radical Change: Books for Youth in a Digital Age.* New York: Wilson, 1999.

———. "Radical Change." In *Theories of Information Behavior,* edited by Sanda Erdelez, Karen E. Fisher, and Lynne (E.F.) McKechnie, 298–302. Medford, N.J: Information Today, Inc., 2005.

———, and Kate McClelland. "Black and White: A Journey." *The Horn Book Magazine* 71 (1995): 704–10.

Goldstone, Bette P. "Ordering the Chaos: Teaching Metafictive Characteristics of Children's Books." *Journal of Children's Literature* 24.2 (1998): 48–55.

Hammerberg, Dawnene D. "Reading and Writing 'Hypertextually': Children's Literature, Technology, and Early Writing Instruction." *Language Arts* 78 (2001): 207–17.

Hassett, Dawnene D. "Reading Hypertextually: Children's Literature and Comprehension Instruction." *New Horizons in Learning* (2005), http://www.newhorizons.org/strategies/literacy/hassett.html (accessed 19 June 2007).

———. "Signs of the Times: The Governance of Alphabetic Print over 'Appropriate' And 'Natural' Reading Development." *Journal of Early Childhood Literacy* 6 (2006): 77–103.

———. "Technological Difficulties: A Theoretical Frame for Understanding the Non-Relativistic Permanence of Traditional Print Literacy in Elementary Education." *Journal of Curriculum Studies* 38.2 (2006): 135–59.

Hutcheon, Linda. *A Poetics of Postmodernism: History, Theory, Fiction.* New York: Routledge, 1988.

Jenkins, Henry. *Convergence Culture : Where Old and New Media Collide.* New York: New York University Press, 2006.

Kaplan, D. "Read All Over: Postmodern Resolution in Macaulay's Black and White." *Children's Literature Association Quarterly* 28 (2003): 37–41.

Latham, Don. "Radical Visions: Five Picturebooks by Peter Sís." *Children's Literature in Education* 31 (2000): 171–93.

Lyotard, Jean-François. *Postmodern Condition.* Minneapolis: University of Minnesota Press, 1984.

McCallum, Robyn. "Metafictions and Experimental Work." In *International Companion Encyclopedia of Children's Literature,* edited by Peter Hunt and Sheila G. Bannister Ray, 397–409. New York: Routledge, 1996.

McClay, Jill K. "'Wait a Second . . . ': Negotiating Complex Narratives in Black and White." *Children's Literature in Education* 31 (2000): 91–106.

McGowan, John. "Postmodernism." In *The Johns Hopkins Guide to Literary Theory & Criticism,* edited by Michael Groden and Martin Kreiswirth, 585–87. Baltimore: The Johns Hopkins University Press, 1994.

Nikolajeva, Maria, and Carole Scott. *How Picturebooks Work.* New York: Garland, 2001.

Pantaleo, Sylvia. "'Everything Comes from Seeing Things': Narrative and Illustrative Play in *Black and White.*" *Children's Literature in Education* 38 (2007): 45–58.

———. "Grade I Students Meet David Wiesner's Three Pigs." *Journal of Children's Literature* 28 (2002): 72–84.

———."'How Could That Be?' Reading Banyai's *Zoom* and *Re-Zoom*." *Language Arts* 84 (2007): 222–34.

———."The Long, Long Way: Young Children Explore the Fabula and Syuzhet of *Shortcut*." *Children's Literature in Education* 35 (2004): 1–20.

———."What Do Four Voices, a Shortcut, and Three Pigs Have in Common? Metafiction!" *Bookbird* 42 (2004): 4–12.

———. "Writing Texts with Radical Change Characteristics." *Literacy* 41 (2007): 16–25.

———. "Young Children and Radical Change Characteristics in Picturebooks." *The Reading Teacher* 58 (2004): 178–87.

Sipe, Lawrence R. "The Stinky Cheese Man and Other Fairly Postmodern Tales for Children." In *Shattering the Looking Glass: Challenge, Risk, and Controversy in Children's Literature,* edited by Susan Lehr. Norwood, MA: Christopher-Gordon Publishers, in press.

———, and Caroline McGuire. "Picturebook Endpapers: Resources for Literary and Aesthetic Interpretation." *Children's Literature in Education* 37 (2006): 291–304.

Sutherland-Smith, Wendy. "Weaving the Literacy Web: Changes in Reading from Page to Screen." *The Reading Teacher* 55 (2002): 662–72.

Tapscott, Don. *Growing Up Digital: The Rise of the Net Generation.* New York: McGraw-Hill, 1999.

Trites, Roberta. "Manifold Narratives: Metafiction and Ideology in Picturebooks." *Children's Literature in Education* 25 (1994): 225–42.

Ward, Glenn. *Postmodernism.* Chicago: McGraw-Hill, 2004.

Zarin, Cynthia. "'Not Nice' (Maurice Sendak Interview)." *The New Yorker* 82.9 (2006): 38.

CHILDREN'S LITERATURE CITED

Gaiman, Neil and Dave McKean. *The Wolves in the Walls.* NewYork: HarperCollins, 2003.

Kanninen, Barbara and Lynn Rowe Reed. *A Story with Pictures.* New York: Holiday House, 2007.

Lehman, Barbara. *Rainstorm.* Boston: Houghton Mifflin, 2007.

———. *The Red Book.* Boston: Houghton Mifflin, 2004.

Macaulay, David. *Black and White.* Boston: Houghton Mifflin, 1990.

Scieszka, Jon, and Lane Smith. *The Stinky Cheese Man and Other Fairly Stupid Tales.* New York: Viking, 1992.

Sendak, Maurice. *Where the Wild Things Are.* New York: Harper & Row, 1963.

———, Arthur Yorinks and Matthew Reinhart. *Mommy?* New York: Michael di Capua Books/Scholastic, 2006.

Wiesner, David. *Flotsam.* New York: Clarion Books/Houghton Mifflin, 2006.

Wild, Margaret, and Anne Spudvilas. *Woolvs in the Sitee.* Honesdale, PA: Front Street, 2007.

Willems, Mo. *Don't Let the Pigeon Drive the Bus!* New York: Hyperion, 2003.

4 Play and Playfulness in Postmodern Picturebooks

Maria Nikolajeva

Ludistics, or play theory, investigates the necessity and importance of play in human development and communication (Huizinga 2000). Due to their intermedial nature, picturebooks have strong potential to be playful, which goes far beyond the well-researched areas such as parody, intertextuality/ intervisuality, and metafiction (e.g., Mackey 1990; Bradford 1993; Trites 1994; Kümmerling-Meibauer 1999; Beckett 2001).

The label of postmodernism is not so much a question of historical period, but of a special aesthetics and special philosophy; therefore it would be inaccurate to say that postmodern picturebooks appear in the 1990s. Conversely, the vast majority of picturebooks published today do not show any postmodern traits whatsoever. In discussing postmodern picturebooks we are then talking about an infinitesimal part of the global picturebook production and primarily about Western Europe and North America. This is obvious from the limited number of authors and books discussed in most critical studies, and this will also be reflected in the argument below.

It feels unnecessary to reiterate the various steps and directions in the emergence of picturebook theory; by now, a solid ground has been set up for investigations of picturebook aesthetics, the most essential premise of which is the synergy of word and image in decoding the iconotext. In the process, the crucial distinction between true picturebooks and illustrated books has been acknowledged; it should, however, be immediately pointed out that contemporary visual interpretations of traditional stories, notably folktales and stories by Hans Christian Andersen have, indeed, occasionally resulted in excellent examples of postmodern approaches. Further, such a specific feature of picturebooks as their materiality has been acknowledged. The established solid spelling of the word "picturebook" emphasizes its terminological usage, to distinguish it from picturebooks, or books with pictures (see e.g., Lewis 2001). Yet the counterpoint of word and image, inherent to postmodern picturebooks, is in itself a playful element. While this element has been repeatedly pointed out in books such as *Rosie's Walk, Come Away from the Water, Shirley, Nothing Ever Happens on My Block, Not Now, Bernard,* and *I Hate My Teddybear*, the present chapter will focus on a few lesser known Scandinavian picturebook creators. All translations are mine.

INTERMEDIALITY

Intermediality is a relatively new concept and a new area of study, although multimedia art is to be found already in, for instance, Egyptian mural paintings and carving, or in Chinese scrolls, featuring a poem and an accompanying painting. Intermediality as a scholarly term was originally applied to art forms combining verbal and visual media, such as film, or combining words and music, such as opera (see e.g., Lagerroth 1997). Nowadays, intermediality is widely used in many research areas, including computer games. However, it is not until recently that the concept and the term have entered picturebook studies. The reason, as I see it, is that studies of picturebooks have been strictly divided into two separate categories: those carried out by art historians and those carried out by children's literature experts. Art critics have examined picturebook images as single pictures, discussing composition, shape, line, color, space, hue, saturation and other purely visual aspects, ignoring not only the textual component, but frequently also the sequential, yet nonlinear nature of the picturebook narrative. Thus the intermedial nature of picturebooks was left out. Children's literature scholars, on the other hand, have been focusing on the educational aspects of picturebooks, perceiving them as any other children's books and viewing images as decorations. The emphasis on intermediality (also expressed as counterpoint, synergy, or polysystemy) has become a cornerstone in the picturebook-specific theory.

The counterpoint of word and image as such presupposes playfulness, since images can show something that not merely adds a dimension to the narrative, but offers a possibility to interpret the story differently from what is expressed by the words only. Gro Dahle's and Svein Nyhus's *Bak Mumme bor Moni* (Behind Mumme Lives Moni 2000) relates the horrors of a nice little boy haunted by a monster, who rides a huge sixteen-legged black horse, breathes smoke, and can grow into a giant in ten seconds. The images appropriately repeat what the words convey; yet in dressing the monster in the same green-checkered trousers as the boy, they clearly suggest that the monster is part of the child's imagination. The book becomes a poignant story of self-exploration, in which images take over when the words are no longer sufficient. The text does say: "Inside his head, Mumme has a long corridor," while the image expands the simple phrase into a terrifying mindscape, in which the hard straight lines of the endless doors contrast the soft edges of the child's face.

In Bent Haller's and Dorte Karrebæk's *Ispigen* (The Ice Girl 2001), the words describe the adults' approval of the two obedient girls, while the images ironically show them being led on a leash on all fours, begging like a dog, and crouching covered with a frog's skin. The words and the images do not directly contradict each other, both conveying total compliance, but their interaction creates a discrepancy between the voice and the view. The title figure, literally turned into ice by the two friends' cold neglect, appears

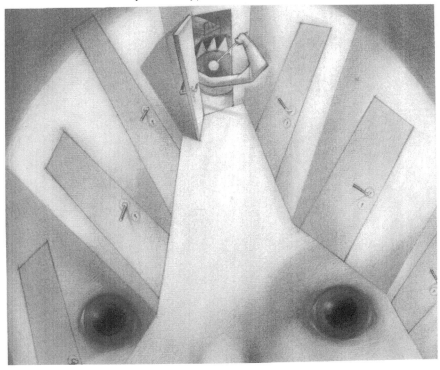

Figure 4.1 Svein Nyhus portrays a young boy's disturbing mindscape in *Bak Mumme bor Moni*. Image courtesy of Svein Nyhus.

in the visual space of the book long before she is mentioned by words. First she is isolated from the two other girls by a frame and placed on the facing page from them; later she is wide awake in bed with her face distorted by fear, as opposed to the other girls with hands piously folded over the blanket in prayer; and her hands passive in front of a blank notebook, while the other two have filled theirs with writing. The bullies' actions are symbolically illustrated by a pair of scissors closing dangerously on the lonely girl, as if rendered inert by their cheerful disregard. The transformation from a human being into an ice figure and finally into a puddle, extended over several doublespreads, is accompanied by the matter-of-fact verbal statement that the girl felt cold. Thus the conflict of the story is introduced visually and evolves mainly through imagery, while the text is considerably less dramatic.

THE PICTUREBOOK AS AN OBJECT

In postmodern picturebooks, playfulness is often expressed through their materiality, their quality as an artifact. Materiality is one of the most self-evident features of any picturebook, yet it is not until the postmodern phase

Figure 4.2 Image of fear and loneliness in *Ispigen*. Ill. Dorte Karrebæk. Image courtesy of Dorte Karrebæk.

that picturebook creators start paying special attention to and utilize this possibility. Peritexts such as cover, endpapers, title page, and doublespread

layout can contribute substantially to the overall meaning of the narrative, as can the size and format of the book, and other purely external qualities. Devices such as impossible space and multiple visual narratives are among picturebooks' unique features, and wordless picturebooks allow further typically postmodern experiments.

In fact, the material form of the picturebook is its inherent element, in which minimal change results in the distortion of the work of art. Even seemingly insignificant interventions in its material existence can destroy its aesthetic totality, which is regrettably overlooked by compilers of anthologies where covers are absent, several original doublespreads placed in the same page, and occasionally a number of images omitted altogether. To begin with, the choice of size and format is by no means accidental. Postmodern picturebooks tend to be of a larger size. Many books from the 1960s and 1970s underscored simplicity and concretism, focusing on the central image and leaving negative space around it (such as Inger and Lasse Sandberg in Sweden and Egon Mathiesen in Denmark). Such books can be easily produced small-sized, 6 x 4, 5 inches, and they would hardly win by being blown up to a full size. Postmodern picturebooks, that make use of whole doublespreads and offer plentiful minute details, demand larger areas, especially when multiple panels are used; or when the doublespread contains multiple images of the same figure, conveying movement and the flow of time. Resized into a tiny book, such images would be impossible to appreciate. On the other hand, when each page carries just one image, with negative space around it, it seems plausible to use a smaller size; for instance, grotesque collages, mixing high and low styles, in Fam Ekman's *PS. Hils morfar!* (PS. Say Hi to Grandpa! 2005). Here, a quite different material concept is employed.

Many picturebook creators vary format and size according to the nature of the book. Books that focus on single episodes and especially those using multiple panels on the doublespread are appropriate for vertical, or portrait, format. The horizontal, or landscape, format is better suited for narratives involving movement, where artists utilize whole doublespreads to create a sense of a wide space. The format itself creates a playful space; it is a part of the picturebook's material form and cannot be disrupted. Thus, the extremely stretched vertical format of Dorte Karrebæk's *Lille frøken Buks og de små sejre* (Little Miss Pants and the Small Victories 2004) emphasizes the character's fear by placing the tiny figure on the bottom of the page, with the rest of the world towering over her. Obviously, format and size are a picturebook creator's deliberate choice.

The saying: "Do not judge a book by the cover" does not pertain to picturebooks, as many contemporary picturebook authors have discovered. The cover of a picturebook is a highly significant part of it and can carry vital information for understanding the story, without revealing too much of the content. In postmodern picturebooks, the common practice of choosing a page from inside the book for the cover is promptly abandoned.

Instead, covers are frequently used as gateways into the book, preferably enticing gateways that alert curiosity. The back cover is also a possible narrative space. Normally, back covers carry some information about the author, a short plot summary, and perhaps some reviews. Yet occasionally the back cover is an indispensable part of the story. At the least, front and back cover present an inseparable whole establishing and accentuating the visual narrative space. In Karrebæk's *Pigen der var go' til mange ting* (The Girl Who Was Good at Many Things 1996), however, front and back cover create a distinct conflict. While the front cover mirrors the optimistic ending of this otherwise joyless book, the back cover shows the character petrified as a doll, the way she is portrayed in the beginning of the book. The words on the back cover, easy to dismiss as the publisher's advertising text, say: "It is never too early to find a good place to stay, where there are flowers to pick." This is the *sens morale* of the story, but can we trust it when the image points back at the initial situation? Or does the gloomy back cover encourage us to turn the book over and start reading again? Whatever the answer, we see that the back cover of a picturebook may add an important dimension to the narrative.

Normally we assume that the narrative begins on the first page. Picturebooks, however, frequently make use of endpapers to create an establishing scene or even start the plot (cf. Sipe and McGuire 2006). The title page can anticipate or initiate the narrative. In Karrebæk's *Den nye leger* (The New Playmate 2001) the narrative starts on the half title page (the page preceding the title page; in this case actually the right-hand page of the endpaper). A tiny image shows a boy and a girl hugging each other; the text underneath states: "The worst thing is not moving. The worst thing is moving away from someone"; while the girl is saying, in an unframed speech balloon: "Will you come and visit me?" and the boy replies "Yes."

If we ignore this detail and assume that the story starts, as they usually do, on the first spread after the title page, we miss the initial conflict of the plot, the separation, and fail to understand for whom the protagonist is waiting during the rest of the story. Moreover, the wordless doublespread, following the title page and preceding the "Monday" chapter (easily perceived as the beginning of the story), is by no means decorative, but continues the plot. It shows the girl's mirrored profiles, one looking back to her old life, the other, with her eye an empty white hole, gazing blindly into the future; as well as the girl's hair as an extension of the motorway, and so on. These initial images, even though alternating with the realistic picture of the girl taking farewell of her friend, alert the reader to the subsequent complex imagery of the book.

DOUBLESPREAD COMPOSITION
AND SEQUENTIAL UNITY

Discussing picturebooks, scholars do not refer to pages, but to openings, or doublespreads, by now a commonly accepted aspect of picturebook

Det værste
er ikke at flytte.
Det værste er
at flytte fra nogen.

Figure 4.3 The story in Dorte Karrebæk's *Den nye leger* starts before the title page. Image courtesy of Dorte Karrebæk.

materiality. The layout of a doublespread includes, among other things, the mutual position of the text and the picture panels, the presence or absence of borders and frames, and the relationship between left-hand page (verso) and right-hand page (recto). Page layout is essential since in postmodern picturebooks facing pages comprise a single whole even when they depict two or more different scenes. Nothing can be moved on a doublespread, neither text, nor image, without destroying the synergetic effect of the narrative. In early picturebooks, text and pictures were separated (mostly for technical reasons, to facilitate printing); pictures could be placed on the recto and text on the verso. In postmodern picturebooks, the

Figure 4.4 The conflict in *Den nye leger* is initiated in the wordless doublespread. Images courtesy of Dorte Karrebæk.

verbal text is integrated into the overall layout, sometimes to the degree that at least part of it appears within the image—intraiconic texts—in form of speech or thought balloons, parallel narratives used as commentary on the primary story, or as additional comic details. The wide range of layouts contributes to the dynamism of the story. The most elementary layout is letting verso and recto create a tension between, for instance, harmony on the left and disruption on the right. Many artists present more challenging solutions. Single-panel doublespread, with or without text, is by far the most frequent layout, which allows infinite possibilities for details, dynamics, balance—or absence thereof, something that disagrees with the general principles of a single-image composition, such as a painting. Because of the sequential nature of the picturebook, every spread is dynamic and tends to lean to the right, by placing a significant

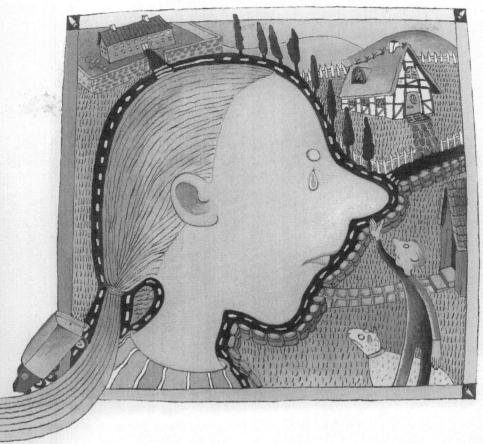

detail in the right bottom corner of the spread, a pageturner. This composition also results in the general direction of movement in picturebooks from left to right, following the direction of reading (it is, or should be, the opposite in languages read right to left). Conversely, a conspicuous detail on the verso may slow down the decoding, resulting in a narrative pause. Simultaneous succession, that is, the recurrent appearance of the same figure or detail throughout the doublespread, not only suggests duration and movement, but also guides the viewer through the various parts of the visual narrative. Sometimes it may prompt a certain order of reading or a swift movement of a character, supported by motion lines; otherwise it promotes careful and repeated browsing.

Multipanel doublespreads create a sense of progression, but they can also convey two or more simultaneous actions or events, and even different points of view. Sven Nordqvist's hilarious *Festus and Mercury* books provide extensive examples, in which unframed panels merge into one another at different angles. Expanding the text, multiple images often

produce a comic effect. Karrebæk's *Mesterjægeren* (The Master Hunter 1999) is an absurd story of a human boy raised by wild cats, while a she-kitten grows up with a human mother. The father feeds his newborn son by creeping "on a lactating female animal and putting the boy among her own young. He did it so quietly and carefully that the mother did not have time to wonder over what happened. Or over that anything happened at all." The succession of images on the verso, continuing into the recto that carries the text, shows vaguely identifiable mammals in bizarre poses and definitely dissatisfied with the intruder, who, in one case, has attached a long tube to the nipple, to nurse with more comfort. The scarce words are unfolded in the images into prolonged and repeated scenes. In the next spread, the words "When the first tooth appeared, milk was exchanged for meat" prompt a sequence of images, separated by frames this time, showing the boy first sneaking at a wild sow, biting at the teat, the sow's violent reaction, and finally father and son at a campfire beside a neatly gnawed skeleton. The situation is further clarified by the recto image, showing the boy chasing a rabbit. The remarkable employment of layout in this book culminates in the sequence of four panels, going left to right through the doublespread, that accompany the verbal statement: "Cats' lives progress much more quickly than humans." The images show the cat first happily sitting at a school desk beside her classmate and successively growing larger as her facial expression changes from sorrow into sheer terror. In the fourth panel, her head has made a breach in the panel frame and is sticking out. The speedy progression is emphasized as the first panel shows the letters A and B in the students' primers, while the fourth features Ø and Å, the last letters of the Danish alphabet. The playfulness of the images emerges through the succession of panels, as well as through enhancement by a separate unframed picture of the poor cat trying on an eight-cup bra in front of the mirror, an episode not mentioned in the verbal text.

Many scholars have pointed out the importance of frames and borders in picturebooks. Frame-breaking in all possible metaphorical senses is part of postmodernist aesthetics; postmodern picturebooks, however, tend to break the frames quite literally and tangibly. Postmodern picturebooks seldom have borders, filling the whole area of the doublespread. Frames are further destroyed by the device of bleeding, which suggests that the boundary between the visual world and the viewer's reality is blurred; the viewer is invited to step into the image and become an active part of the story; the book intrudes into the viewer's space. Multiple, overlapping and embedded frames create an additional metafictional effect. The inventive play with frames is especially tangible in Karrebæk's *Pigen der var go' til mange ting*. The closed visual space of the first spread, with wide speckled red borders, suggests captivity, emphasized by the protagonist's passive and downcast body language. In the subsequent spreads, she has escaped through the constraining frame into a space of

Figure 4.5 The adult world penetrates the child's sanctuary in Dorte Karrebæk's *Pigen der var go' til mange ting*. Image courtesy of Dorte Karrebæk.

her own, occupying the border where she can perform the actions necessary to care for herself. However, the developments inside the frame, depicting the parents' drunken quarrels, intervene into her visual sanctuary, as earsplitting sounds, visualized by jagged color lines, as feathers from pillows that the parents fight with, and finally with an empty bottle falling through the frame into the girl's quiet starry night.

When the girl decides that she has had enough she literally steps out of the frame and the border, and the last spread shows her walking out of the book (the image actually shows the lower part of her body in the right top corner). The restrictive frame has disappeared, and the white negative space suggests opening and freedom. Thus the compositional organization of individual doublespreads and of the sequence enhances the theme and message of the story, where the text is sparse and relatively calm.

IMAGES WITHOUT WORDS

Wordless narrative picturebooks are almost without exception built on the continuity of doublespreads, where a chain of details can be used to emphasize the uninterrupted flow of the story. This is ingeniously employed in Tord Nygren's wordless *The Red Thread* (1987), where the thread guides the reader's gaze through the book (see Nikolajeva and Scott 2001a 10–11). In Karrebæk's *Det er et hul i himmelen* (There is a Hole in the Sky 1989) each doublespread combines a full-area panel with a sequence of smaller panels, the position of which changes from spread to spread. While the small images depict a realistic flow of events, the large pictures reflect the imaginary world of the protagonist, closely connected with her everyday experiences. The layout itself is thus playfully used to create a tension between the external and the internal visual space.

Duften i luften (The Smell in the Air 1991), by Peter Lind and Bente Bech, has a very simple plot about adventures and misadventures of a little field mouse. In terms of layout alone the book is interesting with its variation of framed and unframed pages combined with small framed panels demanding extra attention. The spreads add up to a cohesive visual space; thus the book is perceived as a single action, like a single shot in a film. This is achieved by swift, dynamic moments depicting pursuit and rescue. A mystical greyish band winds across the doublespreads and finally appears to be the smell from the cooking meal in the mouse's home, the smell that the title alludes to and that the mouse has been following during his wild run. The last spread shows that the mouse is not a child, but the family father, which immediately changes the whole interpretation of the narrative. In his visual speech balloons he boasts in front of his children about his bravery, which makes him into a different kind of hero than the tiny frightened creature he has been throughout the story. The playfulness of the book depends on the discrepancy between the images in the speech balloons and what has been depicted in the previous pages. Since there are no words to comment on the adventure it can be interpreted in an ambivalent manner with an ironic closure.

Rejsen (The Journey 1999), by Hanne Bartolin, is quite a different kind of wordless picturebook. It does have a vague plot, accentuated by the title; yet its dreamlike nature and postmodern space construction do not suggest any particular storyline. Each viewer is at liberty to invent an adequate narrative to accompany the images. The relationship between the two characters, a dog and a giraffe, is equivocal; the ending is open, and the interpretation depends entirely on the viewer, although many of the images suggest a kind of creation story. *Vejen til festen* (The Road to the Party 1994), by Bente Olesen Nyström, is more detailed and complex than *Rejsen* in its surrealistic images and rich intervisual links. There is a clearly delineated plot, likewise emphasized by the title, where the viewer can follow as the two figures wander through bizarre landscapes; yet the universe of the book contains considerably more than merely this trip. There are many more dynamics and several movement

directions. While *Duften i luften* is relatively simple, even though the ending supplies an unexpected turn, *Rejsen* and *Vejen til festen* are not merely ambiguous, they are open, writerly narratives offering endless interpretation options. Yet one is sparse, while the other extremely rich in detail.

PLAYFUL INTERACTIVITY

In postmodern aesthetics, the boundary between art and artifact becomes vague. A vast output of products nowadays lies in the borderline between books and toys, employing cut-outs, flaps, and other purely material elements that add to the playful dynamics and demand a certain degree of interaction to engage the viewers and make them co-creators. While most of these toy books are mass-market goods, a few are examples of the highest artistic quality, not least the early forerunner Tove Jansson's *Moomin, Mymble and Little My*, that uses holes to enhance playfulness. Naturally, holes also emphasize the material existence of the book. However, interactivity of a more subtle nature lies in decoding complex iconotexts that require the viewer's full attention to appreciate the visual signs as well as the word/image interplay.

Parallel visual narratives, also called running stories (Doonan 1993) and syllepses (Nikolajeva & Scott 2001a), are undoubtedly one of the picturebook's unique features. The side actions can comment on the primary narrative, or be completely independent, or can even prove more interesting than the primary story itself. Again *Festus and Mercury* books provide the best example of this device, portraying a vast gallery of tiny imaginary creatures who copy the main events in a world of their own. Interestingly enough, Nordqvist anticipated his use of syllepses in the *Festus and Mercury* books in his illustrations to Hans Christian Andersen's tale *What the Old Man Does is Always Right* (1982), in which the original story is mirrored in a wordless narrative at the bottom of the page, featuring a dog instead of a man. In Nordqvist's most recent book, *Var är min syster?* (Where is my sister? 2007), which he worked on for twenty-five years, there is a linear plot appearing symmetrically in the verbal and visual narrative, a little mouse looking for his lost sister. However, around this rather flat story, a wild universe of multifarious creatures and distorted objects appears with elaborate visual allusions to world artists of all times.

Intertextuality, or rather, intervisuality as a more appropriate term in connection with images, references to well-known works of art, naturally creates a playful atmosphere. The best-known examples in Scandinavia are Fam Ekman's *Hva skal vi gjøre med lille Jill?* (What Are We Going to do With Little Jill? 1976), *En sky over Pine-Stine* (A Cloud Over Pining Stine 1987), *Kattens skrekk* (The Cat's Terror 1992), *Dagbok forsvunnet* (The Lost Diary 1995), and the above mentioned *PS. Hils morfar!*, in all of which famous art objects are parodied and distorted (see also Beckett 2001). Little Jill enters a painting, a well-known mythical motif, that, when employed visually,

adds to the frame-breaking, metafictional level of the book. Play with visual intertexts has become all the more common with the picturebook creators' growing awareness of picturebooks' double audience, since most often they are perused by children and adults together, a phenomenon comparable to the explosion of family movies, offering adults something to enjoy alongside the children (for instance, *Cars*). Interpictorial links to earlier picturebooks or other well-known stories add still new dimensions. In Pija Lindenbaum's *Bridget and the Gray Wolves* (2000), the title's obvious allusion to Little Red Riding Hood is accentuated by the girl's red jacket, while the plot adheres to the long line of postmodern visual interpretations of the fairy tale. Fam Ekman's gender-reversed *Rødhatten og ulven* (Redcap and the Wolf 1985) is part of the same tradition. Many postmodern picturebook creators teasingly put intertextual details in the images that can easily be missed. For instance, in *Chokoladeeskapade* ("The Chocolate Escapades" 1998), by Kirsten Hammann and Dina Gellert, a tiny book in the foreground bears the title "Uncle Tom's chocolate cabin."

Not least, postmodern picturebooks abound in the devices of nonsense literature, expressing them through visual means. Some picturebook creators have come up with fascinating images, and often the whole book is based on this principle. *Anton elsker Ymer* (Anton Loves Ymer 2006), by Lilian Brøgger, introduces the concept of antonyms by placing two cats on the facing pages; the oppositions evolve from simple and unambiguous, such as big and little, fat and thin, toward complex, absurd imagery, such as crumpled and straight, unified and diverse, broken and patched, or switched on and switched off. *Hoved & hale* (Heads & Tails 1997), by Helle Vibeke Jensen, displays a variety of images that lack verbal correspondences, referents without signifiers. One can also say that the verbal text pretends that the images do not show anything other than normal. For instance, it merely says: "a little girl" without any comment on the girl having a fish instead of a head. The visual hybrid in the book is never explained and presents a typical example of the postmodern play for play's sake. The subtitle, "A book about contradictions," emphasizes the nonsensical story, and the use of impossible space, inspired by expressionism and surrealism in art, adds to its joking dimensions.

Den dagen det regna kattungar (The Day it Rained Kittens 1988), by Hans Sande and Ingunn van Etten, translates a metaphor ("it rains cats and dogs") into a literal image. Dahle's and Nyhus's *Tikk takk, sier tiden* (Tick Tock, Says Time 2005) depicts time as a robot-like figure illustrating set phrases such as "time goes by" or "time will show." Karrebæk's *Go' morgen frue* (Good Morning, Lady 1999) plays with the literal meaning of the names of various plants portraying them in an unexpected and ingenious manner (an English correspondence would be, for instance, a dandy lion). The human protagonist poses questions based on the literal interpretation, wholly in the tradition of Lewis Carroll. A more sophisticated way of visualizing a verbal statement and at the same time conveying a subjective point of view is to be found in Pija Lindenbaum's *När Åkes mamma glömde bort* (When Åke's Mom Forgot

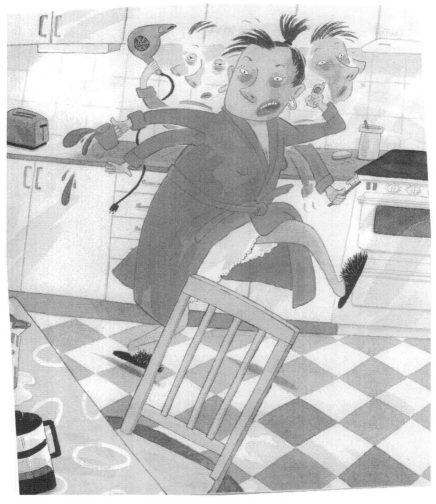

Figure 4.6 Stressed mother shattered into pieces. From *När Åkes mamma glömde bort*, by Pija Lindenbaum. Image courtesy of Pija Lindenbaum.

2005). The text informs the reader that the little boy Åke's mother is "totally wild in the mornings" and that she herself says: "I'll go crazy."

The dynamic image reflecting the mother's literal going to pieces also shows the boy wearing a dragon mask and playing with toy dragons at breakfast table. The text explains that the boy puts on the mask to screen off his mother's shouts: "It is somewhat silent inside." In the next spread, the mother has turned into "a kind of dragon." The text/image interaction feels a bit redundant here, but the image shows exactly what kind of dragon it is: pink, matching the color of the mother's dressing gown in the first spread, and

Figure 4.7 Metafictive play with two narrative levels: who is telling the story and who is the character? From *Historien*, ill. Lilian Brøgger. Images courtesy of Lilian Brøgger.

with a bobble of hair held by a rubber band. The expression "go crazy" is expanded visually into a whole plot. Notably, the boy is not at all amazed at his mother's metamorphosis, which supports the interpretation of the images being a transposition on the one hand the mother's state (she is obviously suffering from extreme stress-related depression), on the other hand the boy's

Figure 4.8 Metafictive play with two narrative levels: who is telling the story and who is the character? From *Historien*, ill. Lilian Brøgger. Images courtesy of Lilian Brøgger.

perception. The other people do not seem to find the dragon extraordinary: the ticket-seller at the terrarium merely informs the boys that animals enter for free; the children at the playground object when the dragon puffs smoke, but when she starts breathing fire, a fire engine is summoned. Granny comforts the boy promising that the mother will be back to her usual self in a

couple of days. The images play cleverly with the fluctuant boundary between human and animal: the dragon walks upright and carries a handbag, while she also eats bugs, attacks dogs, and sleeps curled up on the floor.

Historien (The Story 2000), by Kim Fupz Aakeson and Lilian Brøgger, employs metafiction to interrogate the existence of an objective universe. The most apparent metafictional feature is the two levels of narrative, one of which involves a Danish father telling a bedtime story for his son. The story is about two elephants in Africa. On the other level, an elephant in Africa is telling a bedtime story for his child about a father and son in Denmark. Initially, each level has its own alternate doublespread. On closer look, already the first spread, featuring Denmark, is connected to the Africa level, since there is a framed sketch of a palm on the wall, a hunting gun, a model airplane hanging from the invisible ceiling, and a picture of two elephants on the chest of drawers. The father thus creates his story inspired by the material objects around him. In the Africa spreads, there is to begin with no evident connections with Denmark, but successively the palms acquire rows of windows, corresponding to houses in Denmark, while the elephants, the father Conrad and the child Little Nu, appear wearing the same clothes as the human father and son. Further, the characters on the two levels are aware of events in each other's worlds: a robber has broken into the flat, and a hunter is stalking the elephants. Finally, the stories merge, in a most ingenious way. The two visual spaces get completely integrated, while the verbal narratives are still separated, but placed together on the same spread. On the penultimate spread, the four lines of direct speech are accompanied by the tags: "asks little Nu," "asks the boy," "Conrad says," "Dad says." On the last spread, the tags are absent, so it may seem that both the boy and the elephant child ask the question, and both the human and the elephant father reply. Then two cues are repeated: " 'Do you think so?' asks the boy. 'Do you think so?' asks little Nu." The answer is again tagless: "Anything can happen in a story." On the spread, the same composition as in the beginning is used, showing the same room, with the child in bed and the father in a chair beside him; but the father and the son are now elephants, and the photo on the chest features the human father and boy. Throughout the book, it is in the first place the images that draw the reader's attention to the blurring of boundaries. The story can be primarily perceived as *mundus inversus*, but in a more sophisticated interpretation it presents the most central question of metafiction and generally of postmodern thought: what is reality after all? The book is a perfect example of a contemporary picturebook that operates on different levels and addresses several audiences.

CONCLUSION

The most exciting development in postmodern picturebooks is their increasing potential for conveying complex mental states, when illustrations

can be used when words are no longer sufficient to depict characters' inner worlds (Nikolajeva and Scott 2001b). It is inconceivable how many words would be needed to evoke the same response in the reader that images do, for instance, the sense of utter despair in *Den nye leger*, the profound loneliness of the bullied girl in *Ispigen*, the abnormal anxiety in *Kattens skrekk*, and the uncontrolled aggression in *Bak Mumme bor Moni*. Contemporary narratologists and psychoanalytically oriented critics have repeatedly pointed out the inadequacy of the verbal language for conveying "subverbal states." Here, picturebooks have superior artistic means, some of which have been presented above. One would assume, for instance, that bedtime stories by their very nature suggest interpreting the narrative as dreams. Yet images can occasionally add a detail that immediately gives rise to hesitation (Nikolajeva and Scott 2001a, 173–210). The indeterminacy of the iconotext, playing with objective and subjective perception, and at length interrogating the possibility of depicting a coherent universe, are in perfect correspondence with postmodern views of the world.

WORKS CITED

Beckett, Sandra. "Parodic Play with Painting in Picturebooks." *Children's Literature* 29 (2001): 175–95.
Bradford, Clare. "The Picture Book: Some Postmodern Tensions." *Papers: Explorations in Children's Literature* 4 (1993): 10–14.
Doonan, Jane. *Looking at Pictures in Picturebooks*. Stroud: Thimble Press, 1993.
Huizinga, Johan. *Homo Ludens: A Study of Play-element in Culture*. London: Routledge, 2000.
Kümmerling-Meibauer, Bettina. "Metalinguistic Awareness and the Child's Developing Concept of Irony: The Relationship between Pictures and Texts in Ironic Picturebooks." *The Lion and the Unicorn* 2 (1999): 157–183.
Lagerroth, Ulla-Britta, et al. eds. *Interart Poetics: Essays on the Interrelations of the Arts and Media*. Amsterdam: Rodopi, 1997.
Lewis, David. *Reading Contemporary Picturebooks, Picturing Text*. London: Routledge, 2001.
Mackey, Margaret. "Metafiction for Beginners: Allan Ahlberg's *Ten in a Bed*." *Children's Literature in Education* 21.3 (1990):179–187.
Nikolajeva, Maria, and Carole Scott. *How Picturebooks Work*. New York: Garland, 2001a.
———. "Images of the Mind: The Depiction of Consciousness in Picturebooks." *CREArTA* 2.1 (2001b): 12–36.
Sipe, Lawrence, and Caroline E. McGuire. "Picturebook Endpapers: Resources for Literary and Aesthetic Interpretation." *Children's Literature in Education* 37.4 (2003): 291–304.
Trites, Roberta Seelinger. "Manifold Narratives: Metafiction and Ideology in Picturebooks." *Children's Literature in Education* 25.4 (1994): 225–42.

CHILDREN'S LITERATURE CITED

Aakeson, Kim Fupz, and Lilian Brøgger. *Historien*. Copenhagen: Høst & Søn, 2000.
Bartolin, Hanne. *Rejsen*. Copenhagen: Alma, 1999.
Brøgger, Lilian. *Anton elsker Ymer*. Copenhagen: Politiken, 2006.
Dahle, Gro, and Svein Nyhus. *Bak Mumme bor Moni*. Oslo: Cappelen, 2000.
————. *Tikk takk, sier tiden*. Oslo: Cappelen, 2005.
Ekman, Fam. *En sky over Pine-Stine*. Oslo: Cappelen, 1987.
————. *Hva skal vi gjøre med lille Jill?* Oslo: Cappelen, 1976.
————. *Rødhatten og ulven*. Oslo: Cappelen, 1985.
————. *Kattens skrekk*. Oslo: Cappelen, 1992.
————. *Dagbok forsvunnet* Oslo: Cappelen, 1995.
————. *PS. Hils morfar!* Oslo: Cappelen, 2005.
Haller, Bent, and Dorte Karrebæk. *Ispigen*. Copenhagen: Høst & Søn, 2001.
Hammann, Kirsten, and Dina Gellert. *Chokoladeeskapade*. Copenhagen: Forum, 1998.
Jansson, Tove. *Moomin, Mymble and Little My*. Seattle: Blue Lantern, 1996.
Jensen, Helle Vibeke. *Hoved & hale*. Copenhagen: Høst & Søn, 1997.
Karrebæk, Dorte. *Det er et hul i himmelen*. Copenhagen: Munksgaard, 1989.
————. *Pigen der var go' til mange ting*, Copenhagen: Forum, 1996.
————. *Mesterjægeren*. Copenhagen: Forum, 1999.
————. *Go' morgen frue*. Copenhagen: Gyldendal, 1999.
————. *Den nye leger*. Copenhagen: Gyldendal, 2001.
————. *Lille frøken Buks og de små sejre*. Copenhagen: Gyldendal, 2004.
Lind, Peter, and Bente Bech. *Duften i luften*. Copenhagen: Høst & Søn, 1991.
Lindenbaum, Pija. *Bridget and the Gray Wolves*. Stockholm: R & S Books, 2001.
————. *När Åkes mamma glömde bort*. Stockholm: Rabén & Sjögren, 2005.
Nordqvist, Sven. *Pancake Pie*. New York: Morrow, 1985 (the first book in the *Festus and Mercury* series).
————. *Var är min syster?* Stockholm: Opal, 2007.
Nygren, Tord. *The Red Thread*. Stockholm: R & S Books, 1988.
Nyström, Bente Olesen. *Vejen til festen*. Copenhagen: Gyldendal, 1994.
Sande, Hans, and Ingunn van Etten. *Den dagen det regna kattungar*. Oslo: Gyldendal, 1988.

5 Postmodern Picturebooks and the Transmodern Self

Karen Coats

There is a long and fairly disreputable (or at least contestable) tradition in Children's Studies of gauging what a culture believes about its children by looking at the way it portrays them in art. Philippe Ariès's primary methodology in his controversial yet still influential book *Centuries of Childhood: A Social History of Family Life* is to look at medieval representations of children's faces, bodies, and clothes; he infamously concludes that childhood didn't exist as a concept in Europe before the European Middle Ages. Eva M. Simms, in a forthcoming book, turns Ariès's notion on its head: using art but also adding in a brilliant reading of the Children's Crusade, she concludes that it wasn't a notion of childhood that was lacking, but a firm sense of adulthood with its attendant rites of passage that kept European peoples from making solid distinctions between childhood and maturity. She points to the importance of a journey away from home, and the emergence of self-reflexive art, as well as to portraits that place age and youth in contradistinction with one another, as her source texts.

Anne Higonnet, in *Pictures of Innocence: The History and Crisis of Ideal Childhood*, offers more philosophically charged conclusions about the attitudes toward childhood one can glean from pictures of children, arguing that critical study of the representations of children over the centuries reveals to us a paradigm shift in the way we view childhood and our relation to it. She mounts an interdisciplinary argument that our vision of childhood has moved from a nostalgic notion of the Romantic, innocent child who acts as a talisman or fetish to ward off our fears regarding death, decay, and loss, to a more disturbing incarnation of the child as a preternaturally knowing fetish of a different kind, one that exposes rather than protects us from the knowledge of sexuality, exploitation, vulnerability, and abuse. I'd like to continue in this more philosophical vein, adopting and adapting the (dubious?) methodology of looking at representations of and for children in order to draw some conclusions about what we believe about the self in postmodern society. Unlike these historians and critics, however, I won't be focusing on the pictures that hang in galleries or turn up in greeting card racks, but at the texts and images that children themselves are more likely to interact with—contemporary, specifically postmodern, picturebooks.

I want to suggest that children's interactions with postmodern picture-books provide a key entry point into the project of self-fashioning in contemporary society. My argument rests on the premise that children's texts, in their many forms, provide children with the cultural and visual literacies and narrative patterns that allow them to craft identities that will be functional and recognizable in their society; they are an important element in the scaffolding on which children build coherent and effective selves. This premise, of course, is based on an ideology informed by postmodern critiques of Romantic and modernist beliefs that the self is an inner potentiality that we grow into (as modernists would have it) or out of (as per the Romantics), and that we live authentically or inauthentically. Postmodernism challenges the very possibility of authenticity by insisting on the self as constructed—a fragmented play of surfaces where any sense of coherence or integration is illusory at best, a violent repression at worst. Hence representations and relationships of all kinds are vastly important in the process of self-construction, and the stories that are available for children at any given time are the material out of which they fashion an identity and formulate an aesthetics and ethics of the self. While I find much to think about and indeed value in that challenge, I believe that such postmodern critiques have largely exhausted themselves because they don't fully account for the lived reality of children. That is, while I acknowledge that much of our reality is socially constructed, I also think that children's desire for internal integrity and coherence is not in fact based on a storied illusion fomented by culture, but on their experience of their own bodies. Likewise, their desire for structure and meaning that expands beyond the situated, local experiences that their experience affords them comes from their positioning within a community of others, and within a system of signs—language and image—that point to a reality outside themselves. Hence I find that, like Eliza Dresang in this present volume, I need a 'beyond' of postmodernism. Rather than locate my argument in contingent digital age principles as she does, however, I want to explore the relationship of postmodern picturebooks to what psychologist Paul Vitz has termed the "transmodern" self. As I will explain in more depth later, the notion of the transmodern attempts to incorporate embodied experience within social and cultural formations; it acts as an important synthesis and corrective to starker versions of the self in modernist and postmodernist thought. Postmodern picturebook authors and illustrators operate at the interstices of these conceptual frameworks, using the playful but philosophically bleak techniques of postmodernism to transform the optimistic but pragmatically untenable dictates of modernism into a vision of the transmodern self.

FROM MODERN TO POSTMODERN

I want to start with a scandalously selective overview of the history of the modern self and its postmodern discontents. As Ariès, Simms, and Higonnet

point out, portraiture is an important indicator of the ideology of a period, especially as it reveals how a culture literally sees the individual. The earliest examples of figure drawing that we know were concerned with depictions of action, relationships, and ideas rather than capturing the distinctive features of individuals. Egyptian, Roman, and Greek funerary portraits and portrait sculptures from as early as 3100 BCE did depict recognizable individuals, but they were still concerned with creating a montage effect by connecting the face of a person with the authority of his or her position. During the medieval period in Europe, most portraits tended to lose the sense of the individual altogether in favor of a stylized representation of a person's occupation or social or religious position, relying on conventional imagery of, for instance, a scholar at his desk, Madonna and child, or a king or religious leader dispensing authoritative pronouncements. As it broke free from these conventional images into the recognizably realistic depictions of patrons and important political personages, postmedieval portraiture suggests the emergence and growing importance of the sense of an individual self; historians of the self concur that the notion of the modern individual self emerged during the Renaissance and Reformation, abetted by the growth of humanistic philosophies, an emphasis on the moral accountability of individuals, and the development of the printing press, which enabled the development of a widespread literacy practiced alone in one's room, encouraging the tendency toward introspection and self-reflexivity.

In the mid-nineteenth century, painterly representations were democratized, as it were, as painters turned their attention not only to ordinary people, but to children as well. Though the motivation for child portraiture was then, as it is now, at least in part to preserve a sense of an individual child's appearance, the poses, attitudes, and dress adopted for these portraits were stylized into ideal representations of childhood, rather than any particular child's habits or preferences. As Higonnet points out, portraits of children were designed to capture the essence of an idea of innocence. Even in representations that were decidedly coy, there is a sense that the child is free of blemish and the taint of adult sensibilities, worries, and preoccupations. The ideas and values of John Locke and Jean-Jacques Rousseau had taken firm hold in the public imagination, positing children as blank slates, a breed apart from their elders, who were responsible for bringing them up in such a way as to ensure that they remained unsullied by the baser imaginings that would prevent them from realizing Enlightenment ideals of moral and intellectual autonomy, reason and rationality, and a strong sense of independence and free will. In children the self is in potential; modernist faith is in progress and development—the progress and development of the individual, and the progress and development of the species. Today, we generally accept these modernist signifiers—independence, freedom, autonomy, reason, self-actualization—as goals the human self is tending toward or striving to achieve; the path is linear, and goes uphill through

predetermined stages from child to adult. The upward trajectory of this path was challenged by the Romantics, of course, who saw these same signifiers as our birthright rather than our achievements, and experienced growing up as a loss of these things rather than their fulfillment, but the absolute rightness of these values remained (and remains, as we shall see) largely unchallenged until a critique calling itself postmodern emerged.

Modernist picturebooks affirm these values and this sense of self in both their form and their substance. Throughout his critical oeuvre, American art theorist Clement Greenberg talks about modernist artistic practice in ways that are analogous to the ways we have just been discussing the self, by stressing art's essential autonomy.[1] Art in modernism is a subject, form, and practice of and for itself; at its maturity, it takes nothing from nor owes anything to the world around it. Consider in this context *The Story of Ferdinand*. Under his cork tree, Ferdinand is accountable to no one. He thinks and decides for himself what is right for him, and exercises his free will despite cultural expectations, maternal worries, and the potential threat of being poked with a sharp stick. The artistic form of the work is quite divorced from representation; the bulls may look like bulls and the matador like a matador, but only insofar as a black line drawing on a white background can resemble the thing it represents. Indeed, Lawson's depiction of the cork tree playfully reminds us of his autonomy from representation. Likewise, Harold with his purple crayon is an iconic representation of the self in modernist theory—a diminutive Descartes, his free will is such that he can create and destroy his world at his own pleasure. Max with his wild things, Peter playing alone on his snowy day, Curious George getting up to one mischief or another—each representation is of a self-contained individual in a self-sustaining narrative world.

The notion of a modernist self with its optimistic (if rather lonely) teleology has undergone a radical critique, however, with the advent of postmodernity. Generally speaking, we have been staging the postmodern critique since the world wars, the horror of which caused us to lose faith in the modernist optimism regarding progress and development. Artistically speaking, however, the postmodern critique did not come to the cultural mainstream until the late 1960s, when people started to really challenge the basis of modernist thought. Clearly, reason, autonomy, independence, and free will do not lead us to seek the good as we had previously assumed they would—we are not like Ferdinand after all, it would seem—nor does rationality ensure even a utilitarian ethics that would prevent us trying to destroy ourselves; our wild things do not always respond to flashing scepters and the promise of comfort and a hot dinner. On the one hand, maybe these modernist values would point us in the right direction if it were possible to actually achieve them, which it apparently is not; on the other hand, perhaps the goals themselves are inherently flawed, steeped as they are in a framework that foregrounds and privileges the autonomy and free will of the individual. Mothers and children know there is no such thing as

autonomy; oppressed peoples understand with their bodies the limitations of a genuinely free will. The self does not grow like a tree, developing its various potentialities toward self-actualization and fulfillment, but rather expands artificially by accruing the detritus of lived experience. If this is in fact the case, and yet we operate on an ideology of ever-increasing social, physical, and moral autonomy, then it's clear that that ideology is a cultural construction, rather than a natural inclination or potentiality, revealing that our core beliefs are also dependent on contingent cultural narratives. Postmodernism, as it relates to theories of the self, calls into question all those narratives, all the big stories of how we live or how we should live and manage our relationships.

Postmodern art, then, also calls into question cherished narratives, notions of organic form, and the autonomy of the artistic process by being overtly irreverent and self-referential. A postmodern picturebook might parody a narrative or an artistic form, or it might present a local version of a "universal" (read white, European) story, such as the myriad culturally specific versions of Little Red Riding Hood or Cinderella. They may poke fun at cultural sacred cows such as "happily ever after" endings, or challenge the softness and stylized beauty of organic forms with impossibly angular or distorted images and caricatures. They call attention to and celebrate their artistic processes rather than their subjects, or their processes as integral to their subjects, as does Lauren Child in her end note to *The Princess and the Pea*, which describes in detail how she selected and created her miniature scenes, and how they were photographed. In fact, I would go so far as to say that the project of well-made postmodern picturebooks is to reveal their constructedness, and to make their materiality thematically relevant, that is, to embody the principles that inspired Marshall McLuhan to pronounce that "the medium is the message." Dave McKean, for instance, in his illustrations for Neil Gaiman's *The Wolves in the Walls*, melds the organic, the inorganic, and the digital into a masterful visual expression of the book's textual themes. The cover shows Lucy, the main character, drawing a picture of a wolf. She isn't looking at her picture, however, and thus doesn't seem to notice that the eyes of her picture have been cut out, and real red wolf eyes are peering out from the holes. The stair wall of her house is covered with pictures she has drawn of wolves, forcing the reader to realize that the wolves coming out of the walls and taking over the house are Lucy's creations rather than some interlopers from outside. This interpretation is reinforced by the fact that the wolves are drawn in pen and ink, unlike the characters, who, though digital, have a dimensional solidity. Thus McKean indicates through his use of artistic technique the thematic message that while these predators are insubstantial and come from within, they are no less alien and scary because of that.

What postmodern picturebooks do not do, however, is present the postmodern critique in its nihilistic or even its angst-y guise. Rather than present the bleak portrait that our once cherished moral compasses no longer

point true, that our sense of autonomy has been grounded on a facile and dangerous illusion, and that we are doomed to a hopelessly incoherent fragmentation of our selves into artificial social roles, the face of postmodernism that gets presented to children in picturebooks is its hopeful, ludic one, as Maria Nikolajeva points out in her essay. If the project of postmodern books is to reveal their own processes, the goal of the revelation is empowerment for the reader; they deliver a strong invitation and even an expectation that readers will participate in meaning making. McKean's illustrations of Lucy and her family's predicament, for instance, don't just inspire wonder at their virtuosity; they inspire analysis: What's real and what's not? How did he create that effect? Could I do that? These questions then lead, consciously or unconsciously, to a reflection on the nature of what is real, and how we might participate in its construction. Postmodern picturebooks may explode cultural myths and reveal the constructedness of reality and identity, but they do so in the name of freedom, to release readers from the thrall of powerful, controlling narratives that threaten to circumscribe their potential. As multiple authors in this volume show, postmodern picturebooks demonstrate a faith in their readers' ability to meet their challenges. Rather than viewing children as blank slates ready to receive and mimic an authoritative word, or as developmentally unready for sophisticated jokes and parodies that reveal the instability of narrative, postmodern picturebook authors and illustrators expect their readers to bring something to the table and be willing to engage in a playful reconsideration of what they know and believe about the world. They expect a large degree of openness, flexibility, and even knowingness in their audience, reflecting a more positive vision of the self than is usually theorized in postmodern theory. Indeed, I would argue that their vision is not generally postmodern at all, but transmodern.

The self in postmodernity has been variously formulated by theorists in the humanities and social sciences. Social psychologist Kenneth Gergen, for instance, posits a "saturated" self, a self characterized by polyvocality, plasticity, and transience. Bombarded by voices and images from a ubiquitous media, the self emerges as a pastiche without a coherent center. Psychologist Philip Cushman (whose connection to children's literature is, irrelevantly, that he is author Karen Cushman's husband) describes the self in postmodernity as empty. Whereas the traditional self emerged from relatively stable community life, the conditions of contemporary social life for many people have destabilized that trace, so that we are now more likely to define ourselves by identifying with more socially recognizable brands. We're Toys "R" Us kids (or we wanna be), members of the Lexus family, Disney Princesses, PCPeople, or AOL Subscribers (Only!). Indeed if the postmodern self does appear anywhere as a category, it is that of consumer, "the bourgeoisie triumphant and enjoying itself" (Jencks 17), which obviously doesn't begin to offer a complete picture of the child self in contemporary culture.

However, it does bring us back around to the importance of representation in children's culture. If we take postmodern critiques seriously, we begin to see the self as, at least in part, a citation, an iteration rather than an expression of some internal originality. Indeed, if the self could be said to have a single structural invariant over time and across cultures, it is that it is mimetic; children learn how to be in the world through watching and imitating others, and by striving to embody those representations that seem to have cultural value. What will happen, then, if the stories that saturate children's subjectivities change—if, for instance, instead of narratives emphasizing growth, coherence, autonomy, and development, they find themselves set to sea in a sieve of narratives that privilege randomness, relativity, polyvocality, fragmentation, and contingency? If postmodern critiques of the self as an empty void ripe for cultural construction and deconstruction are valid, then we might be in serious cultural trouble. But just as postmodernism set limits on the optimism of modernism, a theory of the transmodern can set limits on postmodernism's potential nihilism.

TRANSMODERNISM AND THE BODY

The notion of transmodernity emerges as an attempt to flesh out a more complete picture of who we are now, or at least what we currently believe about ourselves.[2] While it accepts the limits of the modern that postmodernism has rightly pointed out, it seeks to form an understanding of the self that, according to Vitz, "both *transforms* the modern and also *transcends* it" (xviii). It seeks to keep the best and most persistent impulses of modernity—the striving for meaning beyond the self, the desire for coherence, the push for freedom—while acknowledging that real limits are imposed on individuals by their bodies, their relationships, their culture, and their language. The three basic tenets that transmodernity takes as its articles of faith regarding the self are as follows: (a) the self is embodied, (b) the self is born into a community, and (c) the self uses language and other semiotic systems to make and communicate meaning. Cultural values vary widely within these parameters, but simply acknowledging their facticity is something that both modernity and postmodernity have been reluctant to do for various reasons, and opens up considerable possibilities for understanding the interface between the images and narratives of children's literature and the development of the self. In both modern and postmodern accounts of the self, for instance, the body is lost—either as an unnecessary hindrance to the concept of a disembodied individual rationality in the former, or as an infinitely plastic substance that is inconsequential to virtual reality in the latter. The transmodern brings the body back into the mix as both limit and as an invariant centering principle around which a child's sense of self circulates.

Take Janell Cannon's *Stellaluna*, for instance. As a bat reared by birds, she is keenly aware of the limits her body imposes on her sense of self. Although she can make compromises—eat bugs instead of fruit, sleep at night instead of during the day, hang by her thumbs instead of her feet, she is not infinitely plastic as a postmodern theory of cultural constructionism might imply. Thrilled that she can fly like her bird siblings, she finds that trying to land like a bird just doesn't work for a bat body; it is awkward and embarrassing. However, on the other hand, her body is not as limited as the narrative Mama Bird has imposed on her would imply. She has accepted that she cannot see at night, and that she must not hang by her feet. Even though these cultural rules do not accord with the affordances of her own body, she internalizes them to the extent that she really believes that she can't see at night. When she reunites with her bat family, she refinds the core embodied self she has lost—she relearns to fly at night, she begins to eat food proper to her species, and she learns that Mama Bird's rightside up is her upside down. The lesson to be learned here is not some regression into an essentialism that admonishes children to stick with their own kind. It is, instead, a celebration of the transmodern body, a body that is adaptable but also sets limits, and if those limits are honored through testing, stretching, and finally, embracing, there can be more joy all around, as she and her bird siblings discover.

Tadpole's Promise, by Jeanne Willis, is another text that takes us through a postmodern critique to a transmodern finish. A tadpole falls in love with a caterpillar, and, in naïve romantic fashion, they promise each other that they will never change. A postmodern reading of this book leads us to cynicism: Love, especially between stupid, stubborn people, is a fruitless exercise that ends badly. Even forgiveness is not rewarded, as (spoiler alert!) the transformed caterpillar decides she can forgive her lover for changing, only to be eaten by him before she can get the words out. But the necessity of change, particularly at the level of the body, is a biological inevitability impervious to the protestation of undying love. Usually, of course, we see this ideology in reverse: The romantic notion of undying love being impervious to changes in the body—sickness and health and whatnot—constitutes a grand narrative whose frequent social failures have proved the validity of its postmodern critique. But if we start with the transmodern acknowledgement that the body is the centering principle of the self, then we can see a new narrative emerging, a narrative that accepts change as its source of constancy. While we laugh at the unreasonable demand for the coherence of an ideal that actively denies the body, we unconsciously take in a narrative that material, physical change is inevitable, and if we don't accept and expect it, we may end up as someone's tasty snack.

Of course, we might end up there anyway, at least in postmodern picturebooks. Chris Raschka's *Arlene Sardine* is a controversial little book that opens itself to many interpretations. It is a parody of a hero's quest, the tale of a little brisling that could, as it were, if one accepts that achieving one's ultimate destiny can in fact mean ending up on someone's plate as a smoked, canned (but

happy) sardine. Unlike more modernist heroes, such as Dick King-Smith's Babe and E. B. White's Wilbur, Arlene embraces her body's destiny with relish (or mustard as the case may be). Admittedly, the ideology conveyed in Arlene's story is less optimistic considered from any perspective—modernist, postmodernist, or transmodernist—but Raschka's lightly poetic touch announces what it's doing. Traditions are being called to account here—a literary tradition of sentimental Romantic poetry dedicated to dead children, a cultural tradition of losing oneself in the service of something larger, and even those modernist transcend-your-biological-destiny narratives mentioned are being challenged. If we read it straight, then Arlene is happy with her choice; read slant, a playful irony emerges. Both *Arlene Sardine* and *Tadpole's Promise* offer ironic articulations of the failures of Romantic and modernist constructions of the self, opportunities to laugh at one's own pretensions to heroism and changeless love, as well as to rethink the possibilities and limitations of one's embodiment.

TRANSMODERNISM AND COMMUNITY

In their emphasis on autonomy and independence, both the Romantic and the modernist self largely ignore the necessity of community in the formation of the self. Often, as we noted above, characters in modernist texts are happy isolates, and community, if portrayed at all, is depicted as a space of threat and violation. In many modernist texts, one finds support in a community only as its leader; consider, for instance, *Babar the King, Madeleine,* and *Where the Wild Things Are.* But social reality makes the idea of the isolate ridiculous on its face. We are dependent on others for our very bodies, our language, our sustenance, and not everyone can be a leader. Moreover, our problems affect others, and often require the help of others to solve them. Thus *The Wolves in the Walls* becomes a transmodern revision of *Where the Wild Things Are*; Lucy's wolves are close cousins to Max's wild things, as evidenced by McKean's intertextual reference to Sendak's picture of one of Max's wild things on the stair wall, but they are not just her problem to face and solve. The entire family is chased from the house when the wolves come out of the walls, and they must fight together to expel the wolves from their home. Just as Stellaluna needed her bird family in order to survive and thrive after the loss of her mother, characters in postmodern picturebooks are often embedded in communities, or experience the lack of community as a problem to be solved.

Karen LaReau's *Ugly Fish* offers a trenchant and very funny critique of the autonomous individual who disdains community. Ugly Fish is very content as the only fish in his tank. He enjoys his driftwood tunnel and his special briny flakes. When a new fish swims into his world, Ugly Fish insists that there is only room for him in his tank, and he chases and eats each new tankmate. Eventually, he regrets his hasty tastes, and longs for a friend with which to

share his driftwood tunnel and his special briny flakes. Shiny Fish, however, is of the same autonomous bent as Ugly Fish, and Ugly Fish is soon dispatched. Once again, we have a main character who ends up being eaten because of a modernist denial of social reality that transmodernity affirms—you gotta have friends.

The Big Ugly Monster and the Little Stone Rabbit, by Chris Wormell, is a more poignant, but no less trenchant, critique of modernist denial, this time of both social reality and the necessities of embodiment. The modernist narrative that this story unmasks and critiques is the one that suggests that love and acceptance in the right community can change ugly people into beautiful people. Doesn't happen here, just as it doesn't happen in John Scieszka's version of the "Ugly Duckling" in *The Stinky Cheese Man and Other Fairly Stupid Tales.* The monster in this tale is so ugly that all living things around him flee or die, blue skies turn gray at his glance, and ponds dry up at his touch. Inside, though, he is sad and lonely, and so one would expect, from our intertextual experiences with both modernist texts and children's literature generally, that he will be rewarded for his inner beauty with a steadfast friend who will change his circumstances. And he is, sort of. He carves a bunch of animals out of stone to act as his companions, but when he smiles all of them shatter except one. His friendship with the hardy little stone rabbit doesn't make him any less ugly, nor does his love for her awaken her from the rock. Her presence does, however, make him happier and less lonely, and the fact that the flowers reappear around his cave the day he dies, turning it into "perhaps the most beautiful place in the whole world" (n.p.) suggests that their friendship was the beauty before the more conventional beauty rushed in to take its place. The humor here is limned with sadness, and the resistance of the text to discerning any ultimate message requires a reader to sort it out for herself, though it is clear that companionship of some sort is necessary for a happy life.

In this book, then, as in *Stellaluna* and *Tadpole's Promise,* we see characters attempting to transcend their own boundaries, to reach out to others, and to develop community despite their limitations. Grand narratives are shattered with humor through irony, rather than sarcasm or cynicism, allowing children the possibility of seeing through their own illusions without utterly shattering them; that is, just because I know that something is a fiction, doesn't mean it can't be a useful fiction to get me past a bad time or teach me something important about how to live. The trick is to know which stories are useful and which are unnecessarily restrictive, which to keep and which to reject.

TRANSMODERNISM AND SEMIOTIC SYSTEMS

As these texts have shown, a theory of the transmodern offers us not only a way to reposition the body as the invariant center that guarantees the self's

coherence, but also calls us to consider the body in relationship to others, and the relative usefulness of cultural narratives. In the above examples we see relationships of family, partners, and friendship. The transmodern also acknowledges the embeddedness of the self in larger cultural systems. Unlike the modern, which insists on the self's autonomy from these systems, or the postmodern, which at once challenges the coherence of cultural narratives and insists that we are constructed by them, the transmodern acknowledges the both/and of these positions. One of the ways in which it does this is through recognizing the complexity and materiality of language and other sign systems as central to an understanding of the self. Insofar as both modernism and postmodernism recognize the centrality of language and image to the construction of the self, this tenet of transmodernism is not as severely neglected as the other two. What I want to emphasize here are the correctives a theory of the transmodern can make to both modernist and postmodernist interpretations of the problem of representation through language and image. While modernist writers and poets like Eliot, Pound, H.D., and Stevens struggled to say something new by dislocating meaning from its usual contexts and referents, and modernist artists eschewed reference of any kind, they still sought a meaningful existence through depth and self-reflection, and despaired at times of ever achieving it. Postmodernists, by contrast, saw the same problems, but abandoned the quest for a transcendent meaning. Instead, they claimed the self-reflexive pose as the source of meaning, rather than as a methodology for finding it.

As I noted earlier, children's picturebooks, modern or postmodern, aren't angst-y, partially because children are viewed as not yet "finished," so there is no reason yet to despair over what they have become. But more importantly, I think the reason why children's books aren't consumed with existential doubt or wholly given over to play and fragmentation is because we aren't yet ready to assent fully to the claims of postmodernism. That is, we aren't yet ready to give up on transcendence and make the fragmented, empty, saturated self the measure of all things. At the same time, however, we have lost faith in the self as inherently cohesive. The transmodern offers us a vision of the self as a constructed coherence, self-aware and self-reflexive, but also culturally indebted and embedded and fully embodied. This, then, is authenticity for the self—not some inner pressure that drives us to become something we have been preprogrammed to be, but a thoughtful and critical responsiveness to our histories, our social stories, and our bodies. And I would contend that no other artistic product gives us a clearer picture of this self than the stunning collage art of contemporary picturebook artists.

Collage art in general renders the subject of picturebooks postmodern by revealing the conditions of its construction. Bits of cut paper and found materials make no pretense to autonomy; they were always already something else before they were selected, cut, shaped, and glued to make this new thing. Hence collage art is an apt metaphor for the postmodern vision

of the self—as something composed of experience and environment, rather than something organic and integral to itself. However, the collage art of Eric Carle, David Wisniewski, and Steve Jenkins, for instance, works differently than the collage art of artists like Lauren Childs, Shelley Jackson, Christopher Myers, David Diaz, and Brian Collier. Whereas Jenkins, Wisniewski, and Carle create pictures from cut paper, their concern is mostly to create forms, colors, and textures that suggest the things they are trying to represent, albeit in a fanciful way; they even create and dye papers to achieve the effects they want. By contrast, Childs, Jackson, Myers, Diaz, and Collier select their materials thematically. They use textiles and materials that surround children in their everyday lives, and put them to new uses to create pictures that are more than the sum of their parts. In so doing, they call attention to the materiality of their subjects, to the ways that our worlds are composed by an overlap of found objects, everyday experiences, and trace memories. David Diaz's collages in *Smoky Night*, for instance, are composed of the objects that would be found in the looted stores and on the streets during the very scary L.A. riots, and yet their very familiarity renders them comforting, as do the firm borders that contain the scenes of chaos that he creates. His painted characters are representations of emotional states as much as human and animal forms, but by composing the figures as separate from and still embedded within their environment through the use of a different yet complementary artistic technique, he emphasizes their bodily integrity in the midst of uncertainty and fear.

Christopher Myers, Shelley Jackson, and Brian Collier also tend to paint their figures, using collage for their landscapes and backgrounds, but occasionally integrating found materials into their painted figures through their clothing, hair, etc. These artistic techniques expose the seams and edges where our identities come together, dispelling forever the notion that we are who we are because we just naturally grew that way, independent of our circumstances. More importantly, they show quite literally how these bits and pieces are not merely disconnected fragments, but how they come together to form something coherent and beautiful.

I want to close, then, with a description of an image that forms for me the quintessential expression of the transmodern vision. The image is found in Doreen Rappaport and Brian Collier's award-winning book, *Martin's Big Words*. The entire book is a miracle of design, from the irony of its wordless cover to the moving portraits of the civil rights leader, surrounded by symbols of his ideology and struggle, throughout his life. The image I want to focus on, however, is of a young black girl wrapped in a flour-sack dress, posed before an American flag. True to the postmodern critique of a narrative of freedom and equality in America that has been racialized through exclusion from its inception, the flag as Collier depicts it is riven and tattered. And yet it is strangely coherent as well; it appears as though it has been torn to bits and then reassembled, using bits of yellow, green, and orange—the traditional colors of the flags of many African nations—as

patches and overlays to fill in gaps. The girl child at its center is painted, suggesting the integrity of her embodiment, but she too has overlays of ragged textiles to signify her poverty, and of flag stripes that turn to yellow and green as they cross her face, suggesting the sources and scars of her oppression. Her arms disappear behind the flag, but she holds them open, suggesting both vulnerability and the possibility of embrace, and yet her expression is one of seriousness and defiant challenge. In this single image, Collier manages to capture the essence of transmodern identity—its hybrid, pastiche, assembled quality, its indebtedness to history and social systems, its material embodiment, and its challenge to reach beyond itself to find meaning and fulfillment.

NOTES

1. See in particular "Modern and Postmodern," *Arts Magazine* 54 (1980), pp. 64–6, and "Modernist Painting" (1965), in *Modern Art and Modernism: A Critical Anthology*, eds. Francis Frascina and Charles Harrison (London: Harper and Row and Open UP, 1982), pp. 5–6.
2. The word transmodern was coined by Paul C. Vitz, and the theory that I am presenting here was worked out collaboratively during a Calvin College Seminar in Christian Scholarship entitled "Loss of the Self in a Postmodern Therapeutic Culture," sponsored by the Pew Charitable Trusts in the summer of 2001. Papers developed as a result of that seminar that explore the topic in multiple ways from various disciplinary perspectives are collected in a volume called *The Self: Beyond the Postmodern Crisis*, edited by Paul C. Vitz and Susan M. Felch (Wilmington, DE: ISI Books, 2006).

WORKS CITED

Ariès, Philippe. *Centuries of Childhood: A Social History of Family Life*. New York: Vintage, 1965.

Cushman, Phillip. *Constructing the Self, Constructing America: A Cultural History of Psychotherapy*. Boston, MA: Addison Wesley, 1995.

Gergen, Kenneth. *The Saturated Self: Dilemmas of Identity in Contemporary Life*. New York: Basic Books, 1991.

Greenberg, Clement. "Modern and Postmodern," Arts Magazine 54 (1980): 64–6.

———."Modernist Painting" (1965), In *Modern Art and Modernism: A Critical Anthology*, edited by Francis Frascina and Charles Harrison, 5–10. London: Harper and Row and Open UP, 1982.

Higonnet, Anne. *Pictures of Innocence: The History and Crisis of Ideal Childhood*. New York: Thames and Hudson, 1998.

Jencks, Charles, ed. *The Post-Avant-Garde: Painting in the Eighties*. London: Academy Editions, 1987.

Simms, Eva M. "Milk and Flesh: From Embodiment to Language in Early Childhood." Place: Publisher, forthcoming.

Vitz, Paul C., and Susan M. Felch. *The Self: Beyond the Postmodern Crisis*. Wilmington, DE: ISI Books, 2006.

CHILDREN'S LITERATURE CITED

Bemelmans, Ludwig. *Madeleine* (1939). New York: Viking, 1967.

Brunhoff, Jean de. *Babar the King*. London: Methuen, 1953.

Bunting, Eve. *Smoky Night*. Illus. by David Diaz. New York: Harcourt, 1994.

Cannon, Janell. *Stellaluna*. New York: Scholastic, 1993.

Child, Lauren. *The Princess and the Pea*. Photographed by Polly Borland. New York: Hyperion, 2006.

Gaiman, Neil. *The Wolves in the Walls*. Illus. by Dave McKean. New York: HarperCollins, 2003.

Johnson, Crockett. *Harold and the Purple Crayon*. New York: Harper & Row, 1955.

Keats, Ezra Jack. *The Snowy Day*. New York: Viking, 1962.

LaReau. Karen. *Ugly Fish*. Illus. by Scott Magoon. New York: Harcourt, 2006

Leaf, Munro. *The Story of Ferdinand*. Illus. by Robert Lawson. New York: Viking, 1936.

Rappaport, Doreen. *Martin's Big Words*. Illus. by Brian Collier. New York: Jump at the Sun, 2001.

Raschka, Chris. *Arlene Sardine*. New York: Orchard, 1998.

Rey, H. A. *Curious George*. New York: Houghton Mifflin, 1941.

Scieszka, Jon. *The Stinky Cheese Man and Other Fairly Stupid Tales*. New York: Viking, 1992.

Sendak, Maurice. *Where the Wild Things Are*. New York: Harper and Row, 1963.

Willis, Jeanne. *Tadpole's Promise*. New York: Atheneum, 2003.

Wormell, Chris. *The Big Ugly Monster and the Little Stone Rabbit*. New York: Knopf Books for Young Readers, 2004.

6 "They are Always Surprised at What People Throw Away"
Glocal Postmodernism in Australian Picturebooks

John Stephens

Postmodernism is an elusive term that may loosely refer to numerous types of cultural practices, including literature, film, architecture, market commodities, and ways of living everyday life. Although it is an international phenomenon, it is not a global monolith, and is apt to have *glocal* manifestations. The purpose of this chapter is to examine a selection of key Australian picturebooks which in some sense can be described as postmodern, in order to determine whether the dialogue between internationalism and local concerns has produced a glocal version of postmodernism, what may be termed a postmodern hybridization. According to Wayne Gabardi, glocalization is characterized by the development of diverse, overlapping fields of global-local linkages:

> This condition of glocalization . . . represents a shift from a more territorialized learning process bound up with the nation-state society to one more fluid and translocal. Culture has become a much more mobile, human software employed to mix elements from diverse contexts. (33)

Because they address young readers still largely bounded by the domestic sphere, picturebooks are usually geographically and institutionally embedded. This embeddedness may be weakened in the case of postmodern picturebooks both because they engage with polymorphous cultural forms and because they address an older audience.

Although in Australia, as elsewhere, the category of postmodern picturebooks is small, it is one of the sites upon which postmodernism has impacted in the context of complex and conflicting social and political conditions. As Margaret Henderson observes, postmodernism in Australia is often perceived as a foreign import, a bundle of knowledges "basically anti-humanist in orientation, such as structuralism, French-influenced feminism(s), poststructuralism, Lacanian psychoanalysis, and certain strands of French philosophy, for example that of Deleuze or Lyotard" (51). Australian postmodernist picturebooks were a comparable global import, first emerging some fifteen years after the distinctive postmodern

turn evidenced in, for example, English illustrator John Burningham's *Come Away From the Water, Shirley* (1977), and a decade after his *Granpa* (1984), radically postmodern in its open form, emphasis on process and performance, polymorphous visual styles, pervasive irony, and indeterminate significance.

When Australian scholars first turned their attention to the postmodern picturebook phenomenon their focus was inevitably on English or American authors, such as Burningham, Ronald Briggs, Anthony Browne, or David Macaulay (e.g., Bradford) and that focus remains strong (e.g., Anstey). The postmodern was also equated with notional postmodernist devices, such as metafiction, parody, spatial innovation, or intertextuality (e.g., Grieve). None of these devices is peculiar to postmodernism, of course, and to equate them with it is to constitute what Ricciardi, in a contrast between Calvino and Pynchon, has cited as a "weakened" postmodernism: in these terms, Calvino is deemed to be "focusing narrowly . . . on the stylistic dimensions of the work of art and foregoing more ethically responsible engagement with social realities" (1062–63). I accordingly distinguish here between *postmodern*, to describe a text that expresses postmodernism both ideologically and stylistically, and *postmodernist*, to describe stylistic traits which have spread from postmodern texts to more traditional texts as picturebook art has extended its range. Contemporary picturebooks remain focused on ethical responsibilities and social issues, and co-opt postmodernist stylistic traits for those ends.

The publication of Gary Crew and Steven Woolman's *The Watertower* in 1994 marked the arrival of the postmodern picturebook in Australia. This imaginative text retells in a postmodern style a common science fiction narrative—alien forces take over or substitute for human bodies, and the effect is only identifiable by a concomitant eradication of emotion. It overtly breaks away from the more traditional picturebook in drawing on several popular culture genres and modes and in addressing an older audience assumed to possess pertinent intertextual knowledge. The dominant visual and thematic pre-texts are the blending of surrealism and hyperrealism cultivated in science fiction illustration, the 1978 remake of *The Invasion of the Body Snatchers*, and subsequent postmodern teen horror films. The blank, staring eyes of those possessed is a common visual motif in science fiction films and illustrations. Thematically and stylistically, then, *The Watertower* constitutes an importation of global (that is, North American) material.

On the other hand, this material is overlaid upon a distinctively Australian ground. The landscapes allude overtly to the stark, surreal representations of inland Australia in the mid-twentieth-century figurative expressionist paintings of Russell Drysdale: the desiccated barrenness of the landscape, the immobile, gaunt figures that inhabit it, and the ochres and rusty reds of the earth and the buildings. A country town hotel depicted in the eleventh opening is a mirror image of a building in Drysdale's *Shopping Day* (1953).

The same opening contains several Holden cars, an iconically Australian object, depicting models released in the 1960s when, according to Holden aficionados, "Australia's own car" had surrendered to American fashions in appearance and design. The point is underlined by a page-turn to opening twelve, where an original 1948 FX Holden stands in a backyard, but adjoined by the mysterious symbol which connects possession with the town's water supply. What, then, is the nature of invasion?

Thematically, *The Watertower* is about the loss of individuality and difference in a surveillance society. It is at best ambivalent about its postmodernism, which seems to be simultaneously the mode of expression and the crux of the problem. It is at this ambiguous juncture that the postmodern becomes a glocal phenomenon, in that it is at the same time embraced, incorporated, and interrogated. Local conditions enable incredulity toward global metanarratives, but those metanarratives are as immanent as the water one drinks and globalization, as Fredric Jameson contends, "threatens the final extinction of local cultures, resuscitatable only in Disneyfied form, through the construction of artificial simulacra and the mere images of fantasized traditions and beliefs" ("Globalization" 56).

The eradication of the (g)local has become a *fait accompli* when, ten years later, Crew and Woolman produced a sequel to *The Watertower*. In the much more explicit and pessimistic *Beneath the Surface* (2004) any space for thematic or representational dialogue has vanished as the book counterpoints the principal character's progress toward erased subjectivity with iconic images of possessed people from all over the planet. The book's title is ironic, in that it affirms both that a globalizing force is at work behind the scenes to reshape the world and that the resultant society consists of surfaces-without-depth, where the surrealism and hyperrealism of representation marks the absence of anything "beneath the surface." The black irony with which the book concludes—"One sip they allowed him . . . Which was both his end [–] and his beginning"—heralds a rebirth into a postmodernity in which subjects are deprived of individuality or cultural citizenship. The source of control is linked with a space station and stern-faced men in grey suits, but nevertheless remains indeterminate, and readers are left to speculate about how and why this conspiracy of power operates to change "people . . . towns . . . worlds . . . even galaxies." Fredric Jameson's argument that "every position on postmodernism in culture . . . is also at one and the same time, and *necessarily*, an implicitly or explicitly political stance on the nature of multinational capitalism today" ("Postmodernism" 3) may be pertinent here, especially with reference to the new world order that emerged between the Gulf War of 1990–1991 and the consequences of the War on Terror after September 11, 2001.

An assumption evident in the Crew/Woolman texts is that Australian postmodernism is conditioned by social and political elements. In her study, Henderson points to a wide range of such elements. These include (among others): the conservative drift of the political landscape, and particularly the

impact of economic rationalist ideology and practices; reorganisation and commodification of higher education; changes within feminism and the women's movement; the weakening of radical political positions in the aftermath of the Vietnam War and the fall of the Whitlam Labor Government in 1975, and a concomitant loss of faith in the adversarial and redemptive functions of the western intelligentsia (Milner 197).

We need to ask, then, what kinds of meaning are being produced and from what position or standpoint in space and time? What cultural work do these meanings perform? How are they manifested in a specific temporal and spatial situation? How effectively do they engage with the semiotic bricolage of a changing society, where local and global struggle to transform one another? How do power relations condition the production, dissemination, and reception of meanings? And to what extent can texts recuperate adversarial and redemptive functions?

In order to suggest some approaches to these issues, I turn my attention now to a couple of the picturebooks of Tohby Riddle and Shaun Tan which work with the abundance of signs and meanings that have accumulated over the past half century or so, and through that abundance explore contrary possibilities of meaning making and meaninglessness in postmodern culture. The frame for these contrary possibilities is the constant impulse toward cultural diversity in modern capitalist societies where there is a more or less booming economy and a fairly free circulation of peoples, objects, ideas, and cultural practices—from exhibitions of art and artefacts to various facets of popular culture (music, TV programs, and so on). It is a condition of postmodernity and functions as a cause both of cultural enrichment and of cultural anxiety, as Riddle's *The Tip at the End of the Street* and *The Great Escape from City Zoo* and Tan's *The Lost Thing* well illustrate.

As the titles of *The Tip at the End of the Street* and *The Lost Thing* indicate, these picturebooks are concerned with representations of culture as bits and pieces of material that lie about in the world, ready to be taken up as "found objects." The finder then constructs texts, and possibly meanings, out of this aleatory material. The process is not merely patchwork or pastiche, which are in themselves acknowledged postmodern textual practices, but a self-conscious expression of diversity and heterogeneity, a site upon which the local and global may hybridise as the glocal. Textually, it is taken to be a marker of the postmodern, but it is also a facet of meaning making in everyday life. It has, potentially at least, particularly powerful implications for picturebooks because of the principle of *relay*, that is, the generation of meaning structures greater than the sum of verbal and pictorial texts. When all the bits and pieces are felt to be a coherent unity, a comparable coherence can be attributed to the culture reflected. But, as *The Watertower* and *Beneath the Surface* demonstrate, the effect can also be one of fragmentation, as when there is an excess of signs so that any desire to cohere the parts into a higher signifying system will be frustrated.

Riddle's *The Tip at the End of the Street* is an optimistic story, but achieves its optimism by its implication that what can prevent Australian society from decline into a postmodern wasteland is the cultivation of the imaginativeness and resourcefulness of its children by means of an exposure to cultural traditions. The book inverts the usual meaning of *tip* (that is, "rubbish dump") and transforms it into a cultural resource. The cover makes this overt by juxtaposing a background iconic of the modern industrial wasteland (a scene which occurs as background seven times within the book) with a foreground collage symbolic of human creativity: there are letters of the alphabet, books, numbers, musical instruments and musical notations, and so on. Configurations such as a clock, teapot, artist's palette, and fishhook signify the creativity of humanity within societies and over time spans. Thus before the book has been opened the cover has signalled that it will signify symbolically. *The Tip at the End of the Street* relates how two children sort through the refuse of a throwaway, consumerist society (a society all too willing to discard its past and its memories) and construct for themselves a deeper sense of culture than possessed by their parents.

The struggle between a culture with a deep sense of the past and a culture with nothing but a shallow, atemporal present is finally realised metonymically when the children find an old man at the tip and proceed to turn an old train carriage into a home for him. Everything necessary is, of course, found at the tip. Once everything that is requisite has been assembled, so "Now the old man was happy," the symbolic old figure mediates the past, and by the time he dies the children are equipped to conserve cultural knowledge and tradition. The process of finding and retrieving in this book is a recurrent structural motif which emphasises notions of loss, discarding and valuing, issuing a warning that contemporary culture is at risk of becoming threadbare.

Like *The Watertower*, *The Tip at the End of the Street* is about postmodern culture, but stylistically makes far less use of postmodernist devices. It includes some elements of collage, and plays with angle of view and canting of scene; it employs *mise en abyme* in two openings, first verbally, describing the "found" old man making toys "out of rubber bands and other bits and pieces," and then visually as a high-angle view of the children asleep in their room leads the viewer's gaze through the window (looking more like a picture frame) to an outside scene juxtaposing the old man's railway carriage and the modern industrial landscape. The effect of these devices is to restore presence to the refuse items from the tip, especially as they are brought into coherence through the old man's everyday use of them and their conjunction with his memories: "the old man could be seen reading books, perusing the globe or listening to old records . . . He would tell [Carl and Minnie] stories about another world—one that he knew a lot about. He called it the past. . . ."

Carl and Minnie's discovery of the past, lying just at the end of the street where it is in the process of being discarded, and their constant amazement

at "what people throw away" is the ground for an exploration of an ethics of difference, embodied in the children's interest in otherness and their dialogue with their parents when they bring the old man home. The parents discuss him in the language used of stray animals brought home by children—"We can't afford to keep an old man . . . who's going to feed him? . . . where are you going to keep him?" The presupposition that community is constituted hierarchically limits the possibility of attaining subjective agency or cultural citizenship by those who are marginalised or attempt to live beyond the boundaries established by society. In this book the freedom to cultivate subjectivity through engagement with cultural diversity is asserted by the children's quietly subversive behaviour.

In contrast to the strong argument about cultural continuity in *The Tip at the End of the Street*, Shaun Tan's *The Lost Thing* dwells on discontinuities. Its futuristic, dystopian setting overtly sets it apart from the discourses of geographically and institutionally embedded picturebooks, and it clearly mixes elements from diverse contexts, but it does not expressively hybridise those elements. Like *The Tip at the End of the Street*, it shows a deep concern with society's postmodern crisis where there is both no meaning and too much meaning. Indeed, its capacity to proliferate meanings, together with the manifest otherness of the Thing itself, also enables it to be read both as a story which deals with immigrant displacement in a postcolonial multicultural state, and as an attack on consumerism and a futurist interpretation of a destroyed environment. Again like *The Tip at the End of the Street*, the book satirizes a culture so fixated on trivia and the inconsequential that it eventually can no longer see even the surfaces.

A number of traits mark *The Lost Thing* as postmodern: radical indeterminacy, the excessive use of signs and the cultivation of self-referentiality, metafiction, and the parodic appropriation of numerous eminent modern paintings from Australia and the U.S. Finally, *The Lost Thing* is a postmodern text in its blending of popular and high culture, its assumption that there are no metanarratives, and the centrality of chance in the unfolding of the story. The overall impression is that of fragmented excess. The illustrations are a version of the postmodern fantastic historiography which gave rise to steampunk (see Hantke), crammed with signs and notices, directions, pipes, bits of machinery, dials, cogwheels and box-like buildings, and convey the impression of a futurist world patched together from the leftovers of the past. These pictures are in turn embedded within and framed by a collage of information which seems even more random than the illustrations. With its yellowed look and disorganised arrangement, the background collage appears to be made up of aleatory bits and pieces: fragments of newspapers, old physics textbooks with diagrams and formulas, postage stamps and rubber stamped forms, ticket stubs, and random strips of typing. It is all a dirty yellow, implying age and uselessness, just as the rusted pipes and water-stained buildings in the illustrations imply decrepitude. There is also an overload of information. Signs and arrows issue a number of different instructions at

once, cancelling each other out in the pictures, and the surrounding commentary in the collage frame is mostly irrelevant, and, at the least, unnecessary, sometimes offering seemingly random comments on events.

As in *The Watertower*, components within the landscape suggest an Australian setting. The second opening displays the vestiges of a suburban beach culture, marked as Australian by the book carried by Shaun, the narrator, who stands in the foreground looking down at the beach behind. The title of this book, *What Bottle Top Is That?*, is a droll parody of Neville W. Cayley's *What Bird Is That?*, Australia's most popular bird-identification guide for the past eighty-five years. The fourth opening includes a surreal version of a surveillance tower associated with Australian beach lifesaving practices. Insofar as these Australian reference points have been reimagined in terms of a postmodern futurism, they suggest that local cultural traits and formations have been subsumed into a global postmodernism. On the other hand, while the style is postmodern steampunk the objects of representation are more geographically embedded: Australia has its own forms of ugliness, and these are also adduced through quotation of iconic paintings from the 1950s and 1960s, John Brack's *Collins St., 5p.m.* (1955) and, for the front cover, Jeffery Smart's *Cahill Expressway* (1962). Citation of high culture art works is endemic in contemporary picturebooks throughout the world—e.g., in books by Anthony Browne, Tohby Riddle, Allen Say, Paul Zelinsky—and in this local production Tan has varied and added to the global phenomenon by incorporating local examples.

On the same page as his reworking of Brack's *Collins St., 5p.m.* (already a satirical depiction of the conformism of everyday life), Tan has also reworked a painting frequently cited in picturebooks, Edward Hopper's *Early Sunday Morning* (1930), a painting inspired by an actual row of buildings on Seventh Avenue in New York. Thus a global practice of citation enables a dialogue between geographically embedded art works. Tan repainted the Hopper and Brack works in a similar palette of browns, red-browns and yellows, muted the compositional constructedness and overt painterliness of Hopper, and replaced Brack's Cubist human figures with cartoon grotesques: drawing the paintings closer to each other by this means produces precisely the dialogue between local and global which is glocal in effect.

As scholarship develops a fuller understanding of the extent and functions of glocalization in children's literature, a better understanding of its effect on significance can be expected to develop. A key question will concern its potential for immanence—how pervasively can it shape the interpretation of a text? *The Lost Thing* presents a pertinent example. When, in a narrowly averted wrong move, Shaun attempts to dispose of the Thing at "The Federal Department of Odds and Ends," he is forestalled by a warning from another "thing" that, "This is a place for forgetting, leaving behind, smoothing over." Such a prospect is in accord with the fate of traditional culture in postmodernity as envisaged in *The Tip at the End of the Street*: it may be reduced to disassociated odds and ends to be forgotten and discarded. That

such a cultural move links to a "Federal Department" identifies it as an influence of U.S. global impact (the Australian term would be "Commonwealth Department"). In a reminiscence of the post horn symbol in one of the twentieth century's watershed postmodern novels, Thomas Pynchon's *The Crying of Lot 49*, this thing gives Shaun a card depicting a wavy arrow, a mysterious sign to seek out, which leads him to "a dark little gap off some anonymous little street." Mattessich's claim that Pynchon's post horn is "appearance as a weave of ambiguous signs which does not stand over and against the real, but in which the real appears or becomes legible as a text" (16), offers a fruitful way to think about the relationship of the glocal to the postmodern. If the postmodern equates with signs as surfaces without depth, the local has potential to function as grounding depth.

The site Shaun arrives at is not an Australian locality: when he finds the door, he and the Thing are confronted by a strange heterotopia, a scene which is a Daliesque painting whose bright colours foreground a celebration of difference. Entry to this world of bizarre and only semi-recognizable things is through a black doorway, set off from the rest of the text both because this is the only opening without collage frames, and to look through this doorway, readers must turn the book forty-five degrees, a device that physically marks a shift in reading process. A paradox here emerges in that the surreal world of the lost things seems more "real" because more unified: the landscape is not sectioned into picture, narration and frame. Bright colours and differing shapes and sizes pervade instead of being disruptive. The creatures are postmodern hybridisations—an accordion/typewriter, a banana peel/lightbulb, a dog/fish, a snake/tap and so on—but none of them seems out of place, and yet nothing is "in place" either. There are no boxes or borders to restrict them to their own category and each thing interacts freely with the other things. This fantasy world (a piece of graffiti shown painted on a wall declares it is "utopia") is the place where the lost thing feels a sense of belonging, although not because it looks like the other beings in this place. Each creature is as diverse from the others as the thing is from people in the "real" world, but all have accepted their mutual differences (their cosmopolitan cultural citizenship) as a cause for celebration.

Having said his farewell to the Thing, Shaun returns home, "to classify my bottle-top collection." His absorption back into the world of meaningless actions is underlined in two ways. First, he is depicted from a long distance, separated from viewers by no less than five frames: the window of the tram he is travelling home in; the tram that frames the window; the cityscape that frames the tram; a formal muddy yellow frame which is a collage of fragmented text and diagrams (including a segment in classical Chinese characters); and finally a brown page frame also consisting of collaged materials. The effect is to emphasise conjunction without significance. Second, his reflection on the story dwells on meaninglessness:

And don't ask me what the moral is. I mean, I can't say that the thing actually belonged in the place where it ended up. In fact, none of the things there really belonged. They all seemed happy enough though, so maybe that didn't matter. I don't know . . .

Once again, comparison with the more overtly articulated theme in *The Tip at the End of the Street* is instructive. Unlike the process of meaning-making embodied by Carl and Minnie's retrieval of "bits and pieces" and reconfiguration of them as a cultural dynamic, Shaun accepts cultural fragmentation. His "happy enough" is a weak description of the dynamic underlying the surreal utopia, because it is very evident that the heterogenous and hybridic things interrelate as dyads in earnest conversation: they are grounding a new cultural formation in intersubjectivity.

A local Australian element is particularly evident in Shaun's speech here (although it pervades the book). While his discourse is not strongly marked by peculiarities of vocabulary, for example, its idioms and rhythm are characteristic of everyday Australian English. The form is predominantly paratactic, but its structure and cohesion depend on cliché idioms: "don't ask me what . . . I mean . . . I can't say that . . . actually . . . the place where it ended up . . . In fact . . . really . . . seemed happy enough though . . . maybe that didn't matter . . . I don't know." Ironically, the contrast between the surreal environment where the Thing finds a place to belong and the paucity of Shaun's thought and expression is the site of the glocal effect. An implication here is that the dialogue between the global and the local need not be weighted equally. A global postmodernism capable of an ethically responsible engagement with social realities can recall local understandings to what they are lacking without having to erase the local.

In other words, the glocal is defined by Shaun's misperception. He proved capable of empathy with the Lost Thing, but this did not lead him either to the understanding that difference is not the same as sadness or to the self-awareness that he too was a lost thing. Readers are conscious of his failure, especially as his final appearance in the book becomes a disappearance as readers are distanced increasingly further from him as the tram he rides loses definition amongst a multiplicity of dabs of yellow paint. Now "Too busy doing other stuff" to become aware of difference, Shaun disappears, absorbed by postmodern meaninglessness and mundane everydayness.

My reading of *The Lost Thing* has argued that glocalization is a translocal category, signifying neither resistance nor submission to postmodern ideology and textuality. I will conclude this chapter by discussing a second book by Tohby Riddle, *The Great Escape from City Zoo* (henceforth, *The Great Escape*), in which the local is text-derived and hence any glocalization is a function of textuality. *The Great Escape* describes a journey to escape identity and its consequences. In this story of four diverse animals who escape the zoo and attempt to live in the wider world, always on the run from the zookeepers striving to return them to their cages, Riddle plays

out an allegory about struggling to find and preserve individuality within community. As three of the four animals are finally recaptured, betrayed by those traits which make them most intensely themselves, Riddle poses a question about the very possibility of freedom if signification pivots on discrimination of what constitutes otherness.

The Great Escape is a game with the idea that there is nothing outside textuality. Drawn in monochromatic tones to evoke the silver screen era, its cited components are a pastiche not just of pictures and images, but also of language and story elements—for example, it is sprinkled with evocative clichés such as "hot on their trail," "things were catching up with them," "heading west, out of town," "time to move on," "head for the border," and so on, all of which hint at various story schemata. Such elements can function as found objects, and thence convey an illusion of local idiom. Further, as well as containing allusions to familiar twentieth-century visual icons, both as whole pages and bits "pasted in" on other pages—art works such as Magritte's *The Treachery of Images*, Munch's *The Scream*, or Hopper's *Nighthawks*, or popular culture images—the book also evokes the work of other picturebook makers, film documentary technique, and pervasively recalls the escape fantasies of film and television. An underlying question, which shifts attention to "real world" questions, is: Is the possibility of escape finally nothing but a cinematic illusion, as the reference in *The Lost Thing* seems to suggest?

The making and unmaking of meaning through the assemblage of found texts is directed by a verbal discourse that evokes the "voice-over" style of film documentary, and the jumping from scene to scene reflects cinemontage. Even when one sentence is coextensive with two or more pictures the visual narrative is disjunctive, so that quotation and fragmentation occur simultaneously. This effect is particularly evident in the three pictures accompanying the sequence, "They wore disguises so that no one would notice them/—so that they could blend in./ Wherever they went." These pictures draw on distinct and diverse cultural domains: popular culture, cult horror film, and high art. The first illustration ("They wore disguises") is isomorphic with the Beatles Abbey Road album cover, although the streetscape behind them is now in New York City. The second picture ("so that they could blend in") depicts the four from behind, as they sit in a cinema watching the scene from *King Kong* in which the giant gorilla fights for his life on top of the Empire State Building. A simple effect is to stress how distinct the escapees' heads are amongst the otherwise human audience, so there is an ironical discrepancy between text and picture. The New York of the setting has now been transposed onto the screen, becoming a simulacrum of a simulacrum.

The third picture (see Figure 6.1) depicts the four in an art gallery. Three paintings hang on the visible walls—de Chirico, *Mystery and Melancholy of a Street* (1914); Magritte, *The Treachery of Images* (1928–1929); and Mondrian, *Broadway Boogie Woogie* (1942–1943). *The Treachery of*

Wherever they went.

Figure 6.1 From *The Great Escape from City Zoo*, by arrangement with Tohby Riddle © Curtis Brown (Aust) Pty Ltd.

Images is frequently cited in picturebooks as a *mise en abyme* to draw attention to the constructedness of texts. It appears here in the company of other recognisable art works, but its key orientation is toward the figures standing around in the gallery. The desire of the four escapees to "blend in. Wherever they went" is mocked not just visually—their bizarre costumes and distinctive body shapes draw attention to them—but mentally by the message of the Magritte painting, which takes us back to the formula, "There is nothing outside text." Their costumes and body language are texts to be interpreted. The spatial distribution of the various visitors to the gallery draws attention to how hard it can be to "blend in" when you don't know the codes of behaviour for a particular situation, and this is exacerbated by the excess of visual signification here. None of the human figures is looking at a painting visible to the book's audience, so viewers are denied a position as co-spectators. But the four animals framed by the human spectators apparently have no idea what to look at, or how to look at it.

A further disruptive aspect of the collage effect here is the juxtaposition of modalities, a point again reinforced by the Magritte reminder about representation. While everything is a cartoon, the human figures approximate to the base modality of picturebooks (Stephens 47). The vector running diagonally from the bottom right-hand corner, though,

moves through a sequence of decreasing modalities (that is, along a cline away from photographic realism: human figure, anthropomorphic elephant, abstract painting (Mondrian's *Broadway Boogie Woogie*). This vector is crossed at right angles by a second vector linking a small spearhead-shaped sculpture, the elephant and the Mondrian. The sculpture (Brancusi's *Bird in Space*) functions visually as a foregrounded vertical line, in a scene heavily marked by verticality. In contrast with *The Tip at the End of the Street*, in which the *difference* amongst diverse objects with no obvious connecting centre is used to extrapolate a core of significance, there is no evident core of relationships of a comparable kind here, except to say, *This is not a. . . .* A clear ironical function is emphasised by the interaction of visual and verbal texts, in that as the central, pivotal figure within those interlocked vectors, occupying his own point on the modality cline, the elephant "blends in" neither visually nor narratively.

The book's excesses of meaning function as key narrative elements in a story about escape and recapture, freedom and transgression. The animals still in the zoo celebrate the exploits of the escapees, who become culture heroes both before and after capture, as they traverse walls, borders, boundaries. Of the three who are recaptured, their bid for freedom fails because of the difference that makes him what he is: the anteater because of his capacity for empathy; the elephant because he gives space to the self; the turtle because of his vulnerability. The flamingo, in contrast, remains elusive:

> And the flamingo?
> Although there were reports of unconfirmed sightings,/
> no one knew if he was dead . . . /
> Or alive!

The pictures toward the close of the book play against this mystery by suggesting that the flamingo has disappeared behind his possible signifiers (a garden statue, the Loch Ness monster, a hotel sign, a visual cliché for "explorer")—hence he becomes an absence, recurrently present because of the images in the world, an absent signified, when identity presumes presence. This absence is the final paradox of subjectivity—to escape interpellation by vanishing behind the culture's accumulated images. Slipping between identities as the flamingo does suggests a falling outside the sphere of official or proper identity. Illegitimate as subjects, the escapees can only endure as blanks and negations.

The greatest illusion in *The Great Escape* is the illusion of simplicity in what is arguably the most thoroughly postmodern of the books I have considered. It is a text which pushes the notion of the glocal into a new domain because, in one sense or another, what functions as the local is already a citation, down to the homemade cabin in the wilderness where three of the escapees find refuge for a while. As in *The Lost Thing*, how-

ever, the local retains potential, as when the anteater manages a normal life until he faints "outside a taxidermist's": the local again needs an enhanced sense of cultural pluralism, and this needs to come from outside. The stability of the local, in conjunction with the play of difference that can derive from the global, points to glocal possibilities as yet unrealized.

The most pressing glocal issue for Australia which these postmodernist books point to is the issue of cultural citizenship. The diversification of social practices in the post–Cold War era, in the context of a faltering multiculturalism and transformative impact of a globalized postmodernization of culture, has undermined the attempt at consensus set in train in the 1970s. Glocalization nevertheless offers a way to think about postmodernism as more than simply a series of shifting styles, proliferating split subjectivities, or multiple identities and differences. It suggests that an accumulation of objects, artefacts, and images can be brought into coherence by means of creative thinking, and those excluded from cultural and political power (the old man, the Thing, the zoo escapees) may achieve a voice and a place within society.

WORKS CITED

Anstey, Michèle. "It's Not All Black and White": Postmodern Picturebooks and New Literacies." *Journal of Adolescent & Adult Literacy* 45.6 (2002): 444–57.

Bradford, Clare. "The Picture Book: Some Postmodern Tensions." *Papers: Explorations into Children's Literature* 4.3 (1993): 10–14.

Gabardi, Wayne. *Negotiating Postmodernism*. Minneapolis: University of Minnesota Press, 2000.

Grieve, Ann. "Postmodernism in Picturebooks." *Papers: Explorations Into Children's Literature* 4.3 (1993): 15–25.

Hantke, Steffen. "Difference Engines and Other Infernal Devices: History According to Steampunk." *Extrapolation* 40.3 (1999): 244–54.

Henderson, Margaret. "Some Origins of A Species: Postmodern Theories in Australia." *Journal of Australian Studies* 57 (1998): 50–60.

Jameson, Fredric. *Postmodernism, or, The Cultural Logic of Late Capitalism*. Durham, NC: Duke University Press, 1991.

———. "Globalization and Political Strategy." *New Left Review* 4 (July–August 2000): 49–68.

Mattessich, Stefan. "Ekphrasis, Escape, and Thomas Pynchon's *The Crying of Lot 49*." *Postmodern Culture* 8.3 (1998).

Milner, Andrew. "On the Beach: Apocalyptic Hedonism and the Origins of Postmodernism." In *Australian Popular Culture*, edited by Ian Craven, 190–204. Cambridge, UK: Cambridge University Press, 1994.

Ricciardi, Alessia. "Lightness and Gravity: Calvino, Pynchon, and Postmodernity." *MLN* 114.5 (1999): 1062–1077.

Stephens, John. "Modality and Space in Picture Book Art: Allen Say's *Emma's Rug*." *CREArTA*, 1.1 (2000): 44–59.

CHILDREN'S LITERATURE CITED

Burningham, John. *Come Away from the Water, Shirley*. New York: Harper, 1977.

———. *Granpa*. *London*: Jonathan Cape Ltd, 1984.

Crew, Gary and Steven Woolman. *The Watertower*. Flinders Park, SA: Era Publications, 1994.

———. *Beneath the Surface*. Sydney: Hodder, 2004.

Riddle, Tohby. *The Tip at the End of the Street*. Sydney: Angus and Robertson, 1996.

———. *The Great Escape from City Zoo*. Sydney: Angus and Robertson, 1997.

Tan, Shaun. *The Lost Thing*. Port Melbourne: Lothian, 2001.

7 Postmodern Picturebooks and the Material Conditions of Reading

Margaret Mackey

2008 marks the twentieth anniversary of the publication of Margaret Meek's influential booklet, *How Texts Teach What Readers Learn* (1988). Although the title refers to "texts," her project effectively entails the study of what readers learn from books—picturebooks and chapter books. The distinction may have seemed insignificant in 1988, but in the past twenty years textual materials for beginning readers have proliferated in a broad range of media: a multitude of online sites aimed at emergent readers, a plethora of CD-ROM and DVD stories, and a large variety of electronically operated reading devices.

Meek wrote her groundbreaking study in what may seem, in retrospect, to be the last moments when the book was unquestionably primary among reading primers. Even a very short time later, at least in the West, huge numbers of small children are comfortable with computer screens, cell phones and other digital apparatus. Has this development had any impact on the artifact of the picturebook itself? I suggest that one consequence is that the apparatus of the book itself is radically more visible to children of a very young age who are at home with contrasting formats.

In this chapter, I explore six picturebooks, all published since Meek wrote her text, that demonstrate a variety of perspectives on the materiality of the book. Such productions display many postmodern qualities with their playful interrogation of their own conditions of existence; is this acknowledgment of their physical manifestation simply an embellishment or a joke, or is it a constitutive element in the reading challenge they supply? And is the fact that a book draws postmodern attention to its own materiality enough to change how it requires to be read?

TACIT LESSONS

Meek focuses on the many tacit lessons about reading that young children internalize from exposure to books. Her discussion is detailed and complex.

I suggest that understanding authorship, audience, illustration and iconic interpretation are part of the ontogenesis of 'literary competences.' To learn to read a book, as distinct from simply recognizing the words on the page, a young reader has to become both the teller (picking up the author's view and voice) and the told (the recipient of the story, the interpreter). This symbolic interaction is learned early. It is rarely, if ever, taught, except in so far as an adult stands in for the author by giving the text a 'voice' when reading to the child. (10)

Meek is profoundly interested in what is "rarely, if ever, taught," and her book is full of examples, gleaned in large part from her reading of *Rosie's Walk* by Pat Hutchins with a struggling young reader named Ben. She refers to technical arrangements of the book, such as the verso of the title page, where the title and author are repeated, "this time in tiny print with the publisher's address and the date. When did you learn that you don't read these words as part of the story?" (9). But Meek also makes note of the larger questions of interpreting:

How do children distinguish the heroine from the villain? How does an author 'recruit' their imagination and 'sustain their emotional regard,' or rather how do they let her? What do they presuppose will happen, and what, exactly, is the satisfaction of the happy ending . . . ? Is it an evaluation of the rightness of things that one comes to expect in a story when it is less evident in life itself? If so, where does this moral judgement come from, if not from games with rules? Is reading an elaborate game with rules? What relation has this game with rules to children's deep play and risk taking? (13)

Such questions are not as simple as they may sound on first reading. Danny Hillis, a pioneer in artificial intelligence (AI), suggests we are in very complex territory:

When early AI researchers began, they assumed that hard problems were things like playing chess and passing calculus exams. That stuff turned out to be easy. But the types of thinking that seemed effortless, like recognizing a face or *noticing what is important in a story*, turned out to be very, very hard. (Pontin 28, emphasis added)

LEARNING TO READ IN REVOLUTIONARY TIMES

Twenty years is a short span of time, but long enough to see a radical shift in how young children may perceive the physical artifact of the book. In 1988, young readers were relatively more likely than today to

experience most or all of their early exposure to printed words through the medium of paper, most often in the form of books and magazines and little workbooks. One consequence of this material framework for reading was that the physical format of the book was comparatively invisible. Young readers were enculturated into the idea that to engage with the story, one has to learn to move "through" the words into some mentally vivified encounter with the characters and events of the story. The words on the page, to express it differently, become transparent, a "window" onto the story.

But today, young children meet paper books as one option out of a range of accessible reading materials. New kinds of tacit lessons may be part of the repertoire they bring to bear on the interpretation of letters and words. To take one obvious example, many CD-ROMs for young children operate under the aegis of heavy branding, which may be internalized as part of learners' understanding of what reading is all about. But as components of new media forms enable different forms of tacit awareness, the contrasts between different tools for reading do render some elements of the printed book available for explicit contemplation.

Have the past twenty years made the material apparatus of the book less transparent to all readers, given that even very new readers now often approach the book from a perspective of sophistication with many different reading formats? Are there new picturebooks that invite very young readers to recognize the artificiality of the format and to enjoy its affordances at an explicit rather than a tacit level? If so, what are the implications for learning about reading? This chapter examines these questions.

THE POSTMODERN PICTUREBOOK

The postmodern picturebook is a paradoxical object. Although it meets the conditions of postmodernism which include "fragmentary sensations, eclectic nostalgia, disposable simulacra, and promiscuous superficiality" (Baldrick 174), it also embodies a fixed and orderly gathering of pages, glued or stitched in linear array. Children learning about the act and power of reading from these books must learn to cope with the inbuilt contradictions of the form.

The books I explore in this little study foreground these contradictions and make them available for contemplation. Each example plays with the potential for anarchy that is made possible by disrupting the schema of orderliness, but many of them also draw on the inbuilt linear qualities of the book to render that anarchy safer, a nursery version where everything is tidied away at the end of the romp. Playing with the contrasts of anarchy and safety in such postmodern forms raises interesting questions about what "readers learn" from these different approaches.

A working definition of postmodernism offers a useful checklist for further exploration of this topic:

> The tendencies of postmodernism include (1) a rejection of traditional authority, (2) radical experimentation—in some cases bordering on gimmickry, (3) eclecticism and multiculturalism, (4) parody and pastiche, (5) deliberate anachronism or surrealism, and (6) a cynical or ironic self-awareness (often postmodernism mocks its own characteristic traits) (http://web.cn.edu/kwheeler/lit_terms_P.html, accessed December 29, 2006).

It is a sophisticated checklist but all of these elements can be perceived within the set of titles under consideration here, with the intriguing corollary that those who know how to make sense of such texts are, by definition, sophisticated readers.

Michèle Anstey argues that postmodern picturebooks may also contribute to the development of more *critical* readers. She says contemporary literacy education, preparing readers for a multimodal future, must tackle a multi-pronged agenda:

> New times and new literacies mean new goals for literacy education. The acknowledgment of change as the one constant of life in new times indicates that literacy education must focus not only on the mastery of certain knowledge and skills, but also on the use of these skills in various social contexts. Furthermore, literacy education must foster the attitudes and abilities needed to master and use the evolving languages and technologies of the future. Literacy education must also focus on critical engagement and understanding of text and its inherent ideologies, in all forms, as well as competency in creating such texts. (446)

Anstey suggests the postmodern picturebook is one route to accustoming readers to being challenged. "Author and illustrator consciously employ a range of devices that are designed to interrupt reader expectation and produce multiple meanings and readings of the book" (447).

The role of the learning reader is complex. One component of reading smoothly is the development of automaticity in decoding. But Philip Ross warns us that complete automaticity can be "impervious to further improvement," and new readers, like the experts he describes, need to "keep the lid of their mind's box open all the time, so that they can inspect, criticize and augment its contents" (70). Learning the importance of inspecting, criticizing, and augmenting one's understanding is as crucial an element in learning to read as mastering the skill of decoding.

In this chapter, I focus on a small selection of books that visually, conceptually and sometimes verbally draw attention to the salient fact that THIS is a BOOK and ask whether or how its qualities of being a book affect how

it should be read: *Wolves* (Gravett), *Bad Day at Riverbend* (Van Allsburg), *Dear Diary* (Fanelli), *The Extinct Files: My Science Project* (Edwards), *The Three Pigs* (Wiesner), and *The Stinky Cheese Man and Other Fairly Stupid Tales* (Scieszka and Smith). These books have been published in the past twenty years, and all address the materiality of words on paper as part of their story-telling content. The first two titles, however, cannot be truly comprehended without the adoption of some form of critical perspective on different rules and conventions of using books in particular settings. The middle two books are much simpler and establish that games with format are not necessarily equivalent to a demand for critical reading; the final two titles, the best known of this sextet, perform the most radical dissection of our understanding of story itself.

A SAMPLE OF PICTUREBOOKS

These six titles comprise a convenience sample, not a definitive bibliography of picturebooks about bookishness. Yet as soon as I started looking at them, I was surprised by a common factor that I should have anticipated. The books I found are not just about the qualities of being a book; they address questions of being a particular kind of book: a story book (Scieszka and Smith; Wiesner), a colouring book (Van Allsburg), a diary (Fanelli), a science project book (Edwards), and a library book (Gravett). When I began this undertaking, I thought I was raising issues of explicitness, but these little books were explicit at a level of detail I had not begun to consider. Of course, their very particularity is essential. Any single title does not represent "the book" in generic ways; it manifests the qualities of "*this* book."

So let us explore one book in more detail, investigating its potential contribution to a sophisticated understanding of reading.

Wolves

Wolves (Gravett[1]) plays with the conventions of the printed text in every conceivable way, starting with the dust jacket. The back cover of the jacket features quotes from spoof reviews in *The Daily Carrot*, *The Hareold*, and *Rabbit Review*. The inside front fold tells us that "This book follows the National Carroticulum," and the price tag appears as part of a picture of a rabbit carrying a stack of books. The endpapers are a mottled brown, neutral at first glance.

The first opening repeats the mottled brown background, and the usual publishing information is represented as papers lying on that background. On the left-hand page, the publisher details are incorporated into a postcard; on the right-hand page, the title information (with author Emily Grrabbit) is conveyed by means of a flyer for new books at the West Bucks Public Burrowing Library.

The next opening begins the story on the left-hand page: "Rabbit went to the library. He chose a book about. . . ." On the right-hand page, we see Rabbit holding a rusty-red book with a black title: *Wolves*. Many readers will already be suspicious enough to check the physical qualities of the book cover lurking under the dust jacket, and sure enough it is identical (the fictional library has presumably removed the dust jacket, as is so often the irritating habit of its real-life counterpart). A close-up on the next opening shows the book cover again, so it is perhaps not surprising that when we turn the page once more, we are back to the endpapers we have already looked at—but this time a library docket is glued to the left-hand page and a date stamp sheet is drawn on the right-hand page. The book identification card in the docket may be pulled out for inspection; it is marked with coffee stains and somebody has doodled on the back.

Finally, on the next opening we get to the "first page" of the book, which contains information about wolf packs. We also see Rabbit reading the book, which he continues to do on subsequent openings. With his nose buried in the book, he fails to see what we external readers notice at once: the wolves are beginning to escape from the pages and take form in what, for want of a better word, we can call the "real" world. Rabbit, absorbed in his reading, walks up the "real" wolf's tail, across his back and onto the top of his snout. He only registers his danger as he reads, "Wolves. . . . also enjoy smaller mammals like beavers, voles and . . ." The inevitable missing word, "rabbits," appears on the next opening as a fragment of paper, and the book cover reappears, severely scratched and ripped. There is no sign of the rabbit on this page.

The next opening tells us, "The author would like to point out that no rabbits were eaten during the making of this book. It is a work of fiction. And so, for more sensitive readers, here is an alternative ending." Torn fragments of previous pictures are glued together to make a rough image of Rabbit and the wolf (who turns out to be a vegetarian) enjoying a jam sandwich together and becoming friends.

On the next opening, however, we are back to that brown mottled background, and it is rather clearer that this surface is a doormat, now littered with an accumulating pile of mail. One envelope, from the West Bucks Public Burrowing Library, can be opened by the reader. Inside, on a separate and free-floating sheet of paper, is a sinister letter to Master G. Rabbit, warning him that his copy of *Wolves* is now seriously overdue.

Postmodern Reading Lessons

What components of postmodernism, as outlined above, contribute to the shaping of this picturebook? Baldrick's list of "fragmentary sensations, eclectic nostalgia, disposable simulacra, and promiscuous superficiality" (174) is reproduced in startlingly literal forms: witness the false ending made of fragments of picture, the nostalgia of the old-fashioned library

card and due date sheet, the disposable qualities of that same library card and the letter at the end, and the superficiality of our relationship with Rabbit, whose main function in the book is to serve as "fodder," both for the wolf and for the joke that the reader enjoys.

How does my second, perhaps more substantial set of descriptors compare to this book? Again, the goodness of fit is substantial. The book mocks the authority of the library and, to some extent, also mocks the virtues of reading itself. The experimentation with the fictional boundaries of the story—so that the *mise en abyme* of the set-up is reinforced by literal documents—is radical and could even be labelled as gimmicky (though I would not agree). The elements of parody and pastiche are unmistakable. The old-fashioned qualities of the library are emphasized not only by the quaintness of the borrowing apparatus but also by the big sign saying "Shh" on the very first page. And the ironic and self-mocking implications of the false, vegetarian ending are evident to even very young readers. Only the quality of multiculturalism is missing, unless you count the mingling of rabbits and wolves as a disguised form of different cultures (an argument could be made but I am not sure I would expend much energy in making it).

When Margaret Meek and Ben read *Rosie's Walk* together, they needed to draw on a number of reading strategies. They needed to apply some external understanding of hens and foxes, farmyards and haycocks. They needed to register that the story was told by the pictures as much as by the words, that the pictures and words did not necessarily agree, and that the ending might be ambiguous. What comparable lessons might be learned by a reader of *Wolves*?

The joke in *Wolves* is not terribly subtle but it is achieved in very sophisticated ways. To comprehend *Wolves*, a reader needs to be aware that the story is being told both within the linear pages and also by means of the two separate documents, the library card and the official letter. An understanding of the general schema of how to use a library is not an enriching extra; it is essential to a basic understanding of the story. To get the joke of the ending, a reader must be able to suspend commitment to either of the two endings until their comparative plausibility can be assessed. At some point during a successful reading, readers must register that they are not simply dealing with an unreliable narrator but that the whole book is untrustworthy: the words belie the pictures; the narrator appears at a very late stage in the book only to deceive readers about the vegetarian wolf; the evidence of the unhappy ending comes on a sheet detachable from the bound book itself (a paper that, in the real world, can be lost—what happens to the story at that point?). A critical reading is the only approach to this book that lets it work.

Yet, after all this interpretive effort, readers achieve a simple, linear story: Rabbit borrows a library book about wolves; a wolf escapes from the book, eats Rabbit and rips up the library book; Rabbit's mail then piles up at home, including a note from the library warning him about

overdue fines for the missing book about wolves. Of course, at this point, readers are themselves holding an intact copy of the same book (and if it has been borrowed from the library, the nesting of layers of fiction and reality become yet more complex). The borders between fiction and non-fiction become part of the territory explored in this reading experience, as the ontology of the actual artifact in the reader's hands becomes a bit blurry, in appealing and entertaining ways.

Bad Day at Riverbend

The apparatus of *Bad Day at Riverbend* (Van Allsburg) is much more sedate than that of *Wolves*. The dust jacket plays no self-referential tricks. The title page contains the publisher information in the usual way, and only the dedication stands out: "To Sophia, My Little Buckaroo." It is presumably Sophia on the back cover, photographed colouring with her father, wearing a yellow shirt and a red cowboy hat.

Using many more words than *Wolves*, *Bad Day at Riverbend* sets out the conditions for a heroic tragedy. Riverbend is a dull, sleepy town where nothing ever happens. It is drawn in simple ink outline, which presumably testifies to its quintessential dullness. But a strange light in the sky presages trouble: soon, horses are riding into town covered with a strange "shiny, greasy slime."

Any reader with the smallest amount of appropriate life experience will instantly recognize this "slime." The horses have been scribbled over with a crayon. It takes a little more deduction to work out that the strange blinding light that reappears from time to time during the crisis represents the page of the book being opened to be coloured on (on pages where the story proceeds without any crisis of colouring, the blinding light appears only far away, if at all). The brave cowboys who set out to tackle the unknown foe that is upsetting their habitat meet a crayon-drawn stick cowboy who they are convinced is the source of their trouble. "But just as they came over the hill, they were frozen in the bright light that suddenly filled the sky." On this opening, the cowboys themselves are coloured in, and for the first time we see the hand of the colourer, painted in much more lifelike detail and casting a heavy shadow on the page so ominously lit by its opening. The next opening shows a child in a red cowboy hat, colouring the page we have just turned. The final page says, "And then the light went out," and we see the closed colouring book and the child leaving the room, followed by black endpapers. Sipe and McGuire suggest that these endpapers reproduce for readers the "lights out" experience of the cowboys: "Thus the endpapers mediate our experience of the metafictive element in the story" (294).

In this book, we have three or maybe even four levels of modality if we count the photograph of Sophia on the back of the dust jacket: the fictional cowboys in their untroubled community, that community under pressure from the force of the slime from the outside world, the painted child wield-

ing the crayons, and the photographed child, also using crayons, on the back cover. Before the colouring book was ever opened, we are asked to believe that the fictional life of the community existed in a very quiet way; but the colouring book is not the same object as the book we hold in our hands to read this story. The action of the crayons creates a border between one world and another, although both can be represented on the same page. A cowboy who has been scribbled over with crayon is disabled and unable to continue his previous existence. Yet the story of the cowboys represented by the picturebook is rereadable in the normal way.

It is a less complex construct than *Wolves*, and supplies more explicit clues to readers, but *Bad Day at Riverbend* does achieve some of the same critical resonances about the material construction of the storybook we are reading, the material construction and constraints of the colouring book within that story, and the virtual construction of the fictional world of Riverbend. It is a very sophisticated contrast, but one that draws on the basic world knowledge of a very young child who knows enough about crayons to recognize a scribble, and enough about where you may scribble to identify the outline drawings of a colouring book. The words do not tell the whole story; even the pictures are not comprehensible without the application of this world knowledge. The book calls for a rudimentary but undeniable form of critical reading in order to make basic sense.

Again, the story told, once it is pieced together from various sources of evidence, is a linear one. Nothing much happens in Riverbend until a child opens the book and starts to colour the drawings. The cowboys who ride out, uncomprehending, to fight the menace of the crayons are themselves defeated by being coloured. The child closes the book and goes elsewhere. Yet the reading experience required to make sense of this book is far more complex than the limits of the deciphered story would suggest.

Dear Diary and *The Extinct Files: My Science Project*

Not all self-referential picturebooks about the material qualities of books necessarily demand such complex and critical reading behaviours. The following two titles play entertaining games with qualities of "bookness" but represent much simpler reading challenges.

Sara Fanelli's *Dear Diary* is created as a facsimile journal. The endpapers contain massive doodles, the publishing information is designed to look like glued-in entries in a scrapbook, and the title page contains an elegantly mounted quote about the virtues of keeping a diary. The book itself is divided into a number of different diaries. We begin with the "handwritten" entries of Lucy, a little girl whose modest adventures include taking a ladybug to school, participating in a classroom rumpus when the teacher leaves the room, being given punitive homework to do as a result, taking her dog late to the park, and setting out the good knives and forks for her parents' party.

Subsequent diaries report the experiences of a chair that was knocked over during the classroom melee, a spider that the chair spotted on the classroom ceiling while it was lying on its back, a firefly that went to a party with the spider and helped a plane with her light, the knife and fork from the party, the dog, and the ladybug. The book concludes with a post-script from Lucy, which ties some of the loose ends together. All the entries are illustrated with collage. The different entries follow one another and all deal with the same period of time, but some are written on graph paper and some on ledger paper, and the handwriting varies.

Certainly it is useful to readers to have some idea of how a journal works, and why it is a joke to have journal entries written in so many unlikely voices. Unlike *Wolves* and *Bad Day at Riverbend*, however, *Dear Diary* presents an understanding of how a diary works that is common both to the characters in the story and to the implied reader. There is no critical necessity to read *against* the understanding of the characters in order to make sense of the book. The book contains many of the elements described above as postmodern: experimentation bordering on gimmickry, eclecticism, parody and pastiche, deliberate anachronism or surrealism, and a modest degree of ironic self-awareness. Nevertheless, it does not demand to be read against itself and the material qualities of the book invoked by the diary format are congruent with the impact of the story.

The Extinct Files by Wallace Edwards purports to be a school science project proving that dinosaurs never became extinct. The pages are designed to look as if they are three-holed loose-leaf, with holes reinforced and pages held together with string. The pictures are "scotchtaped" in place. The verbal format also mimics a science report, organized under categories such as Objective, Hypothesis, Apparatus and Method.

There is a frame narrative that also plays with the book's material qualities: a classified note from the Dinosaur Intelligence Agency is "paper-clipped" to the front page of the project, warning that dinosaurs are threatened by this report and should take appropriate precautions:

> We urge all dinosaurs to proceed with caution. Stay away from café patios as much as possible. Do not listen to your music too loudly. Do not wear overly flashy clothing. Try to refrain from hula-hooping and uprooting trees in public. Disguises, especially sunglasses, are encouraged.

The second-last opening, after the conclusion of the report, shows a group of dinosaurs roaring with laughter over a project book that looks tiny in their giant claws. The final opening shows a hand-printed note on file paper, written to Ms. Walker from Wally, and claiming that when he awoke on the morning his assignment was due, he could find only one small fragment of his report, which he tapes to his letter. "I think the dinosaurs ate my homework," he concludes.

As with *Dear Diary*, this book presumes that readers will recognize the physical format and enjoy the joke. However, once again, there is nothing in this story that is not self-explanatory; readers will benefit from bringing an appropriate schema of school reports to their encounter with the book but do not need to apply much external understanding of the workings of such reports in order to comprehend and enjoy the story. The strongest metafictional element in the book lies in the back fold of the dust jacket: the information about the author is cast as a file note from the Dinosaur Intelligence Agency, and describes his occupation as "Science project researcher, but moonlights as an award-winning children's author and illustrator."

The Stinky Cheese Man and *The Three Pigs*

Far better known than the books I have explored up to this point, *The Stinky Cheese Man and Other Fairly Stupid Tales* and *The Three Pigs* are books that investigate the role of book apparatus in the presentation of story itself. Of all the books discussed in this chapter, they are probably the most complex, but as they are also the most frequently discussed (e.g., McGillis; Tozer; Stevenson; Pantaleo; Silvey), I will attend to them more briefly.

The Three Pigs draws (literally!) on the concept of the margin; the pigs are saved from their predestined fate of being eaten by the wolf through being blown out of the picture when he huffs and puffs. Once they register the potential of this ontological trick, they are able to use their "outsideness" from the picture panels to render these panels into tools for flying to the rescue of other story characters. The boundaries of the story world are marked by the images, as the pigs mutate visually when they cross into a new fictional universe. To read this book with understanding, it is necessary to invoke the idea that a story is a construct, that it is *made* and may thus be changed; the fact that in this case the changes are accomplished by characters from other stories is part of the joke. To comprehend the illustrations, it is important to know (or to *learn* from developing an awareness of how this story works, as the pigs move in and out of the different images) that pictures have distinctive styles, that they are not simply transparent and faithful renditions of the world outside the book. Any alert reader will also establish that words are similarly tricky; in this case, the words not only carry on parroting the original story long after its premise has been exploded in the pictures, but also wind up being part of the game of the final page as the characters reassemble the letters to end the story.

Although its contents are complex, *The Three Pigs* plays it completely straight in the peritext. Cover, dust jacket, title page, verso, all conform to the most standard conventions of book publishing. The story itself begins very conventionally indeed, both verbally and visually, and the

sudden interruption to smooth reader expectations that occurs on the third page of the story is part of the reading experience. But the elaborate readerly games serve a relatively simple and straightforward story.

The Stinky Cheese Man is the oldest and most anarchic book of this specimen set. The back cover (both on the book itself and on the matching dust jacket) sets the tone, with the Little Red Hen attacking the "ugly" ISBN and bar code that feature on every book. The opening end pages are bland enough, with blue and yellow swirls (perhaps representing emanations from the eponymous hero), but the next page features the Little Red Hen again, making valiant efforts to get the story started, only to be interrupted by Jack the narrator, who points out that she is still on the endpaper and that the title page has yet to appear. The dedication appears upside down, with Jack observing that nobody ever reads this stuff anyway. The introduction tells readers to stop reading right now, and the tale of Chicken Licken, which follows, is once again interrupted by Jack crying that he forgot the table of contents—which, when it appears, falls instead of the sky and "squashed everybody. The End."

More parody stories follow, but Little Red Running Shorts and the Wolf decide to cut out of their story early, and the Little Red Hen seizes the chance to inveigh against the book once again: "How do they expect me to tell the whole story by myself? Where is that lazy narrator? Where is that lazy illustrator? Where is that lazy author?"

And so it continues, with games being played with the stories, with the fonts in which they are told, with the relationships between characters and narrators, and so forth. The Stinky Cheese Man makes his appearance in a parody of "The Gingerbread Man," and at the end of this story we see the blue and yellow swirls of the endpapers. Famously, however, the story continues over the page; Jack has "moved the endpaper up here so the Giant would think the book is over. The big lug is finally asleep. Now I can sneak out of here. Just turn the page very quietly and that will be The . . ."

But over the page is the Little Red Hen, still talking and waking up the giant who ultimately finishes the book by eating a Little Red Hen sandwich, while Jack disappears through the giant words that finally announce "The End." Sipe and McGuire report on a first grader who is surprised by this peritextual game (2006, 301), a good example of a learning reader who has registered both the significance of conventions and the potential for subversion.

Although Jack does make good his escape, it would be difficult to assert that the anarchy of *The Stinky Cheese Man* is designed to be "read into" a more linear story. There is no way to read this book into neatness or linearity. It is designed to be read as mayhem and uproar and nobody packs the building blocks of story tidily back into their case at the end of the book. Fragments of story remain hurled in all directions and the ensuing chaos is one source of the pleasure of this book.

CONCLUSIONS

Picturebooks and their readers exist in a world of many narrative options. Other forms of text involve moving and interactive images; it is relatively easy to think of the picturebook as the option of the static image. These books, however, interrupt and interrogate the static qualities of the picture-book; they demand and help to create a plasticity of mind that is also honed on other textual forms.

Kurt Squire, talking about player agency in digital games, says, "[C]ontemporary games literally put players *inside* game systems" (25). In ways that are both similar and different, the stories I have discussed in this chapter virtually put readers *inside* book systems. To read these books coherently, it is necessary to know these systems and to bring their possibilities and constraints into play. Not every book in this little set calls for a multiply-constructed reading stance; some are simpler than others. Nevertheless, all of them make visible the power and the constraints of the bound page.

A literary education grounded in such stories develops both tacit and explicit awareness of books *as* systems of conventions and expectations. Young readers who grow up with such literary awareness are better equipped to understand how books work and to understand that they may be cri-tiqued and challenged. Far from undermining book literacy, such radical understanding makes it possible to register books as dynamic forms of text. In an era when other dynamic texts are so seductively available, knowing that books can also play lively and entertaining postmodern games is a les-son that cannot be learned too young.

NOTES

1. These picturebooks are unpaginated, so I have omitted page references, rather than repeating "n.p."

WORKS CITED

Anstey, Michèle. "'It's Not All Black and White': Postmodern Picturebooks and New Literacies." *Journal of Adolescent & Adult Literacy* 45.6 (2002): 444–457.

Baldrick, C. *The Concise Oxford Dictionary of Literary Terms.* Oxford: Oxford University Press, 1990.

McGillis, Roderick. "'Ages: All': Readers, Texts, and Intertexts in *The Stinky Cheese Man and Other Fairly Stupid Tales.*" In *Transcending Boundaries: Writing for a Dual Audience of Children and Adults,* edited by Sandra L. Beck-ett, 111–126. New York: Garland, 1999.

Meek, Margaret. *How Texts Teach What Readers Learn.* Stroud, Glos: Thimble Press, 1988.

Pantaleo, Sylvia. "What Do Four Voices, a Shortcut, and Three Pigs Have in Common? Metafiction!" *Bookbird: A Journal of International Children's Literature* 42.1 (2004): 4–12.

Pontin, Jason. "Q&A: Danny Hillis: Thinking Machine." *Technology Review* 109.5 (2006): 28–29.

Ross, Philip E. "The Expert Mind." *Scientific American* 295.2 (2006): 64–71.

Silvey, Anita. "Pigs in Space." *School Library Journal* 47.1 (2001): 48–50.

Sipe, Lawrence R., and Caroline E. McGuire. "Picturebook Endpapers: Resources for Literary and Aesthetic Interpretation." *Children's Literature in Education* 37.4 (2006): 291–304.

Squire, Kurt. "From Content to Context: Videogames as Designed Experience." *Educational Researcher* 35.8 (2006): 19–29.

Stevenson, Deborah. "'If You Read This Last Sentence it Won't Tell You Anything': Postmodernism, Self-Referentiality, and *The Stinky Cheese Man*." *Children's Literature Association Quarterly* 19.1 (1994): 32–34.

Tozer, Steve. "Playing Against Conventions: The True Story of the Stinky Cheese Man." In *Handbook of Research on Teaching Literacy through the Communicative and Visual Arts*, edited by James Flood, Shirley Brice Heath, and Diane Lapp, 822–828. Mahwah, NJ: Earlbaum, 1997.

CHILDREN'S LITERATURE CITED

Edwards, Wallace. *The Extinct Files: My Science Project*. Toronto: Kids Can Press, 2006.

Fanelli, Sara. *Dear Diary*. Cambridge, MA: Candlewick Press, 2002.

Gravett, Emily. *Wolves*. London: Macmillan Children's Books, 2005.

Hutchins, Pat. *Rosie's Walk*. London: Bodley Head, 1969.

Scieszka, Jon, and Lane Smith. *The Stinky Cheese Man and Other Fairly Stupid Tales*. New York: Viking, 1992.

Van Allsburg, Chris. *Bad Day at Riverbend*. Boston: Houghton Mifflin, 1995.

Wiesner, David. *The Three Pigs*. New York: Clarion Books, 2001.

8 The Paradox of Space in Postmodern Picturebooks

Bette Goldstone

It is in the nature of picturebooks to be cultural artifacts reflecting societal mores, values, and beliefs. It is also in the nature of picturebooks to demonstrate extraordinary flexibility, openness, and inventiveness due to their brevity and the interplay of two artistic forms—narratives and illustrations (Nodelman). In a world that is changing at an almost unfathomable speed, it is not surprising that this highly dynamic and culturally reflective artistic form is evolving at an accelerated rate. In the last three decades, picturebooks have become "increasingly experimental, with thematic complexities and sophisticated artistry that have entirely changed their look" (Mikkelsen 31). These changes have been so dramatic that a new subgenre has evolved—the postmodern picturebook (Goldstone).

Equally true, it is in the nature of postmodern picturebooks to continue to experiment: break boundaries, question the status quo, challenge the reader/viewer, reflect technological advances, and appeal to the young who are at least as comfortable (if not more so) playing on the computer screen than they are on a jungle gym (Pantaleo). Postmodernism, whether reflected in picturebooks for children or in art and literature targeted for adult audiences, demonstrates a profound shift in societal perception and behavior. Rather than trying to interpret and represent a stable reality with clear parameters and mores, postmodern artists reflect upon a world—complex and confusing, a world which questions its purpose and function and has unstable and quixotically changing boundaries. In a quest to untangle this quagmire, postmodern illustrators and authors infuse their books with playfulness, parody, self-referentiality, nonlinearity, multiple perspectives, and irony (Nikola-Lisa). But more importantly, in their desire to better comprehend our existence and convey these insights to the young reader/viewer, artists present a new visual world, a new way of seeing.

One significant reason for this unique visual interpretation is the reconceptualization of space both in terms of illustration and text. Postmodern picturebook artists transform book space in ways which simultaneously are inventive while reflecting concepts and ideals from fine arts, technology, and scientific theory. Artists, and thus viewers, conceptualize traditional illustrative space as having three hypothetical planes of spaces.

The illustration/painting/photograph may exist on all three planes giving the illusion of depth. To better understand this, picture in your mind's eye—a TV screen. The glass front is impermeable. Characters and props are located in three general spatial areas: The spot very close to the screen (foreground), another further back (mid-ground), and one removed to the far distance (background). Characters move and objects are placed within this carefully constructed and circumscribed space. Traditionally, picturebooks compress the space even further, creating a relatively narrow stage for the story to visually unfold, with much of the action occurring in and on the space of the mid-ground. Also in this traditional form, the text is neatly placed most often at the bottom of the page, existing often in its own space separate from the actual illustration. In *Where the Wild Things Are*, Max, for most of the book, hangs out in the mid-ground. The creatures and Max come close to the picture surface only when their wildness gets out of control—as if the foreground were not the most comfortable place to be. The background is used sparingly with some scattered greenery; the text goes from left to right along the bottom of the pages. In Leo Lionni's *Frederick*, the protagonist by the same name and his mouse community live in a narrow band of space, with our poet-at-large and the busy animals moving in between fore- and mid-grounds. Peter, in *The Snowy Day*, has the most freedom. As Peter wakes up in the morning, he is seen—close to the viewer—on his bed in the foreground. When he plays outside, he moves almost exclusively between the middle and backgrounds. After he returns home, he settles in once again more closely to the viewer, moving between fore- and mid-grounds. Again in both *Frederick* and *The Snowy Day*, the story line runs along the bottom of the page, describing and amplifying the images but not part of them.

Postmodern picturebook creators continue to utilize these three traditional spatial dimensions, but now have expanded useable story space in three ways:

1. Space has been redefined, reconnoitered, and manipulated into five dimensions. The fourth dimension is the space shared between the physical book and the reading/viewing audience. Characters and objects can leave the standard three planes of space and move into space traditionally reserved for the audience. The fifth dimension is a spatial area that lies beneath the physical page. Characters now step off the page surface into spaces hidden underneath the flat rectangular page area. There the characters engage in newly formed story lines.

2. The picture surface is now porous and dynamic. This permeability allows characters and audience to move back and forth from the illusionary world of the story into "real" space and then back again. Book characters and story elements spill out of the book into the audience space, while audience members enter the story world. This dynamic

page surface allows room for alternative realities to lie beneath the page. The page surface now has an atmospheric quality; it is translucent and mobile.

3. These additional two dimensions and the porous surface plane allow new possibilities for location and function of the text. The text is now not necessarily segregated from the pictorial space but is woven around characters, objects, and settings. Words can now be placed literally all over the pages, can be manipulated by the characters in the story, and can become props within the space. Although text still can be seen as a separate component, there now are new ways for narration to be integrated within the whole.

These three conceptual innovations allow for movement and interactions not before seen in picturebooks. Children's picturebooks have always been magical in their creative offerings, but postmodern picturebooks present startling new ways to read and view a page. Picturebook pages, text, and illustrations can evaporate, multiply, pile up on top of one another, be peeled back, be constructed into things other than picturebook parts, and are far more versatile than Gutenberg could have ever imagined. These changes create a tableau for ingenious and out of the ordinary fictional and artistic representations.

To further define this new fourth dimension, characters now have the ability to see the audience, to speak with the audience, and move toward and into the audience's space. The reader/viewer becomes an "insider," lost in text and image at that moment in time (Benton). In David Wiesner's quintessential postmodern picturebook, *The Three Pigs*, the wolf not only first huffs and puffs and blows the house down but also blows the pig out of the story. The audience, pig, and wolf are equally perplexed and astonished. Midway through the story, another pig breaks through the picture plane. Nose to nose, eyeball to eyeball with the audience, the pig ponders, "I think . . . someone's out there." On the cover of *Good Night, Gorilla*, the protagonist—a little gorilla, looks out to the audience and lets us in on the joke. He has the keeper's keys. Gorilla incorporates us into the story as dear friends—because you only let friends into a secret conspiracy. In *Officer Buckle and Gloria*, Peggy Rathmann begins utilizing this new special plane on page one. Officer Buckle literally slips out of the picture into our space as he attempts to thumbtack a safety tip to the bulletin board. With chair moving toward us, papers and thumbtacks flying, our humble police officer creates "Safety Tip #77: Never stand on a swivel chair." Anytime an artist has a character lean beyond, fall out of, step clear of, reach outside the picture's border, this fourth dimension is formed. *Knuffle Bunny*; *Hey, Al*; *Buz*; and *Lullabyhullaballoo* all contain examples of this fourth dimension of pictorial space.

Just as book characters are no longer confined to page space, members of the audience are no longer relegated to an out-of-book experience. We

can (and do metaphorically) move directly into the book. Human hands— life size and realistic—enter *Bad Day at Riverbend* and *Black and White,* manipulating the pages and story. In *Bad Day at Riverbend*, "shiny, greasy slime" begins to cover the town in mysterious irregular lines (Van Allsburg). At the story's end, the audience sees a human hand armed with a crayon. Evidently, some little person has been happily scribbling away in a coloring book of the old west. In *Black and White*, four distinct stories mingle with each other creating astonishing connections. Just as the reader/ viewer believes he/she understands the story, a human hand reaches into the last page, picking up one of the important story components—a train station—as if it was a toy in a Lionel train set.

Although this blurring of real and fiction could create mayhem, it does not. Rather a very clear invitation is delivered, "Come on in!" These postmodern elements engage the reader/viewer powerfully. The reader/viewer has a clear mandate; think about this story, relate this story to other reading experiences, manipulate the story so it makes sense. Do not be shy, be a coauthor. Feel free to play with story, add to it and alter it!

The postmodern illustrated fifth dimension is the space designated underneath the physical page. Characters can peel back, fly through, see around, gnaw through the physical white page and find an expanded universe; their world is not confined by a rectangular page space. Again in Wiesner's 2002 Caldecott winner, the three pigs explore the world around the physical pages. By pushing, shoving, and folding pages of their story, they discover new worlds with alternative realities and a freedom to go beyond their intended destiny. But these pigs, like others before them, eventually realize that there is no place like home. Empowered with newfound knowledge and friends, they rebuild their original story-land, making it a better place to live. In *The Story of a Little Mouse Trapped in a Book*, the title tells it all. A mouse is stuck in a book. Determined to find freedom, the ingenious protagonist nibbles the perimeters of the white page, carefully lifts the sheet away revealing a green pastoral landscape. Undaunted, the creature now makes an airplane out of the paper and flies down to a new bucolic existence. Max, Frederick, and Peter explore, play in and comprehend one universe; that which is the standard, stable, thirty-two white-paper pages found in traditional picturebooks. It is outside their comfort zone to go beyond the relative safety of the page space.

This new spatial arena—worlds hidden beyond the physical pages—is also the underlying premise of *Zoom, Re-Zoom,* and *The Red Book*. All three of these books fold into themselves. As the reader/viewer looks intently at an illustration, an insight develops: "This is not an illustration in the book I am holding, but an image of another place—a space that exists underneath the pages—beyond the book." This new space has its own potential story awaiting. In *Zoom*, this wordless picturebook opens with an image the viewer cannot quite identify. On subsequent pages the image recedes and we learn it is the face of a wristwatch. As each page

To Charlotte Valerie

Figure 8.1 Illustration from *Black and White* by David Macaulay. ©1990 by David Macaulay. Reprinted by permission of Houghton Mifflin Company. All rights reserved.

turns over, a new understanding of the story takes place. On the next page we see the watch is on the arm of an archeologist tracing hieroglyphs in an ancient Egyptian room. We cognitively shift the story's meaning and predict a new possible scenario. On the next page the illustration shows us that the archeologist is working in an obelisk in a square in modern Paris. The story does not stop here. The story's space and plot changes and expands. The story is built on layer upon layer of realities which turn into imaginary spaces over and over again. Existing in this book (as well as *Re-Zoom* and *The Red Book*—both similarly designed) are complex and highly imaginative worlds hidden beneath the picture planes. These books convey very clearly to the young reader/viewer that hidden within the mundane and obvious are exciting possibilities that await discovery. The books urge the reader/viewer to actively search out the extraordinary and inquire about the unlikely.

These two new spatial planes can occur only because the picture surface is porous and permeable. The TV set we imagined has a glass surface that is impenetrable. It contains all the action behind it. In postmodern picture-books, the page now is a dynamic, interactive surface that permits movement. Obviously the fourth spatial dimension, with characters, objects, and viewers sharing common space, could not exist without this feature. Likewise, the fifth dimension of multiple spatial planes existing behind the page could not occur if the page was static and inert. This porous surface truly broadens the possibilities for artistic interpretations. For example, in *Mysterious Thelonious*, Chris Raschka builds his surface planes with small rectangular blocks of color. Depending on the intensity of color, the darker blocks appear to recede; lighter colors move forward. At times the blocks become translucent, figures and pictorial images blend and merge. All of this dynamic interchange of color, space, and form reflects the jazz melodies composed by the book's namesake. These illustrations would not be possible without the understanding of a porous surface plane. Raschka creates illustrations—not with three, four, or even five spatial planes, but with space that is in flux, creating at will different planes for the story to unfold.

Instead of using small blocks of color, Peter Catalanotto, in *A Day at Damp Camp*, paints planes of semitransparent images to develop depth of image and comprehension. The premise of the book is simple; it describes a child's experiences at summer camp. The visual presentation, however, is far from simple. Centering on George Ella Lyon's sparse poem, the artist is able to convey a rich emotional meaning of summer to a child—its activity, heat, unfettered fun, camaraderie, and new adventures. On a page midway through the text are just two words, "Cool Pool." Catalanotto creates a background space of shimmering water in bright sunlight that the viewer looks down upon. He then superimposes a slightly smaller image of girls diving into the water. On top of this, a third image is projected. The viewing perspective has shifted. The reader/viewer looks up from underneath

the water to the swimmer as she paddles across the pool. This illustrated page provides different vantage points simultaneously, builds up a complex image with three distinct yet interlocking connected pictures, and utilizes a porous, open surface plane. Catalanotto interlinks multiple illustrations on each page to develop his story. He builds his images into a three-dimensional pyramid form rather than laying the illustrations flat. Once again, this illustration could never have been produced without the concept of a dynamic surface plane.

Another innovative use of space is the placement and function of the alphabetic text on the page surface. The function of the text has expanded to go beyond the job of narration to now entering into the illustration's spatial domain. This allows characters to manipulate the words. In *Arlene Sardine* the letters in the words vary in thickness and their angles have been softened. These letters now appear to be sea creatures swimming alongside the school of brislings. In *Zin! Zin! Zin! A Violin* the words swirl across the space to the tempo of the violin's music. In *Mysterious Thelonious* the words are placed on a grid background in patterns akin to notes on a staff. In *Black and White* the words on the title page slip off the page, just as the burglar has slipped out of his prison cell. In *The Three Pigs* the letters get knocked about quite a bit. At the end of the story, the characters pick up letters from the alphabetic mess on the floor, and write a new ending. This integration of text within the actual image space allows for the illustrator to remind the reader/viewer of the artificiality of text, allows the reader/viewer to witness the construction of the story, and permits a nonlinear reading of the text. In texts such as these, the words are "read" in the same process as we "read" pictures. When viewing an image we are attracted to colors, forms, lines, and compositional elements which may be located anywhere in the picture. In traditional picturebook formats, text is sequential and linear, linked to time. Images on the other hand are linked to space—nonsequential, spontaneous, and not bound by temporal restraints (Kress). For example, the sequence of words read, what is printed (and thus viewed) first, second, and third is of consequence. When reading pictures, it does not really matter what we look at first, second, and third. What is of significance is where objects and characters are located, how they are positioned to one another, and in what spatial plane they lie.

This represents a significant change. In postmodern picturebooks, the text loses, at times, its temporal quality. Text and image are always inextricably intertwined in picturebooks. This is a crucial element. Readers/viewers/listeners are pulled between image and text—wanting to linger over the pictures, but also needing to move quickly ahead to learn what will happen next (Nodelman). When text takes on this dual role of telling the story and being part of the illustration, the act of reading slows down—the tension between word and picture diminishes. Where the words and letters are situated, how they relate to the characters in position and form become as important as what they say. We are witnessing a change in the reading

process. Postmodern picturebook artists make the synergy of words and images more apparent. The former boundary between words and pictures has been broken. This characterizes a change in text function as moving from describing the world to showing it. Writing is now display oriented (Kress).

The illustrations described, although quite different, are all brilliant in their inventiveness and ingenuity. They all use space in unique ways. These books contain images that interrupt the flow of linear, three-dimensional traditional picturebook patterns, establishing new ways to visually interpret and read, play with the artifice of fiction, and make book production visible. But it also needs to be recognized that postmodern picturebook artists incorporate visual techniques and styles used before. As mentioned previously, children's literature does not emerge from a vacuum, but rather from a deeply embedded and complex multicultural heritage that artists and authors then interpret. In any picturebook, the illustrations, the presentation format, underlying themes, portrayal of character and setting reflect cultural knowledge, belief systems, mores, literary conventions, and artistic styles. This does not diminish what postmodern picturebook creators do. Their innovation and excellence lie in the fact that they experiment with and manipulate these previously used visual concepts by placing them in a new milieu—the picturebook. By understanding their antecedents, we can better appreciate, evaluate, and teach the special qualities of these books.

Postmodern picturebooks' unique spatial interpretations have roots in the changing conceptualization of time and space beginning in Western society in the mid-nineteenth century. Time and space are culturally bound and defined; with each society sharing a particular bias toward these two dimensions. This bias alters what people think about, where they think, and how they think (Jameson). Prior to the Industrial Revolution, Western society understood matter as something which occupies space. Matter could be manipulated and relocated within space. Space, on the other hand, could not be manipulated. Time, based on Newton's eighteenth-century experiments, was described in a similar manner. Time and space were fixed and inflexible, categorical and absolute. From the 1850s to 1917 a series of technological innovations created distinctive, new modes of thinking about the time/space continuum. Imagine if you will, a time when speed was measured by a galloping horse or traveling in a carriage pulled by horses or oxen. Then imagine the speed of traveling on a train; the amazing panorama that rapidly unfolds as a traveler glances out of the window. As one train passenger remarked in 1903 upon looking out the window: It is a "rapid crowding of changing images . . . the unexpectedness of onrushing impressions" (Charney 279). Time and space are becoming understood in new ways. Likewise the inventions of telephone and wireless telegraph compressed time and space. Information traveled much more quickly, whether it was family gossip or news of larger consequence. "The result was a transformation of the dimensions of life and thought" (Kern 2).

As the twentieth century opened, Einstein theorized "that time is meaningful only in association with space" (London 423). Time has meaning only when linked to an associated space, and that in every place there are an infinite number of spaces—each in constant motion to one another (London). Three new characteristics of space now appeared:

(1) Multiplicity of space—many spaces can exist within the same space;
(2) Space itself can be manipulated; and
(3) Space has a constant energy within itself (Bolter).

Although these concepts were seemingly quite contrary to current thinking, they were quickly embraced and rapidly spread throughout western culture (Tyler and Ione). The artistic revolution of the twentieth century "kept pace with the scientist's; both developed from a concept of space as pliable, dynamic and adaptable" (Wynne 59). John Marin, a prominent American printmaker and painter of the first half of the twentieth century wrote, "[Space] is no longer a passive field on which objects are placed, but an active one with a will of its own. A space becomes a live thing, it reacts against other live things . . . objects . . . can no longer remain tranquil, but are potentially mobile" (Wynne 65). The multiple perspectives in Cubists' paintings, the vibrating space of op art, the floating images of Chagall, and Frank Stella's breaking of surface plane into the viewer's space (Tyler and Ione) all attest to and reflect the changing conceptualization of space. Postmodern picturebook illustrators are recipients of the new definition of space and changing artistic traditions.

To put this reconceptualization of space (different special planes may exist within another space, space can be manipulated, and space contains an energy of its own) into picturebook language, let us again compare a traditional picturebook to postmodern ones. In Munro Leaf's *Ferdinand*, space is solid and nurturing. For almost the entirety of this story, matter occupies space, space remains immutable. Characters move within the safe confines of open, airy mid- and fore-grounds. Even in the bullring, even with the taunts of the Banderilleros, the Picadores, and the Matador, Ferdinand feels safe. The space is clear, unencumbered, with no miscellaneous objects, no unexpected shifting, and one with distinct limits, i.e., the edges of the page. The only time space and time are disrupted is that fateful moment when Ferdinand is about to sit upon the bee. This image of bee, clover, and bull, is telescoped into the reader/viewer's range, freezing the second before the bee, in an attempt to save its own life, stings the young bull. Due to the focused close-up angle, we are propelled into this catalytic image, knowing what unpleasantness will ensue. Once the sting and reaction occur, space returns back to an open arena for characters to move along at their own pace in the mid-ground. The space in *Ferdinand* is calm, white, expansive, and unchanging. The large areas of white space on most

pages focus the reader/viewer very clearly on the undisputable message of the story and pictures.

Space is reconceptualized within the domain of postmodern picturebooks. In *A Day in Damp Camp*, the multiple spaces existing on and within each single page space, allow the reader/viewer far more flexibility and imagination in decoding and comprehending the storyline. The multiple interlocking planes of space on each page invite imaginative speculation and intensify the complexity of viewing. In *Zin! Zin! Zin! A Violin* and *Mysterious Thelonious*, the spaces on the pages space are charged with an energy of their own. Characters, colors, lines, and graphic text elements move to the beat of the music alluded to in the stories. In *Black and White* and *The Story of a Little Mouse Trapped in a Book*, the respective authors/ illustrators Macaulay and Felix manipulate space, building multiple planes for the characters and readers/viewers to use in story construction.

This elastic, palpable space describes hypertext (Bolter) just as it does postmodern picturebooks. Much like the space seen in postmodern picturebooks, hypertext creates multiple spatial planes stacked on top of one another, a space full of movement and energy, and information within the space that can be manipulated by the user. Hypertext, like postmodern picturebooks, can show words and images as a collection of interrelated floating units in space, multiple perspectives and multiple pathways. Their presentation style, integration of text in pictorial space, and involvement of user/reader are very similar (Dresang and McClelland). Computers' visual presentation and use of space is now a part of mainstream experience. These images—as all images in the culture, whether from popular media or the fine arts—become incorporated into our mental processes. Hypertext's manifestations on the computer screen, such as multiple screens layered on top of one another, influence our thinking, problem solving, and mental imaging (Salamon). It is not surprising that postmodern picturebook artists use these culturally integrated images as part of their inspiration. And this is one reason why postmodern picturebook images are so accessible to a young audience weaned on computer technology. They have seen variations of the picturebook formatting and images in other contexts.

The importance of pictorial space in terms of complexity of viewing and comprehension is often overlooked in both book evaluation and in decipherment of semiotic codes. Although space is frequently mentioned, its function is limited to location and proximity of objects in space (Kress and Van Leeuwen), relationship of the picture to the page edges (Moebius), and descriptive qualities such as negative and positive, two and three dimensionality (Nodelman and Reimer). These comments add depth and insight in the evaluation of the traditional picturebook form. They do not, however, fully explain the postmodern aspects of picturebooks. With the changes postmodern picturebooks bring, it is necessary to rethink the artistic properties of their images by adding an expanded explanation of spatial illusions found on the page. We still need traditional elements of style and

pictorial image: color, line, composition, size and placement of objects and characters, intended movement and action, artistic style and medium. This list needs to be broadened with vocabulary and concepts of new postmodern spatial features: (a) A study of the surface plane—is it porous to allow movement from the story into the audience space and vice versa?; (b) An awareness of the actual space areas utilized—the traditional fore- mid- and backgrounds and the new spaces found underneath and around pages and the shared space between book characters and audience; and (c) The way the printed text now may move into the pictorial space contributing as physical props to the story plot and character development.

The inclusion of new criteria does more than help in communication. Recognizing and addressing the new postmodern spatial aspects ensure that readers and viewers do not lose meaning and delight in the reading experience. Spectatorship—how we look, scan, gaze, track, gain personal pleasure, understand cultural connections, envision artist's point of view, interpret line, color, shape, and space—is as important and complex a process as the act of reading with its decipherment, decoding, interpretation, aesthetic and efferent stances, understanding cultural connections, authors' point of view, style, and grammar (Wallis). We use different mental processing capabilities to decode and interpret different symbolic forms of representation (Salamon and Leigh). Therefore, it is highly significant that we evaluate, investigate, and teach both artistic and narrative components of the picturebook. Comprehending images and text deeply introduces children "to a significant and strategic process, preparing them to interpret the wider world of iconic information that characterizes the information age" (Considine, Haley, and Lacey 2).

These new uses of space in postmodern picturebooks are obviously paradoxical. How can characters disenfranchise/disentangle/disengage themselves from a story and move into spaces not part of the book? How can characters take pages of the book and use them for purposes other than holding the words and images of that particular story? How can the physical page become multilayered or become porous? This is antithetical—contradictory to intuitive thinking. Equally paradoxical is that Albert Einstein's immortal formula of $E=mc^2$ is a catalyst—albeit an unconscious one—in the reconfiguration of space in postmodern picturebooks. Postmodern picturebook landscapes are filled with the commonplace but then spiked with startling maneuvers and strange conceptualizations. We as viewers and readers are welcomed into these landscapes; then the world is turned upside down, helter-skelter, pushing us to reconsider initial assumptions. This is the power and the nature of paradox. Paradoxes force the questioning of ambiguities that lie beneath time-honored, culturally valued assumptions. This is the dissonance that promotes thoughtful action, careful analysis, and multilayered evaluation. It is these paradoxes of spatial use that contribute to the highly engaging, highly challenging, and highly enjoyable characteristics of the postmodern picturebook. It is also these

paradoxes that enlighten the imagination, banish ennui, and engender endless possibilities.

WORKS CITED

Benton, Michael. "The Self-Conscious Spectator." *The Centre of Language in Education, University of Southampton, Occasional Papers* 30 (1994): 1–22

Bolter, John. *Writing Space: The Computer, Hypertext and the History of Writing.* Mahwah, NJ: Erlbaum, 1991.

Charney, Leo. "In a Moment of Film and Philosophy of Modernity." In *Cinema and the Invention of Modern Life,* edited by Leo Charney and Vanessa R. Schwartz, 279–298. Berkley: University of California Press, 1995.

Considine, David, Gale Haley, and Lynn Ellen Lacey. *Imagine That: Developing Critical Thinking and Critical Viewing through Children's Literature.* Englewood, CO: Teachers Idea Press, 1994.

Dresang, Eliza, and Katherine McClelland. "Radical Changes: Digital Age Literature and Learning." *Theory into Practice* 38.3 (1999):160–167.

Goldstone, Bette. "The Postmodern Picture Book: A New Subgenre." *Language Arts* 81.3 (2004):196–204.

Jameson, Frederick. "Postmodernism or the Cultural Logic of Late Capitalism, A New Left Review." In *The Bias of Communication,* edited by Harold. A. Innis, 53–92. Toronto: University of Toronto Press, 1984.

Kern, Stephen. *The Culture of Time and Space—1880–1918.* London: Weinfeld and Nicolson, 1983.

Kress, Gunther. *Literacy in the New Media Age.* London: Routledge, 2003.

———, and Theo Van Leeuwen. *Reading Images: The Grammar of Visual Design.* London: Routledge, 1998.

London, Barbara. "Time as Medium: Five Artists' Video Installments." *Leonardo* (1995): 423–426.

Mikkelsen, Nina. *Words and Pictures: Lessons in Children's Literature and Literacies.* Boston: McGraw, 2000.

Moebius, William. "Introduction to Picture Book Codes." *Word and Image* 2.2(1986): 41–158.

Nikola-Lisa, W. "Play, Panache, Pastiche: Postmodern Impulses in Contemporary Picturebooks." *Children's Literature Association Quarterly* 19.3 (1994): 35–40.

Nodelman, Perry. *Words about Pictures: The Narrative Art of Picturebooks.* Athens, GA: University of Georgia Press, 1988.

———, and Mavis Reimer. *The Pleasures of Children's Literature.* Upper Saddle, NJ: Merrill, 2003.

Pantaleo, Sylvia. "Grade 1 Students Meet David Wiesner's Three Pigs." *Journal of Children's Literature* 28.2 (2002): 72–84.

Salamon, Gavriel. *Interaction of Media, Cognition and Learning.* San Francisco: Josey-Bass, 1981.

———, and Tamar Leigh. "Predispositions about Learning from Print and Television." *Journal of Communication* 34.2 (1981): 119–135.

Tyler, Christopher, and Amy Ione. "The Concept of Space in 20th Century Art." Online posting. www.ski.org/cwt/CWTyler/Art%20/Investigations/C20th_Space/C20thSpace.html (accessed 6 December 2006).

Wallis, Brian. "Picture Theory: Essays on Verbal and Visual Representation." *Art in America.* Online posting, www.findarticles.com/p/articles/m1_m1248/is_n5_v83/ai_16878533 (accessed 18 December 2006).

Wynne, Carolyn. "Aspects of Space: John Marin and William Faulkner." *American Quarterly* 16.1 (1964): 59–71.

CHILDREN'S LITERATURE CITED

Banyai, Istvan. *Re-Zoom*. New York: Penguin, 1998.
———. *Zoom*. New York: Viking, 1995.
Egielski, Richard. *Buz*. NewYork: HarperCollins, 1995.
Felix, Monique. *The Story of a Little Mouse Trapped in a Book*. La Jolla, CA: Green Tiger, 1988.
Inkpen, Mick. *Lullabyhullaballo*. New York: Western, 1993.
Keats, Ezra Jack. *The Snowy Day*. New York: Scholastic, 1962.
Leaf, Munro. *Ferdinand*. New York: Viking, 1938.
Lehman, Barbara. *The Red Book*. Boston: Houghton Mifflin, 2004.
Lionni, Leo. *Frederick*. New York: Knopf, 1967.
Lyon, George Ella. *A Day at Damp Camp*. New York: Orchard, 1996.
Macaulay, David. *Black and White*. Boston: Houghton Mifflin, 1990.
Moss, Lloyd. *Zin! Zin! Zin! A Violin*. New York: Scholastic, 1995.
Raschka, Chris. *Mysterious Thelonious*. New York: Orchard, 1997.
Rathmann, Peggy. *Officer Buckle and Gloria*. New York: Putnam, 1995.
———. *Good Night, Gorilla*. New York: Putnam, 1994.
Sendak, Maurice. *Where the Wild Things Are*. New York: Harpers Collins, 1963.
Van Allsburg, Chris. *Bad Day at Riverbend*. Boston: Houghton Mifflin, 1995.
Wiesner, David. *The Three Pigs*. New York: Scholastic, 2001.
Willems, Mo. *Knuffle Bunny*. New York: Hyperion, 2004.
Yoricks, Arthur. *Hey, Al*. New York: Farrar, Straus and Giroux, 1996.

9 Imagination and Multimodality
Reading, Picturebooks, and Anxieties About Childhood

Christine Hall

In September 2006, 110 British psychologists, children's authors, educationalists, scientists, and doctors wrote to a national newspaper insisting on the need for an urgent debate on child rearing in the twenty-first century. The letter raised alarms about corrosive influences on childhood: about children's freedom to play, their use of time, and the authenticity of their experiences of adults and of the world about them.

These concerns were not new. Equivalent anxieties about child rearing can be traced through the centuries (see, for example, Buckingham; Cohen; James, Jenks and Prout; Kenway and Bullen; Moss and Petrie; Postman. But the social, cultural, and technological context has changed and the twenty-first-century formulation of the anxieties resonated with debates—already well rehearsed in the popular media—about diet, uncontrollable behaviours, and rampant consumerism. They also chimed with educational debates about testing in school, changing literacy practices related particularly to screen reading and virtual learning environments, and the place of creativity and the imagination in modern children's lives.

The fears, then, are that the stresses, the pace, and the commercialism of modern life are undermining childhood as a time for play, for developing the imagination, and for direct engagement with the natural world. The language commonly used to express such fears invokes images of pollution, poison, and loss of vitality. The novelist Jacqueline Wilson, for example, acting as a spokesperson for the campaign, identified a particular concern about the stifling of children's imaginations:

> We are not valuing childhood. I speak to children at book signings and they ask me how I go through the process of writing and I say "Oh you know, it's just like when you play imaginary games and you simply write it all down." All I get is blank faces. I don't think children use their imaginations any more. (*Daily Telegraph*, December 9, 2006)

Michael Morpurgo, Wilson's predecessor as Children's Laureate, condemned the "virtual play" represented by electronic games and internet surfing. "That is where children are getting their ideas from and I find it

quite 'toxic' and pretty scary for the future" (ibid., punctuation retained from the original report).

These concerns about the imagination and the impact of technological change—particularly screen reading—are the starting point for my argument. I develop my discussion through the analysis of four well-regarded (prize-winning) picturebooks, published between 2000 and 2006, which take play and imagination as their theme. I want to take seriously Wilson and Morpurgo's fears that new technologies are making children less active in their imaginative as well as their physical lives; that screens are creating a metaphorical as well as a material barrier to engagement with the real world. This chapter is therefore set out in the following way: I begin by offering an analysis of two picturebooks—each of which I consider to be well-produced, engaging, and of merit—which, I will argue, encode a particular, conventionally literary view of the imagination in both their theme and their structure. I follow this by an analysis of two postmodern picturebooks—which I also consider to be of high quality and engaging, but which I think work rather differently and suggest subtly different definitions of imagination and play. My analysis draws on the work of Kress (Kress "Literacy") and the analytical framework developed by Kress and van Leeuwen, so I discuss that theoretical framing for the analysis before drawing some conclusions which, I hope, will contribute to the wider debate about these matters.

BOXES AND VERBAL TRICKS

The two picturebooks I consider in this section are:

- *Crispin The Pig Who Had It All* by Ted Dewan, which won the Blue Peter prize in 2002;
- *I Will Not Ever NEVER Eat a Tomato* by Lauren Child, which won the Kate Greenaway medal in 2000.

In offering a brief analysis of each book, I draw on Kress and van Leeuwen's grammar of visual design in which, for example, they suggest that in the composition of pages mixing visual and verbal text, different areas of the page (right/left; top/bottom) encode particular messages. I hope it is clear how I have used the ideas in my own interpretations; for readers unfamiliar with Kress and van Leeuwen's rationale for claiming these significances, I have included the page references where the full explanations can be found.

Crispin The Pig Who Had It All (henceforth, *Crispin*) is the story of a rich but solitary male piglet who is given, and soon tires of and breaks, large numbers of expensive toys and gadgets. He lives in a fancy house with a housekeeper and parents who are preoccupied with their own

interests. At Christmas he receives a large box from S[anta], labelled "the only thing you do not have. It's the very best thing in the world." The box is empty. Crispin is upset and puts the box outside. Rabbit and raccoon immediately see its potential as a plaything but Crispin drives them off since the box belongs to him. However, he can find no use for it. The other animals return the next day; Crispin tries to drive them away and they engage in a play fight over the box which develops into an extended and enjoyable game in which the box becomes a base in outer space. At the weekend Crispin's father hands him large amounts of pocket money and encourages him to go to the arcade but Crispin prefers to see if his new friends will visit him. The friends arrive and they play, using the box as a shop, a pirate ship, a castle, and a space base. After a rainy night, Crispin fears his friends will abandon him because the box has been destroyed. However his friends are loyal (and growing in number) and they recreate their space game from the broken toys in Crispin's bedroom. Later, while he is at school, the housekeeper takes delivery of a new fridge and has Crispin's room cleared of the broken toys. Crispin is distraught and again believes his friends will abandon him. However, the packaging for the fridge is in the garden and when Crispin looks inside the new box he finds that it is full of his friends.

Crispin is a thirty-two page book with 660 words of text. The challenge implicit in the definition of the title—*The Pig Who Had It All*—is immediately restated visually in the image on the first page: the piglet is slumped in an oversized leather swivel chair, surrounded by toys and food, clutching a remote control. This is what Kress and van Leeuwen call a 'demand' image (126): the gaze is directly at the reader/viewer and is reinforced by the eye-like buttons in the upholstery of the chair's headrest. The chair with its contents is given high salience by the use of colour and light, the lack of background detail, and the fact that it is framed above and below by a line of text. The text is challenging and, like the image, invites distaste and disapproval:

> Crispin Tamworth was a pig who had it all.
> And at Christmas, he got even **more**. [*sic*]

A narrative pattern of acquisition, boredom, and then destruction is established through a verbal refrain and 'classificatory' images of the new toy followed by images of turning away and destruction (ibid.79). Although these images are 'scientific' in style, set on a plain white background, demonstrating a process, they are associated with images of food, particularly fizzy drinks. The gift of the box breaks this pattern: on a warmly coloured double-page spread, the huge box carries a message from beyond the consumerist world of the pig family. The piglet in his red pyjamas, running back to the 'given' of the box on the left-hand page from the potential 'new' of the right page recaptures a sense of Crispin as young, vulnerable,

Crispin Tamworth was a pig who had it all.

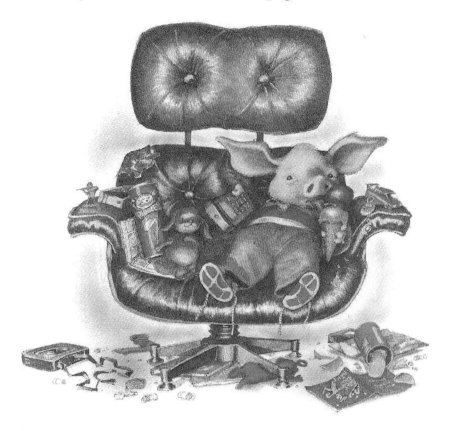

And at Christmas, he got even more.

Figure 9.1 Image from *Crispin The Pig Who Had It All*, by Ted Dewan, published by Doubleday/Picture Corgi. Reprinted by permission of The Random House Group Ltd.

and excited rather than ugly and greedy (ibid. 186). The story is carefully sequenced, supported by the images and carried largely through the words, which mark the chronological stages of the narrative, develop rudimentary characterisation through dialogue, and articulate Crispin's fears.

Midway through the book is a powerful doublespread. The left-hand page depicts the interior of the house which is spacious, expensive, and littered with broken gadgets and junk food. The vectors within the image—trailing

wires which connect the isolated individuals through communications technologies to some outside world—guide the viewer towards the central transaction being depicted: father pig looking up from his book to hand over a pile of cash to his young son. Meanwhile the housekeeper works mopping the floor in the darker 'given' area of the kitchen on the top left of the page while mother pig, her back turned to the family, creates work for herself on her exercise bike in the right-hand, 'new' side of the page. A symbolic bucket catches the leaks in the family home. Opposite this recto is the book's most powerful image of exclusion: another demand image, paralleling the first picture in the book but emphasising the smallness of the piglet looking out imploringly from behind a glass screen, doubly and sometimes trebly framed by the wood of the door, glass bricks, steps, and a porch roof. Crispin's wistful, tentative responses are located at the bottom of the pages: "Not today," said Crispin. "Nick and Penny might come by."

Though the collaborative games are brightly coloured, vigorous and interactive, the final 'demand' image of Crispin is forlorn and located in the 'real' of the bottom of the page, while the images of his friends scamper across the 'ideal' space at the top of the page, leached of colour and presented as colour-washed pencil sketches, fading and not fully realised (ibid. 193). These two images are mediated by an explanatory text which forms the central panel of the triptych:

"All my pals will go away.
There's nothing here to play with."
Crispin wept.

The final image of the book is an 'offer' rather than a demand: the friends look at one another rather than out to the reader and the vector of the gaze is entirely inclusive. Meanwhile stars and arrows radiate from the box to suggest the excitement and emotion contained within.

The book's resonances with the anxieties expressed in the debates about modern childhood will be immediately apparent: the consumerism, the junk food, the detachment of the parents, the child's isolation and destructiveness. Crispin does not know how to play: owning the box does not enable him to imaginatively create anything with it. Imagination here is about metaphorically being able to fill an empty box; it is an attribute to be developed socially; it brings colour and engagement, the ability to construct from what is available, to create the coherent worlds of the space base or the pirate ship. Above all, it is about moving from the outside to the inside, from the alienation and isolation of the material world to an inner world which is social and warm, filled with personal resources and relationships.

Lauren Child's *I Will Not Ever NEVER Eat a Tomato* (henceforth *I Will Not*) is also a thirty-two page (570 words) book about transforming the domestic, in this case the various foods that the younger of the two

siblings in the story refuses to eat. Lola's brother, charged with giving her dinner, proposes ways of recasting the food to make it exotic and acceptable to the little girl. Peas become green drops from the skies of Greenland, fish fingers become ocean nibbles from a mermaids' supermarket. The first nine pages of the text establish the problem, classifying both verbally and visually the foods Lola refuses to eat. Page one establishes that this is a power struggle between a brother and sister: Lola, arms folded, sits tight on a chair on the left-hand, 'given' of the page, looking suspiciously across to Charlie who stands slightly uncertainly beside his chair on the right-hand side of the page, ready to lead us into a new way of dealing with the stubborn intractability she personifies. The doublespread that follows establishes that conventional logic will not prevail with Lola, and the next one depicts the size of the problem, with each of the foods carefully specified through labelling and apparent hand drawing and colouring, set out on a plain white, potentially infinite, background. As Charlie begins to take control of the situation he marshals the images into words, classifying them neatly into a scientific style of table which simultaneously suggests kitchen shelves. The positions of the children in this doublespread are reversed: Charlie, verso, now represents the status quo and through the vector of his arm links the 'real' territory of the kitchen with the more abstract and ideal pink space in which the foods have been classified in the table/shelf unit. Lola, now occupying the 'new' space, recto, tipping towards the right, indicates that movement is possible.

In part it is the close, photographic encounters with the particular foods which enable the transformations to take place. The scale and the proximity of a potato, for example, which occupies two thirds of a doublespread and is therefore larger than an actual potato, create a hyper-real quality which prepares the reader for the surrealism of the following image, of Lola spooning up clouds from the peak of Mount Fuji. But the transformations, defined in the text by Charlie as a "trick," are primarily verbal reformulations, renamings which trigger visual landscapes. In the final reversal, Lola demonstrates that she enjoys and knows how to play the game. The final page depicts Lola inhabiting the left-hand, given space of knowingness and Charlie learning something new on the right as Lola changes her mind about eating tomatoes. But both children are now situated in the upper, 'ideal' region of the page: the transformed foods sit, classified, in a circle of labelled dishes, renamed, 'real' and ready for consumption on the kitchen table which dominates the page. Balance is established between the siblings and in their diet.

Imagination in *I Will Not* is a faculty for problem solving, for creating analogies and metaphors which reframe the object or issue. Imagination here operates where reason has failed, unhindered by the demands of logic or the obstacles of false logic. But the 'trick' in firing the imagination is first of all a verbal one, an analogy and renaming from which a setting, experiences, and encounters can be developed. Lola's coining of the name "moonsquirters" is the entry point for imaginative play. The narrative demonstrates the process

of imaginative engagement as Lola is gently supported by Charlie into the play related to each of the four foods: seated in an alien landscape with Charlie looking on in the first encounter; mimicking Charlie's actions in the second; enacting Charlie's ideas with his support in the third; and leading the way, claiming prior knowledge of the game, in the fourth episode. This scaffolding could be interpreted as supporting the final episode in which Lola initiates and controls the imaginative activity.

These two picturebooks, then, though very different in style, address current concerns about childhood—consumerism, eating habits, the nature of play—and find some resolution for children through the exercise of the imagination. There is a sense in these books that people have to be taught to use their imaginations. In *Crispin*, the empty receptacle needs to be filled to enrich the protagonists' lives; in *I Will Not* the landscape behind the words needs to be embroidered and coloured in.

I want now to consider two picturebooks in which, I think, are inscribed somewhat different notions of imagination. Because of the relationship between the verbal and visual modes of the books and the self-consciousness of the way they represent their own textuality, I think of these as postmodern picturebooks. But the label is not really the issue; I am most interested in the relationship between the modes and modalities of the texts and the understanding of imagination that might be read from them. In pursuing this line of inquiry I hope to return to the question of whether new technologies, and the ways of reading they establish, create barriers to imaginative engagement and engagement with the real world.

TRACTION AND TERROR

Traction Man is Here, by Mini Grey, is a thirty-two page picturebook with about 570 words of text presented as captions torn from sheets of graph paper. There are about seventy-five more words in a variety of forms of speech bubble. The title page is used to establish the context for the narrative: an unsigned letter to Santa asking for a new Traction Man toy. The letter, written and drawn on the graph paper which carries the main text throughout the book, includes careful drawings of Traction Man's various outfits. Scattered crayons heighten the sense of the constructed nature of the book and of work in progress. The author/illustrator is adopting the child's perspective. The child's focus is on Traction Man.

It is already clear, from the title page, that the child knows a great deal about Traction Man: when the box is unwrapped on the first double-page spread, it is clear that the child already knew the advertised features of the toy ("dazzle-painted battle pants") and had a sense of Traction Man's voice and philosophy ("Hallo! All in a day's work!"). In contrast to Crispin, whose empty box comes from an anonymous Santa who knows what a pig needs, a leg disappearing through the bedroom door and the label tell us that this

is a present from Mum and Dad, who hope they have bought the exact toy their son wanted. The salience of the image of Traction Man, addressing the viewer directly with his gaze, bursting forth from the ripped-open paper, leaves us in no doubt that this is indeed the object of the boy's desire.

The action starts immediately. The next doublespread is a comic strip style rescue of farm animals from marauding pillows; there is a four-page underwater exploration in the sink, a three-part rescue of some buried dollies from a living grave, and a double-page deep sea adventure in the bath. In between the adventure stories, on fully bled, unframed single pages, is the chronology of the boy's day: breakfast, play in the garden, a visit to his grandmother's house. Traction Man is also depicted in full page but framed poses between his adventures: guarding two cowed-looking slices of toast in a breakfast table close-up, opening his Christmas present, and adopting a scrubbing brush as his pet. In this last, tripartite image Traction Man mediates between the ineffectual chemical cleaning fluids on the kitchen windowsill and the seething creatures peering up from the drain. From this authorial perspective, Traction Man's services are clearly valuable.

Disaster strikes at the grandmother's house when Traction Man is presented with "an all-in-one knitted green romper suit and matching bonnet." The blow to Traction Man's image and standing as an action hero are conveyed effectively through the language ("'I knitted it myself,' says Granny") but most effectively through the visual images of his mortification.

The resolution of his style problems involves a further adventure, which requires the unravelling of the romper suit in the rescue of some distressed spoons, and we leave Traction Man lounging on a sea-blue carpet, his romper suit reduced to swimming trunks, and his next adventure approaching from the left. This final, fully bled page establishes in its composition the 'given' nature of the succession of threats and dangers, the renewableness of Traction Man's ingenuity and valour, and the closely focussed realism of this adventure world from the author's perspective. The endpapers dedicate the book and an edible medal, identical to the one Traction Man is awarded, to "my big brother Tony."

Opening the book *Traction Man Is Here* is in some senses like opening the Traction Man box and getting started on the game; in contrast to the picturebooks discussed earlier, it offers direct engagement with imaginative play rather than advocacy for it. Written in the present tense, with direct speech inserted throughout both the adventures and the naturalistic chronology of the narrative, the imaginative is inserted into the experiences of the child's day. The imagination operates in a parallel rather than a separate and bounded world, and when they meet—for example in the toast-guarding episode or at the kitchen sink—it is not necessarily clear which take on reality has primacy. This is similar to what Todorov (1975) describes as an engagement with the fantastic in fiction, where imagination is layered into the fabric of the everyday and there is potential for slippage

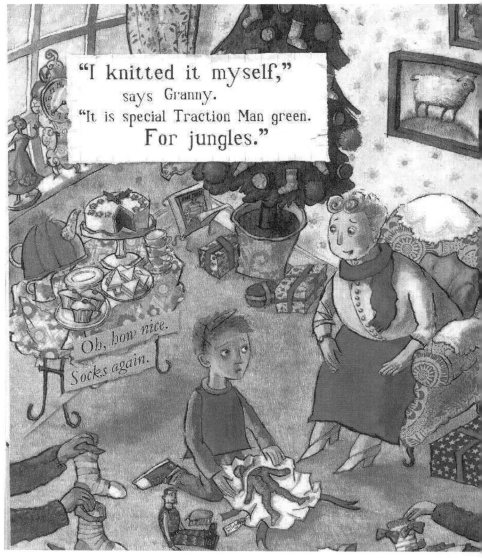

Figure 9.2 Image from *Traction Man is Here* by Mini Grey, published by Jonathan Cape/Red Fox. Reprinted by permission of The Random House Group Ltd.

between the real and the imagined. This is imagination as action, triggered not through words or looking into receptacles but through deep commitment to an object—in this case, a toy, to the extent that it takes on fetishistic qualities (Marsh 2005).

The child uses the toy as an avatar; he controls events rather than simply spectating. He plays out the roles, performing the highly gendered identity

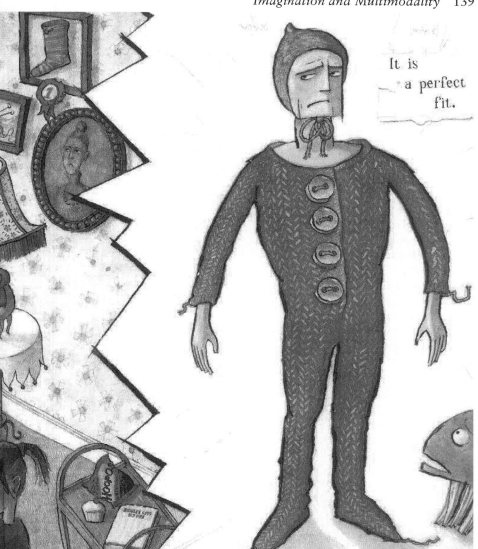

It is
a perfect
fit.

of the action hero in the third person and, where possible, before a notional audience (the pet, the dollies, the farm animals, the spoons). This leaves room for irony and humour (in the language and punctuation and in the visual images) as well as deep commitment to the imaginative enterprise. The child acts as the creator of texts in ways that parallel the author/illustrator's creation of the book, and the inserted narratives, which both enact and parody the adventure genre, contribute to the self-conscious textuality of the whole book, building on the visual impact of the torn paper, the crayons, and the adoption of the child's perspective.

Wolves, by Emily Gravett, is a bleaker tale than *Traction Man is Here,* but they share a sense that the imagination is not entirely controllable or beyond the realms of disruption by the real. For Traction Man the intervention from the real world involves the mild humiliation of feeling obliged to wear granny's knitted romper suit; in *Wolves* it appears to involve the violent death of the rabbit protagonist. This is a less benign, less secure form of imagination than the imagination constructed in *Crispin* or *I Will Not.*

Wolves is a forty-page book with about 170 words of text and up to two hundred more (many repeated) on labels, envelopes, and advertisements that feature in the book. The endpapers suggest an alternative set of covers and introductory pages. At least four versions of the book are suggested: the white-covered book the reader has picked up, written by Emily Gravett; the red linen-covered book suggested in the endpapers; a rabbit version of the white-covered book by Emily Grrrabbit, advertised on a flier; and the red linen-covered version picked out by the rabbit in the library. The verbal text of *Wolves* offers facts about the habitat and characteristics of grey wolves while the visual, and some introductory verbal, text simultaneously chart the rabbit's experience of reading the book and of being devoured—either metaphorically or actually (or both)—by a wolf.

The slippage between the constructed 'reality' of the book and the terror of the imaginary is presented visually. As the rabbit gets further into the book and as we readers get further into our book, the rabbit gets closer to the wolf until he is actually exploring his body, walking through his fur. The enormity of the threat is powerfully realised visually in an extreme close-up: the startled rabbit, stranded on the end of the wolf's nose, stares out in a direct address to the reader, caught in the wolf's cross- eyed glare. The constructed textuality of this moment of terror is underlined by the fact that the doublespread is designed to represent a book within the book we are reading, open on a page about what wolves eat, and the rabbit is depicted as clutching a further copy of the book open at the same page. The doublespread that follows suggests that the book has been destroyed: the cover, damp and ripped by claw marks, points towards a torn fragment of information which confirms, probably redundantly, that wolves eat rabbits.

The verbal text in the final pages of the book is fragmentary: an apologia from the author pointing out that "no rabbits were eaten during in the making of this book" in the manner of a film or television programme, and a weak and unconvincing alternative 'happy' ending typed on a slip of crumpled paper, occupying the 'ideal' space at the top of the page above a visual scene in the 'real' space reconstructed from the torn elements of earlier illustrations.

Most conclusive amidst the general indeterminacy of the book's final pages is the doublespread of rabbit's doormat, which parallels a similar

image near the start of the book. In contrast to the earlier image, the doormat is now covered in letters and messages. Rabbit is no longer around to pick up his mail.

This is a far cry from the vision in *I Will Not* of words controlling the world and making it palatable. Words here have no power to stave off terror. In the face of death and a destructive natural order, they are shown to be inconsequential and unconvincing. The act of reading and imagining is risky: it leads rabbit into the danger zone but it could also have warned him or turned out differently—and indeed, perhaps it did turn out differently. Readers make their own meanings and in the iconography of *Wolves* the individual nature of meaning making is underlined by the re-inscription of rabbit's meanings in the pictures of the book he is reading. So the text "Grey wolves live in packs of between two and ten animals" is illustrated in rabbit's book by a picture of seven wolves in a cardboard box, and the image for the Arctic Circle is of a snowman with a carrot nose.

Wolves is a book about terror and risk but also about timing and knowledge. The fragment of information which could have saved rabbit came too late. But it is important to note that it is the rabbit reader who approaches the wolf, not vice versa. The rabbit is, in this sense, the author of his own fate. For us as readers of *Wolves*, the timing and knowledge the book offers might be more apposite: like rabbit, we are drawn in our reading towards investigating the dark side of life, but unlike rabbit we have the advantage of reading the full tale, bound within the book, from which we can create our own meanings, including cautionary and advisory ones. There are alternative conclusions to be drawn from the story. Perhaps rabbit would have been better off never thinking about wolves. Perhaps he would have been better off knowing more about them. Both the vicarious pleasures and the terrors of the experience are suggested.

My argument, therefore, is that both *Wolves* and *Traction Man Is Here*, like *Crispin* and *I Will Not Ever NEVER Eat a Tomato*, are thematically concerned with contemporary discussions about the imagination and play. The emphasis in *Wolves*, as in *Traction Man is Here*, is on the immediacy and power of imaginative engagement, on the imagination in action and as an aspect of everyday life. The slippage between the 'real' of the text and its concurrent and parallel imaginary dimensions is rendered in more literary terms in *Wolves*, but both books give a degree of agency to the protagonist as meaning maker which is, I think, greater than the agency of the protagonists in *Crispin* and *I Will Not*. Traction Man's owner and rabbit do not need to be taught to use their imaginations because imagination is not separate from everyday living and activity.

I want now to relate these points, and the points I have made about the modes and modalities of the different texts I have analysed, to the concerns with which I started this chapter: about the influence of new ways of reading on children's imagination and play.

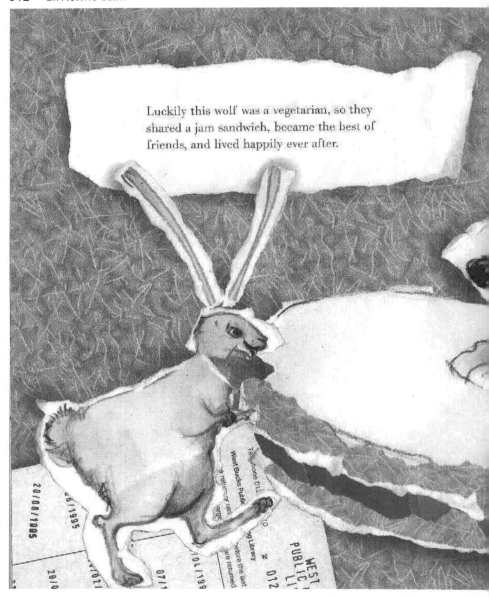

Figure 9.3 Image from *Wolves* by Emily Gravett, published by Macmillan Children's Books. Reprinted by permission of Macmillan Children's Books, London, UK.

MODE AND IMAGINATION

Speculating on the future of literacy at this time of technological, social, economic, and cultural change, Kress makes the following predictions:

Language-as-speech will remain the major mode of communication; language-as-writing will increasingly be displaced by image in many domains of public communication. . . . The combined effects on writing of the dominance of the mode of image and of the medium of the screen will produce deep changes in the forms and functions of writing. This in turn will have profound effects on human, cognitive/affective, cultural and bodily engagement with the world, and on the forms and shapes

of knowledge. *The world told* is different to *the world shown*. (Kress "Literacy" 1)

Clearly, whether you encounter a text on the television or in a comic strip, a novel or an email will make a difference to how you understand, value, respond to and think about it. Different modes and media have inherently different representational potential and different potential for meaning making, and will therefore have different potential for influencing the subjectivities of the reader/viewer/listener or creator of the text (Kress and van Leeuwen 39). This leads Kress—as it leads the campaigners quoted at the start of this chapter—to the "truly profound" question about how shifts in the modal uses in a culture will affect forms of imagination ("Literacy" 59).

Kress argues that the cultural dominance of writing and speech has led to a conceptualisation of imagination as "receiving ordered structures, the elements of which need to be filled with our meanings" ("Interpretation" 152). The structure of the modes themselves, which involve temporal sequencing and grammatical ordering, determines the "space for imagination" and an orientation towards an inner world:

> in speech or writing the work of 'imagination'—at the simplest level—consists in filling the relatively 'empty' elements along the strictly prescribed reading paths with the reader's meaning. Of course, these elements are then configured, at other levels, into more complex elements, whether larger narrative structures or other generic/textual entities, themselves interacting with each other in complex designs both of the reader's and the writer's making. (Kress "Literacy" 170)

The increasing dominance of the visual mode, however, involves working with more open, less easily identifiable reading paths whereas "the entities themselves [the images] were plain full of meaning" (ibid.). In relation to reading images, then, imagination needs to be defined more actively as "the making of orders of our design out of elements weakly organised, and sought out by us in relation to our interests" (Kress "Interpretation" 152). Imagination in this sense becomes an "imposition of order on the representational world, whether as text-maker or as reader" and is "a move toward action in and on the outer world." Literary imagination is "the move to contemplation; the other is a move toward involvement in outward action" (ibid.).

The four picturebooks discussed in this chapter illustrate some of the changes referred to in this thinking. In some senses, all four books are 'about' the imagination, and the metaphors they employ to develop their themes offer clear exemplification of Kress's thesis. In *Crispin* and *I Will Not*, the pictures tend to support the words in moving the narrative forward; in *Wolves* and *Traction Man is Here* the images rather than the words tend to predominate.

The former two books encode the more literary view of imagination as supplying extra meaning to a given structure, moving inwards to develop a landscape or world. The latter pair of books more readily exemplify the idea of imagination as the active making of meanings, guided by a sense of personal interest and engagement, from a relatively loosely ordered design.

If we accept Lewis's definition of the features of the postmodern picturebook (boundary breaking, excess, indeterminacy, parody and performance/interactivity) then I hope my analysis makes it clear that I think *Traction Man* and *Wolves* contain more of these features than the other two texts (Lewis 94–101). But these postmodern features are closely related to the modal shift from the predominance of words to the predominance of images. The boundary breaking, excess, and indeterminacy of *Wolves* are expressed visually, through the design of the book; the parody, performance and interactivity of *Traction Man is Here* are created largely through the perspective, the salience of the toy and the visual humour.

The modality of these picturebooks—by which I mean their claims to truth or credibility through the use of particular markers or codes (Kress and van Leeuwen 165)—differs, and those differences are also closely related to the postmodern elements of the texts and to the views of the imagination instantiated in and through them. So while *Crispin* and *I Will Not* gently lead the reader, by means of a mediating device (the bucket, the box, or the verbal trick), from the more naturalistic domestic environment to a fantasy world, *Wolves* and *Traction Man* launch the reader straight into a world where fantasy and reality coexist. The toy and the book, like the avatar in the computer game, are objects to be desired because they are material symbols of imaginative action. Through them the reader tries out identities and experiences, works through consequences, learns to think strategically. This is active imaginative engagement promoted in no small part by screen reading and design. It differs in kind from the more contemplative, verbally oriented, reflective uses of the imagination that Jacqueline Wilson no doubt calls upon to write her novels. But what matters here, in my view, is understanding change and supplementing experience, rather than identifying and regretting decline. There are gains and losses from the different ways of being, and the multimodalities of contemporary picturebooks offer a valuable entry point for thinking about what those losses and gains might be.

WORKS CITED

Buckingham, David. *After the Death of Childhood*. London: Polity, 2000.
Cohen, Michele. "'A habit of healthy idleness': Boys' Underachievment in Historical Perspective." In *Failing Boys? Issues in Gender and Achievement*, edited by Debbie Epstein, Jannette Elwood, Valerie Hey, and Janet Maw. Buckingham: Open University Press, 1998: 19–34.

James, Allison, Chris Jenks, and Alan Prout. *Theorising Childhood*. London: Polity, 1998.
Kenway, Jane, and Elizabeth Bullen. *Consuming Children*. Buckingham: Open University Press, 2001.
Kress, Gunther. *Literacy in the New Media Age*. London: Routledge, 2003.
———. "Interpretation or Design: From the World Told to the World Shown." In *Art, Narrative and Childhood,* edited by Morag Styles and Eve Bearne, Stoke on Trent: Trentham, 2003.
———, and Theo van Leeuwen. *Reading Images: the Grammar of Visual Design*. London: Routledge, 1996.
Lewis, David. *Reading Contemporary Picturebooks: Picturing Text*. London: RoutledgeFalmer, 2001.
Marsh, Jackie "Ritual, Performance and Identity Construction: Young Children's Engagement with Popular Cultural and Media Texts." In *Popular Culture, New Media and Digital Literacy in Early Childhood,* edited by Jackie Marsh. London: RoutledgeFalmer, 2005.
Moss, Peter, and Pat Petrie. *From Children's Services to Children's Spaces*. London: RoutledgeFalmer, 2002.
Postman, Neil. *The Disappearance of Childhood*. New York: Vintage Books, 1982.
Styles, Morag, and Eve Bearne, eds. *Art, Narrative and Childhood*. Stoke on Trent: Trentham, 2003.
Todorov, Tzvetan. *The Fantastic: A Structural Approach to a Literary Genre*. New York: Cornell University Press, 1975.

CHILDREN'S LITERATURE CITED

Child, Lauren. *I Will Not Ever NEVER Eat a Tomato*. London: Orchard Books, 2000.
Dewan, Ted. *Crispin The Pig Who Had It All*. London: Picture Corgi, 2001.
Grey, Mini. *Traction Man is Here*. London: Jonathan Cape, 2005.
Gravett, Emily. *Wolves*. London: Macmillan, 2006.

10 Postmodern Picturebook as Artefact
Developing Tools for an Archaeological Dig

Michèle Anstey

This chapter is concerned with developing tools that reveal the complexities of the postmodern picturebook and its role as an historical artefact. The utility of such tools is that they assist students of literacy and children's literature to

1. understand how texts work and how this knowledge improves their literacy skills and their responses to, and enjoyment of, literature;
2. further develop their concept of literature as an artefact that provides insight, commentary and critique on different worlds.

I have previously defined the characteristics of postmodern picturebooks and established that they are an excellent vehicle for developing the new literacies or multiliteracies. They challenge the readers' concepts of picturebook and require the reader to participate actively in meaning making (Anstey, "It's Not All Black and White," 447–448; Anstey and Bull, "Teaching and Learning Multiliteracies," 90–99). Drawing upon these previous definitions a picturebook is defined as postmodern if the author and/or illustrator have consciously or purposefully employed some of the following metafictive devices:

- nontraditional ways of using plot, character, and setting, mixing or drawing upon multiple genres
- unusual uses of the narrator's voice to position the reader/viewer
- indeterminacy in written or illustrative text, plot, character, or setting
- a pastiche of illustrative styles
- unusual book formats and layout
- contesting discourses (between illustrative and written text)
- intertextuality
- the availability of multiple readings and meanings for a variety of audiences

In Table 10.1 I have demonstrated how this list of metafictive devices can be used to identify the extent to which a picturebook can be defined as

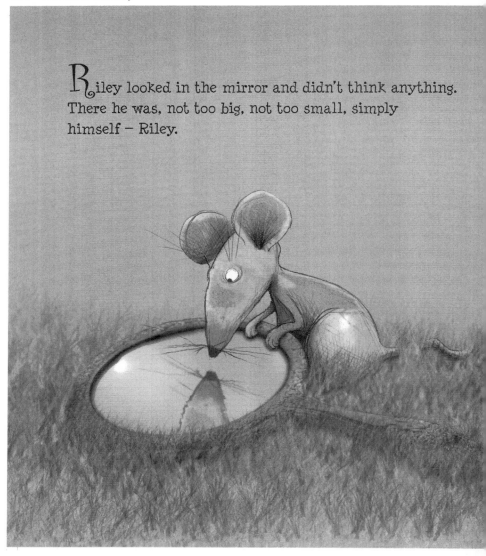

Riley looked in the mirror and didn't think anything. There he was, not too big, not too small, simply himself – Riley.

Figure 10.1 Image reproduced with permission from *The Short and Incredibly Happy Life of Riley* by Colin Thompson, Lothian Children's Books, 2006.

postmodern using *The Short and Incredibly Happy Life of Riley* (hereafter referred to as *Riley*) by Colin Thompson and Amy Lissiat. This sophisticated picturebook won the 2006 Australian Picture Book of the Year Award. The book contrasts aspects of the life of an appealing fat, pink rat called Riley with those of 'people'; for example how people and rats see themselves, what they desire, and how they relate to others of their

People look in the mirror and get very depressed.

kind (see Figure 10.1). The comparison is not kind, concluding that rats, as the saying goes, 'lead the life of Riley' (happy and uncomplicated); while people make life very hard for themselves and could learn from rats by being happy with a lot less. The final page of the book, which is the imprint page, has written across the top, slogan-like, "Release your inner Riley."

Postmodern literature (and therefore the postmodern picturebook) is generally characterised as questioning how to interpret the world (Waugh, "Postmodernism," 206); being self-conscious and drawing attention to itself as an

Table 10.1 Identification of Postmodern Picturebook Characteristics in *The Short and Incredibly Happy Life of Riley*

Postmodern Picturebook Devices	Presence in *The Short and Incredibly Happy Life of Riley*
Nontraditional ways of using plot, character, and setting, mixing or drawing upon multiple genres.	Does not follow narrative genre, does have main character: Riley and an unnamed adult male representing 'people.'
Unusual uses of the narrator's voice to position the reader/viewer.	Narrator assumes the role of informant through a series of statements comparing the lives of rats and people.
Indeterminacy in written or illustrative text, plot, character, or setting.	Readers must fill in gaps from their own experience and draw inferences to provide examples of people's problems and dissatisfactions.
A pastiche of illustrative styles.	Yes, uses computer generated images, modifies well-known historical artwork.
Unusual book formats and layout.	Font is unusual and page layout varies, though a significant number of double-page spreads contrast Riley and the male character representing people. Imprint convention is varied as it appears on last page with slogan and illustration that has significance for the theme: "Release your inner Riley."
Contesting discourses between illustrative and written text.	No.
Intertextuality	Yes, well-known historical artwork.
The availability of multiple readings and meanings for a variety of audiences.	Yes, appeals to multiple age groups whose life experiences and maturity would generate different meanings. Reports from bookshops indicate significant sales to adults for significant birthdays.

artefact while posing questions about the relationship between fiction and reality (Waugh, "Metafiction," 2); and showing readers how texts work and meaning is created (Lewis 94). As is evident from the analysis in Table 10.1 and the brief description of *Riley*, it is not a conventional 'story' and it appears to be making social comment. In this way it fulfils other characteristics of postmodern literature in terms of its role as an historical artefact.

Postmodern picturebooks are artefacts as they are a product of their social, historical, political, and technological times. By definition they invite critical inquiry and analysis and their metafictive devices require active engagement

by the reader. A rigorous and ordered investigation of a postmodern picturebook is required to determine its significance as artefact and to examine how various metafictive devices have been employed to make meaning. In this chapter I present tools to use as readers engage in an 'archaeological dig' of postmodern picturebooks and demonstrate the use of these tools by furthering developing my initial analyses of *Riley*.

ABOUT PICTUREBOOKS, LITERACY, AND PEDAGOGY

Pantaleo ("Young Children and Radical Change," 185–187) has previously written about the need for specific tools to facilitate engagement with postmodern picturebooks. Similarly, the literature on the teaching of reading has suggested the need for more specific and strategy-based pedagogies to assist students to engage more analytically and critically with the multimodal and increasingly visual nature of texts (Comber, Badger, Barnett, Nixon, Prince, and Pitt 268; Hill, Comber, Louden, Rivalland, and Reid 13). These two bodies of work inform the development of an analytical tool.

The research on picturebooks, including postmodern picturebooks, focuses on two major areas, analyses of their construction, particularly the visual images; and analyses of students' responses to picturebooks. Nikolajeva and Scott (4–6) suggest that a metalanguage is needed for categorising and describing the variety of text-image interactions and go on to provide a detailed analysis and some tools for examining picturebooks. By focussing on a language and tools for analysis and the structure of image and text, Nikolajeva and Scott (260) acknowledge that they have avoided the influence of audience and context on how images and words are read and interpreted. They do however recognise that culturally and chronologically different audiences will use different tools and that the picturebooks themselves, particularly the postmodern or metafictive, are products of a changing world.

In the literature on the nature of students' responses to picturebooks, what they respond to, and the skills they bring to the task, Kiefer (24) classified students' response to pictures according to Halliday's functions of language. Arizpe and Styles (1–2) extended the body of research by investigating how children read visual texts, how they understand narrative through pictures, and the skills students bring to interpreting visual texts. Arizpe and Styles (230) identify sixteen types of language used by students in their responses to picturebooks, including questioning the text, indicating awareness of the author's intent, justifying opinions, analogising, and demonstrating awareness of metacognitive implications. Such responses indicate that students are engaging with the text in strategic and critical ways and have a desire to examine the relationship between the fictional world portrayed and their own world. More recently, Pantaleo ("Young Children Engage with the Metafictive") specifically examined

students' responses to the metafictive devices in postmodern picturebooks, concluding that students were aware of the conscious construction of these texts and could engage with them at this level. She concluded that there is a need to further examine how students respond to these books because of the books' significance as a response to social and cultural change. Pantaleo also discussed the need for examination of the pedagogical implications of her research, specifically the use of multiple passes through the text as a way of enhancing the nature and depth of engagement with the book.

The emerging themes in this body of literature concern the nature of picturebooks and postmodern picturebooks, and the knowledge and skills necessary to responding to them; in particular:

- The need for tools to analyse the pictures, words, and the text created by interaction of the verbal and visual semiotic systems.
- The significance of the characteristics of the audience in shaping engagement with text, in terms of both the tools employed and the nature of the response.
- Acknowledgement that the picturebook is a product of and response to historical, social, cultural, and political contexts and change.
- Students' responses indicate an awareness of picturebooks as consciously constructed and that postmodern picturebooks employ metafictive devices.
- Students' responses to picturebooks are strategic, demonstrate critical awareness, and include the ability and desire to compare the worlds portrayed in picturebooks with their own and other realities.

As stated previously, pedagogy with picturebooks was also an emerging theme of the literature. Although the focus of their research was on what students knew about picturebooks, Arizpe and Styles (243) concluded that their research methodology of questions led to the development of an implicit and complex teaching and learning experience that could be developed as a pedagogy. Furthermore, similar to Pantaleo ("Young Children Engage with the Metafictive"), Arizpe and Styles (245) acknowledged that the sustained and repeated exposure to the picturebooks and the discussions around them, including multiple passes through the books, were partly responsible for the sophistication of the students' engagement. Research on children's first classroom experiences with books by Freebody and Baker (164–167, 198, and 206) indicated that the ways in which teachers construct questioning and discussion around texts (such as picturebooks) in the classroom shape the students' ways of interpreting, responding to, and engaging with texts generally. Indeed, in the field of literacy pedagogy, researchers (Baker; Heap; Freebody and Baker) have established that classrooms are social settings recognised by students as places where ways of behaving with and interpreting texts are taught.

Currently the literature on literacy pedagogy draws on sociocultural theory (Anstey and Bull, "The Literacy Labyrinth," 39 and 57). Literacy is viewed as a social practice that pervades every part of our lives. Almost all the activities we engage in during a day involve some sort of literate activity, be it reading, writing, listening, or speaking; for example, reading the newspaper, viewing television, playing games, or engaging in a business transaction. The texts that are used in these social practices are produced for particular purposes and there are agreed upon ways of behaving with these texts that are learned informally through observation and modelling by parents and others, or through more structured educational settings such as the classroom. Because texts are social products, produced for particular purposes, audiences and contexts they are not neutral (Luke 35). They reflect (with or without the author's intent) the sociocultural background of those that produced them and the times and context in which they were produced. This concept is not new as literary circles have long examined literature as a reflection of time and context.

Drawing upon these ideas about text and literacy, and the literature on postmodern picturebooks, the postmodern picturebook can be seen as an artefact that draws attention to and provides information about its origins. Taking this metaphor further, the reader/viewer of the postmodern picturebook becomes an archaeologist and, similar to an archaeologist, draws upon a range of expertise organised into a system for investigation to examine the artefact. An archaeologist examines the whole artefact, including its social, historical, and political context, where it was found, and the way in which it was manufactured, by whom and for whom. In other words the archaeologist, using a framework for investigation, examines the artefact from a number of perspectives and uses a variety of investigative tools. Drawing upon the ideas presented in the previous section, if we view the postmodern picturebook as an artefact and investigate it as an archaeologist then the postmodern devices of the book should be investigated in terms of the following eight areas:

1. The physical characteristics of the book and its design
2. The language/written text
3. The illustrations/illustrative text
4. How the theme(s) of the book (the text created by the reader/viewer) is realised through physical characteristics, design, illustrative and written text
5. The social, cultural, economic, and political context in which the book was produced
6. Knowledge about the author and illustrator and their previous work
7. Reflection upon the possible purposes and audiences of the book
8. Reflection upon its commercial origins, including why it was selected for publication

THE FOUR RESOURCE MODEL

As I stated previously, just as an archaeologist needs an organisational framework to structure his/her explorations, investigations of the postmodern picturebook also need a heuristic. The framework I have developed draws upon recent work in the teaching of reading. Luke and Freebody developed a model called the Four Roles of the Reader that identified and described the ways individuals use reading. The model was designed to help develop better pedagogy for the teaching of reading. The framework they developed has more recently become known as The Four Resource Model (see Anstey, "Literate Futures: Reading," 27). The Four Resource Model is situated in a view of literacy as social practice that acknowledges the sociocultural origins of text and focuses on the use of strategies and resources to make meaning. These ideas are concomitant with the emerging themes identified in the literature about postmodern picturebooks reviewed earlier. Postmodern picturebooks are characterised as consciously constructed, self-conscious, drawing attention to how they work as texts, and inviting the reader to explore different worlds. Thus, the tools and framework needed for an archaeological dig must enable us to investigate how these characteristics are achieved. The Four Resource Model encourages readers to make multiple passes through a text, and to consider how they have made meaning of it, thus making the process of meaning making more transparent, which in turn illuminates how the text, in this case the postmodern picturebook, has been constructed and how the postmodern characteristics contribute to the text. Therefore, the theoretical base of the Four Resource Model facilitates my archaeological interrogation of the postmodern picturebook as an artefact.

The Four Resource Model describes four practices of reading; code breaker, meaning maker, text user, and text analyst. To aid interrogation of the text Luke and Freebody (216), often present their model together with a series of questions that readers can use to focus their reading. For example: How does the text work and what codes or semiotic systems are used in it? (code breaker); How are the ideas sequenced and how do I make meaning of them? (meaning maker); How might I use this text and in what contexts might I use it? (text user); or, What are the origins of this text and how is it attempting to shape my beliefs or actions? (text analyst). My model described below also incorporates the use of questions to aid readers' examination of the semiotic systems used, their meaning making, the text use, and their critical analysis as they make multiple passes through a text.

DEVELOPING A MODEL TO FRAME THE DIG

The notion of the postmodern picturebook as an artefact has suggested use of an archaeological-type investigative model for analysis of postmodern picturebooks. The model presented here provides steps and a framework of

focus questions that can be used for these purposes by teacher, student, and/ or researcher. It is important to remember that the model is a guide and not a prescriptive tool. The intent is that, similar to an archaeological investigation, it can be adapted and focussed depending upon the user's role, goals, and the context in which the model is being used. While the full model presented here may seem long and detailed, only Steps One and Two would be completed in full; only some of the questions in Step Three would be selected for completion, in accordance with the focus of the investigation.

A Model for Investigating Postmodern Picturebooks

Step One

Focus on postmodern features and literary analysis
 Use a tabular format and read and identify any devices that characterise the book as postmodern (see Table 10.1).

Step Two

Focus on in-depth familiarisation in preparation for further work
Scan the physical, visual and linguistic features of the book with a view to developing a comprehensive knowledge of these features prior to further specific investigations. Examine the following features:

1. Book Format

 • Size, shape (e.g., portrait, landscape, square)
 • Range of page layouts used, i.e., placement of written text and visuals (e.g., double-page spread)
 • Manipulation of pages (e.g., cutouts, half pages, foldouts)
 • Font (e.g., style, sizes used, colour)

2. Visual text

 • Style of illustrations and medium used (e.g., watercolour)
 • Computer generated images
 • Dominant elements in illustrations (e.g., colour, line, texture, shape and form)
 • Balance and layout of illustrations (e.g., vectors, juxtaposition of items, framing)
 • Any other graphic features or elements (e.g., diagrams, maps)

3. Written text

 • Features of vocabulary (e.g., unusual use of words, repetition)

- Style (e.g., rhyme, repeated phrases)
- Genre and features of the genre (e.g., fairytale, compare contrast, exposition)

Step Three

Focus on the significance of the features and devices: literary and literacy pedagogy

In order to identify how the postmodern devices and physical, visual, and linguistic features contribute to a postmodern picturebook's significance the overarching questions in Step Three are as follows:

A. What are the meanings and themes in this postmodern picturebook and how are they realised?
B. How might this postmodern picturebook be used to make meaning? Who might use it and for what purpose?
C. What does a critical examination of the meanings and origins of this postmodern picturebook reveal and what is their relevance in or to the world?

Depending upon the specific nature of the investigation some of the following questions might be chosen to aid investigation in Step Three. The questions have been grouped according to the three questions (A, B, and C) that guide Step Three.

A: Questions to guide identifying meanings and how they have been made.

1. What is your purpose in reading this book today and therefore how will you approach it?
2. How do each of the devices and features you identified during Steps One and Two contribute to the meaning/s you have made of this book? For example, the book's physical characteristics, characteristics of the visual and linguistic text, or the postmodern devices.
3. Have you encountered any of these devices and features in other texts and is there anything from these encounters that might help you make meaning in this book?
4. Are there any experiences in your life that are similar to those depicted in this book? How do these experiences influence the meaning/s or theme/s you have made of this book?
5. How do the visual and linguistic texts interact to make meaning? (e.g., Do they enhance, oppose, complement, or mirror one another? Do they interact in the same way throughout the book?)
6. Has the author /illustrator made any intertextual references? If so what is their significance to your meaning making?

7. Is there more than one possible meaning in the book? (e.g., multiple themes or ideas)

B: Questions to guide examining how the book is used to make meaning, who might use it and for what purpose.

1. Given the meaning/s made during initial investigations (Steps One and Two), what might be the possible purposes and audiences of this book?
2. How might different audiences use the physical, visual, and linguistic features of the text or the postmodern devices to make meaning?
3. If using this book for a different purpose (e.g., to learn about something rather than for entertainment) how would you use the physical, visual, and linguistic features of the text or the postmodern devices to make meaning?
4. Examine the way in which aspects of the book's physical features have been placed or sequenced in the book. (e.g., Where have particular features such as double-page spreads, page layouts, cut-outs been used?) How do you use the sequence to make meaning of the book? How does the way the sequence has been constructed influence the meaning?

C: Questions to guide critical examination of the meanings, their origins, and their relevance in or to the world.

1. How have the themes and/or characterisation (or other features of the genre) been developed? What aspects of the physical, visual, and linguistic features of the text, and the postmodern devices (or interaction of these) contributed to this development?
2. Does the book reflect any aspects of the social, cultural, economic, or political context in which it was produced?
3. If so, how do the physical, visual, and linguistic features of the text or the postmodern devices reflect these aspects of the social, cultural, economic, or political context in which it was produced?
4. What values, attitudes, or ideologies do you see reflected in the physical, visual, and linguistic features of the text or the postmodern devices and the ways in which they have been brought together to convey meaning?
5. What is this book suggesting you believe or do? How are these suggestions made? Are any beliefs or positions silenced or absent from the book?
6. Are the positions, attitudes, and beliefs presented in the book supported by particular parts of the text; for example, the physical, visual, and linguistic features of the text or the postmodern devices?
7. Consider the commercial origins of this book. Why do you think it was selected for publication?

8. Investigate the publisher of the book. Is there any information provided about why it was published and how the publisher is marketing it? Are particular meanings, ideologies, or beliefs being presented in this material and do they match your interpretations of the book?
9. Investigate the author and illustrator. Is there any information provided about why they wrote/illustrated it and how this book is similar or different to their previous work? Do the author or illustrator present particular meanings, ideologies, or beliefs when talking about the book and do they match your interpretations of the book?

TESTING THE MODEL WITH *RILEY*

Step One of the model has already been completed with *Riley* (see Table 10.1). Although I have completed Step Two there is insufficient space in this chapter to document my findings. I can report that using the questions in Step Two ensures a methodical and thorough perusal of the physical, visual, and linguistic features and prevents the intrusion of possible preferences for examining illustrative style or visual over linguistic features.

One of the postmodern devices identified in *Riley* is nontraditional ways of using plot, character, and setting, mixing or drawing upon multiple genres. It was observed that the book does not follow a traditional narrative genre, that is, it does not have a traditional plot with complication and resolution. However it does have two characters who appear throughout the book, a plump, pink, contented rat called Riley and an unnamed, sad-looking adult male who appears to represent 'people' as Riley's opposite character.

Before commencing Step Three I reviewed what my examination of the book in Step Two revealed about the genre used. Examination of the linguistic text revealed that *Riley* is a comparative exposition. It presents a thesis (everyone wants to be happy, healthy, and live forever but these goals are very difficult to achieve even though some aspects are easy to attain) and supports it with examples comparing how a rat achieves happiness and health by leading an uncomplicated and content life while 'people' make their lives and relationships unnecessarily complicated. The thesis is then reiterated and a concluding comment is made that the solution is simple—you just have to be happy with less. The visual and physical features of the text support the comparative exposition. The comparisons mostly appear on opposite pages (see Figure 10.1) and colour is used to contrast the happiness of Riley (bright, pink rat and colourful settings) with the unhappiness of 'people' (mostly a monochromatic man and grey/brown, settings). Posture, body position, and expression of Riley and the man representing 'people' also contrast sharply. From a linguistic perspective the language describing Riley's life

is simple and succinct, the language describing 'people' often includes long complicated and hyphenated descriptors of what people do or want, emphasising the simple/unnecessarily complex comparison. The comparative exposition is not 'pure' however. Personalising the genre by using two main characters for the comparison is a mixing of the exposition and narrative genre. Similarly the time frame depicting the entire life of Riley, and specific aspects or events in it, is not a traditional way of presenting a comparative exposition.

Steps One and Two indicated that the postmodern device of unusual use or mixing of genres contributes to the meanings and theme and is reflected in physical, visual, and linguistic features of the book, but these steps did not help with conclusions about significance. I chose to use Step Three to examine how this postmodern feature

- contributes to the meanings and themes of the book;
- might influence how the book is used and who might use it;
- whether this feature and its contribution to the themes and meanings of the book has relevance in or to the world.

In order to accomplish the above, I perused the sets of questions (A, B, and C) and considered if each question would reveal information about the device and the significance of the book. In this way I identified the most relevant questions for the focus of my investigation. I cannot document every question I examined and all I thought. However, I found the questions useful, they drew together pieces of information identified in Steps One and Two, provided further insights about the book, and precipitated contact with publisher and author/illustrator (Colin Thompson sometimes uses the pseudonym Amy Lissiat) to question them about the significance of the theme in current times and whether it was a deliberate social or political comment.

Below are some examples of the questions that particularly resonated and provided insights. In the set of questions about how meanings are made (group A) questions three, four, and seven provided insights. The use of the exposition genre in a picturebook is unusual and because such expositions are usually found in authoritative texts, it gives the theme more authority as an issue of significance. The use of the comparative adult character as representing 'people' makes the book resonant more with me as an adult, and because the examples of how people make life complicated are not always complete, I found myself supplying examples from my own life and reflecting upon my life. Thus, the way in which the postmodern device is realised in the book reinforces the importance or significance of the theme as a social comment. It became apparent that the book has multiple meanings, for example: an amusing tale about a rat called Riley comparing his life with that of people or a comment on society generally rather than a rat's life. The meaning depends upon where one focussed the comparison: 'people' or Riley.

In the set of questions on how the book is used to make meaning (group B) all questions were relevant. Combined with the information from Steps One and Two and consideration of the questions in group A it becomes apparent that this device and the way it is realised contributes to the book having child to adult appeal and being used for different purposes apart from pure entertainment and enjoyment. For example, it might be used to initiate examination of one's own values, reflect on life balance, and examine a group or society's values, or relationships with others. It could be used in school, psychological, or adult settings. Booksellers and the publisher have revealed that adults quite often purchase it for significant birthdays (fortieth, fiftieth, and sixtieth) when such issues might be thought about.

In the set of questions about the book's origins and how its theme and meanings might be significant on or to the world (group C, questions two, four, seven, and eight were particularly relevant) it seems that the use of the comparison exposition and its resonance in the linguistic, physical, and visual aspects of the book foregrounded the theme of people's self-inflicted unhappiness and the underlying question of what people value. The theme and questions reflect current global and local social issues that are attracting media attention, for example, increasing global conflict, humans' contribution to global warming and climate change, an increasing gap between rich and poor, and in parts of the western world, over-consumption of goods and increasing obesity.

I therefore wondered if the book was a deliberate social comment by the author/illustrator and whether the publisher considered the themes would make the book more commercially successful. I put these questions to both author/illustrator Colin Thompson and the editor at Lothian, Helen Chamberlin, and they kindly agreed to answer them. Their answers are intriguing.

Colin was asked by email firstly, if he sets out to write with a particular theme or message and secondly, to comment on how he came to write and illustrate *Riley* and his decisions about style, content, and its social themes etc. His answers to each question including his emphases with uppercase:

> I'm reading 'Theme' as 'Message'—I have NEVER set out to produce a book with a 'theme' ALL books that set out with that aim will be patronising . . . This does not mean I haven't had quite strong messages in some of my books, but they have ALWAYS been incidental to the story. Many of the 'themes' are put there by adults afterwards. . . . No. You are being FAR TOO intellectual. It's VERY SIMPLE. Here's a very well known phrase in the UK—The life of Riley—which means someone is having a great time/life. That gave me the idea for the story, simple as that. (Thompson, "E-mail Interview")

Yet when asked about the role of picturebooks generally he replied:

Entertainment, pleasure and escapism and sometimes, maybe a little bit of thought provoking. STOP trying to analyse all the soul and beauty out of everything. Very large parts of life are simply "What you see is what you get." Anything else is stuff you put into it afterwards which is really nothing to do with the original creation. (Thompson, "E- mail Interview")

Helen Chamberlin was asked by email if she consciously looked for books around the themes of people's dissatisfaction, greed, appearance, materialism, and consumerism that appear to be the focus of Riley. She replied, "Absolutely not—the idea was entirely Colin's. He sent me the text out of the blue" (Chamberlin, "E-mail Interview). I also asked what she saw as the current trends in the picturebook market and where she saw *Riley* in those trends. She answered:

I see the current trends as towards homogenous young, warm and fuzzy on the one hand, and graphic novels on the other, and precious little in between, which is doing young readers a great disservice. Riley was a breath of fresh air because it was NOT (her emphasis) a response to any trend or received wisdom about the market . . . It was salutary and timely in my view, and he did it with great wit and lightness. Using a contented little rat as his everyman was a stroke of genius. (Chamberlin, "E-mail Interview")

It seems that Colin and Helen, while both stating that they do not consciously set out to respond to social, cultural, and political features of the times, in fact do so unconsciously. The slight contradictions in both their answers indicate that.

CONCLUSIONS

Investigations into the one postmodern feature of *Riley* and correspondence with Colin and Helen indicate the need for us to understand how postmodern picturebooks such as *Riley* are artefacts and how the messages and themes within them are created. The literature on response and literacy, my investigations, and Helen and Colin's answers all indicate that no text is neutral, all are artefacts of their times and context, and that their meanings are made not only within the text but between text, reader, and the reader's purpose and context. Therefore it is necessary to understand more about how the meanings are made and the model I have developed and trialed, using the metaphor of an archaeological dig, viewing the artefact many times from different perspectives, facilitates that. Moreover because the model draws upon The Four Resource Model it also facilitates the development of pedagogy with postmodern picturebooks, enabling students to better understand how the postmodern devices

and physical, visual, and linguistic features of a picturebook work and how they, as readers, make meaning with them.

WORKS CITED

Anstey, Michèle. "'It's Not All Black and White': Postmodern Picturebooks and New Literacies." *Journal of Adolescent and Adult Literacy* 45.6 (2002): 444–457.

———. *Literate Futures: Reading.* Coorparoo, AU: State of Queensland Department of Education, 2002.

———, and Geoff Bull. *The Literacy Labyrinth.* 2nd ed. Sydney, AU: Pearson, 2004.

———. *Teaching and Learning Multiliteracies: Changing Times, Changing Literacies.* Newark, DE: International Reading Association, 2006.

Arizpe, Evelyn, and Morag Styles. *Children Reading Pictures: Interpreting Visual Texts.* London: Routledge Falmer, 2003.

Baker, Carolyn. "Literacy Practices and Social Relations in Classroom Reading Events." In *Towards a Critical Sociology of Reading Pedagogy,* edited by Carolyn Baker and Alan Luke, 161–189. Amsterdam: John Benjamins, 1991.

Baker, Carolyn, and Peter Freebody. *Children's First School Books: Introductions to the Culture of Literacy.* Oxford: Basil Blackwell, 1989.

Chamberlin, Helen. "E-mail Interview." 19 March 2007.

Comber, Barbara, Lynne Badger, Jenny Barnett, Helen Nixon, Sarah Prince, and Jane Pitt. *Socio-economically Disadvantaged Students and the Development of Literacies in School: A Longitudinal Study.* University of South Australia: Department of Education Training and Employment and University of South Australia, 2001.

Heap, James. "A Situated Perspective on What Counts as Reading." In *Towards a Critical Sociology of Reading Pedagogy,* edited by Carolyn Baker and Alan Luke, 103–140. Amsterdam: John Benjamins, 1991.

Hill, Susan, Barbara Comber, William Louden, Judith Rivalland, and Jo Reid. *100 Children Go to School: Connections and Disconnections in Literacy Development in the Year Prior to School and the First year of School.* Canberra, AU: Canberra Department of Education, Training and Development and Youth Affairs, 1998.

Kiefer, Barbara. *The Potential of Picturebooks: From Visual Literacy to Aesthetic Understanding.* Englewood Cliffs, NJ: Prentice-Hall, Inc., 1995.

Lewis, David. *Reading Contemporary Picturebooks: Picturing Text.* New York: Routledge Falmer, 2001.

Luke, Allan. "The Social Constructions of Literacy in the Primary School." In *Literacy Learning and Teaching,* edited by Len Unsworth, 1–54. Sydney, AU: Macmillan, 1993.

———, and Peter Freebody. "Shaping the Social Practices of Reading." In *Constructing Critical Literacies: Teaching and Learning Textual Practice,* edited by Sandy Muspratt, Luke Allan, and Peter Freebody, 45–76. St Leonards, NSW: Allen and Unwin, 1997.

Nikolajeva, Maria, and Carole Scott. *How Picturebooks Work.* New York: Garland Publishing, 2001.

Pantaleo, Sylvia. "Young Children and Radical Change Characteristics in Picturebooks." *The Reading Teacher* 58.2 (2004): 178–187.

———. "Young Children Engage with the Metafictive in Picturebooks." *Australian Journal of Language and Literacy* 28.1 (2005): 19–37.

Thompson, Colin. "E-mail Interview." 2 April 2007.

Waugh, Patricia. *Metafiction: The Theory and Practice of Self-conscious Fiction.* London: Methuen, 1984.

———. *Postmodernism: A Reader.* London: Edward Arnold, 1992.

CHILDREN'S LITERATURE CITED

Thompson, Colin, and Amy Lissiat. *The Short and Incredibly Happy Life of Riley.* Melbourne, AU: Lothian, 2005.

11 Lauren Child
Utterly and Absolutely Exceptionordinarily

Susan S. Lehr

Lawrence R. Sipe, Caroline McGuire, David Lewis, and Bette Goldstone describe an evolving genre of postmodern book illustration that is radically jarring the conventions of the picturebook by subverting conventional applications of color, text, form, format, and superimposed messages—what Eliza Dresang describes as radical change in a digital age. The joke is on the reader. The joke is on the characters. The breakaway boldness of these graphic books catapults book illustration into new ways of interacting with visual literacy. Space and placement are multidimensional. Illustrators make use of multiple artistic styles including digital art. Font becomes part of the visual plane rather than just relating the story. The designs of these types of books are as important as the text and designers can hold positions similar to those of editors. The texts of these stories are equally innovative. Narrators talk to readers and pull them directly into the story. There may be no closure. Authors and illustrators call attention to the fictive nature of their works. Picturebooks can be silly, serious, chaotic, or episodic. Humor and irony are everywhere. The deconstruction of the traditional picturebook has given rise to a postmodern subgenre as Goldstone ("New Subgenre," 198) has called it that is both startling and innovative in its synergistic blending of elements. In this subgenre the reader of necessity plays an interactive role with the text.

Sipe and McGuire have identified six attributes which they envision as "interconnected nodes" that "display different constellations of these characteristics" in this subgenre of the picturebook (1). The characteristics include blurring, subversion, intertextuality, multiplicity of meanings, playfulness, and self-referentiality. Similarly Goldstone ("Ordering the Chaos," 49) defines the postmodern picturebook as being nonlinear, having multiple story lines running concurrently or containing multiple perspectives. A key attribute Goldstone considers is the contradictory interface between text and illustrations, in which the author and illustrator may reveal the artificial nature of fiction (197, 201). Most radical of all is the revelation that this is not real. Lewis emphasizes that postmodern fiction "exposes the fictional nature of fictions" (94), which is also apparent in postmodern illustrations. This self-referentiality appears in Lauren Child's collages in

which she blatantly reveals the seams of her artwork, thereby deconstructing the art itself. There is no attempt to hide or blend the pieces; rather these uneven pasted pieces become part of the revelatory texture that the reader sees. I can see snips of the scissors and where she missed some parts and ripped the paper. This is the essence of the postmodern book. It laughs at its own seams. It revels in its own crudeness.

Another aspect of the changes occurring in picturebooks is the shifting of boundaries to include topics that were once taboo, settings and communities that have been overlooked or are new and fresh, and complex ways to introduce and explore the lives of characters (Dresang 26). Taboo topics once the domain of young adult literature now appear in chapter books for younger children (Lehr, "Shattering the Looking Glass," 190). In postmodern picturebooks topics are once again undergoing significant change, thus illuminating and mirroring the chaos and uncertainties faced by modern children. For example, in *Voices in the Park* Anthony Browne examines multiple perspectives on social stratification and the resulting economic inequities in a seemingly simple story about children going to the park to play. Interpretation is left to the reader.

Postmodernism provides a powerful lens for examining literature within the framework of an evolving and chaotic technology driven twenty-first century. Postmodern picturebooks have transformed the scope of the picture book. While the picturebook is still a playground for young children it has also been transformed into a landscape that conveys the complexity of living in an overcrowded and contentiously conflicted world. Capricious juxtapositions exist in a postmodern world. Families eat dinners while looking at television images of other families with swollen bellies in villages in Darfur, Sudan. The surrealistic quality of modern life is captured by postmodern picturebooks in a multiplicity of ways.

LAUREN CHILD

Lauren Child's picturebooks capture the chaos of the modern Western family through the eyes of the young child. As both author and illustrator she designs the visual landscape and gives voice to her young protagonists. Child is concerned with the daily bits of life and shows how individual children move from day to day in a British middle-class setting. Her families don't seem to be terribly conscious of world events, nor do they seem to be overly concerned with global warming or saving the children in Darfur. If you asked them they might tell you that they cared and were concerned, but essentially Child's depictions of Clarice Bean, Herb, and Charlie and Lola represent children in millions of families who live well and focus on their daily routines, perhaps having a social conscience, perhaps not.

How Child portrays the pastiche of daily life from the child's perspective will be the focus of the remainder of this essay. Lauren Child's text and

illustrations are a composite I have chosen to discuss as the amalgamation they are, rather than as separate entities under a literary microscope. Discussing these books by dissecting each of the elements and treating them individually is fraught with difficulty and is distinctly pre-postmodern. I will examine the Clarice Bean and Herb books as whole entities, identifying key elements of Child's written and artistic style, recognizing that they flow in and out of postmodern elements and reflect the digital impact discussed in Dresang's Radical Change theory.

Clarice, Charlie, Lola, and Herb's Twenty-First-Century Landscape

Lauren Child's collaged art is the antithesis of sophisticated and beautifully finished pieces that have been called "kaleidoscopic collages" of the chaos of twenty-first-century family life (British Council Arts 1). Without patronizing young readers Child reveals the crowded middle-class family, the harried parents, the squabbling siblings—modern life in the picturebook, although ironically she's a bit nostalgic, and incorporates some gender anachronisms which I'll address later. In this visual scrapbook format Lauren Child illuminates modern family life with all its inherent quibbles, harping, and daily battles. She raises realistic fiction in the picturebook to a novel level because Clarice Bean also has her own chapter books, Charlie and Lola have their own television series, and Herb lives in his bedroom but escapes at night into his own parodied fairy tales. The interplay between media formats is distinctly unique because it emanates from one creator, thus blurring the boundaries between literary genres and technologies, within and without of the actual frame of the physical book.

Clarice Bean, That's Me, winner of the Smarties Prize in 1999, was the first picturebook Child published, but it took five years to find a publisher. Child says that her work has a scrapbook look with lots of mishmashed ideas that British publishers thought too American (Henry 44). She says that American books were "more adventurous and boldly made use of different typefaces and type that moved across the page in unusual ways" so that she was "determined to get her ideas printed in a picture book" (Henry 44). Child's humorous cartoon illustrations contain diverse media including magazine cuttings, collage, actual fabric, photography, pencils, and watercolors. Starting with pencil drawings, Child now scans most of her artwork and uses the computer to design her illustrations, because she likes the flexibility and fluidity it provides. The process involves drawing figures, scanning them, printing them in black on cartridge paper, creating collages, and then cutting out the figures and rescanning the art (British Council Arts, 1). She has also experimented with set production for the picturebook *The Princess and the Pea* in collaboration with photographer Polly Borland. Additionally, the Charlie and Lola books have morphed into a BBC2 and Disney Channel cartoon series with books generated based on scripts and animated images. Although she has artistic direction over

the development of the series and reviews the dialogue to ensure that it is consistent with her vision, there are distinct differences between Child's original Charlie and Lola books and those based on television scripts and cartoon animation. The cartoon characters on TV are more politically correct and careful not to do things that parents would challenge, find offensive, or consider dangerous.

With all of this focus on the illustrations and design of the books it is surprising to learn that Child typically writes the story first before any illustrations are drawn (Pike 2). The themes she explores constitute everyday situations from wolfish nightmares, to fussy eating, to a fear of going to school for the first time, to wanting one's own personal space. In an interview with Jeffrey Yamaguchi she explained that she draws on her own childhood growing up in the seventies and shows the close personal world of the child playing at home in familiar spaces like the bedroom or garden (1). Ironically Child seems to ignore modern technology and presents a childhood of the past in Charlie and Lola's world where readers won't find parents or a lot of modern toys or technological gizmos and games.

Child understands children completely and her dialogues are exquisite. Charlie is a devoted brother and a homespun child psychiatrist. In *I am too Absolutely Small for School* Lola comes to breakfast dressed as an alligator for her first day of school and Charlie tells her "Alligator is for fancy. For school stripes are nicer." In *I Will Not Ever NEVER Eat a Tomato* Lola is a fussy eater and will have nothing to do with vegetables or cheese or fish sticks or sausages. Charlie announces (to the reader?) that one day he played a trick on Lola when he introduced her to orange twiglets from Jupiter, green drops from Greenland, cloud fluff from Mount Fuji, and ocean nibbles from the supermarket under the sea. Lola gobbles up this delicious and alien food but the kicker comes at the end when Lola asks Charlie to pass a bowl of moonsquirters, which look a lot like tomatoes. Lola frequently has the last laugh after Charlie cajoles her into eating vegetables, going to bed, or going to school for the first time, indicating that she is humoring her older brother because he plays with her so well. TV Lola and TV Charlie are different from their literary counterparts in the script based book *But excuse ME THAT is my book*, in that Charlie is more patronizing and Lola is more temperamental. The book illustrations based on animation are also less cleverly designed.

Radical Change theory addresses the shifting boundaries between the Charlie and Lola books, the television cartoon series, and the books based on scripts and animation, creating a blurring of literary and media genres. Labeling these books postmodern does not quite work, however, because this group of books taken alone does not exhibit the characteristics described by postmodern literary critics like Sipe, McGuire, and Goldstone. Child has, however, blurred the boundary between the traditional picturebook and the animated cartoon. Similar to the Magic School Bus series by Joanna Cole and Bruce Degan, the Charlie and Lola books morphed into a

cartoon empire with the result that books based on TV scripts and anima-
tion have been published, with sales over three million books by 2007.

Although the collages are similar to her other works, the format of the
Charlie and Lola stories is patterned after the traditional picturebook. Space
and placement are multidimensional and Child makes use of multiple artistic
styles including digital art and placing font in the visual plane of the book;
however, the stories are sequential, characters don't interact with the reader,
and the use of parody, multiple story lines, and multiple perspectives are non-
existent. None of this diminishes the authenticity of the characters, the whim-
sical illustrations, and the captivating stories.

Clarice Bean, however, is a different story entirely. In the next section I
examine the postmodern picturebook world of Clarice Bean, the cartoon girl
who made the leap into her own first person chapter books.

Clarice Bean's Postmodern Family: A pastiche of endpapers with pages in between

In *Clarice Bean, That's Me* art and text create a synergistic world inhabited
by a cartoon character and her caricatured middle-class urban British family.
Clarice Bean begins *her* story on the beginning endpapers where her family is
sprawled across a rose-colored room, thereby breaking the frame or violating
the boundaries of the story as Sipe and McGuire (6) have referred to it. Each
member of the family is introduced by Clarice who informs the reader that
her family is always raising a ruckus. Her younger brother, Minal Cricket
is shown lurking under the table. Her Mom (wondering where she's left her
purse) is dressed fashionably in a cropped t-shirt that displays her bellybutton.
Her Grandad is asleep as usual. Cousins Yolla and Noah are brown-skinned,
Uncle Ted is eating, and an older sister lounges on the couch. Older brother
Kurt holds his head in his hand providing a preview of his existential teen
angst. In the right-hand corner a mysterious woman in a checkered raincoat
is identified only as "I don't know who this is." This same mystery woman
appears peering over a stone wall in *Clarice Bean, Guess Who's Babysitting?*
and at the base of Uluru in *What Planet Are You From, Clarice Bean?*, but
is never identified. She bears no resemblance to the author. The beginning
endpapers are essentially a double-page spread with extensive first person nar-
rative and captions, all of which humorously identify each member of the
family. These initial thumbnail descriptions of Clarice Bean's family remain
consistent throughout the picturebooks and chapter books.

Clarice talks to herself and an unidentified audience in these endpapers,
while sitting on a table in the middle of this family portrait, thus welcoming
the reader into her chaotic world. This blurring of the boundary between
author and reader invites "greater participation or performance on the part of
readers" (Sipe and McGuire 4). The title page shows a cut and pasted Clarice
presumably in school uniform standing in front of a giant clock reading 8:50.
Clarice speaks directly to the reader to say that she has drawn a watch on

her arm in felt-tip. Each of the three picturebooks shows Clarice in front of a large clock on the title page. In *What Planet Are You From, Clarice Bean?* the clock reads 3:40 and has the caption: "Usually I rush out of school like a lunatic." Ironically though, Clarice is frequently late for school and is therefore typically in trouble with Mrs. Wilberton. All of this information is conveyed before the story officially begins.

Clarice Bean's hair is straggly and a nondescript brown. Her three-pronged squiggle nose and big black cartoon eyes that stray to the edge of the oval never looking at the reader full on, provide her with startling looks of curiosity, surprise, and mischief. Clarice is bursting with so much to show and tell the reader that she can't wait for the conventional beginning of the story. By optimizing the physical space of the book Child has gained six additional pages in which to present Clarice Bean's world. Traditionally endpapers have provided glorious sneak previews of art and story. Child's use of endpapers to introduce all the characters and to insert extensive text, however, is novel and rather bold. What's more astonishing is that she uses the final endpapers to conclude the story and even solves the mystery of the missing purple purse.

The story between the pages is equally quirky in its layout with much to explore in each of the carefully designed double-page spreads. Backgrounds are in bold jazzy colors, minimizing the use of white space. The most striking double-page spread shows Clarice in her cluttered room lying in bed, doing handsprings across the room. Words scrunched together declare that she likes peace and quiet but doesn't get much in her shared bedroom. A ripped white strip slashes down the page visually dividing the space. Words on this strip form a boundary making it clear that Minal Cricket must not put one toe on Clarice's side of the room. Minal's space shows no detail at all except a luscious orange background and a giant squiggly foot with a toe inching toward the middle of the room.

The dialogue is child perfect. "Twit." "Twit and a half." "Twit with carrots in your ears." Clarice flicks his nose with her ruler and he screams "Mooom!" Placement of text and font are integral to the illustrations, appearing in squiggles and large font as both characters face off in this verbal battle. Mom, unseen, speaks in an elegant cursive font. Attack words are in large bold letters as if printed by a child.

Cleverly, Child erases the room and uses bold cadmium yellow and splashy blood orange backdrops, focusing exclusively on the characters and their taunts. The children are giant cartoon figures in cartoon settings, which are orchestrated like sets. When Clarice goes to Marcie's bedroom the dialogue is not much different. "Go away. "Why?" Because I don't want to talk to you." "Why?" "Because you are very irritating." Older sister Marcie and her room are a pink caricature of a girl in a girly room, preoccupied with painting her toenails, talking on the phone, and dreaming about boys. Older brother Kurt on the other hand locks himself in his room, which smells like stinky socks and has posters declaring the futility of it all. His father whines that Kurt

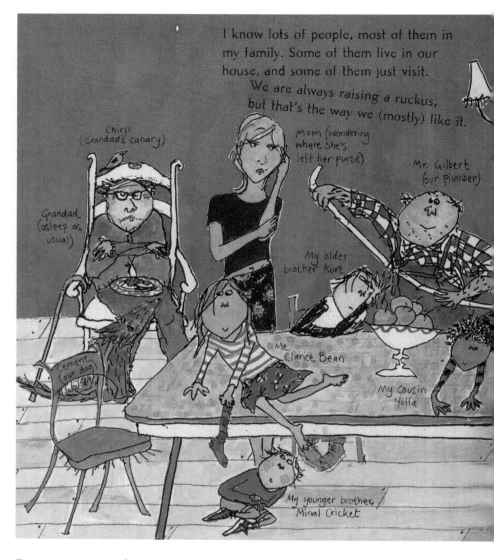

Figure 11.1 Image from *Clarice Bean, That's Me*. © 1999 by Lauren Child. Reproduced by permission of the publisher, Candlewick Press, Inc., Cambridge, MA.

should try being forty-four, while mom takes refuge in yoga and a candlelit bath while learning Mandarin. A brilliant lampoon of the modern family.

Child's view is episodic. Each double-page spread stands alone as a story of its own. Child is less concerned with an overarching story than she is with creating snapshots. After dumping a bowl of spaghetti on Minal Cricket's head after chucking his blanket out the window, which causes her dad to get

into a fight with the beer-bellied unshaven neighbor next door, Clarice is in such big trouble that she is sent to her room for three glorious hours. Alone. In solitude. She sits in a large beanbag chair reading. "**I love it.** Finally, some peace and quiet." After Clarice's brief respite in her room, the endpapers show the family sitting together munching chips and watching their favorite television show—*Martians in the Kitchen*. Even Kurt is smiling while Mom rubs his head. The missing purple purse sits on the television. This first book is orchestrated bedlam, completely cohesive in its deconstructed chaos.

In *What Planet Are You From, Clarice Bean?* endpapers show the culture of Clarice's classroom, introducing best friend Bette Moody and uninspired

I like peace and quiet but
I don't get much in my room.
I'm always busy rushing around.
My room is small so I have to
squash everything in.
I like to have lots of things
just in case.

Figure 11.2 Image from *Clarice Bean, That's Me.* © 1999 by Lauren Child. Reproduced by permission of the publisher, Candlewick Press, Inc., Cambridge, MA.

neighbor and pest, Robert Granger. The burned-out Mrs. Wilberton stands before the class with the look of a grim reaper pointing to her message: "You have to do what Mrs. Wilberton says because it will mean staying behind cleaning the board if you don't." In a seemingly disconnected manner Clarice writes: "Sometimes I fall off my chair on purpose. This makes Mrs. Wilberton **very irritated**." In the chapter books *Utterly Me, Clarice Bean, Clarice Bean*

Spells Trouble, and *Clarice Bean Don't Look Now* Clarice's world at school is fraught with difficulty. Mrs. Wilberton is mean-spirited and small-minded and has decided that Clarice Bean is trouble, which provides Clarice with incentive to fill those expectations.

Child's collages include simple cartoon drawings of humans placed on textured backgrounds comprised of wood floors, tile, linoleum, and rich fabrics. White space is used minimally as a dramatic focal point, to highlight a character, or to highlight similar objects. Background colors are bold and sassy ranging from fire-engine red to brick orange to electric blue. Photos or

real items and people are incorporated on walls, on counters, or in containers. Cartoon characters' faces are alive with expression and details that make them distinctly different from each other. The character of Clarice is a tumble of energy in each double-page spread. She catapults across many pages. This is a feisty active female who gets into trouble, has a big heart, and lives in a large loving family.

What is unique about the world of Clarice Bean? Clarice tells her story in first person and continues her story in chapter books, beginning with *Utterly Me, Clarice Bean*, which entirely blurs literary genres and the linguistic registers that readers bring to the act of reading (Sipe and McGuire3). The characters presented in the picturebooks have well-rounded distinct personalities, which are consistently developed and extended in the chapter books. In the first chapter book Child has chosen to include numerous cartoon drawings of Clarice and her family. In all three novels Child intersperses varying font sizes and types, adds diary inserts, notes, portions of novels, and designs or sketches to extend the text. The humor in the Clarice books is outrageously funny, and is central to all of Lauren Child's books.

Themes are typically about growing up in a large family and going to school, but in the third picturebook, *What Planet Are You From, Clarice Bean?*, Child has also included the theme of getting involved in ecological concerns at the local level. Older brother Kurt of the existential angst decides to save a local tree that is to be chopped down. Clarice incorporates this into a school project and on the final endpapers writes about her project: "This week I have been being an ecowarrior." Messages from Clarice include the explanation that "Trees are also like gynormous vacuum cleaners sucking up pollution." Child's eco-theme is small and fits her story. Ecowarrior is grand and fits Clarice's gynormous view of self, in contrast to Mrs. Wilberton of the tight smile, who begrudgingly says "Well done, Clarice Bean!" Clarice's vocabulary is utterly splendid. She favors words like absolutely, utterly, and exceptionordinarily.

Surprisingly, gender anachronisms appear with frequency in the Clarice picturebooks. These types of stratified roles are clichés so it is startling to see them rooted in Child's picturebooks. "This stratification is so deeply embedded within our culture that we are often unaware of its existence and therefore rarely examine its underpinnings" (Lehr, "Beauty, Brains, and Brawn," 11). Mom stays at home while dad works in a big important office. Clarice's mom finds solace soaking in a bathtub or doing yoga, while her dad hides in his office with a desk the size of a bed. In one picture he is shown talking to his wife who says, "I'm going bananas here, Bernard." He replies: "I can't talk now. I've got another call coming through." (In the chapter books mom has a job at the local nursing home.) Older sister Marcie has a pink room and is preoccupied with makeup, boys, and gossip magazines. Older brother Kurt is the bored brooding thinker who finds purpose when a local tree is going to be destroyed. Clarice's uncles are a policeman and a fireman. No aunts are mentioned. Mrs. Wilberton is a burned-out teacher who should probably be

climbing mountains and not working with children. At one point Clarice's mother must go take care of her brother the policeman, but can find no one to watch her four children. Her husband is not available, but refreshingly, her younger brother the fireman is. In terms of gender Clarice's world is essentially a haven for gender stereotypes. While Clarice is a feisty and spirited female, she exists in a picturebook world comprised of males who enjoy a range of physical work and play, juxtaposed to a limited group of women who take care of children, bosses, and patients. I doubt if this is parody at work in the postmodern picturebook and suspect it has more to do with unexamined underpinnings based on a nostalgic view of the world.

Beware of Wolves and Books: The manipulated fairytale

Imagine a one-eyed fierce little wolf in a frilly ball gown with matching heels dancing rather adeptly with the prince under a golden spotlight, while a bedraggled Cinderella is stuck washing a pile of dirty dishes (*Beware of the Storybook Wolves*). In a completely different book imagine that same, almost completely unnoticed wolf making a cameo appearance in the very same ballroom. Cinderella is nowhere in sight (still doing dishes) and the ugly sisters and their mother are stuck upside down on the following page. The prince has been missing for some time.

In *Who's Afraid of the Big Bad Book?* Lauren Child's collage panels of the palace are crudely cut and pasted together, the pencil-scribbled colors are reminiscent of preschool art, the mustachioed women appear ludicrous in their richly patterned ball gowns, which all comes together in a hilarious and cohesive caricature of fairy tale characters and the inevitable nightmares that children are prone to have about hungry creatures in the night. Lauren Child deliberately chose to use known and familiar fairy tale characters so that children would directly access Herb's story (Ridge 6). This intertextuality makes the author's role easier in that she does not have to reinvent the tale and provide additional context for the reader. It makes the spoof for readers in the know all the more poignant.

Adults use books like *Goodnight Moon* by Margaret Wise Brown to reassure and soothe their young at bedtime, but in *Beware of the Storybook Wolves* Herb learned that he was not safe if his mother left the fairy tale book in his room at night after reading *Little Red Riding Hood*. "Whenever his mother finished this bedtime story, Herb would say, 'Don't forget to take that book with you!'" But one night she forgot. In three panels Child illustrates Herb's mother on the telephone (unavailable for saving a frightened son) and two rather large eyes and one small eye against a black background. There is very little background in these illustrations. Rather, color and patterned clothing dominate. The action heightens when Herb smells a not very nice smell and hears the rumbling of several tummies. When Herb switches on his lamp two clownish wolves stand near his bed licking their chops. Even his

bunny slippers look fearful. These wolf creatures look a lot like Clarice Bean's dog, Cement. The little wolf is wearing a white shirt and tie, while the big wolf has on a suit. This is more spoof than horror and children will recognize the difference.

Child uses different fonts for different characters. The fairy godmother speaks in fancy cursive, which matches her elaborate dress and heels. When called out of her tale she is just about to use her wand to transform Cinderella. Instead the fierce little wolf ends up in the ball gown and is so pleased with his look that he jumps into the book and goes to the ball. The book ends with the fiercer wolf being turned into a caterpillar while Herb falls asleep. In the final picture Child uses a completely different palette and cartoon style to show that the reader is no longer in Herb's world. A puzzled little red-caped girl stands in front of a fierce, but tiny caterpillar.

In the second installment, *Who's Afraid of the Big Bad Book?* Herb falls asleep into the fairy tale book and meets the famous stepmother, ugly sisters, fairy godmother, three bears, and Goldilocks, thus confounding any expectations the reader might have about these well-known fairy tale characters (Sipe and McGuire 5). In fact, Goldilocks, the Paris Hilton of the story, is infuriated that Herb is the center of attention on her page and in her story.

> " 'WHAT ARE YOU DOING HERE?
> HOW DARE YOU BE ON THIS PAGE?
> I AM THE STAR AND I SAY
> YOU ARE NOT ALLOWED
> IN THIS STORY!'
> shrieked the shrieking thing."

In a twist on the story of Goldilocks and the three bears Herb wakes up in a lumpy and huge bed. As he stammers, Goldilocks shrieks again, "I am Goldilocks, of course! And this is MY story!" In contrast three well-dressed bears are rather polite and offer Herb some porridge. Child manipulates the known and expected profiles for these established characters with humorous and unanticipated personality twists. One might expect a child who enters a house uninvited to have deviant behavior, but that's not how the fairy tale has traditionally been told. Still shrieking almost unnoticed in the background Goldilocks tells the "pea brains" that the title of her story is "NOT 'THE LITTLE SHOW-OFF IN PAJA-MAS HAS BREAKFAST!'" Goldilock's temper tantrum is delicious fun for readers, who may see echoes of themselves in this character. This clever parody of fairy tales continues as Herb stumbles past a pair of rude children nibbling on a gingerbread house. "I wouldn't do that!" he warns, but they scream in unison, "Oh, get lost!" Passing an agonized Rapunzel who has a man climbing up her rope of hair and a well-dressed

cat in high-heeled boots Herb finally lands in front of two enormous yellow doors. These familiar images become quick spoofs, which provide a multiplicity of meanings that are not necessarily sequential but create "multiple pathways through the text-world" (Sipe and McGuire 9).

At this point the reader's role changes from page turning to opening a quadruple-page spread, turning the book upside down and around to see characters and to read upside-down dialogue. This is not a passive experience. Opening two giant yellow doors reveals four pages of a gynormous hot pink ballroom. When the queen discovers that Herb is the doodler who has ruined her looks with a mustache and snipped her throne out of the room, Herb realizes that his scribbling, cutting, and drippy bits of food have invaded the fairy tales. Again Sipe and McGuire's notion of polyphonic narration (10) is evident as one listens to the complaints of the queen, wonders about the missing prince, and knows that there is a wolf loose in this story.

Herb is able to manipulate the story events much like Harold did with his purple crayon, thus subverting conventions, destabilizing certainties, and mocking the fairy tale traditions (Sipe and McGuire 4). The difference is that Herb has drawn in mustaches, added telephones to each room, has cut out and placed characters upside down or removed them completely. In a clever reversal Herb discovers his lost pencil box in one room of the palace and uses the contents to erase the queen's mustache and draw a new throne, but the queen is not appeased. Herb escapes through a hole he cuts into the page and ends up in a room where everyone and everything are upside down except for him and the words he speaks. Determining the sequence of the dialogue is wicked fun and chaotic reading. The book must be turned upside down and downside up to read the dialogue. The stepmother's dialogue begins in the lower right-hand corner and goes from bottom to top. As she glares at Herb and calls him a measly little rodent she speculates whether he is the "vile, good-for-nothing child [who] tore out our page and put it back upside down?" Herb has the grace to blush slightly.

Herb has a conscience. Child doesn't endlessly moralize in her stories but Herb blushes and feels guilt for the shabby way he has treated his fairy tale book. He meets Cinderella. "She was really nice and Herb was beginning to feel extremely guilty, because he had just remembered where Prince Charming was" (in a birthday card he made for his mom). As the characters close in Herb calls on the fairy godmother, who gives voice to his conscience. "What do you expect when you go about **scribbling** and **snippering** . . . This is NO WAY to treat a book, you know!" Herb's escape is achieved by climbing up on the text, holding onto the letters, and "scrabbling" up the sentences on a pile of "wobbly" words. Using the words as an escape route is ingenious. Herb spends the remainder of the night putting his storybook "to rights." His friend Ezzie puts a wig on Goldilocks, and she remains a "very cross little girl with mousy

brown hair." Humor, new interpretations of familiar images, novel juxta-position of words on the page, and quirky multimedia collages create an exhilarating synergy.

LAUREN CHILD: BRICOLEUR

Barbara Kiefer says that when pictures and text come together there is an integral partnership. This congruence is "the interdependence of pictures and text in the unique art object that is a picturebook" (6). The basic premise of the illustrated picturebook has never been static. The multimedia creations of Lauren Child are indicative of the shifting boundaries between literature and technology. The resulting bricolage impacts the way children interact with the written and spoken word, and with the placid image of the illustrated book and the shifting animated images of television. Moving from picturebooks to chapter books is equally challenging. When I taught first grade a young girl talked about watching music. She gave no explanation. None was needed for her. She understood completely, but I had to sort it out. In the same way that music has become visual, books are shifting and interacting with other tech-nologies. Harry Potter books and movies are released simultaneously but non-consecutively. Illustrated books can be designed on computers while animated cartoons can be transformed into illustrated books. The interplay between technologies is charging forward. Lauren Child creates and illustrates picture-books, writes chapter books, creates sets that become double-page spreads, and works with animated cartoons. Meanwhile there are other dimensions in which toys based on her creations are marketed worldwide and websites offer interviews, previews, and animated segments about Charlie and Lola.

Eliza Dresang's Radical Change theory begins to describe the impact of multimedia synergies. Postmodern books have digital possibilities that do not yet exist. The potential of the picturebook is equally alarming and cause for excitement, because there are no boundaries. A decade ago I could not have envisioned the kaleidoscope of images that comprise Lauren Child's work. Additionally, the interface between her illustrated picturebooks and her chap-ter books has created a visual landscape in tandem with a literary landscape. Technologies have been crossbreeding for decades; however, today's cross-pollination and the resulting bricolage have added uncharted dimensions. That Lauren Child does not take herself seriously is evident in the ludic nature of her texts and illustrations. Her sense of play and mischief evoke blissful secondary worlds even as the air is being let out of the tire.

WORKS CITED

British Council for the Arts Web. "Lauren Child Interview." April 29, 2005. magicpen-cil.britishcouncil.org/artists/child/ (accessed July 12, 2007).

Four characteristically postmodern strategies which draw attention to the fictional nature of a picturebook are: overt intertextuality; inversion of the narrative voice (so that the story is told from another character's point of view); metaleptic[1] disruptions to the diegetic level of narration, which breach conventional relationships and hierarchies between characters, texts, authors, illustrators, and readers; and modal[2] contrasts and disruptions within the pictorial discourse. This chapter will examine the interrelationships between these four strategies in the following metafictive fairy tale picturebooks: *What Really Happened to Little Red Riding Hood: The Wolf's Story* (Forward and Cohen), *Oops!* (McNaughton), *Beware of the Storybook Wolves* (Child), *Who's Afraid of the Big Bad Book?* (Child), *Wait! No Paint!* (Whatley) and *The Three Pigs* (Wiesner). In combination, the broadly metafictive strategies used in these books raise questions about the nature of narrative and the possibilities for reshaping and changing traditional stories. Not all of the books use all four strategies, but they are all overtly intertextual, as each retells a version of Little Red Riding Hood, The Three Little Pigs, Goldilocks, or Cinderella—and other fairy tales and nursery rhymes to a lesser extent. Further, many of them use innovative pictorial techniques to position readers in interrogative positions, and they all at least to some extent problematise the relationships between fiction and reality, and the world of stories and that of readers, potentially offering readers more empowered reading positions and strategies.

An obvious, and within contemporary fairy tale retellings almost conventionalized, strategy for engaging with and potentially problematising the metanarratival structuring of fairy tale is the use of overtly parodic forms of intertextuality, resulting in what has become known as "the fractured fairy tale." In such stories, the narrative is typically organized so as to foreground the formulaic structure of fairy tale characterization and outcomes in particular—common strategies for example include retelling the story from another character's point of view, retelling the story as an epilogue for the traditional version, or switching the gender of a central protagonist. In general, such overt forms of parodic intertextuality can have three main effects: they can foreground the ways in which narrative fictions are constructed out of other texts and discourses; they can indicate possible interpretative positions for readers; and they can enable the representation of a plurality of voices, discourses, and meanings. However, while strategies such as these may draw attention to the conventionality of the forms of traditional story, they are not always successful in circumventing the inevitable outcomes to which such forms typically lead. The effect may be comic but often the metanarratival structure of the story remains intact. Furthermore, while parodic intertextuality can highlight fictionality, the boundaries between the fictional and the real are apt to be kept firmly intact through pictorial and narratival strategies which affirm the fictionality of the represented world. However, strategies such as unusual visual perspectives and mixed modality within the pictorial discourse and

innovative narrative techniques can disrupt and blur distinctions between the represented worlds of reality and fantasy, encouraging readers to adopt more active interpretative positions.

The Wolf's Story (Forward and Cohen) uses the quite conventionalised strategy of retelling the story of Little Red Riding Hood from the Wolf's point of view and hence recasting him as the "hard-done-by" hero of the story rather than the villain. Forward's use of an ironic narrator and Cohen's manipulation of visual point of view together position readers to actively engage with the narrative. The story opens with a direct address from the Wolf:

> NO, PLEASE. Look at me. Would I LIE to you? It was the old woman who started it. I did *nothing* wrong. Would I? We hit it off from the beginning. Not everyone likes a wolf, do they? Look at *you*. You're not certain. Would you like to come and sit a bit closer while I tell you about the kid? I don't bite. No? Sure? Okay. **Up to you.**

The smiling Wolf in the accompanying illustration gazes directly at the viewer, making eye contact, and his paw is depicted in a beckoning gesture which creates a diagonal vector to the picture he is holding of an amiable-looking old woman—these features all realize visually the "demand" imperative explicit in the verbal address ("Look at me"). However, the modal shift from an imperative to a more polite, interrogative syntax with "Would you like to . . . ?" implies a narratee who is clearly skeptical of the Wolf's story and who in refusing to move closer to the Wolf, also refuses to be interpellated into the subject position constructed by his address. As Kress and Van Leeuwen have argued, "demand" pictures, that is, "pictures from which represented participants look directly at the viewer's eyes," have two related functions. They "create a visual form of direct address . . . [which] acknowledges the viewers explicitly, addressing them with a visual 'you'"; and they "constitute an 'image act,'" that is "the participants gaze . . . demands something from the viewer, demands that the viewer enter into some kind of imaginary relation with him or her" (122). Insofar as the narratee implicitly refuses that demand, there is an ironic tension created by the different subject positions constructed by the verbal text and the visual text, which in turn situates readers in an active questioning relation to the Wolf and the story he tells.

Visual point of view is also manipulated throughout *The Wolf's Story* in ways that maintain this tension. The use of high aerial viewpoints to depict the Wolf and Red Riding Hood in the forest as they part ways (opening 5) and for her entry into the cottage (opening 6) imply she is in a position of threat. Likewise, the use of extreme close-ups, shifting points of view, size contrasts, and visual framing devices imply her vulnerability once she enters the cottage. An extreme close-up of the Wolf's eyes on opening 7 depicts a very small Red Riding Hood reflected in and visually "framed" by

the Wolf's red-tinged eyes—the accompanying text ironically reiterates the conventional "What big eyes you have." On the next opening the viewer is positioned behind the Wolf who is in the extreme foreground and Red Riding Hood is framed by the bed, the bedpost and the Wolf's ear—the narration is again explicitly ironic: "she wasn't that bad, really. Looked good enough to eat, if you know what I mean," and is followed by Red Riding Hood's next statement, "what big ears you have." On the ninth opening, as she asks about the Wolf's teeth, viewers are positioned inside the Wolf's mouth looking out at Red Riding Hood who is framed, but slightly off-centre, by the Wolf's four canines.

Visual strategies such as these effectively undercut the Wolf's narrative and his assertions of innocence. One implication of this undercutting is that another story, an alternative to the Wolf's story, is inadvertently being told through ironic dissonances between and within the visual and verbal texts. Furthermore, that this "alternative" story implies that Red Riding Hood and Granny are the victims and the Wolf, despite his assertions to the contrary, is the villain, suggests that it is actually a version of the traditional story, as told by the Grimm brothers or Perrault for example, and raises questions about the possibilities for changing stories and characters. (The strategy also introduces a very young audience to the concept of ironic and unreliable narration, encouraging that audience to question the Wolf's story.) As Maria Tatar has suggested, the simplicity of fairy tale plots allows for a multiplicity of interpretations: traditional versions of the Little Red Riding Hood tale might be read as a symbolic struggle between strength and weakness, so that "any predatory power can be substituted for the wolf, with any innocent standing in for the heroine" (51). Thus, one interpretation of the tale might be that it is a story of stranger-danger and rape—as the moral to Perrault's version more or less implies (see Zipes). Forward and Cohen's Wolf is initially represented as an "odd job man" who puts up shelves, does the shopping, tidies the garden, and does the mending, and the language used plays on late-twentieth-century discourses of "new" masculinity: "I'm versatile. Sort of a new wolf. Vegetarian cuisine a speciality. . . . Are you *sure* you wouldn't like to sit just a little closer?" (opening 2). In other words, he is the sensitive "new" man of the 1990s, if readers are prepared to believe his story. The narrative closes with an ironic reiteration of this characterization and his opening address:

> Anyway, thanks for listening. And, if you ever want any odd jobs doing around the house, just get in touch. Here's my card. I don't charge much, I'm a neat worker, completely trustworthy, and I won't make a meal of it! **No, please. Look at me. Would I lie to you?**

Again the Wolf's ironic punning ("make a meal of it") undercuts his self-characterization, and the narratee's implicit response prompts the reader to answer "yes" to his final question. He is not so much a "new" wolf, as the

old wolf, made over in the guise of the "new man" of the 1990s. Pictures which use the demand gaze (for example, openings 1, 2, and 12) depict the Wolf as quite friendly, inviting reader trust and belief. However, he appears much more sinister in those pictures in which he is a represented participant, most notably, for example, in the illustration of his encounter with Red Riding Hood in the forest (opening 4) in which his smile is close to a leer. The contrasting sizes and general appearance of the two characters in this picture also echo Gustave Dore's illustrations of the same scene. However, Red Riding Hood's expression here is one of disdain, in contrast with the look of knowing sexuality on the face of Dore's Red Riding Hood (see Zipes 240–42). Furthermore, "demand" pictures are also of a much lower modality than this picture, and like Dore, Cohen here does not attempt to humanize the Wolf—he is quite clearly a very large wolf and, hence, it is quite understandable why Red Riding Hood might choose to ignore him.

Another wolf who is intensely aware of his traditional character role and function is McNaughton's Mister Wolf in *Oops!*, a comic reworking of the Little Red Riding Hood story in which the female child is replaced with a male piglet. This change in protagonist, in combination with the characterization of the wolf as comically ineffectual, overturns traditional interpretations of the story, transforming it into a comic fantasy. Like the wolf in *The Wolf's Story*, Mister Wolf also uses direct address and the demand gaze. The metafictive framebreaking effect is, however, much more radical here as the story is framed by third-person narration. Thus, Mister Wolf's metaleptic intrusion on the third opening—"Don't look at me like that, I'm the Big Bad Wolf" accompanied by a picture of an open-armed wolf who makes direct eye contact with the viewer—disrupts the hierarchical relations within diegetic levels of narration. Furthermore, he goes on to discuss with his audience his own character function and the necessity of particular story conventions: "It's my job to be nasty. These stories would be pretty boring if I was good, wouldn't they?"[3] And from the following page onwards, the book unfolds two parallel narratives: Preston Pig's journey to his grandmother's house and Mister Wolf's attempts to catch him; and the story about how that story is being told, especially Mister Wolf's struggle to work out which story he is actually in and what its outcome is likely to be.

Explicit metaleptic disruptions can also be signaled by overtly self-reflexive references to storytelling within a narrative. That *Oops!* is likely to be a story about telling stories is playfully intimated at the outset: "It was the same old story. Mister Wolf was hungry. Mister Wolf was very hungry and Mister Wolf had his eye on Preston Pig." The last sentence suggests a Wolf and Pig story (for example the Three Little Pigs), and the picture seems to affirm the latter, although it quickly becomes apparent that if this narrative is "the same old story" it is perhaps not a version that Mister Wolf remembers. Surprisingly few story elements are needed to allude to the story of Little Red Riding Hood. For example, Mister Wolf's list on the

fifth opening—a "red hood, basket of food, granny's house"—is probably enough for most readers to infer which story it is. Furthermore, the question which follows—"That reminds me of a story, but which one?"—invites the audience to actively participate in the storytelling process. However, the list of story components is not enough for Mister Wolf, who inadvertently leaves out a crucial clue given in the text on the preceding page—Preston's dad's comment that he will be over later to chop some wood for Granny. (The woodchopper is, of course, a relatively modern addition to the story, and perhaps he does not know those versions.) Mister Wolf's problem is twofold: he does not know which story he is in and he keeps being positioned on the margins of that story. Visual framing and framebreaking devices emphasise this situation. For example, the three pictures on the second opening each depict him being thrown or driven out of the visual frame. The use of windows and doorways in the latter part of the book also position him on the margins of the story. The point at which he remembers which story it is, after recognizing that Granny is saying his lines, is also the point at which he literally jumps into the story by jumping through the frame of the window.

Similar to *Oops!*, the opening sentences of Child's *Who's Afraid of the Big Bad Book?* signal that this book will be about books and reading:

> Herb loved storybooks. Although he wasn't a very good reader, it didn't matter because he could tell a lot from the pictures. Herb liked the scary ones best with pictures of dinosaurs gobbling up other dinosaurs, or swooping vampires chasing people who had foolishly decided to go for a midnight stroll without any garlic. (opening 1)

The first sentences suggest that perhaps readers too should also pay attention to the pictures, while the last sentence draws attention to the picture on the page, which depicts a boy reading a book whilst eating his dinner. A simple metafictive move here is to depict Herb reading a version of the book we are reading: the text page is the same, and the illustrations include the same monsters, but not Herb. One implication of Herb's absence is that his imaginative engagement with the book brings the characters to life, out into his level of reality, even as he drops his peas into the book. The book he is reading has a pea sitting at the bottom of the left-hand page, just as the book we are reading has a picture of a pea in the same place. However, while it might be inferred that Herb has dropped the pea, it is not, of course, a real pea but a picture of a pea in a book painted within another book—in other words, it is a picture of a picture of a pea. From the outset, then, this book raises complex philosophical questions by problematising relationships between fiction, the imagination, and the real. This process of blurring fiction and experiential reality is taken a step further when two pages later Herb wakes up inside the story of Goldilocks and the Three Bears having fallen asleep while reading one of his favourite storybooks.

Herb's reaction to discovering that his bed has become large and lumpy is to quote one of the recurrent formulas of the Goldilocks story: "Herb had always found his bed to be just right" (opening 3). And just in case readers don't get the joke the first time, the phrase is repeated by the medium-sized bear on the next opening when she offers Herb porridge which he may find is "too hot or too cold," apologizing for being out of "just right." British and Australian audiences will recognize the doubled intertextual reference to the formulaic phrase of the fairy tale and to contemporary culture in the form of the breakfast cereal, Just Right.

The incorporation of characters or narrators, such as Mister Wolf, the narrator of *The Wolf's Story*, Herb and the various fairy tale characters who appear in Child's books, who reflect on the nature of storytelling and narrative processes, can be a playful and amusing part of a story. This strategy can also perform key thematic functions in that it often highlights relationships between narrative structure and characterization, agency and self-definition. A character who recognizes his/her position and role in a story may also recognize how that position limits and denies him/her agency—in other words, the way in which the formulaic structure of fairy tales may deny characters the capacity for deliberate thoughts or actions which might result in an alternative outcome. However, a character, such as Mister Wolf, who recognizes that there is a story happening around him and thinks he might have a role to play in it, but cannot remember which story it is or what the ending is likely to be, lacks agency. Freedom and agency, it would seem, lie in the capacity to take an active part in the story and thereby change it and create one's own story. However, Mister Wolf's attempts in the forest to insert himself in the story and create an alternative ending by setting up various "cunning wolf tricks" are thwarted, though not because of any greater cunning on Preston's part (opening 8). Unlike Red Riding Hood, Preston does not talk to the wolf; instead, he remains completely unaware of the wolf's presence until the third to last opening. Thus, it would seem that Preston's childlike innocence and self-absorbed "sticking to the path" saves him. Devices characteristic of slapstick comedy and pantomime also frustrate Mister Wolf's attempts to construct an alternative ending. Pantomime conventions are evoked explicitly by the birds on the front pages and the motif of a comic villain following an unaware and clumsy hero is also a convention of pantomime and slapstick comedy in general, as are the wolf's cunning tricks—as is foregrounded by the language and layout of the verbal text in opening 8. The tricks also fail because the formulaic components of the Red Riding Hood story are utilized in ways which limit alternative narrative possibilities—for example, Mister Wolf's decision to take a shortcut through woods is borrowed from Perrault, while Preston's stopping to pick flowers comes from the Grimm Brothers. Finally, the outcome is inevitable because Mister Wolf is simply playing out the role he has been cast in: he is the "Big Bad Wolf"; it is his "job to be nasty"; and within the comic genre his plans are bound to fail.

In the books discussed so far, metafictive devices are used in ways that might prompt readers to think about the ways in which fairy tale conventions may restrict the possibilities for changing traditional stories. The extent to which formulaic components of fairy tales constitute parameters which shape and restrict narrative forms is explicit in Child's two books, *Beware of Storybook Wolves*, another reversion of Little Red Riding Hood, and *Who's Afraid of the Big Bad Book?*. Both incorporate metaleptic disruptions, which evoke questions about the extent to which a fairy tale can be changed and still be the "same story." In *Beware of Storybook Wolves*, two wolves from Herb's bedtime storybook of Little Red Riding Hood escape from the book and appear in his bedroom. Herb shakes Cinderella's Fairy Godmother out of another fairy tale book to help him, and her actions set off a chain of events, which could have potentially drastic consequences for various other fairy tale characters. She accidentally waves her wand at the little wolf, dressing him in Cinderella's ball gown; he is "so pleased with his new look" that he jumps into the book and goes to the ball himself, leaving Cinderella "having a night in, cleaning the kitchen after all" (opening 11). After turning the large wolf into a caterpillar, the fairy godmother decides to take a holiday, and the next time Herb's mother reads the wolf storybook to him there is "no wolf to be seen—just a tiny caterpillar trying with all his might to terrify a little girl in a red coat" (opening 16). The close of the book thus prompts the question as to whether there can be a story of Little Red Riding Hood in which there is no wolf.

This kind of questioning is even more explicit in Child's later book, *Who's Afraid of the Big Bad Book?*, in which Herb finds himself being pursued by Goldilocks through his fairy tale book and into the story of Cinderella. The story has become a little complicated, because Herb doesn't take good care of his books, and has drawn in the book, cut out characters and objects, and pasted the book back together with key pages upside down. These changes result in plot complications, which foreground the extent to which fairy tale conventions shape and limit narrative progression and story events and outcomes, as well as character behaviour and actions. For example, Prince Charming has failed to arrive at the ball because Herb has cut him out of the book to make a birthday card for his mother. Hence, despite folding out to be four pages wide, the scene inside the palace consists of unconnected components because the catalyst figure, the prince, is missing and Cinderella has had to return to the kitchen (again). Changes also encourage readers to engage actively with the narrative. By simply compelling readers to turn the book around and back as they read each line of dialogue, the upside-down pages make readers very aware of the books artifice and artificiality. The graphic presentation on these pages emphasizes this, especially the use of varying font styles to visually represent the character speech (with a very thin font for Cinderella's thin stepsister for example) as well as genre (with a gothic font being used for the stepmother).

At the end of the story, after Herb has escaped (or woken up from his dream), Herb and Ezzie repair and put the book back together more or less as it used to be before Herb defaced it. However, there is a tension between that book (the book inside the book) and the book we are reading, which playfully flouts conventions of closure. The book inside the book thus shows Cinderella and Prince Charming dancing together, while the verbal text articulates a common formula for concluding a fairy tale: "And they lived happily ever after. The End." The framing book, however, substitutes another ending, which blocks narrative progression in the story of Goldilocks in a manner similar to the close of *Beware of Storybook Wolves*. The last page is the only page in which formal framing is used—that is, it has a white border around the edge of the picture separating the world of the picture from that of the reader implying a sense of distance, detachment, and objectivity. This invocation of formality coincides with a final joke which is also a comment on fairy tale conventions: can the story survive if its key components are changed? If Goldilocks cannot get into the Three Bears' house because Herb has drawn a padlock on the door, can there still be a story? Furthermore, can she still be "Goldilocks" if Ezzie has stuck a "mousy brown" coloured wig on her?

The problematising of the relations between the fictional and the real can also be played out through pictorial strategies that mix the visual modality, or truth value, of images. Insofar as the level of modality corresponds to a level of "realism," modal shifts and contrasts can be used in overtly metafictive texts to reflect metaleptic disruptions between levels of narration and between fictional and fantastic realities. Thus, Mister Wolf's final entry into the story of Preston Pig and his visit to his grandmother is marked by a shift in the modality of the visual discourse. Low to mid modality is used in most of the pictures, with the exception of opening 12, which depicts Mister Wolf in the foreground with Preston Pig in a sack on his back and Granny tied up behind him. The picture takes up the whole page, and a greater degree of contextualization and perspective, compared to other pages, give it a heightened sense of "realism," just as Mister Wolf has finally remembered what the story is and how it (usually) ends. Thus, the picture ironically becomes more "real" at the point that he enters into that (fictional) story. Furthermore, a vector from the wolf's mouth across to the door where Preston's dad is standing cuts through the object with the highest modality, and hence the most salience, in the picture, that is, the axe held by Preston's dad. This is, of course, also metonymic of the key clue which, as I mentioned earlier, Mister Wolf missed in his list of story components (opening 5)—the allusion to the woodchopper. The likelihood that the outcome of the story will conform with traditional versions of the Red Riding Hood story is actually signaled on the first opening through the various objects scattered around—a wooden sword, a soccer ball, a slingshot, a basket, and an axe. The first three are all in the foreground, but the basket and the axe are given more salience through the vector between

the wolf and the pig, which cuts across the basket and the axe, and again by the higher modality of the axe, which is placed almost in the centre of the page.

Modal-mixing and contrasts are more overt in the visual discourse of Child's *Who's Afraid of the Big Bad Book?*, where she uses collage technique and a combination of photographs and drawings to play with relations between the represented "fictional reality" and the fairy tale book. The story-within-a-story structure mixes and blurs different fictional realities and the pictures reflect the latter through the combination of images high and low in modality and the manipulation of picture space. The opening page, for example, combines a very rudimentary cartoon-like (low modality) approach for the figures with (high modality) photographic images for details such as the plate of food, the strawberry milk, and the squashed pea on the left-hand page. The use of collage implies the surface texture (and hence tangible reality) of objects, but the obvious cut-and-paste technique emphasizes the two-dimensionality of the image and mitigates against the illusion of realism. Thus, distinctions between "real" and "represented" are blurred. Other pages, for example opening 5, play with perspective and spatial depth, flouting the (dominant Western) conventions of single-point perspective; thus many of the pictures do not depict a single coherent space, but instead a series of unrelated incidents and unconnected story components. And at the point at which the story is perhaps at its most chaotic (opening 12), the text is scattered across the page as Herb climbs up it, a technique which flouts formal picturebook layout conventions while also drawing attention to the artifice of the text itself. While Herb, the central protagonist of the story, is positioned centrally, at eye level, on the first page, once he is inside the fairy tale book, he is consistently viewed from high angles and placed very low and/or on the very outer limits of the page—strategies which suggests his relative disempowerment within the confines of a fairy tale narrative, perhaps, or simply that he does not have a place within the world of fairy tale.

Metalepsis and modal shifting are also combined in Bruce Whatley's *Wait! No Paint!* and David Wiesner's *The Three Pigs*, two versions of the story of The Three Little Pigs, where these two strategies are used to disrupt the boundaries between the represented world of fairy tale and the "real" worlds of authors, illustrators, and readers. Whatley's text has a conventional fairy tale opening and the illustrations are very low modality cartoon-style. Metaleptic disruption occurs, however, when the illustrator spills his juice on the page and converses with the pigs. These disruptions are paralleled by modal contrasts in the pictures—the illustrator's glass, paint tubes, and brushes are all represented with a higher modality than the pigs, implying the higher "reality" of the (represented) world of the illustrator. Despite the disruptions within the visual and verbal discourses, the narrative follows the formulaic path of The Three Pigs story with a relentless logic. Thus, when the illustrator runs out of red paint, the pigs are unable to light the fire to keep the wolf out, at which point the pigs declare they "don't want to be in this story

anymore" (opening 14). Hence, the text on the last page reads: "Once upon a time there were three bears"; and the picture depicts three bears (with very pig-like noses and standing in the same configuration as they appeared on the first page) and a rather wolfish-looking Goldilocks. An implication of the narrative progression and the outcome is that the story cannot be changed; all the illustrator can do is move the characters out of the story into another story—he is, after all, the illustrator, not the author.

Wiesner's version of the same story is more radical in its envisioning of alternative narrative outcomes. Like Whatley's book, *The Three Pigs* has a very conventional textual opening, reinforced by the use of conventional picturebook layout, framing, and modality in the pictures. When the wolf blows the first pig's house down, however, he also blows the pig out of the framed picture space and "right out of the story" (opening 2), where he is eventually joined by the other two pigs, the cat from the "Hey Diddle Diddle" nursery rhyme, and a dragon (who is not dissimilar to the dragons in Wiesner's *The Loathsome Dragon* and *Freefall*). Once outside of their stories all the characters have higher modality, but are depicted against a low modality white space through which the pages of the book-within-the-book float—one implication might be that the white space is the liminal space between fiction and reality where new stories might be created. Certainly, Wiesner reverses the modal shift occurring in *Oops!*. Whereas the higher modality of the axe and the final page suggests fairy tale has a higher "realism" than the represented "reality" of Preston and Mister Wolf, characters in Wiesner's book have a higher modality (and hence "reality") once they leave the world of books and create their own story. The wolf, however, remains trapped inside the story, where similar to Whatley's book, the narrative progresses with a relentless logic: while the pigs have disappeared, the verbal text still asserts that the wolf "blew the house in . . . and ate the pig up," though the ellipsis suggests some uncertainty and the accompanying picture shows a somewhat puzzled wolf. The pigs, cat, and dragon do return to the original story on the same page they left from, but they do so by standing the pages up the right way and smoothing out the one they have used as a paper plane. The narrative reverts, partly, back to its traditional form on the next page, as the wolf begins to "huff and puff" and the characters are once again low modality. However, the story is disrupted again because they have opened the door and the text is scattered across the page by the dragon's head. The facing page shows the pigs outside the story again putting the text back, and the final page depicts them all inside the house eating soup, with one pig still replacing the last letters of the text. As in *Who's Afraid of the Big Bad Book?*, the characters' manipulation of the text breaches boundaries between the fictional world and the "real" world, while drawing attention to the artifice of the text itself. At the same time, the replacement of the text suggests that the story cannot be changed. There is a crucial ellipsis, however, in the last two openings: the scattered text seems to indicate that the wolf climbs up to the chimney and the pig's

speech "Come inside everyone. Soup's on!" implies the traditional ending to the story. However, in the next frame the wolf is seated across from the house. He also appears in the final picture in a framed image behind the dragon—but the image could be a picture on the wall or the actual wolf seen through a window frame. The gaps in the narrative leave the wolf's fate, and the ending of the story unresolved, opening the way for reader speculation. Certainly the new configuration of characters at the close of the book suggests possibilities for creating new stories.

As I asserted at the outset, retelling traditional narratives poses a particular challenge for contemporary writers and the books examined all illustrate the difficulties of such a task. The broadly metafictive devices in each of the books I have discussed add an extra level of amusement to the stories they tell, but they do so in ways which also encourage audiences to engage imaginatively with the books and participate in the meaning-making process. An important component of early critical literacy is a metacognitive and metalinguistic awareness of language and texts. The books examined in this chapter all have the potential to foster such an early critical literacy insofar as they all position their readers in actively interrogative and participatory positions. Metaleptic and modal disruptions in particular construct spaces within texts for readers to actively engage with stories. Such engagement may potentially expand an audience's knowledge of what stories are like, how they work, and how they might be played with, changed, and retold, and potentially how new stories might be written.

NOTES

1. In brief, metalepsis refers to the disruption of logical and hierarchical relations between different levels of narration (McCallum, 1992, 403) and between the world of "story" and that of "reality."
2. Derived from linguistics, modality refers to the "truth value" or credibility of statements about the world (Kress and Van Leeuwen, 1996, 160) and hence to the extent to which a linguistic or pictorial representation approximates what we think of as "real" within a particular sociocultural context.
3. The narrative reverts to third person after this intrusion. My eldest son, for whom this book was a particular favourite at about the age of three, interjected one day at the fifth opening, turned the pages back to Mister Wolf's intrusion and asked, "Who is telling this story?" Needless to say, it is difficult to surmise exactly what he recognized or understood about narratival functions but the question is interesting in that it does at least indicate that he perceived the metaleptic disruption and that it had implications for storytelling functions and processes.

WORKS CITED

Kress, Gunther, and Theo Van Leeuwen. *Reading Images: The Grammar of Visual Design*. London: Routledge, 1996.

Stephens, John, and Robyn McCallum. *Retelling Stories, Framing Culture: Traditional Story and Metanarratives in Children's Literature*. New York and London: Garland Publishing, 1998.
Tatar, Maria. *The Hard Facts of Grimm's Fairy Tales*. Princeton, N. J.: Princeton University Press, 1987.
Zipes, Jack. *Don't Bet on the Prince*. Aldershot: Gower, 1986.

CHILDREN'S LITERATURE CITED

Child, Lauren. *Beware of Storybook Wolves*. London: Hodder, 2001.
———. Who's *Afraid of the Big Bad Book?* London: Hodder, 2002.
Forward, Toby, and Izhar Cohen. *What Really Happened to Little Red Riding Hood: The Wolf's Story*. London: Walker Books, 2005.
McNaughton, Colin. *Oops!* London: Picture Lions, 1998. First published 1996 by Anderson Press.
Whatley, Bruce. *Wait! No Paint!* New York: Harper Collins, 2001.
Wiesner, David. *Freefall*. Lothrop, Lee and Shepard: New York, 1988.
———. *The Three Pigs*. New York: Clarion Books, 2001.
———, and Kim Kahng. *The Loathsome Dragon*. New York: Clarion Books, 2005.

13 "It Doesn't Say How?"
Third Graders' Collaborative Sense-Making from Postmodern Picturebooks

Caroline McGuire, Monica Belfatti, and Maria Ghiso

A plague has struck a small town in the Old West. A team of horses staggered back to the town of Riverbend, covered in a mysterious greasy slime. The sheriff rode out in search of their driver, only to find him similarly afflicted. Viewing an image of this man, covered in erratic streaks of color, third grader Oumar wondered, "Um, why did it only got greasy things on him and not the other people? It doesn't say how?" Oumar's first question points to the central indeterminacy of *Bad Day at Riverbend* (Van Allsburg): the source of the Technicolor slime. His second question, in which he seeks confirmation that the story does not explain how the slime appeared, underscores the significant interpretive challenge posed by texts that do not supply ready answers and instead inspire and sustain children's wonderment.

Oumar, one of five students in a third-grade (eight year-olds) literature discussion group, raised a number of questions about the meaning of the verbal text and illustrations as the group tried to collaboratively make sense of the ambiguities of the picturebook. *Bad Day at Riverbend* and other texts like it were chosen for use with this group because of their more writerly (Barthes, *S/Z*) nature, which requires active readership to interpret possible meanings and fill in textual gaps (Iser). The challenge for students is to figure out how to navigate texts that require significant coauthoring—what to do when it "doesn't say how" to read and make sense of the text.

The unconventional narratives presented in postmodern picturebooks have led many teachers and researchers to recommend providing young students with explicit direction in navigating the substantial gaps in these texts (Goldstone, "Traveling"). This may take the form of sharing the books with children in the context of a genre study, which may involve more or less explicit naming and instruction about postmodern textual features (Pantaleo, "The Long, Long Way," "Young Children and Radical Change," "Young Children Interpret;" Serafini). Teachers may actively direct students' attention to these features as well as scaffold their sense-making by weaving together the multiple sign systems to build toward coherence. While Pantaleo's research has revealed that young children can respond to postmodern picturebooks with great sophistication when

teachers scaffold the sense-making process, she signals the need for more research on children's responses to postmodern picturebooks in a variety of instructional frames.

This study responds to Pantaleo's ("Young Children Interpret" 230) research suggestion by considering what resources students drew on in navigating postmodern texts in a more dialogically organized literature group discussion. The pedagogical approach used in this study, *Shared Evaluation Pedagogy* (Aukerman), involves teachers inviting students into "grand conversations" (Eeds and Wells) and refraining from "hypermediating" (Gutiérrez and Stone) the conversation so that students can engage in "cross-talk" (Chinn, Anderson, and Waggoner) as they collaboratively reason about texts. In this alternative instructional frame the teacher purposely decentered herself as "primary knower" (Berry) so that students could become "possible knowers" (Aukerman) and determine the directions of interpretive inquiry. In these joint inquiries, students engage in intellectual grappling with the texts and with one another. In a participation structure of this nature, the indeterminacy and nonlinearity of postmodern texts (Goldstone, "The Postmodern;" Sipe) become opportunities for the children to co-construct meaning and examine the multiple interpretations forwarded in this dialogic arena.

The data for this study were collected as part of a larger, semester-long study of children's responses to picturebooks in a small group setting facilitated by Caroline, one of the researchers. The study took place in an urban public school in which 81 percent of students qualified for free or reduced lunch. Five third-grade students (four female, one male) were identified by their classroom teachers as proficient at decoding, but struggling with comprehension. All of the students were African American, while the teacher/researcher was European Canadian. The postmodern picturebooks we focus on in this chapter—*Voices in the Park* (Browne), *Shortcut* (Macaulay), and *Bad Day at Riverbend* (Van Allsburg)—were interspersed among more traditional picturebooks (including fantasy, fables, and mysteries), as we were curious to see how children would negotiate these books outside the context of a genre study. We sought to answer the following question: When the teacher did not explicitly name or focus discussion on postmodern features, what did the children rely on in order to make sense of these texts? In this chapter, we will present several instances of talk that illustrate the intellectual and social work that the children engaged in together and the range of resources they drew on in doing that work.

"THAT'S THE SAME ONE": BUILDING ACROSS OPENINGS AND STUDENT IDEAS

Returning to the plague of greasy slime, we will examine an excerpt of group talk from the beginning of the discussion about *Bad Day at Riv-*

erbend (Van Allsburg). The front cover of the book's dust jacket shows an outline drawing of a man, rendered in thick black ink on a cream background, staring seemingly in horror as multicolored scribbles swirl around him. Similarly, the title page contains a vignette of a black-outlined man atop a bucking steed, now facing toward the orange and yellow lines scrawled haphazardly over the horizon. When the students encountered the dust jacket image, they remarked on the man's facial expression, speculated about the cause of his distress (why it's a "bad day"), and wondered why he was untouched by the colored lines. Upon encountering the second image, on the title page, the following exchange occurred:

Oumar: That's the same one, the same person.

Teacher: You think it's the same person?

Alysia: That's the—it is 'cause, the hat.

Teacher: Mm hmm.

Alysia: And the scar—and the little scarf thing. See?

Teacher: Oh, yeah, mm hmm.

Dee: But he just on a horse.

Teacher: This time he was on a horse?

Alysia: Mm hmm. Well, he probably got off the horse and saw something and then he got back on the horse trying to get away from danger. Probably.

Oumar directed the group's attention to a possible connection between the two images, and Alysia supplied evidence in support of this interpretation, citing the parallel accessories (cowboy hat and neckerchief) worn by the figures. Dee pointed out a discrepancy: on the dust jacket, no horse is visible, but on the title page, the man appears astride a horse. Alysia wove together Oumar's suggestion that it is the same person with Dee's observation about the inconstancy of the horse, spinning out a possible plot that integrates both students' ideas and is consistent with the available semiotic resources of the text. In this interaction, the students drew on the information in the peritext (a term developed by Genette in *Paratexts* to describe all the parts of the book that surround the text of the story, including the covers, dedication, endpapers, and title page) to supply a possible explanation for the pallid cowboy's expression and action.

The teacher's participation in this vignette can be characterized as non-evaluative acknowledgement of student ideas or as uptake (Nystrand), in which the teacher incorporates a student's preceding utterance into hers, maintaining the student idea as the topic of conversation. As the teacher refrains from resolving textual ambiguities and setting the topics of talk, it is the students who focus the gaze of inquiry and decide what merits further inspection. With space to introduce questions and observations,

the students relied on intratextual connections across peritextual features and one another's ideas as resources for the collaborative construction of meaning.

Students' inquiries took recursive paths through the discussion, with the students moving back and forth through the text to examine different openings and revisiting earlier questions in light of new evidence. For example, over the course of more than 1,270 transcript lines, students reworked their questions and hypotheses to probe the origins and deployment of the mysterious slime plaguing the town of Riverbend. The students grappled with issues such as the means by which the slime was applied, its possible purpose, approaches to the containment of the slime, and the reasons for the slime's selective appearance on particular people and animals. Oumar first raised the issue of the slime's selectivity:

> Oumar: Why, why are the, are the cow—whatever they are—don't have slimes on them?
>
> Alysia: Because there's probably certain, certain of them they probably don't want to put slime on. Or they probably ran, try to run away very fast and some of them like, all the rest of them was slow.
>
> Teacher: What do you think? Do you have other ideas about why some of the cows are slimy and some of them aren't?
>
> Dee: Because some of the cows are, I don't know, different? Maybe because they are different.
>
> Alysia: They probably female or male. So they probably put slime on the male and no slime on the female.
>
> Teacher: What do you think, Oumar, do you have an answer to your own question?
>
> Oumar: How they gonna know if it's female or male?
>
> Teacher: Whatever put the slime on, how would it know? Mm hmm.
>
> Alysia: Or, it probably be like, like one probably knows about cows. 'Bout which, which cows are female and male.

The students noticed that only some of the cows were afflicted with slime, and given that this remains ambiguous in the verbal text, the students stepped in to author a number of explanations: variable running speed, general difference, and gender discrimination. This topic recurred five openings later, when the students took to counting the occurrences of different colors of slime in the illustration sequence to try to discern a pattern that might explain the slime's deployment. The flexibility of students' questions and interpretations allowed them to reckon with the sudden appearance of a stick figure made entirely of slime on the twelfth opening of the picturebook, as they began to wonder if "somebody scribbled in the book"

(and how the sheriff would "put on those handcuffs if he's [the stick figure] so skinny"!). The appearance on the fourteenth opening of a realistically drawn hand and arm, applying the slime to the posse of cowboys, revealed an additional layer within the fictional world. The connection between the fictional world and the real world is suggested by the photo on the back cover of the dust jacket of Chris Van Allsburg with his daughter Sophia, red crayon in hand and cowboy hat on head, applying slime liberally to what appear to be the illustrations from the picturebook. The blurring between the real world and the fictional world, and the depiction within the book of the process of the book's creation, draw attention to the book as a construction and to reading as a process of construction. By talking together, and without explicit teacher direction, the children were able to make sense of the text and its multiple layers, arriving at the conclusion that "the little girl did it."

"THIS IS A GORILLA TOWN": CONTESTED TALK AROUND TEXTS AND LIFE-TEXTS

When engaging in collaborative sense-making, the students' conversations and interpretations were not always harmonious or convergent. In reading *Voices in the Park* (Browne), a multistranded narrative that presents the perspectives of four zoomorphic characters (with human bodies but ape heads) who visit a city park, the students wrestled with the nonlinearity and indeterminacies presented by the verbal text in concert with Browne's trademark surrealistic images. As the children responded to the text, entertaining multiple competing hypotheses, they seized opportunities to critically engage with each other's ideas and defend their own. A major node of contestation for this group was the adult male character, who first appears on the third opening of the picturebook, where the text describes the disappearance of a child character named Charles. The male character of interest, an apelike figure dressed in speckled, muddied trousers and knit cap, is sitting on a park bench reading a newspaper. Following Oumar's suggestion that the man might be a kidnapper due to his raggedy clothes, disagreement ensued among the members of the group (overlapping talk indicated in square brackets):

Maya: I don't think so.

Briana: Turn to the next page.

Teacher: Do you have a reason why you don't think so, Maya?

Maya: Uh, because the man is an elderly man and he

Oumar: How do you know?

Maya: Because it looks like he's an elderly man and he's reading a newspaper [like old people do. I'm not sayin' that—]

Oumar: [So? Young people, young people] read newspapers. Young people do. I do.

Teacher: Alysia?

Maya: Okay, I'm not talking 'bout you.

Alysia: Uh, can I see the page?

Teacher: Which page? This one?

Alysia: Yeah, I think he's just, he probably just came from his job or something, probably he's a worker.

Maya: A trash worker, because he got all that dirt.

Alysia: He can't be.

Briana: A painter?

Alysia: He's jus—Yeah, yeah.

Teacher: So, so it was his job that made him look like that?

Oumar: Or a digger.

Maya: Because he either did paint or trash.

Oumar: Or dig.

Teacher: Or dig?

Maya: I don't think so.

As the students forwarded a number of different interpretations regarding the apelike figure's appearance and intentions, the hermeneutic discord challenged them to reconcile their ideas with evidence from the text. Students reentered the text and used the details of the illustration, for example the newspaper and the dirt on the man's pants, as semiotic resources in an attempt to quell the dissonance. The postmodern text is ambiguous and does not provide ready-made answers to the children's queries. Thus, students needed to draw on additional resources.

Two approaches that proved useful to the students' making sense of the presence of the zoomorphic characters were text-to-text and text-to-world connections. On the fifth opening, the aforementioned apelike figure appears slouched in a muted green armchair, supporting his weary gorilla head with his peach-colored, human forearms. The students immediately recognized him as the same character that was "reading the newspaper," then noticed the juxtaposition of human and gorilla features:

Briana: He look all white right there but he a gorilla. He look like a human with the arms.

Maya: Oh my goodness, what happened?

Alysia: Something strange happened like the um *The Wretched Stone*.

Briana and Maya were taken aback by the blurring of the character's species, at which point Alysia drew on her "intertextual history" (Pantaleo, "Young Children Interpret" 222), invoking another picturebook to provide a possible account for the character's curious form: in *The Wretched Stone* (Van Allsburg), the discovery of a mysterious rock leads to the transformation of a ship's crew from humans to monkeys. This text-to-text connection led the other children to speculate that it was some element depicted within the illustrations, perhaps the surrealistic trees which change in shape across openings, that might have caused a metamorphosis in purely human characters.

The idea of transformation spawned a number of lines of inquiry as the students noticed changes in the trees, lampposts, and clouds. The blurring of realistic events, like a visit to the park, with the surrealistic shifts in imagery, led the students to question the genre of the text. For example, they debated whether the monkey characters wearing clothing was realistic, and posited a fictional world with features parallel to those they have seen in their own city. Maya suggested that the characters go to "the monkey store, the monkey Forman Mills and then they get the same outfit." Forman Mills, a large clothing store that sells school uniforms, is Maya's real-life reference point for a place where children "get the same outfit." One plausible explanation for the ape-like characters being clothed is that they shop at stores just like she does—that in an analogous gorilla world, "they are gorillas and this is a gorilla town."

In the initial vignette in this section, as the children discussed the appearance and intentions of the male character, they also used their life-texts as resources. When Maya argued that the character is elderly because he is reading a newspaper, Oumar contested this interpretation by stating, "Young people do. I do." Oumar grounded his rebuttal in his own literacy practices. Similarly, the students took issue with Oumar's suggestion that the character is a kidnapper, treating his unkempt appearance as an index of his occupation rather than his questionable moral status. Through Alysia, Maya, and Briana's ideas about the work the character might do, Oumar also began to think about alternatives to his initial interpretation. In hypothesizing these employment scenarios, the children used their knowledge of clothing as an occupational identity marker and suspended moral judgment by considering alternatives and questioning one another's assumptions.

The children's discussion of the characters also helped them to make sense of the multiple voices in the text. At the very beginning of the discussion, the children questioned the meaning of the title, *Voices in the Park*: Maya thought it might be "different people with different voices," Oumar suggested that people in the park were "making different animal sounds," and Dee thought that the book would be about "everybody talkin' in the park to other people." When Briana noticed the hat on the title page, Dee linked the hat to the voices in the park, and Maya built on this idea:

I think the hat is there because they come to the park and do dress up and they, when they put it on, they have it over their head and then they

disguise their face and then they talk like [high voice] "Eeeee" or [low voice] "What you doin'?"

Oumar agreed that putting on different hats could allow people to take on different personas with corresponding different voices.

As the students read further and discussed the book, however, their understanding of the "voices in the park" changed. Rather than understanding the book as involving characters that assume multiple voices, the students came to understand the book as including the four distinct voices of four different characters (two children, Charles and Smudge, and two adults, Charles' mother and Smudge's father) and their perspectives on the park. Since Browne does not clearly spell out for the reader which voice is attributed to which character (the four chapters are labeled "First Voice," "Second Voice," "Third Voice," and "Fourth Voice" respectively), the students used the semiotic resources of the text (including Browne's labeling of the chapters) and what they understood about the characters' relationships to deduce how to assign the voices.

During the narration of the third voice, for example, the children used their understandings of the characters and their relationships to arrive at the conclusion that the third voice belonged to Charles, the young boy. Maya posited that the adult female character, Charles' mother, was "real ignorant" because she objected to Charles talking with Smudge, the young girl in the park. Oumar elaborated on her motives:

I think his mom don't want them to be talkin' to each other because um her dad on this picture, 'cause she don't want him to be near her dad and she don't want him to 'cause they're dirty.

At the conclusion of the third voice, the text reads, "Maybe Smudge will be there next time." Briana interpreted this as the mother articulating her fear that the undesirable girl would again be at the park and might corrupt her son. However, Maya countered that the voice must be that of Charles because "she didn't know the little girl's name." By doing significant intratextual work—linking what each voice said about the outing to the park and what images accompanied the narration of each voice—the children were able to distinguish among the voices, connect the voices to the major characters, and weave together plausible interpretations of the book as a whole. Doonan writes, "What we do when we experience a picturebook is to put together the story told by the text and the story told by the pictures, whereupon an expansion takes place" (164). As the children's understanding of the characters and of the multivocal structure of the picturebook expanded, the conversation became messy, with ideas rubbing up against one another, overt and implicit contestation, and the reemergence of topics of inquiry that required further investigation.

"IT'S STILL GONNA BE A LONG, LONG WAY": RECURSION WITHOUT RESOLUTION

When reading *Shortcut* (Macaulay), a picturebook comprised of nine chapters and an epilogue, students collaboratively grappled with the nonlinear structure of this postmodern text. The chapters in the book shift in focus among various characters and events, such as Albert's trip to market with his horse, June, pulling a cart of melons; the disappearance of Patty's pig, Pearl; Professor Tweet's unexpected hot air balloon voyage; Sybil's wild car ride through the countryside; Bob's realization of his dream of owning a fleet of boats; and Clarinda's retrieval of her errant cockatoo. As the narration of the story shifts from one focal character to another, it moves nonsequentially through time and space. The subplots are loosely connected by verbal and visual cues that suggest the interrelatedness of the characters' experiences. The trajectory of the children's talk about these cues provides insight into the ways in which the students worked together to integrate the multiple semiotic resources throughout the text to craft possible story lines. In much the same way as the narrative circled back to particular characters and events, students' talk moved recursively as they sought to "ferret out connections, and investigate how the narrative strands or pictures support or contradict one another" (Goldstone, "The Postmodern," 199).

One central node of student inquiry, which was a sustained topic of discussion at three different points in the conversation and across 1,237 transcript lines, was the meaning of a hand-lettered sign staked into the side of a dirt road, indicating two alternative routes. Readers first encounter a close-up view of the makeshift sign on the third opening of the picturebook. The verbal text indicates that Albert and his horse June will take the shortcut to save time on their way to the market. As the students discussed the accompanying illustrations, they called into question how to read the sign in relation to Albert's chosen route. The illustration on the left side of the opening shows a close-up of the sign, which includes two panels, one affixed above the other. The top panel reads "Shortcut," with a vertical arrow to the left of the text pointing upward. The lower panel reads "Long Long Way," and features a horizontal arrow to the right of the text pointing to the picturebook's gutter and the full-bleed illustration on the facing page. The words on the lower panel are stacked so as to occupy the same proportion of horizontal space as the upper panel's arrow. Likewise, the lower arrow mirrors the length and position of the word "Shortcut" on the upper panel. This leads to some ambiguity in how to read the sign: should each label be associated with the arrow on the same panel as it, or the arrow that occupies the same horizontal space as it? The sign appears again in the image on the right side of the opening, but from a different orientation. This time, the sign is seen sideways, so the text is no longer visible, though this time we do see Albert's coat hanging from the upper panel as Albert pushes his melon cart to the right, up a steep incline.

The initial reaction to the sign was to question its trustworthiness. Dee suggested, "Probably somebody just wrote 'shortcut' and probably they gonna get lost." The makeshift nature of the sign as depicted in the illustration seemed to raise the issue of the authenticity and origin of the sign— perhaps somebody had "unofficially" erected the sign, potentially with malicious intent. Alysia picked up on this idea, saying, "They probably gonna say it's a shortcut. They probably take the shortcut but it's probably gonna be a long, long way." This points to the ambiguity the children saw in the meaning of the sign: its questionable provenance led them to predict that Albert and June might be duped into taking a circuitous, rather than abbreviated, route. Briana reacted to this response by returning to the verbal text: "This is all you read. They about to take a shortcut." However, the text, in combination with the images, did not resolve the students' uncertainty about Albert and June's chosen path; as Albert toils to push the cart off the top right corner of the page, it remains unclear whether the characters have taken the shortcut or, in fact, a more arduous route. Maya, for example, made a prediction that involved the motorist featured on the cover of the book, who is speeding through a city street, leaving dust and destruction in her wake. She hypothesized that after Albert and June take the shortcut, the motorist is going to "come pass in her car and then they get swept, they get lost," suggesting that the path taken will actually be a "long, long shortcut" due to the obstacles they will encounter.

The cover image of the speeding car recurs on the nineteenth opening of the picturebook, in the fifth chapter, which takes Sybil the motorist as its focal character. The children recognized the image and suggested that the character is in a rush. The twentieth opening marks the return of the sign. The image on the left (which repeats the image on the back cover of the book) shows Sybil driving past the sign, which is partially obscured by Albert's jacket. The jacket covers the vertical arrow and the "Long Long Way" text, leaving exposed the word "Shortcut" and the horizontal arrow. The text reads, "Though she follows the sign, it is still a long, long way," suggesting that this version of the sign led her to take the horizontal path rather than the road up the hill. The students noticed that the sign looked different on this page than it did on the third opening, and sought to resolve the discrepancy. Briana posited, "Somebody might have changed the sign." Building on this idea, Maya imagined a more specific scenario: "Because some people be working at night and they change stuff." One potential inspiration for this theory was an image two openings prior, showing workers in hard hats altering a train track. When asked how workers change signs, Maya replied confidently, "They take out the nails." Briana offered another possible explanation by connecting the illustration on the left side of the opening with the full-bleed image on the facing page, in which Albert has retrieved his jacket from its perch on the sign, exposing it in its entirety, and Sybil has continued on her destructive path. Briana noticed, "He [Albert] probably changed it. 'Cause see the purple jacket. Here he go right there

[pointing to his feet in the left image], there he go right there [pointing to the fully-clothed Albert in the image on the right]." She used illustration details from various locations in the opening to substantiate her interpretation of how the sign may have changed.

While Briana's explanation could have brought closure to this area of inquiry, the students revisited the different representations of the sign after reading the epilogue of the picturebook. Still trying to construct a coherent narrative from the multiple chapters and various sign systems, the children decided to page through the text to revisit particular episodes. Prompted by Dee's recollection that Albert "had to take off his jacket, remember?," Briana reasserted her interpretation that Albert was the agent of sign obfuscation. However, Briana's interpretation did not bring the issue to rest, as she herself forwarded another likely scenario for the changing of the sign. Gazing at the twentieth opening, Briana suggested that Sybil "was driving so fast she changed the sign and it went like that [waving her hands to indicate spinning]." This interpretation harkened back to a lengthy discussion of the cover, which features Sybil's sedan wreaking havoc and kicking up a cloud of debris. The students debated whether the cloud was made of dust or smoke, but agreed that the fast-moving car generated the cloud behind it. Alysia remarked, "She's telling them to eat her dust." Briana picked up this idea of Sybil as a speed demon (which was echoed in the verbal text on the nineteenth opening that she "races through town and country") in emphasizing the possibility of Sybil's agency in her own misreading of the sign. Indeed, the countryside featured on the full-page illustration has been uprooted by her reckless journey, which overturned several vehicles, injured a number of people, and left a bunch of picnicking bunnies gesturing with indignance. Between the two images of the opening—the first, of Sybil approaching the sign, and the second, with Sybil miles past the sign—lies a gap that is open to interpretation, for the verbal text does not specify the intermediary events. It is thus plausible for Briana to posit that regardless of the placement of Albert's jacket, it was Sybil's speed that made Sybil's reading of the sign challenging and therefore unreliable.

Both of Briana's interpretations were consistent with the semiotic resources available throughout the picturebook (peritextual features, verbal text, and illustrations), pointing to the rich opportunities that postmodern texts provide for authoring by readers. While Goldstone ("The Postmodern" 203) argues that postmodern picturebooks reassure children that indeterminacy can be *overcome*, Briana's forwarding of multiple plausible scenarios suggests that these texts teach students that indeterminacy can *stand*, that in fact reading such texts can be a process of entertaining possibilities rather than coming to resolution. Lewis notes that "undecidable outcomes and irresolvable dilemmas" (89) frequently characterize postmodern literature, and it is this high degree of indeterminacy that generates multiple interpretations.

"I GOT A WHOLE BUNCH OF ANSWERS":
STUDENTS' RESOURCES FOR INTERPRETATION

Postmodern picturebooks do not provide the seamless reading experience of being immersed in a fictional world. Instead, by calling conventions into question and exposing their own constructedness, these texts demand quite a different kind of readership. They "prod and entice the reader" (Goldstone, "Traveling" 29) to piece together readings and to interrogate the text and textual interpretations. The heightened demands of active coauthorship can be unsettling; "it is not uncommon for readers of the postmodern to be left not knowing which way to turn" (Lewis 89). However, by relying on the resources of their interpretive community, the students were able to treat the metafictive nature of *Bad Day at Riverbend* (Van Allsburg) and the multistranded narratives of *Voices in the Park* (Browne) and *Shortcut* (Macaulay) as significant opportunities to collaboratively reason and assert their interpretive authority.

Without explicit teacher direction, students noticed postmodern features in the three texts, and made these features rich sites of investigation. When encountering indeterminacies such as zoomorphic characters, loosely connected plots, and metafictive intrusions, students wrestled with these potentially disorienting aspects by drawing on a variety of resources. Students' intertextual connections—both to visual and written texts they had encountered and to the texts of their own life experiences—provided interpretive lenses through which possible story lines could be imagined. The children also mined the texts' semiotic resources, frequently turning back and forth between openings and peritextual features to integrate available sign systems across all the parts of the picturebook.

Through this recursive process of reading, students did not always converge on a single interpretive endpoint. As students shared ideas, a common text was forged that acted as a resource for further sense-making. At times, this collaborative process served to develop an idea: the group integrated multiple perspectives, evidence, clarifications, and connections to refine and buttress particular interpretations. The texture of this collaboration was as rife with ambiguities, discontinuities, and disruptions as the postmodern picturebooks themselves. The messy and contested nature of these discussions is evidence of the sophisticated interpretive work that students were undertaking without a teacherly authority to tidy the discussion or align it behind his or her interpretive priorities. Students' contestations required other members of the group to substantiate assertions with evidence from the text or elaborations of their rationales. The controversy in the discussion raised the stakes for students, who were invested in the conversations to convince one another of the merits of particular interpretations. This contestation represented students' involvement in the evaluation of ideas, which has traditionally been the province of the teacher (Nystrand). Under the scrutiny of each other's gaze, interpretations that lacked credible evi-

dence as judged by the hermeneutic community were abandoned as topics of conversation. At times, after the group's examination, multiple competing hypotheses were allowed to coexist.

What, then, might be the role of the teacher in facilitating a literature discussion group's intellectual work around postmodern picturebooks? The teacher can participate as another voice rather than the omniscient and authoritative voice in the interpretive community. In acting as a co-participant the teacher reminds the students to hold one another accountable for listening as well as responding, and ensures that no voice is silenced, since a diversity of perspectives is valued in this arena. In addition, by refraining from questioning, evaluating, and setting the topic of inquiry, the teacher shapes a space for students to engage in these actions themselves. One way to support students in taking on these roles is to provide them with texts that require active readership. Postmodern picturebooks are ideal in this regard, presenting students with intriguing verbal and visual information but no familiar road map for weaving the semiotic resources together.

In writing about *The Pleasure of the Text*, Roland Barthes (1975) forwarded a distinction between texts of *plaisir* (pleasure) and texts of *jouissance* (bliss). Texts of pleasure content the reader and represent a familiar—and therefore comfortable—experience of reading. Texts of bliss, on the other hand, are discomfiting because they represent a break from the familiar, and Barthes contends that this unsettling represents a different kind of pleasure. Postmodern picturebooks can be texts of bliss for readers, as they seemed to be for the children in this literature discussion group. Although taken aback that each text, in its own way, "doesn't say how" it should be read, the children embraced and wrestled through the newness and ambiguity, playing, debating, flipping backwards and forwards, ventriloquizing characters, raising questions, and voicing their own stories. Faced with these texts, students often labeled as deficient were in fact able to form sophisticated literary interpretations and engage in critical dialogue and argumentation in support of their readings.

WORKS CITED

Aukerman, Maren. "Who's Afraid of the Big 'Bad Answer'?" *Educational Leadership* 64.2 (2006): 37–41.

Barthes, Roland. *The Pleasure of the Text*. Translated by Richard Miller. New York: Hill, 1975.

———. *S/Z: An Essay*. New York: Hill & Wang, 1970/1974.

Berry, Margaret. "Systemic Linguistics and Discourse Analysis: A Multi-Layered Approach to Exchange Structure." In *Studies in Discourse Analysis*, edited by Malcolm Coulthard and Martin Montgomery, 120–45. London: Routledge and Kegan Paul, 1981.

Chinn, Clark A., Richard C. Anderson, and Martha A. Waggoner. "Patterns of Discourse in Two Kinds of Literature Discussion." *Reading Research Quarterly* 36.4 (2001): 378–411.

Doonan, Jane. "The Object Lesson: Picturebooks of Anthony Browne." *Word and Image* 2.2 (1986): 159–72.

Eeds, Maryann, and Deborah Wells. "Grand Conversations: An Exploration of Meaning Construction in Literature Study Groups." *Research in the Teaching of English* 23 (1989): 4–29.

Genette, Gerard. *Paratexts: Thresholds of Interpretation.* Translated by J. E. Lewin. Cambridge: Cambridge UP, 1987/1997.

Goldstone, Bette P. "The Postmodern Picture Book: A New Subgenre." *Language Arts* 81.3 (2004): 196–204.

———. "Traveling in New Directions: Teaching Non-Linear Picturebooks." *The Dragon Lode* 18.1 (1999): 26–9.

Gutiérrez, Kris, and Lynda Stone. "Hypermediating Literacy Activity: How Learning Contexts Get Reorganized." In *Contemporary Perspectives on Literacy in Early Childhood Education,* edited by Olivia N. Saracho and Bernard Spodek, 25–51. Greenwich, CT: Information Age Publishing, 2002.

Iser, Wolfgang. *The Act of Reading: A Theory of Aesthetic Response.* Baltimore: Johns Hopkins UP, 1978.

Lewis, David. *Reading Contemporary Picturebooks: Picturing Text.* New York: Routledge/Falmer, 2001.

Nystrand, Martin. "Dialogic Instruction: When Recitation Becomes Conversation." In *Opening Dialogue: Understanding the Dynamics of Language and Learning in the English Classroom,* edited by Martin Nystrand, with Adam Gamoran, Robert Kachur, and Catherine Prendergast, 1–29. New York: Teachers College P, 1997.

Pantaleo, Sylvia. "The Long, Long Way: Young Children Explore the Fabula and Syuzhet of *Shortcut.*" *Children's Literature in Education* 35.1 (2004): 1–20.

———. "Young Children and Radical Change Characteristics in Picturebooks." *The Reading Teacher* 58.2 (2004): 178–187.

———. "Young Children Interpret the Metafictive in Anthony Browne's *Voices in the Park.*" *Journal of Early Childhood Literacy* 4.2 (2004): 211–233.

Serafini, Frank. "Voices in the Park, Voices in the Classroom: Readers Responding to Postmodern Picturebooks." *Reading Research and Instruction* 44.3 (2005): 47–64.

Sipe, Lawrence R. "What Is 'Postmodern' About Postmodern Children's Picturebooks?" National Reading Conference, San Antonio, TX, December 2, 2004.

CHILDREN'S LITERATURE CITED

Browne, Anthony. *Voices in the Park.* New York: DK Ink, 1998.

Macaulay, David. *Shortcut.* Boston: Houghton Mifflin, 1995.

Van Allsburg, Chris. *Bad Day at Riverbend.* Boston: Houghton Mifflin, 1995.

———. *The Wretched Stone.* Boston: Houghton Mifflin, 1991.

14 The Voices Behind the Pictures
Children Responding to Postmodern Picturebooks

Evelyn Arizpe and Morag Styles
with Kate Cowan, Louiza Mallouri and
Mary Anne Wolpert

> Children now have available to them many forms of text which include
> sound, voice, intonation, stance, gesture, movement, as well as print
> and image. These texts have changed the ways in which young readers
> expect to read, the ways they think and the ways they construct mean-
> ing. . . . a different kind of orchestration of elements which make up
> any act of reading. (Bearne 128)

In our previous study, *Children Reading Pictures* (Arizpe and Styles), we
were delighted by the way children responded to postmodern picturebooks,
inspiring us with their enthusiastic and insightful interpretations of mul-
timodal texts, especially as they construed the emotional, spiritual, aes-
thetic, and intellectual content.

In the case studies that follow, we have gathered and analysed further
data with our students in the same spirit as the original project. We have
continued to investigate a wide age-group of children who give voice to
the pictures and the ironic spaces between word and image. This time, we
concentrate on their reactions to metafictive devices in selected postmodern
picturebooks which "amplify the fictional status and self conscious nature
of the text" (Pantaleo, "Young Children" 214). In particular, we consider
many forms of *playfulness* within the unstable texts themselves, as well
as the behaviour of young readers, including their performative physical
responses (Mackey, "The Most Thinking Book") and spontaneous use of
intertextual references. We believe that it is the particular features of post-
modernist picturebooks (so creatively approached by the authorial talents
behind them) that encourage responses in readers that involve the "new
orchestrations" (Bearne) of playfulness, performance, and intertextual
recognitions through which they construct meaning. Once again, we find
young readers becoming ventriloquists of their picturebooks as they rise to
the challenge of "playing the texts" (Meek).

This chapter includes the research of students[1] working at the Master's
level at the Faculty of Education University of Cambridge in 2007. Two of
the three were women who had recently completed undergraduate degrees
without significant experience of working with children; the third was

a mature teacher with many years of classroom experience and latterly teacher education and advisory work. They were all interested in finding out how children[2] would respond to the challenges offered by postmodern picturebooks. They worked in one Cambridgeshire, one Hertfordshire, and one inner London primary school to get their evidence, following a similar format to the *Children Reading Pictures Project* [3]. Their questions were also exploratory, often following some variation on "Tell me what you find interesting about this." The children also drew in response to the texts with fascinating results, but there is not space here to include this data. Because of our interest in linguistic diversity, economically disadvantaged pupils, and readers who struggle with print, one-half the chapter is devoted to this constituency, including Evelyn Arizpe's research into recently arrived immigrant children in a Glasgow school.

WE BEGIN WITH KATE COWAN'S RESEARCH USING SIMON BARTRAM'S *DOUGAL'S DEEP-SEA DIARY* WITH FIVE- AND SIX-YEAR-OLDS.

Simon Bartram has been hailed as one of the most original picturebook artists to emerge in recent years. The written narrative is presented in first-person diary form by the woefully shortsighted Dougal, presented as a sort of naive Everyman catapulted into a bizarre underwater fantasy journey where he chances upon the lost city of Atlantis and is welcomed by the Mer-people. The emotional undercurrent to the text is one of belonging and acceptance, though Bartram's illustrations are bold, graphic, and full of detail. This multilayered text demands careful scrutiny with its recurring themes and motifs, subtle similarities and differences, visual jokes and intertextual references. Dougal's written diary entries present what he sees, but the illustrations also show what he does not notice, putting the beholder in a position of superiority, resulting in ironic counterpoint between written and pictorial text (Nikolajeva and Scott).

Performance

All three children engaged physically with the text and shared their observations without being prompted, often articulating their responses through nonverbal means. On the first reading, before any questions were asked, the children began pointing and making remarks, frequently showing enthusiasm for, and immersion in, the text. They were aware of Bartram's use of viewpoint, particularly the privileged positioning of the beholder, compared with the limited viewpoint of the protagonist. The children all grasped the irony and articulated their understanding primarily through pointing out the contradictions or the unexplained

within the visual narrative. The affordance of the picturebook enabled this exploration, allowing the children to point, pause, consider, and discuss.

Playfulness

When connections and consistencies began to emerge, the children were quick to turn back through the pages and flick between points of interest, sometimes moving their faces so close to the text that they were only inches away. They gasped and giggled as if immersed in play. When looking at the busy close-up picture of Atlantis, Jack suggested, "Let's play a game of I-Spy with the pictures," while Sam mentioned "the odd one out from that lot." Daisy liked the bit "when you had to spot the mermaid." As they became more familiar with the text, the children began to develop expectations about how it might behave. Sam stated, "I think there might be a mermaid in nearly every page. Right, I'll just see if there's a mermaid in this part (turns to previous page). No it's . . . yes! There is! I think there's one on every page."

Sam described the text as "sort of like a guessing book," a term that showed his awareness of play within the text as well as referring to the "guessing work" the beholder must engage in to make sense of the dual narratives. He also considered the misleading nature of the written text: "It's just playing a trick . . . the story doesn't tell you it but actually he's always wrong . . ." Jack noted, "That's another thing the words don't tell us . . . it tells us is what *he* sees, 'cos this is like, the words in his diary."

Jack stated that he thought the pictures told us more than the words. Sam added, "I remember the pictures, because *they tell you more.*" The children enjoyed Bartram's use of irony and visual jokes and Daisy particularly responded to his wordplay, remarking, "He said the water was quite nippy (pointing to picture) and it's crabs!" All three children showed an impressive understanding of perspective and adeptly used the visual alongside the written text to negotiate cohesive meaning, as evident by Sam's comment: "The words don't tell you everything, but the pictures tell you the rest of the stuff."

LOUIZA MALLOURI CONDUCTED HER RESEARCH ON LAUREN CHILD'S *WHO'S AFRAID OF THE BIG BAD BOOK?* WITH SEVEN- AND EIGHT-YEAR-OLDS.

Child's books and videos have had huge popular appeal. *Who's Afraid of the Big Bad Book?* is a dazzling sequel to Child's *Beware of the Storybook Wolves* where our protagonist, Herb, once again gets himself into scrapes with storybook characters. Herb functions both as a character who is constructed within the text, as well as an authorial figure that changes the

structure of the text (McCallum 1996) as he snips holes and draws escape doors to avoid unpleasant confrontations with the infuriated fairy tale heroes. The format and design of *Big Bad Book* subverts traditional forms and conventions; print appears in a variety of fonts in a dynamic fashion—twisting, dancing, ascending, descending, and curling around objects according to what is being communicated each time. Furthermore, Child has created a book which requires "tactile engagement" (Kress 188); with holes to peep through, pages to unfold, sentences written upside down, and artwork that invites pointing and touching, thus foregrounding its own nature as an object, an artefact to be handled and manipulated as well as read. In this text, as we shall see, "readers are given agency" (Pantaleo, "Postmodernism, Metafiction" 35).

Narrative Framing Devices

Not only is the metafictive evident in the thematic and plot elements of this picturebook, but it also permeates peritextual features such as the front cover. Here Herb is presented reading the same book we are about to start reading. The small picture of the book within the larger "actual" book, often called *mise en abyme* (McCallum; Nikolajeva & Scott), was appreciated by Ellie:

> Ellie: That's quite funny because he's on a book and he is in a book and he is in a book! . . . [*pointing at Herb in the little picture*] And so he is in a book and it goes on forever . . . cause he's reading the book we are reading.
>
> L: What did you think of that?
>
> Ellie: Quite cool?
>
> David: It's funny because we are reading it now and he's reading it there except in this book, Herb is in it and when he is reading it right now he is not in it.

Child's picturebook engaged the children in critical thought about textuality and challenged them to read interpretively and at abstract levels of understanding (Philpot). They drew conclusions through crossing and recrossing the fluctuating boundaries between fiction and reality:

> L: "And that's when it dawned on Herb that he had fallen into the book."
>
> Ellie: That's figurative language I think, 'cause you can't really fall into a book, can you?

The children recognized that Herb was no less fictional than the rest of the fairy tale heroes.

L: How can Herb get in the book?

Ellie: Because he is shrunk.

David: And is not a real person!

Claire: It's not a real story.

David: And he is not a real person!

Claire: No one can really get in a book in real life.

David: And he is not a real person!

Herb, then, is one of us, a reader, but then again he is not, as he is also a character in a picturebook. This inventive alignment of readers' fictional worlds and the world of lived experience put "questions of fictionality on display" (Mackey, "Metafiction for Beginners" 185). For example, the children conceded to Herb's authority to tamper with his surroundings and alter the fiction of which he is part (Lewis 85), thus differentiating him from the other fairy tale heroes:

L: Can all characters do that? Let's say the Queen?

Claire, David, Ellie: No, no!

David: No, cos if you think, she's been in the story the whole time and Herb has only been in there for a little while, because he is in the book, he is not normally in the book he found all the things he did to the book.

The text entices readers into a notional game that takes place between reality and textual fantasy, creating a puzzle to solve. The children found this amusing and the reading of the book was punctuated with bubbles of laughter.

Playing with Typography

Aspects of typography such as the size, typeface, position of display lettering, length of lines, spacing between lines, and break of lines (Doonan) are consonant both to what is being signified and the accompanying illustrations. The children felt that both pictures and words were equally important to them in this picturebook. Claire stated, "Well, both really because there are pictures of falling down chairs and he drew phones everywhere and then there is like real outside pictures and I like words because Goldilocks shouts and the daddy one is like really he is got bold writing because he is big . . . And the baby one's got small writing because he is small."

Child has integrated words into pictures and has, thus, created a picturebook that appears to be "genuinely composite: a single fabric woven from two different materials" (Lewis 4). Claire noticed that the font of the letters communicates the feelings or the status of the person who articulates them.

Ellie would raise or lower the pitch of her voice and alter its tone according to how words were written. When I asked why the text is written in this way, David reported that he could hear the voices: "Because it's kind of speaking."

Intertextuality and Performance

According to Nikolajeva and Scott "intertextuality presupposes the reader's active participation in the decoding process" (228). This participation can be illustrated by the responses of the children to the relocation of known fairy tale characters in a new context. For example, David stated, "It's really interesting. . . . 'cause you got loads of fairy tale characters, and the characters are set out differently 'cause if you look at this page Hansel and Gretel are not anything like that 'cause in the real fairy tale they are poor and they don't look poor in that page 'cause he's got a haircut, he's got real clothes!" David's unspoken comment could also refer to the arbitrariness of pictures as "iconic signs" (Nodelman 131) and the gap between the representations of reality and their ascribed meanings. Similarly, Claire was puzzled but welcoming to the collaboration of two fairy tale heroes who normally inhabit their own story worlds:

> Claire: That really . . . It's weird because you don't normally have Goldilocks in the story with the stepmother because they are all from different stories and they just they like put them together to make another story.
>
> L: Did you like it?
>
> Claire: Yeah! Because they are like working together but they are both from different books, they are working together and help making Herb run away . . .

As the fictionality is made explicit, readers are distanced from the text and are made aware of the constructedness of the story and its potential to be reconstructed. Child created a three-dimensional world in a two-dimensional surface and invites readers to play with words, meanings, and realities, as she does in the book. The back cover, for example, became a playful site of intertextual abandon where children took on the voices and personalities of the characters as this lengthy extract from the discussion makes clear:

> L: Who is that?
>
> Claire: Herb.
>
> David: No! No! It's Goldilocks!
>
> [*All laughing*]
>
> David: [*Pretending to be Herb trapped in the body of Goldilocks*] Oh my goodness, look at my hair!

[*All laughing*]

L: What is she doing here?

Claire: She's writing, she's writing.

David: I can't stand my hair, please send a hairdresser!

[*All laughing*]

Claire: She's writing because she wants to be the best star. [*Reads from the cover*] "The divinely . . ."

Ellie: I love Lauren Child! [*She takes the book and kisses it*]

David: [*Looking at Ellie*] She could jump out of it and kiss you on the lips!

[*All laughing*]

David: If pictures are real and people can jump out of books . . .

Ellie: Yeah, that would be so cool! And they will come alive. . . . And then imagine it happen . . . Imagine!!

Here conventional classroom discussion is abandoned as the children use the book as a launching pad for the expression of their own creativity (Sipe, "Talking Back"), as a stage to enact their own narrative, to tell their story and make it their own. Their sheer delight in this delicious enterprise is best expressed by Ellie as she fondles the book announcing, "I love Lauren Child!" The intellectual game has provoked a strong emotional response, her imagination exploding with the world of possibilities. If pictures were real and characters could come alive—"Imagine!"

BILINGUAL LEARNERS RESPONDING TO POSTMODERN PICTUREBOOKS

Several recent studies have focused on the literacies of ethnic minority readers and some have looked at how they make sense of children's literature in English. However, only a few of them have concentrated on picturebooks. Research by Gregory, Bromley, Colledge, Laycock, Mines, Walsh ("Reading Pictures" and "Text-related Variables"), Coulthard and also by researchers working within other cultures (see Enever and Schmid-Schönbe in 2006) have explored the role picturebooks can play in the development of emergent readers and in the integration of children from culturally diverse backgrounds to their new communities. All of them provide evidence that shows how, despite the cultural gaps, the picturebooks managed to activate a range of cognitive and affective processes in readers, regardless of their level of English proficiency. They also reveal ways in which readers create connections between their previous literacy experiences and their culture and how they can enhance the meanings generated by their peers through dialogue and other means of interaction.

Mary Anne Wolpert used Mini Grey's *The Pea and the Princess* with ten-and eleven-year-old bilingual pupils.

The Pea and the Princess is a parody of the traditional tale, narrated from the Pea's point of view. Plucked from obscurity by the Queen, the Pea relates the Prince's unsuccessful search for his Princess, which results in a scrap-book of unsuitable candidates and an irritated Queen. The eponymous hero is subjected to months of darkness under a pile of mattresses, feather beds, and would-be Princesses. Finally, a girl referred to in the text only once, yet who has been visible working in the Palace gardens throughout, is whisked off for trial-by-mattress. She triumphs, marries her Prince, and the Pea emerges exultant in its very own glass case on display in a museum. The written narrative supplies a chronological sequence, while pictures bleed off the pages, inviting consideration of an untold narrative. Readers are encouraged throughout to take an active role, with the illustrations teaching the conventions of narrative and conveying emotion (Graham).

The principal aim was to investigate how a postmodern picturebook is read by children at different stages of English language acquisition and from a variety of cultural and linguistic backgrounds, including those identified by their teacher as struggling readers. Heath has demonstrated how the literacy traditions children are socialised into differ according to cultural context and that they learn different ways of being readers through social involvement. *The Pea and the Princess* fitted into what the children already knew about a range of stories, media texts, and personal experiences, illustrating, as Kendrick and McKay stated, a "rapidly increasing fusion of text forms embedded in children's lives" (109). The depth of deductive and inferential reasoning displayed by the children was impressive and Grey's inventive picturebook offered them a way of demonstrating thinking that had previously been unrecognised by their teachers.

Reading Word and Image: Filling in the Gaps

The children enjoyed the pictures, which with the relatively bland written text employ what Nikolajeva and Scott call "perspectival counterpoint" (233). There is much use of internal framing, and the gap between the plot-telling of the words and the depiction of the characters invites readers to create their own stories and alter the narrative thrust of the text. Sana, schooled in England all her life and diagnosed with a language processing disorder, commented, "It's winter here. She was by herself and she wasn't the princess then [in the first endpapers] but now they're married it's a much brighter place . . ." She showed not only an empathetic insight into the princess's state of mind, but also an appreciation of Grey's use of colour as a metaphor. Sana was reaching beyond the literal to a level of understanding at odds with her un-graded performance in national tests. So too Rajveer, who had begun to read English less than two years ago, yet was alert to the use of visual signifiers to denote themes and emotions. "It was

winter in the front page and there's only one bird flying and the cat is not playing around properly . . . there's only one frog. In summer when them two got . . . get happy there's two birds . . . and the cat is entering and playing around and there's two frogs and they got married."

The children also interpreted the way Grey used spatial organisation, repetition of visual motifs, and the gaze as visual connectives and conjunctions. Rajveer remarked, "The Prince saw the lady was trying to cut some trees. He's looking at her." And later, "When the girl came he was smiling and looking like he was start[ing to fall] in love with her." Sana questioned the girl's motives: "Was she really chopping the wood or was she just eardropping [eavesdropping]? I think it was her plan. . . ." Kumar commented, "He's going to marry her because every single page her picture comes up." In reading the text, children showed how aware they were of voices, intonation, stance, gesture, and movement as well as print and image, using what Browne describes as, "a visual language which would tell part of a story that the words don't tell" (186). Indeed, the children always referred to the pictures to interpret how the characters were feeling and often inferred emotions through body language and tone of voice. Rajveer interpreted the mood, using his whole body and voice, "The queen is so angry. By looking at the face and the eyes. I mean the eyebrows. If it's like that [drawn in one straight line] it means angry. I saw in the TV in a programme they draw it like angry, sad. And I can say her hands, her arms are fold[ed] . . ."

Ibrahim and Amir drew more analogies with their reading of media texts, showing technical understanding as they commented on Grey's use of perspective:

Ibrahim: She has made it 3D. Like perspective.

Researcher: Can you explain to me?

Ibrahim: It makes it stand out more so it makes it more like 3D, like it's actually moving. Like we're looking from down and she's looking from up. The camera angles are on top of her.

Amir: Like TV.

Ibrahim: Like TV. Yeah cartoons.

There were different opinions about the relative merits of words and pictures. Amir stated, "It's better if you make up your own words. When I'm reading something I can look at what happening instead of imagining it. . . . Pictures are exciting to see and they give me a better idea than the words." Ibrahim noted that "It would be better [without words] because it's like a challenge. It's like, a picture, now you can make up your own words . . ." Kumar believed, "Pictures show us the expressions and the background. It's like you can guess . . . challenging us, it's kind of fun." References to and questions about visual features were alluded to throughout the interviews and we found significant evidence of children's artistic

understanding. They were able to infer meanings in the text, "and so spur the reader into co-coordinating these perspectives" (Iser 169).

Intertextual Links: Creating Shared Worlds

Sipe ("Talking Back") argues that intertextual links enable readers to make hermeneutic and aesthetic connections, entering the books, to play, perform, and create their own stories. He claims that readers continually forge links between their history as readers and what is in front of them, resulting in a complex tissue of interrelated texts. Our question was which, if any, intertextual links would resonate with bilingual learners? The notion of heteroglossia (Bakhtin 1981), with multiple voices acting on multiple planes of meaning, illuminates how this text echoed with the voices of those that came before in a language reverberating with previously acquired cultural, social, linguistic, literary, and visual experience to add texture and meaning for these young readers. On a double-page spread with a variety of would-be princesses, photographed by the prince, Ibrahim made literary analogies: "This one reminds me of when she's sleeping like for a thousand years and the prince comes and kisses her and then she wakes up. This one is when the princess and the frog . . . This one Cinderella." Sana noted, " . . . and this pink one [is] like Barbie. . . ."

Unlike Kenner and Gregory, who found evidence of children actively bringing their reading experiences of home languages into the classroom, the children in this study were not accustomed to using their mother tongue in school and asserted that they did not know many stories from their own cultural backgrounds. However, as the interviews progressed, the "blue touch paper" (Bromley 103) of recognition was lit as they began to talk about stories from their home cultures. Kumar drew parallels with Tamil stories and was able to recognise metafictive techniques authors use to entice their readers. "This like my mum used to tell me, some God stories in comic books and they made it into funny stuffs. It was written seriously in olden days but now they changed it in funny stuff to make people laugh." Rajveer related two stories from Hindu and Muslim traditions which both illustrated the "familiar morals and values" (Gregory 134) he had noticed in *The Pea and the Princess*. "These lady's mum and dad are so poor and they [the queen and prince] are rich. They will become poor and to stay rich they will have to help poor people."

Mines suggested that the way children in her study, who were at various stages of English language acquisition, responded to pictures was determined by a mental template that was largely cultural in construction. In this case, the cultural construct to which the children referred most frequently was a shared selection of contemporary visual texts through which they were able, as Dyson observed, to "forge identities which are shared by a group, mark out their common cultural territories and feel part of a network which extends beyond their immediate home environment" (190).

Linguistic and cultural differences were transcended by the intertextual analogies the children made to visual texts and popular culture. Indeed, the children could read between the lines and pictures, read layers of meaning, read a wide range of cultural references, cross-refer to other texts, fill in the gaps, and generally handle various studies of complexity with apparent ease (Watson and Styles 180).

THIS CHAPTER CONCLUDES WITH RESEARCH UNDERTAKEN BY EVELYN ARIZPE AT THE UNIVERSITY OF GLASGOW USING OLIVER JEFFERS' *THE INCREDIBLE BOOK EATING BOY* WITH TEN- AND ELEVEN-YEAR-OLD BILINGUAL PUPILS.

The Incredible Book Eating Boy is Jeffers' third award-winning picture-book. In a straightforward manner, the text tells the story of a boy who likes to eat books. The strange thing is that the more books Henry eats, the brighter he becomes! However, because he begins to swallow books whole and does not "digest" them properly, he begins to feel ill and all the information gets confused. Finally, he stops eating books and discovers that he can also "get smart" by reading them. The last sentence in the book is "Now, Henry reads all the time . . . although every now and then [. . .]." In the place of the words that should complete this sentence is a bite mark: the whole bottom left hand corner of the book is missing. As he has done throughout the text, this final visual and tactile joke draws the reader's attention to the physicality of the book, to the fact that it is made of paper and cardboard and that as such it has an ephemeral quality: it can be cut, torn, scribbled on and, even, bitten. The visual aspect of the picturebook is based on this metafictive idea, as the images appear to be drawn on discarded bits of books—covers, spines, and endpapers—most of which are torn, crumpled, or stained. In this way, the picturebook makes a statement about books as objects of "consumption" and conveyors of knowledge. As Eshan (Pakistani-Scot) said, "all this book is about books."

The project on which this research is based, *Learning to Read a New Culture*, involved reading and talking with immigrant and asylum-seeking children about children's fiction in order to explore issues of literacy and meaning making as well as identity and belonging (McGonigal and Arizpe). As in Wolpert's study above, this group of ethnic minority children in their last year of primary school were capable of making responses to texts that were more mature than their language levels suggested, including audience awareness and critical judgement, achieved within a context of dialogue and discussion where meanings were negotiated with attention to textual evidence and the opinions of others.

As well as finding out how children responded to the postmodern features of these picturebooks, they were also asked to imagine how a younger child

might react and whether there was anything in the picturebook that might need explaining. In this way it was possible to get some insight into what they themselves made of the book through the discussion of the challenges it posed for a younger audience. In what follows, the focus is on Jeffers' postmodernist style and design techniques, his parody of "consuming" books for knowledge and his use of self-referential and metatextual play.

Most of the replies to what younger children might find difficult to understand about Jeffers' text were based on literal readings of words and pictures, highlighting the difficulty of the language. Our sample usually decided that the "wee ones" would like the book and even think that it was "cool." However, most of them expressed worries that younger readers would want to imitate Henry and start eating books or drawing on them! This concern was closely connected to their simple understanding of why Jeffers had made this book: to teach children to read rather than eat books, get smart by reading and studying, and to eat healthy food.

The children were most intrigued by the illustrations, particularly the "writing at the back." Although they lacked the technical vocabulary for describing the artistic techniques employed by Jeffers, they were able to discuss basic features such as style, colour, and pattern. Several compared his style to "comics" or "cartoons" and they also recognized thought and speech bubbles, marks indicating movement, onomatopoeia, cliff-hangers, and the use of fonts for making things "stand out" or have "effect" and "expression." Most of them agreed that younger readers would not have problems understanding this sort of visual grammar because they were familiar with cartoons and comics.

They were particularly interested in the way Jeffers had superimposed the letters, the drawings, and the photographic images on the pages and whether he had "stuck" things on or used a computer. The backgrounds prompted them to pore over each spread. Soraya (Malaysian) perceived the background words as ornamental ("patterns") made of letters instead of flowers; Eshan thought they were "very imaginative" and "added more detail." The boys believed Jeffers' choice of paper drew the reader's attention:

Abdul (Algerian): In other books [you] just get white paper, white, white. Well he use line papers or something on papers that makes it more exciting [so] we like to read this book lots of times.

Gabriel (Congolese): He's got like lots of different paper . . .

Abdul: That's good so you don't get bored with the same thing.

Gabriel: Yeah and like the background is much much much nice for the wee ones because they're gonna go "oh look!" . . .

After the first few pages, the children realized that the words on these backgrounds did not have a direct effect on the main narrative, but they were concerned that younger children might be confused and try to read them.

However, Jeffers' print backgrounds provided subtle intertextual references.[4] Towards the end of interview, the children began to notice these and relate the background papers to the story; for example, Andzej (Slovakian) said there was a map because "maybe he was travelling" and Neylan (Turkish) said he used graph paper because "it's like paper you'd use in class."

The "bite" at the end of the book was a source of much excitement, laughter, and speculation, particularly as the researcher had kept it out of sight until the end of the book was reached.

> Researcher: [*reading*] "although every now and then . . ."
>
> Abdul: A hole!
>
> Researcher: What happened there?
>
> [*All laughing*]
>
> Abdul: Because he's eaten books and this book is eaten a wee bit, so he's trying to say it was him that ate it!
>
> Gabriel: You think it looks normal, but when you look at the back there you find somebody who ate the book [. . .] I think that's a good idea because [reads ending] if you read that to the wee ones they'll say 'the guy ate this book' and they're gonna go "Oh that's so cool!" [. . .] They'll think Henry ate the book!

Research on bilingualism has demonstrated that young children who participate in cross-linguistic and cross-cultural practices call upon a greater wealth of metacognitive and metalinguistic strategies (Cummins; Gregory). In many ways they are better positioned to understand more complex texts as they are also more used to having to draw upon meaning-making skills in order to adapt to their contexts. However, the cultural reading traditions can also mean that they sometimes need help to go beyond the literal approach. *The Incredible Book Eating Boy* proved to be an interesting stimulus in this sense, because the written text is deadpan but the illustrations shocked them into going beyond literal meanings, encouraging a more creative interpretation of the picturebook. The children were clearly challenged by its "weirdness" and, as they discussed the unusual features, were able to increase their enjoyment of the postmodern stylistic features as well as their critical understanding of the idea of books making you smart.

CONCLUSION

The results from the studies summarized above support the findings of *Children Reading Pictures* (Arizpe and Styles), such as the sophisticated negotiations, the cognitive skills, and the enjoyment of the challenges that are part of the process of reading text and image in picturebooks. As Mallouri concluded in her study: "Far from being intimidated, the children entered the book and

took over those blank spaces, filling the silences with roars of laughter and the gaps with all kinds of play."

The findings show how children respond to the specific features that define postmodern picturebooks, taking disruptions and ambiguities in their stride and distinguishing between different narrative frames. Their "performance" of the text and their interest in how the images were created also attest to the physicality of their response to challenging postmodern texts and their interest in the materiality of the book.

Although children from other cultural backgrounds sometimes needed more explanations and prompts to make sense of the picturebook, visual texts from popular culture, particularly media texts, provided intertextual bridges to understanding. More importantly, the studies by both Wolpert and Arizpe suggest that it was the stimulating combination of words and pictures in their chosen picturebooks that enabled bilingual children to look beyond a literal approach to the text, into the multiplicity of meanings as well as how these were constructed.

Throughout this research, we see children interacting, often physically, with perplexing narratives. We hear their voices reconstructing the stories in ways that made sense to them, almost like a voice-over putting the puzzles back together. Stunningly clever, aesthetically appealing picturebooks make this intellectual feat hugely enjoyable. The children were aided in their endeavours by the huge range of contemporary visual media they have access to, all the time laughing and playing as they orchestrated a complex array of elements with flair and grace.

NOTES

1. This chapter contains large chunks of writing produced by Kate Cowan, Louiza Mallouri, and Mary Anne Wolpert during a Master's course taught by Morag Styles. We have taken some licence (with their permission) in editing their work. All the children's names have been changed for anonymity.
2. The mixed-ability pupils were selected by their class teachers on the basis of those who might benefit most out of the experience of looking closely at picturebooks. The cohort included those who had read a wide variety of picturebooks and those to whom the genre was new.
3. See Introduction to *Children Reading Pictures* (2003) pp. 1–15.
4. Not surprisingly, some intertextual/cultural references proved difficult to grasp without some explanation from the researcher. For example, the text tells us that Henry loved to eat storybooks and the illustration shows a plate with chips and peas and also the book *Moby Dick*. It was not until the researcher explained that this was a book about a whale that they understood the "fish and chips."

WORKS CITED

Arizpe, Evelyn, and Morag Styles. *Children Reading Pictures: Interpreting Visual Texts*. London: Routledge Falmer, 2003.

Bakhtin, Mikhail. *The Dialogic Imagination: Four Essays by M.M. Bakhtin.* Translated by Caryl Emerson and Michael Holoquist. Austin, TX: University of Texas Press, 1981.

Bearne, Evelyn. "Ways of Knowing; Ways of Showing-Towards an Integrated Theory of Text." In *Art, Narrative and Childhood,* edited by Morag Styles and Evelyn Bearne, ix–xxvii. Stoke-on Trent: Trentham Books, 2003.

Bromley, Helen. "'Madam! Read the Scary book, Madam'—The Emergent Bilingual Reader." In *Talking Pictures,* edited by Victor Watson and Morag Styles, 136–144. London: Hodder and Stoughton, 1996.

Browne, Anthony. "Making Picturebooks." In *The Prose and the Passion,* edited by Morag Styles, Eve Bearne and Victor Watson, 176–198. London: Cassell, 1994.

Colledge, Marion. "Baby Bear or Mrs Bear? Young English Bengali-speaking Children's Responses to Narrative Picturebooks at School." *Literacy* 39 (2005): 24–30.

Coulthard, Kathy. "'The Words to Say It': Young Bilingual Learners Responding to Visual Texts." In *Children Reading Pictures: Interpreting Visual Texts,* edited by Evelyn Arizpe and Morag Styles, 164–189. London: Routledge Falmer, 2003.

Cummins, Jim. *Negotiating Identities: Education for Empowerment in a Diverse Society.* Ontario CA: CABE, 1996.

Doonan, Jane. *Looking at Pictures in Picturebooks.* Stroud, UK: Thimble Press, 1993.

Dyson, Anne Haas. *Writing Superheroes.* New York: Teacher's College Press, 1997.

Enever, Janet, and Giselle Schmid-Schönbein, eds. *Picturebooks and Primary EFL Learners.* Munich: Langenscheidt, 2006.

Graham, Judith. *Pictures on the Page.* Exeter, UK: NATE, 1990.

Gregory, Eve. *Making Sense of a New World.* London: Paul Chapman, 1996.

———, and Clare Kelly. "Bilingualism and Assessment." In *Assessment in Early Childhood Education,* edited by Geva M. Blenkin and A. Vic Kelly. 144–162. London: Paul Chapman, 1992.

Heath, Shirley Brice. *Ways with Words: Language, Life and Work in Communities in Classrooms.* Cambridge, MA: Cambridge University Press, 1983.

Iser, Wolfgang. *The Act of Reading.* London: Routledge and Kegan Paul, 1978.

Kendrick, Maureen, and Roberta McKay. "Drawing as Alternative Way of Understanding Young Children's Constructions of Literacy." *Journal of Early Childhood Literacy* 4.1 (2004): 109–128.

Kenner, Charmian, and Eve Gregory. "Becoming Biliterate." In *Handbook of Early Childhood Literacy,* edited by Nigel Hall, Joanne Larson, and Jackie Marsh, 178–187. London: Sage, 2003.

Kress, Gunther. "Multimodality.". In *Multiliteracies: Literacy Learning and Design of Social Futures,* edited by Bill Cope and Mary Kalantzis, 182–202. London: Routledge, 2000.

Laycock, Liz. "A Way into a New Language and Culture." In *What's in the Picture? Responding to Illustrations in Picturebooks,* edited by Janet Evans, 79–95. London: Paul Chapman, 1998.

Lewis, David. *Reading Contemporary Picturebooks. Picturing Text.* London: RoutledgeFalmer, 2001.

Mackey, Margaret. "Metafiction for Beginners: Allan Ahlberg's *Ten in a Bed.*" *Children's Literature in Education* 21.3 (1990): 179–187.

———. "'The Most Thinking Book': Attention, Performance and the Picturebook." In *Art, Narrative and Childhood,* edited by Morag Styles and Eve Bearne, 101–114. Stoke-on-Trent: Trentham Books, 2003.

McCallum, Robyn. "Metafiction and Experimental Work." In *International Companion Encyclopedia of Children's Literature*, edited by Peter Hunt, 397–411, London: Routledge, 1996.

McGonigal, Jim, and Evelyn Arizpe. *Learning to Read a New Culture*, forthcoming e-publication, 2007.

Meek, Margaret. *How Texts Teach What Readers Learn*. Stroud, UK: Thimble Press, 1988.

Mines, Heather. *The Relationship Between Children's Cultural Literacies and their Readings of Literary Texts*. Unpublished PhD thesis, University of Brighton, 2000.

Nikolajeva, Maria, and Carol Scott. *How Picturebooks Work*. London: Garland Publishing, 2001.

Nodelman, Perry. *Words About Pictures*. London: University of Georgia Press, 1988.

Pantaleo, Sylvia. "Postmodernism, Metafiction and *Who's Afraid of the Big Bad Book?*" *The Journal of Children's Literature Studies* 3.1 (2006): 26–39.

———."Young Children Interpret the Metafictive in Anthony Browne's *Voices in the Park*." *Journal of Early Childhood Literacy* 4.2 (2004): 211–233.

Philpot, Don K. "Children's Metafiction, Readers and Reading: Building Thematic Models of Narrative." *Children's Literature in Education* 36.2 (2005): 141–159.

Sipe, Lawrence R. "Talking Back and Taking Over: Young Children's Expressive Engagement During Storybooks Read-alouds." *The Reading Teacher* 55.5 (2002): 476–483.

———."Those 2 Gingerbread Boys Could be Brothers': How Children Use Intertextual Connections During Storybook Readalouds." *Children's Literature in Education* 31 (2000): 73–88.

Walsh, Maureen. "'Reading' Pictures: What do They Reveal? Young Children's Reading of Visual Texts." *Reading* 37 (2003) 123–130.

———."Text-related Variables in Narrative Picturebooks: Children's Responses to Visual and Verbal Texts." *The Australian Journal of Language and Literacy* 23 (2000): 139–156.

Watson, Victor, and Morag Styles, eds. *Talking Pictures*. London: Hodder & Stoughton, 1996.

CHILDREN'S LITERATURE CITED

Bartram, S. *Dougal's Deep-Sea Diary*. Dorking: Templar, 2004.
Child, Lauren. *Who's Afraid of the Big Bad Book?* London: Hodder, 2002.
Grey, Mini. *The Pea and the Princess*. London: Red Fox, 2004.
Jeffers, Oliver. *The Incredible Book Eating Boy*. London: Harpercollins, 2006.

15 First Graders Interpret David Wiesner's *The Three Pigs*
A Case Study

Lawrence R. Sipe

In this chapter, I analyze the responses of a first-grade class (six-year-olds) to a one-time reading of David Wiesner's brilliant postmodern version of *The Three Pigs*. By doing so, I will demonstrate that young children can rise to the challenge of this complex text by doing hard interpretive work, and, in the process enjoy a great deal of intellectual pleasure[1]. Before I report on the children's responses, however, I will (a) briefly summarize Wiesner's book; (b) contextualize the children's responses by providing some background information about the classroom and the teacher; and (c) describe how I analyzed the case study data. After these preliminaries, my goal is to highlight and interpret the children's voices as they puzzled their way through this complex text.

WIESNER'S POSTMODERN TALE

Wiesner's *Three Pigs* begins in the traditional manner. The pigs build their houses of straw, sticks, and bricks, and the wolf comes prowling. As soon as the wolf blows down the straw house, however, Wiesner departs radically from the conventional versions of the story and into an intertextual adventure. The wolf's lung power is more than he bargained for, because the pig literally gets blown out of his own story. He appears at the stick house of his friend[2], and there the same thing happens. All three pigs find themselves "outside" the story world, and using a page from their own story, they construct a paper airplane, which they use to fly to . . . another story, evidently an illustrated version of the nursery rhyme, "Hey, Diddle, Diddle." The illustrations in this book are purposely cartoonlike, with crude colors, and the pigs do not like the way they look, so they decide to move quickly out of the nursery rhyme book (with the "cat and the fiddle" accompanying them) into . . . yet *another* story, illustrated in sepia line drawings. This story is the typical dragon-guarding-a-treasure tale. They leave this tale with the dragon in tow, and find themselves in a liminal space, a "place between," a virtual library of stories represented by "storyboards" (as the teacher in the study called them). Instead of exploring more stories, the pigs decide to

return to their own tale, where, with the help of the dragon, they scare the wolf away and live (with the dragon and the cat as permanent immigrants) happily ever after.

THE CLASSROOM, THE TEACHER, AND RESEARCH METHODS

The setting for the storybook readaloud was a classroom in a public elementary school (prekindergarten through sixth grade) located in a middle-class suburban community in the Northeastern United States. The class consisted of thirteen European-American children (seven boys and six girls). In this self-contained classroom, there was a large library of children's books and other print-rich elements, such as posters, displays of children's work, and computers. There were two picture storybook readalouds each day: one in the morning, and one immediately after lunch. The classroom teacher, Ms. Blair (all names are pseudonyms) conducted these readalouds in an interactive manner (Barrentine), encouraging the children to respond orally to the text and illustrations before, during, and after the reading of the story. In other words, the children were not expected to wait until the end of the story before making comments; indeed, they responded enthusiastically after every page.

Ms. Brightman, a graduate student who conducted the readaloud, was a volunteer in Ms. Blair's classroom for two days each week from January through May. She led a variety of literacy activities with the students, including reading aloud to them. The data for the study were collected in March; thus, the children were quite familiar with Ms. Brightman, and considered her another teacher; moreover, they had already engaged with hundreds of picture storybooks.

It is also important to note that the readaloud of the Wiesner version of *The Three Pigs* was the last in a series of readings of other versions of the tale, including variants by Marshall, Kellogg, and Scieszka. This sequence was carefully chosen to constitute a sequence of versions that began with the most traditional rendering of the tale, continued with variations that increasingly departed from the well-known story, and ended with Wiesner's version. Our reasoning was that, for full appreciation of Wiesner's postmodern antics, the children had to be clearly aware of the base from which Wiesner was departing. Although the children had heard other books by Wiesner, they were relatively unfamiliar with postmodern picturebooks.

My research question was: what major themes emerge when first graders respond orally to Wiesner's *The Three Pigs*? After the readings, Ms. Brightman transcribed the discussions, since she was in the best position to recognize individual children's voices. Using the transcript (the first stage of data reduction [Marshall and Rossman 113]), I analyzed the children's

and teacher's words by standard qualitative content methods, with two units of analysis: the conversational turn, "everything said by one speaker before another speaker continues the conversation" (Sinclair and Coulthard) and the topic unit (Roser and Martinez) that chunked the data into topics of discussion. Strauss and Corbin's three-stage model of qualitative content analysis was employed: (a) assigning conceptual labels to each conversational turn and topic unit; (b) grouping the conceptual labels into a manageable number of conceptual categories; and (c) relating the categories to each other, in order to provide a grounded answer to the research question.

FIRST GRADERS' RESPONSES

Close Examination of Peritextual Features

The children were clearly accustomed to talking about the peritext (Genette; Higonnet), including the dust jacket, front and back covers, endpapers, title page, etc., of picturebooks, and they made the most of the information they got from it. Indeed, the first responses after the teacher read the title *The Three Pigs* started a thread that ran throughout the entire discussion:

> Steven: *The Three Grownup Pigs.*
>
> Nathan: They're real pigs.
>
> Norman: They're, they look like *real* three pigs. And in the other stories, the other pigs didn't really look a lot like real pigs.
>
> Morgan: They're pigs like animal pigs and the other ones are like people pigs.
>
> Teacher: There are animal or people pigs, oh, what do you mean by people pigs?
>
> Steven: Like they walk on their two feet. They talk.
>
> Mandy: And they wear clothes.
>
> Nathan: These [*gesturing toward the front dust jacket cover*] are going to die.

In this interesting vignette, Steven is quick off the mark to observe that, rather than *The Three Little Pigs*, this title and the accompanying illustration suggest that these are "grownup pigs," and that already this story is going to be a little different. Nathan then begins an exchange of ideas relating to the fact that these are "real" pigs as opposed to what Morgan terms "people pigs"—anthropomorphized pigs that talk, walk upright, and wear clothes. Nathan logically predicts that, because these pigs are not the usual cute, "people" type, they will die: in other words, that their real appearance is a foreshadowing of a more realistic plot.

After examining the grey board covers with their blind stamping of three pigs in a circular design, the children ascribed some semiotic significance to the color: "the piggies are sorta that color." They also discussed the back dust jacket cover, and were not surprised to see a brick house. They were, however, puzzled by the presence of the cat (which they would later recognize as the cat from the nursery rhyme "Hey Diddle Diddle"). They also had several ideas about the light tan color of the endpapers: "because the wolf is that color" or "their houses are that color," or a "piggy color," because two of the three pigs on the front dust jacket cover are a similar color. Clearly, they had been taught to take nothing for granted in the design of a picturebook.[3]

The title page, with its illustration of the three pigs carrying their loads of straw, sticks, and bricks, confirmed the children's expectation that the pigs would build houses of these materials. The illustration depicts the pig with the straw in the foreground, the pig with the sticks in the middle ground, and the pig with the bricks farthest away in the background.

> Steven: They're actually real pigs.
>
> Alex: I bet I know why the, that one, the straw is in the middle.
>
> Teacher: Why?
>
> Alex: Because that one comes first and then if you look right there [*pointing to the far left with the partial illustration of the pig with the sticks*] it's a little bit closer because it goes second and that one is far [*pointing to the pig with the bricks*] and it's third.

In this vignette, we see Steven's continued fixation on the idea that these pigs look real; it is both a continuation of the discussion of the front dust jacket cover and a precursor of the idea of what constitutes "real" in this story. Indeed, the children understood that the pigs became even more "real" when they left the story, only to assume less real characteristics when they entered the two subsequent stories in the course of their adventures. Another noteworthy observation is Alex's comment that we shouldn't read the order in which the pigs build their houses from left to right, but rather from foreground to middle ground to background—a sophisticated interpretation of the illustration. However, the peritext as a whole gives only subtle clues that the story is going to be quite different from the versions the children had heard before. Only the "real" quality of the pigs and the presence of the cat on the back dust jacket cover suggest that anything out of the ordinary will happen. Alex's appreciation of the design elements through his close inspection of the title page illustration and his prior intertextual knowledge of the order of straw, sticks, and bricks is also an indication that the children will be examining the illustrations very closely—something that came to be very important as they navigated their way through the story.

Cognitive Dissonance

The first opening of the story, beginning "Once upon a time . . ." continues the traditional course of the tale; the children recognized the phrase "went out into the world to seek their fortune" and that the first house would be built of straw. However, it was on the second opening that the children's firmly built schema for *The Three Pigs* began to fall apart. Their puzzlement is evident in their responses to the first pig breaking the frame and looking more "real" by being covered with bristles as he yells, "Hey! He blew me right out of the story!":

> Steven: It looks like he's falling out of the story!
>
> Melanie: It says "I'll blow your house in" like the other one.
>
> Anthony: I don't think he's in the story.
>
> Steven: 'Cause it looks like he's falling.
>
> Mandy: It looks like he's falling . . . out.
>
> Dominique: Cuz, cuz, cuz, if he was in the, cuz it kinda looks like
> . . .
>
> Steven: He's real!
>
> Dominique: He's got hairs.
>
> Mandy: It doesn't make sense.
>
> Teacher: Look at what it says up here . . . [*reading*] **and ate the pig up**.
>
> Dominique: Huh!?

Here we see that, despite Melanie's observation that the story is proceeding along a familiar route, the other children express their surprise. Dominique's hesitating comment, "Cuz, cuz, cuz . . ." reveals her struggle to understand, and Steven sees that the pig looks more real as the frame is broken because "he's got hairs." Mandy sums it up: "It doesn't make sense." But the teacher simply reads the familiar words, " . . . and ate the pig up."

At this point, the children were very confused, and tried their best to reconcile the clear contradiction between the words "and ate the pig up" with the illustration, which shows the pig—very much alive—and the confused wolf, surrounded by the shattered remnants of the straw house. The children strove valiantly to explain this with their established story schema, as well as their conviction that words and pictures must complement and match each other. After all, intertextual knowledge had served them well in interpreting previous versions of the story. And yet, far from confirming their expectations, this knowledge served only to confuse them:

> Mandy: How does he eat him up?
>
> Dominique: [*in a wondering tone*] He blew him out of the story.

(1) Steven: Maybe he jumped out of the story with him and ate him.

(2) Tim: Maybe the wolf's looking for him.

Dominique: No.

(3) Alex: And *then* he ate him up.

(4) Dominique: Pretend he was, maybe he was just joking that he ate him up.

(5) Alex: Maybe he thought when he blew the house down he might have ate a lot of straw and *thought* he ate the pig.

At the lines marked 1 through 5, the children suggest various ways of reconciling the words and pictures. Maybe the words refer to an action that happened *after* the illustration, when the wolf jumped out of the story and ate the pig there, after looking for him (1, 2, and 3). Or maybe the wolf (or the narrator) was "just joking" about eating the pig (4). Or, perhaps the wolf, in all the confusion, ate a bunch of straw and just "*thought* he ate the pig" (5).

Of course, none of these theories held true when, in the third opening, the wolf arrives at the house of sticks, blows it in, and the words of the story again say, " . . . and ate the pig up." This is clearly contradicted by both the illustration of the first pig outside the frame, and by the other words in the pig's speech bubble: "Come on—it's safe out here." As Pantaleo suggests, *The Three Pigs* contains several types of words—the words of the traditional story, the words of the speech bubbles (and later, the words of the other stories that the pigs enter), all of which contradict one another, in addition to their subversion of the visual information in the illustrations. But the children still clung to their disintegrating schema:

Tina: There's the other pig. He didn't eat him up.

Mandy: Well, he's looking for the pig. He's going [*shrugging her shoulders, in imitation of the wolf's puzzlement*]

Melanie: He *thinks* he eats the pig.

Tina: He mighta eats a lot of sticks.

Melanie: He might of eat all the sticks. He's going, "This doesn't taste very good!"

Keith: This is weird. They said they ate him up, but he's like trying to get in, but he's going out.

Melanie: The other pig's going out of the story

Tina suggests, similar to Alex's previous hypothesis, that the wolf might have eaten a lot of sticks, and only *thought* he ate the pig, even though the sticks (according to Melanie) obviously don't "taste very good."

But Melanie convinces herself that the illustrations and speech bubbles trump the traditional narration: both pigs are definitely out of the story (and out of harm's way).

By the fourth opening, the children were starting reluctantly to abandon their traditional schema and to construct an expanded one:

> Dominique: It's getting all, hey!
>
> Alex: It's like disappearing. Every place they're going.
>
> Mandy: But the wolf can't get out.
>
> Teacher: The wolf's stuck on the storyboards.
>
> Tina: Because the wolf's really big and the pigs are small. So he can't get out.
>
> Martin: They're blowing away.
>
> Steven: This story isn't making sense.
>
> Teacher: Right. So our storyboards are getting all messed up and the pigs are on the outside. Let's see what happens.

Clearly, the children were now understanding that this narrative was not going to follow any version of *The Three Pigs* that they had ever heard before. The story world (even a postmodern tale) still must make sense to them, however, as Tina's comment reveals. If the pigs can escape from their own story, why can't the wolf? The teacher offers her own explanation: the wolf is "stuck" to the storyboards. But Tina isn't satisfied with this; she reasons that the wolf's large size has something to do with his being unable to "get out," even though the pigs can escape the story.

Traveling out of the Story and into Other Stories

At this point the story "unfolds" by folding: the pigs construct a paper airplane from a page of their own story. The plain white background suggests that they are in a space between stories with limitless possibilities. The children understood that the page chosen by the pigs was "the wolf's page," noticing the "wolf's arm" on the underside of the plane. But where are the pigs going? There were some interesting predictions:

> Dominique: Maybe to the trash.
>
> Melanie: It's not over yet.
>
> Keith: Maybe the plane will go out of control and go back to another script and the story will continue.
>
> Martin: They're still flying.
>
> Anthony: There's his [the wolf's] leg again.
>
> Steven: It's just a piece of paper.

Alex: Maybe the airplane is going to fly into the trash and there will be this white paper and the pigs will be out.

Teacher: They are going to escape forever? No more three little pigs' stories?

Dominique and Mandy: [*Gasp*]

Although Dominique suggests that the pigs are flying to the trash (after all, that's where most paper airplanes eventually end up), Melanie cautions, "It's not over yet": if this happened, the story wouldn't resolve. Steven responds to Anthony's observation of the wolf's leg by saying, "It's just a piece of paper." Clearly, he has distinguished the reality of the pigs from the mere illustration of the wolf—at this point, the wolf is not "real" in the same sense that the pigs are. The teacher responds to Alex's suggestion that the pigs will be permanently out of their own story world by playfully suggesting that this would result in the disappearance of the tale itself, a result that Dominique and Mandy greet with surprise and dismay. The most interesting comment in this extract, however, is Keith's: he already has an idea that the plane will lead to "another script"—probably an alternative *Three Pigs* story?—and that the story will then be able to continue.

When the teacher read "Uh-oh" on the ninth opening, the children anticipated dire consequences on the tenth opening, and responded playfully:

Mandy: They're going to crash!

Nate: They're going to come down.

Steven: We got shot down! Mayday! Mayday! Crashed! Waaaa! Waaaa!

Many children: Mayday! Mayday!

Steven momentarily becomes the pigs, ventriloquizing for them, and many of the children call out the distress signal. At this point, the field is wide open for their interpretation, with little or no help from their intertextual knowledge. At the eleventh opening, the children made no comment about the foregrounded pig's intrusion into our space as readers (see Goldstone's chapter in this volume) on the verso, but did notice "the kitty cat" on the recto. These comments were followed by a set of fascinating metaphysical speculations:

Keith: I bet they're in another story.

Mandy: Another three little pigs.

Steven: No more three little pigs!

Mandy: It might be another three little pigs story.

Melanie: And then they meet themselves.

What, indeed, happens to story characters when they leave their own story? Do they just disappear, as Steven suggests, or are they destined to enter a different story? If they enter "another three little pigs story," do they eerily meet their own doppelgangers? Luckily, this disquieting fate is not in store for them: the twelfth opening depicts a version of "Hey, Diddle Diddle," illustrated in outline style with bright, "perky" colors:

Mandy: They went into another story.

Steven: There's a bunch of pigs. There's one, two, three, four, five, six.

Melanie: Hey! The pigs are different colors.

Mandy: They're changing into different colors.

Anthony: *The Six Little Pigs*!

Dominique: See the colors they are. They're turning like marker colors.

Nathan: They made different characters. Look—this is from a different story. The cow jumping over the moon.

Anthony: He turned into a real pig [*pointing to the far right of the recto*]

Alex: It was showing their, like, story color and he's walking out of it and it's like the regular color and right there's story color.

After momentarily misunderstanding the spread as one continuous illustration, and thus seeing six pigs (three on the verso and three on the recto, causing Anthony to postulate that there is a new story, called *The Six Little Pigs*), the children were beginning to understand that, in the nursery rhyme, the pigs change colors (Dominique calls them "marker colors") to correspond to the illustration style of the story in which they find themselves, but that when they leave the story, they turn back into what Anthony terms "real" pigs again. Alex explains this by referring to the "story color" and the "regular" (real) color. This transformation occurs again on the fourteenth opening, where the illustration style is sepia line drawing. Again, on the recto, the dragon and one of the pigs are turning "real" as they break the frame, while part of their bodies (rendered in line drawing) remains inside the story:

Steven: He's sticking, only part of them is sticking out. And they're turning colors. Dragon's turning like scaly and the pig's turning back into a, like, black and white.

Prompted by the teacher ("So is it a real-looking cat or a cartoon-looking cat?"), the children also noticed that the cat is "real" because "it's outside."

Entering the Liminal Space

At this point, the children were accustomed to the idea of the pigs moving from story to story. On the fifteenth opening, they observed that there was a whole set of storyboards for another story ("a big duck from another story," "probably *The Ugly Duckling*") behind the dragon's story. The sixteenth opening, however, brings them not to yet another story, but to a collection of storyboards, arranged like the corridors of an enormous library. The children noticed that the stories are permeable to each other:

> Mandy: This is weird because this story's [*points to the series of storyboards on the verso*] going into this story. And this is another one. The fish are like floating in nowhere.
>
> Tina: And this is like a picture story.
>
> Anthony: And there's no talking in it.
>
> Dominique: It's like a bunch of pictures.
>
> Mandy: This story is going into every story! The fish are going crazy and going everywhere! In that picture and in that picture!
>
> Dominique: It's like a bunch of picture frames all over the place.
>
> Steven: There's a bunch of little different pictures in between.

The children struggle to describe this mysterious space. Not only are there a lot of storyboards in sequence, but a story set in the ocean (on the extreme left of the verso) seems to be leaking into the other stories, with "the fish . . . floating in nowhere," according to Mandy. Alternatively, also according to Mandy, "the fish are going crazy and going everywhere!" "Nowhere" and "everywhere" are indeed good descriptors of this space: it contains every story imaginable, and these stories are permeable to each other; yet the pigs, dragon, and cat are nowhere "in" any of them. But this is soon to change, because among the storyboards, the pigs discover the pages from their own story.

Arriving Home

On the seventeenth opening, the pigs, dragon, and cat examine the pages of the pigs' own tale, and the children predicted that "they're going to back into their story." They also suggested that "maybe the dragon goes with them." The eighteenth opening shows them unfolding the paper airplane, revealing a somewhat crumpled-looking wolf, and arranging the storyboards. Tina observed, "They're outside the story," and the children made several predictions about how it would resolve:

> Melanie: Maybe the dragon went, um, the wolf is going to break in the house and then the dragon's gonna scare him.

Anthony: I know what the wolf is going to do. He's going to blow so hard that this [*gesturing to the brick house*] will even fall down.

Mandy: Maybe he's going to go, and when he's not in he's going to go in and go "hah hah!" The pig will say, "Hah hah, you can't blow down my house." And he'll open up the door and the dragon will scare him really.

Steven: How can the dragon scare him when his head is over there [*points to the dragon holding one of the storyboards with its mouth*] and that's just his body [*pointing to the storyboard with the wolf about to blow at the brick house*]?

Despite Anthony's pessimism, Melanie and Mandy offer the idea that the dragon will scare the wolf. Steven, however, raises a problem: the dragon is still outside the story. This was resolved on the penultimate opening, which (on the verso) depicts the dragon's head jutting out of the open door, and a surprised and frightened wolf. The dragon's head has also bumped into the letters of the text and scattered many of them about, so that the text is only partially readable. The recto shows the dragon catching some of the scattered letters in a basket, and one of the pigs saying, "Come inside, everyone. Soup's on!" This provoked several responses:

Mandy: He blew and then all the words, like, fell all about.

Melanie: No, the dragon's neck, head, went in to the picture and wrecked it.

Mandy: And look, he's catching the letters with a basket.

Morgan: They'll have some soup!

Mandy: Alphabet soup! Alphabet soup!

Morgan: He's catching those and he might put them into the soup.

What better thing to do with the extraneous letters than to put them into the pot of soup? The last page of the story shows the odd assortment of animals enjoying their soup, while one of the pigs holds the letters "e" and "r," having already arranged the other scattered letters so that the text reads, "And they all lived happily ever aft." The children's last comments demonstrate some further insights into this resolution:

Morgan: The dragon saved, the dragon saved them.

Melanie: Good thing they got him out of the story because if they just went back into this they would have gotten eaten.

Dominique: If, um, 'cause the dragon wasn't there then they would have gotten eaten.

Keith: I know. This all makes sense. They probably had it all planned
out because they told the dragon to come and they would scare the
wolf.

Morgan's comment that "the dragon saved them" is extended by Mela-
nie and Dominique. The story itself has been reinvented. Keith suggests
that the pigs "probably had it all planned out," a good piece of inferential
thinking, although it perhaps ascribes a bit too much intentionality to the
twists and turns of the pigs' adventures.

DISCUSSION

In summary, the children accomplished a great deal of interpretive work.
They used the idea of "real" pigs and "people pigs," generated during the
discussion of the peritext, to good effect when they reached the part of
the story where the pigs enter the other stories. This intertextual pastiche,
characteristic of many postmodern picturebooks, initially presented dif-
ficulties for the children, yet it was easily overcome—possibly because of
their extensive experience with interactive and dialogic readalouds where
multiple interpretations and viewpoints were encouraged, and the teacher
did not expect one "correct" answer. This served the children well in their
interpretations of Wiesner's tale, because of its postmodern ambiguities
and tendency to elicit what Bakhtin ("Discourse in the Novel") calls "cen-
trifugal" rather than "centripetal" responses: a widening and broadening
of the interpretive possibilities rather than a narrowing to one univocal
meaning (Scholes). It is possible that young children are more comfort-
able than adults with this new definition of text as a collection of signifiers
with infinite possibilities for meaning making and no fixed or stable referent, as
McClay's work suggests.

It is intriguing that they did not resist the story (Sipe and McGuire,
"Young Children's Resistance to Stories"), except for a few comments that
it "doesn't make sense," but rather went with the flow, even though it was
not what they were accustomed to. Indeed, they seemed to quite enjoy the
ways in which their expectations and certainties about stories were "rela-
tivized, inverted, or parodied" (Dentith 68). As well, the children were able
to keep track of the entrances and exits of the pigs and the other creatures
by noting that when they were "in" the stories, they assumed the coloration
and illustration style of the story, and became "real" when they exited.
This continual frame-breaking is characteristic of many postmodern pic-
turebooks, and is part of the metafictive aspect of Wiesner's book: this is a
book about the making of (and the nature of) stories as much as it is about
three pigs and their adventures. Much of the children's talk turned on the
meaning of the word "real": the world of our own sense impressions out-
side the covers of the book; the world of the traditional story; the worlds of
the other stories; and the world "between" the stories. Wiesner plays with

all of these meanings in this postmodern text, and they interpenetrate and blur into each other in his story.

The children responded to this text by accommodating their schema to include Wiesner's innovative plot, and they interpreted the liminal space "between" stories in a remarkably sophisticated way. In this liminal space, they recognized, in the metaphor of the fish that swim through a series of stories, that stories blur into each other, an aspect that postmodern picturebooks endorse emphatically (Sipe and McGuire, "The Stinky Cheese Man and Other Fairly Postmodern Tales"). They played in a carnivalesque way (Bakhtin, "Rabelais and His World") with this playful story, shouting "Mayday!" when the paper airplane was about to crash, and amusingly suggesting that alphabet soup was the appropriate fare at the conclusion. If, as Barthes argues, texts of *"plaisir"* represent the "comfortable practice of reading," *The Three Pigs* is a wonderful example of a text of *"jouissance,"* in which part of the pleasure lies in unsettling and disrupting our "comfortable practice" in novel and surprising ways. I have fully quoted only ninety-five of the 624 conversational turns in this extensive picture storybook readaloud; thus both the children's struggles and their interpretive exuberance have been only hinted at.

Although this discussion focuses on the children's responses rather than the teacher's role, I will briefly note that she allowed a lot of cross-talk (Nystrand) among the children, and intervened at certain strategic moments to further the discussion, but generally allowed the children to puzzle out the story for themselves. When I looked across all four transcripts (discussions of the Marshall, Kellogg, Scieszka, and Wiesner versions), I found (rather surprisingly) that the teacher actually intervened *fewer* times in the Wiesner version. Instead, she asked proportionally more open-ended questions, encouraging the children to amplify, extend, and clarify their own interpretations (see Sipe and Brightman). Because of the children's extensive prior experience with interactive, dialogic readalouds of picture storybooks, the teacher stated that she was interested in knowing how they would negotiate meaning in Wiesner's postmodern text, in which many elements of their firmly built schemata for fairy tales (and picturebooks in general) were subverted and contradicted. The teacher therefore played a less authoritative role in the Wiesner readaloud in order to push them to rise to the challenge of a book that was so qualitatively different from those they had interpreted before. From the children's responses, it is clear that the teacher's decision to "pull back" and place herself in a relatively nonauthoritative stance had successful results.

Finally, it is important to emphasize that this was the children's first (and only) readaloud of Wiesner's book. Further rereadings of the book may quite likely have produced even richer and more sophisticated interpretations; a book this complex demands multiple visits. Even in this one-time reading, however, the first graders performed impressively, at first trying to fit the story events into their highly developed schema for *The Three Pigs*,

and then realizing that they would have to radically change and expand it in order to accommodate the postmodern elements. Perhaps most importantly, they experienced a great deal of pleasure in attempting to make sense of this book; so I will let the last words be Wiesner's own, in his Caldecott Acceptance Speech for *The Three Pigs*: "The word most often used in reviews of *The Three Pigs* has been 'postmodern.' The word most often used by me while making the book was 'fun.'"

NOTES

1. A study by Pantaleo, entitled "Grade 1 Students Meet David Wiesner's Three Pigs" was the first published empirical examination of young children's responses to this book, and, as such, constitutes another case study that would be profitable for readers to compare and contrast with the study reported here. According to Spiro et al., learners (including both children and adults) who are dealing with "ill-structured cognitive domains" (such as reader response) build up their knowledge across cases, crisscrossing the cognitive territory in order to expand, refine, and extend their schemata for these domains. With their different children, different classroom contexts, and different teachers, yet with the same text, Pantaleo's study and my study afford this opportunity.
2. Most versions of the story present the three pigs as siblings; however, Wiesner's decision to make the trio look like three different actual breeds of pigs (Yorkshire, Hampshire, and Duroc, from left to right on the dust jacket) makes this impossible (Personal Communication, August 2, 2007). Thus, there is no mention of a mother pig at the beginning of the story.
3. Wiesner himself has commented in an interview, "So the reddish spine represents the brick, the gray body of the binding [the board cover] the sticks and the ochre endpapers the straw of the story" (Silvey, 49).

WORKS CITED

Bakhtin, Mikhail. "Discourse in the Novel." In *The Dialogic Imagination: Four Essays*, edited by Michael Holquist. Translated by Caryl Emerson and Michael Holquist, 259–422. Austin, TX: University of Texas Press, 1981.

———. *Rabelais and His World*. Translated by Helene Iswolsky. Bloomington: Indiana University Press, 1984.

Barrentine, Shelby J. "Engaging with Reading through Interactive Readalouds." *The Reading Teacher* 50.1 (1996): 36–43.

Barthes, Roland. *The Pleasure of the Text*. Translated by Richard Miller. New York: Hill and Wang, 1976.

Dentith, Simon. *Bakhtinian Thought: An Introductory Reader*. London: Routledge, 1995.

Genette, Gerard. *Paratexts: Thresholds of Interpretation*. Translated by Jane E. Lewin. Cambridge: Cambridge University Press, 1997.

Higonnet, Margaret R. "The Playground of the Peritext." *Children's Literature Association Quarterly* 15.2 (1990): 47–49.

Marshall, Catherine, and Gretchen B. Rossman. *Designing Qualitative Research*. 4th ed. Thousand Oaks, CA: Sage, 2006.

McClay, Jill. "'Wait a Second . . . ': Negotiating Complex Narratives in *Black and White*." *Children's Literature in Education* 31.2 (2000): 91–106.

Nystrand, Martin. "Dialogic Instruction: When Recitation Becomes Conversation." In *Opening Dialogue: Understanding the Dynamics of Language and Learning in the English Classroom*, edited by Martin Nystrand, 1–29. New York: Teachers College Press, 1997.

Pantaleo, Sylvia. "Grade 1 Students Meet David Wiesner's Three Pigs." *Journal of Children's Literature* 28.2 (2002): 72–84.

Roser, Nancy L., and Miriam Martinez. "Helping Young Children Learn to Read Chapter Books." The National Reading Conference. San Antonio, TX, December 2004.

Scholes, Robert. *Protocols of Reading*. New Haven: Yale University Press, 1989.

Silvey, Anita. "Pigs in Space." *School Library Journal* 47.1 (2001): 48–50.

Sinclair, John McH., and Richard M. Coulthard. *Towards an Analysis of Discourse: The English Used by Teachers and Pupils*. London: Oxford University Press, 1975.

Sipe, Lawrence R., and Anne E. Brightman. "Teacher Scaffolding of First-Graders' Literary Understanding during Readalouds of Fairytale Variants." *Yearbook of the National Reading Conference* 55 (2006): 276–292.

Sipe, Lawrence R., and Caroline E. McGuire. "The Stinky Cheese Man and Other Fairly Postmodern Tales for Children." In *Shattering the Looking Glass: Challenge, Risk, and Controversy in Children's Literature*, edited by Susan Lehr. Norwood, MA: Christopher-Gordon Publishers, forthcoming.

———. "Young Children's Resistance to Stories." *The Reading Teacher* 60.1 (2006): 6–13.

Spiro, Rand, W. Vispoel, J. Schmitz, A. Samarapungavan, and A. Boerger. "Cognitive Flexibility Theory: Advanced Knowledge Acquisition in Ill-Structured Domains." In *Theoretical Models and Processes of Reading*, 4th ed, edited by Robert Ruddell, Martha Ruddell, and Harry Singer, 602–615. Newark, DE: International Reading Association, 1994.

Strauss, Anselm, and Juliet M. Corbin. *Basics of Qualitative Research: Techniques and Procedures for Developing Grounded Theory*. 2nd ed. Thousand Oaks, CA: Sage, 1998.

Wiesner, David. "Caldecott Medal Acceptance." *The Horn Book* 78.4 (2002): 393–399.

CHILDREN'S LITERATURE CITED

Kellogg, Steven. *The Three Little Pigs*. New York: Morrow Junior Books, 1997.

Marshall, James. *The Three Little Pigs*. New York: Dial, 1989.

Scieszka, John. *The True Story of the 3 Little Pigs*. New York: Penguin, 1989.

Wiesner, David. *The Three Pigs*. New York: Clarion Books, 2001.

16 Ed Vere's *The Getaway*
Starring a Postmodern Cheese Thief

Sylvia Pantaleo

Pssst! Hey reader! Yeah you! Listen, you gotta do me a favour and read this chapter about a picturebook called The Getaway *by Ed Vere. This metafictional selection of literature is about a notorious international cheese thief, Fingers McGraw, who is pursued by ace law elephant Detective Jumbo Wayne Jr. for robbing Moo O'Sullivan's Cheese Parlour. So keep "your peepers open" and enjoy!*

The Getaway was one of several postmodern picturebooks that I used in a study that explored Grades 3 and 4 students' (eight and nine year-olds) understandings of and responses to literature with interactive characteristics. Although readers should always be actively involved in constructing meaning and responding as they read, interactive devices require, and in some cases demand, readers to be even more active during their reading transactions. Picturebooks with interactive characteristics may contain multiple narratives, multiple narrators, nonlinear plots, and/or narrators or characters who directly address readers, such as Fingers McGraw in *The Getaway*. Many interactive devices reveal the constructed nature of texts. Such self-referential and self-conscious texts are called metafiction because they draw attention to their status as fiction and text through the use of a number of devices or techniques. Indeed the devices the Grades 3 and 4 students learned about are metafictive techniques but during the research I referred to the literary and illustrative devices evident in the picturebooks as interactive devices to emphasize the participatory and co-constructing roles required of readers.

The objectives of this chapter are twofold: to discuss, in some depth, the metafictive nature of *The Getaway*, and to describe some of the students' responses to and interpretations of this postmodern picturebook. A description of the research context follows to provide readers with background information for understanding the children's responses.

THE RESEARCH CONTEXT

Participants

The research site was a Grades K-5 public school with a culturally and ethnically diverse student population. Of the eleven girls and ten boys in the Grades 3 and 4 classroom, all but one student chose to participate in the multifaceted study. During the duration of the research, absenteeism was an issue for several students in the classroom. With respect to ethnicity, fourteen students are European Canadian, and the other students are Asian (two), Korean, Chilean, Jamaican Canadian, Asian Canadian, and Pilipino Canadian. For three students in the class, English is not the only language spoken at home; two children were designated as ESL at the time of the research.

I asked Mrs. K. (the classroom teacher) to describe the students' academic performance in Reading and Writing using the general criteria of the four levels of student achievement described in provincial publications distributed by the British Columbia Ministry of Education ("BC Performance Standards: Reading Revised Edition," "BC Performance Standards: Writing Revised Edition Writing"). Achievement information about the twenty participants is combined because identification of student grade level may compromise the children's anonymity. According to Mrs. K., the work of one student exceeded provincial grade level expectations in Reading and Writing (i.e., level 4), another student's achievement was between fully meeting and exceeding grade level expectations (i.e., level 3.5), and the work of five students fully met grade level expectations (i.e., level 3). Mrs. K. stated that ten children's achievement in Reading and Writing fluctuated between minimally and fully meeting grade level expectations (i.e., level 2 and 3), with seven of these children requiring much scaffolding and support to succeed at an achievement level of 2.5. The work of two students was described as level 2, minimally meeting expectations, and the work of one student met the criteria for level 1, not within grade level expectations.

Investigative Procedures

The study with Mrs. K. and her students used investigative procedures similar to my three-year research project with Grade 5 students ("Readers and Writers as Intertexts," "'Everything Comes From Seeing Things,'" "Exploring the Metafictive," "'How Could That Be?,'" "Scieszka's Subversive Little Red Hen"). The research began in early January 2007 and I worked with the Grades 3 and 4 students for approximately eighty minutes each morning for nine weeks. I began the study with the children by talking about the notion of "response." Through a variety of activities, we discussed with the children how humans are constantly responding to multiple stimuli in their lives, and that there are various kinds of responses and ways to respond. Teacher and student modeling, as well as various

instructional activities were used to develop the children's understanding of the qualities of a "good aesthetic response" (i.e., articulating one's opinions, emotions, thoughts about the selection and supporting the latter with reasons/explanations). Initially, nearly every student struggled with writing a personal response and although growth was evident in the response writing of all students, most children needed instructional scaffolding with response writing throughout the research. Finally, time was devoted to talking about small group discussions with the goal of developing a communal understanding of the expectations, behaviours, and protocol of "successful" discussions.

Willy the Dreamer (Browne) was used to introduce the children to the semiotic notion of intertextuality and to underscore the importance of thoughtfully viewing the illustrations in picturebooks. The sequence of the other picturebooks used in the research reflected an increasing complexity of the use of literary and illustrative devices: *Re-zoom* (Banyai), *Shortcut* (Macaulay), *Voices in the Park* (Browne), *The Three Pigs* (Wiesner), *Who's Afraid of the Big Bad Book?* (Child), *Wolves* (Gravett), *The Getaway* (Vere), *An Undone Fairy Tale* (Lendler & Martin), *The Stinky Cheese Man and Other Fairly Stupid Tales* (Scieszka), and *Black and White* (Macaulay). The students read each picturebook independently, completed at least one written response, and participated in discussions in small groups that were peer led and mixed gender. Following the audio-recorded small group discussions, the interactive devices were explicitly taught and/or reviewed during various whole-class activities that involved the students discussing and examining the picturebooks. Further, throughout the study the children were encouraged to make connections between the interactive devices they were learning about in the literature and the existence of these devices in other print and digital texts.

The students also read *Zoom* (Banyai) (after reading and discussing *Re-zoom*) and each student created her/his own "Zoom" book emulating Banyai's zooming technique. Further, the children read *Tuesday* (Wiesner; before reading *The Three Pigs*), *Beware of the Storybook Wolves* (Child; before reading *Who's Afraid of the Big Bad Book?*) and *Why the Chicken Crossed the Road* (Macaulay; before reading *Black and White*) but they neither wrote responses about nor discussed these books. As well as the required texts, I brought other picturebooks with interactive devices into the classroom for the children to peruse. Finally, the culminating activity of the study involved the students creating their own print texts with interactive devices.

As described previously, this chapter focuses on one of the postmodern picturebooks that the children read and responded to during the multifaceted research project. *The Getaway* is described in some detail below to assist readers in appreciating the metafictional character of the book and in understanding the students' written responses.

The Getaway exhibits many of the postmodern characteristics described in the introduction of this book, including several metafictive devices. Metafictional texts, as I have explained elsewhere ("Grade 1 Students," "The Long, Long Way," "Young Children Interpret," "Readers and Writers as Intertexts," "Exploring the Metafictive"), draw readers' attention to how texts work and to how meaning is created. Waugh describes metafiction as "fictional writing which self-consciously and systematically draws attention to its status as an artefact in order to pose questions about the relationship between fiction and reality" (2). Authors and illustrators use a number of devices or techniques to draw attention to the fictional and textual nature of their work. Often the "specific strategies through which metafictions play with literary and cultural codes and conventions" (McCallum 400) are used concomitantly and the synergy of multiple devices serves to amplify the fictional status and self-conscious nature of a text. Some of the metafictive devices evident in *The Getaway* are narrators or characters who directly address the readers; multiple narrators or characters telling stories; multiple narratives/stories; stories within stories; disruptions of time and space relationships in stories/narratives; intertextuality; parody; typographic experimentation; mixture of genres, language styles and speech styles, and ways of telling stories; a pastiche of illustrative styles; a design or layout feature that is new and/or unusual; and indeterminacy.

The first four sentences at the beginning of this chapter parody Fingers McGraw's initial interactions with readers in *The Getaway*. Readers are acknowledged and addressed explicitly both visually and verbally. Fingers looks directly at readers and this "demand" image requires viewers to "enter into some kind of imaginary relation with him" (Kress and van Leeuwen 118). The mouse thief also attempts to promote "an atmosphere of camaraderie" (Georgakopoulou 3) by verbally soliciting assistance. "Pssst! Pssst! Hey kid! Yeah you! Listen, you gotta do me a favour!" (unpaginated). The mouse bandit asks readers to be on the lookout for an elephant (i.e., Detective Jumbo Wayne Jr.) and to whistle if they see him. Readers are promised a 30 percent share of the valuable cheese loot. Although Fingers firstly attempts to build an atmosphere of solidarity and friendship, the crook does not hesitate to later reprimand readers when they do not whistle during the chase.

The book itself is a parody of a "cops and robber" caper. Indeed, the intertextualities and parodies are plentiful in *The Getaway*. The initial endpapers feature the front pages from three different newspapers superimposed on each other. The stories on the front page of "The Daily Tribune" are about the high-profile cheese heists, a gang of feral biker cats, performance artist birds migrating on foot, and the theft of a yellow scooter. The news story on the cheese thefts includes comments by the escaped convict, Frankie "Spatz da Rat" Capone. Louisa Layne, the leading reporter for "The Daily Tribune," has traced Frankie to his

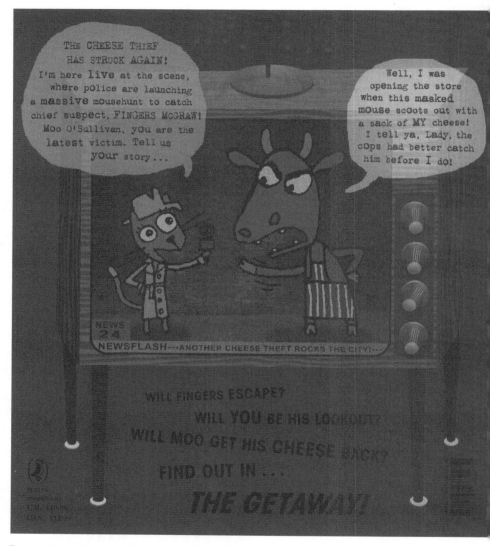

Figure 16.1 Front and back cover from *The Getaway* by Ed Vere (London, Puffin, 2006) reproduced by permission of Penguin Books Ltd. © Ed Vere, 2006.

downtown hideout and in stereotypical gangster-like discourse, he extols the expertise of Fingers. At the bottom of the endpapers, Vere includes white dashes or lines that symbolize the trail of Fingers who seems to walk into the book, travel behind the pages of the newspapers, and exit on the recto. Indeed, as readers turn the page, the dashes, which are now black, continue along the bottom of the white verso, and onto the next recto. The dashes reveal Fingers' ascent onto a table displaying several

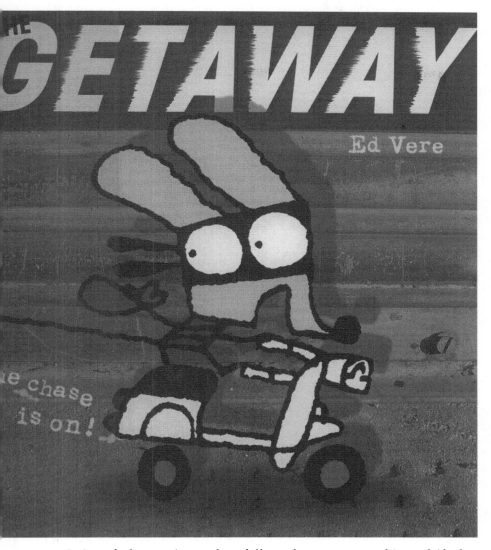

varieties of cheese. As readers follow the mouse crook's path/dashes among the pieces of cheese, they see that Fingers samples nearly all of the cheese selections (except Petit Livarot, whose aroma is known to be strong and smelly).

A black-and-white photograph of Chicago (Vere, "e-mail Interview") is the background of the double-page spread that constitutes another frontis-piece and the title page. The verso features a superimposed pinkish red star-like shape with a coloured photograph of Moo O'Sullivan's Cheese Parlour placed on top of the star shape. Moo, who like all of the book's characters is drawn in cartoon-like style, is yelling, "Stop thief!" at Fingers. On the recto,

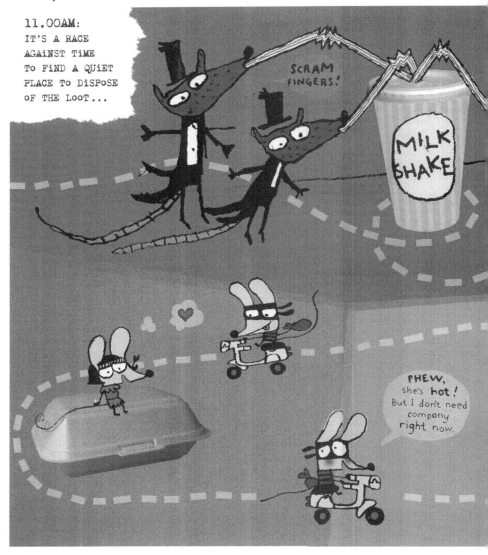

Figure 16.2 Double-page spread from *The Getaway* by Ed Vere (London, Puffin, 2006) reproduced by permission of Penguin Books Ltd. Copyright © Ed Vere, 2006.

the masked rodent is depicted on a green star-like shape that is superimposed on the background photograph. Red dashes across the double-page spread reveal the getaway trail of Fingers.

According to the text on the first verso of the book, Fingers robs Moo's at 6:00 a.m. On the third opening when Fingers directly addresses readers it's 6:30 a.m. Conveniently, a yellow scooter is in the downtown

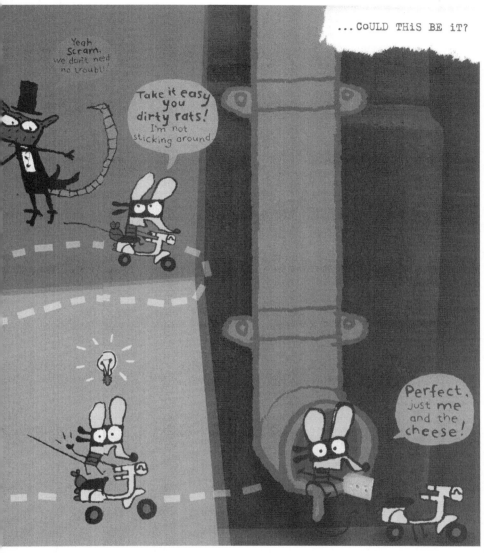

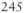

alley and on the subsequent opening, Fingers speeds away while offering readers a share of the loot if they whistle when the elephant is nearby. A wanted poster of Fingers McGraw is displayed on a building's wall in the background.

By the fifth opening, it's 11:00 a.m. and Fingers continues to search for a site to dispose of the booty. As he traverses across another double-page spread in a unique fashion (see Figure 16.2), he communicates with three "dirty rats" donned in tuxedos. Although tempted by a flirtatious female mouse, Fingers rides on and spies a possible location to consume the cheese.

However the next opening of the book reveals trouble for Fingers. Is it the elephant? When readers open the recto foldout (i.e., half of a gatefold), three members of the feral feline gang are revealed, and although they verbally tease Fingers in a threatening manner, he continues on his way. These pages contain visual narrative layering as two of the performance artist birds are depicted in the recto's bottom right-hand corner, and a rat (possibly one from the previous page) emerges furtively from a sewer grate on the verso's bottom left-hand corner. The body language of the birds and rat communicates apprehension and concern at the sight of the feline gang but no verbal text accompanies these creatures.

When readers turn the next page, Fingers reproaches them and reminds them to "keep those peepers open!" (unpaginated). The mouse thief is so involved in conversing with readers that he fails to notice the presence of a large-footed grey character behind him. The eighth opening reveals an anxious-looking McGraw superimposed on a pinkish red star-like shape. Across the double-page spread, the large feet are moving, creating dust and making "STOMP STOMP" noises. Another page turn reveals that, luckily for Fingers, the feet belong to a rhinoceros, but that unluckily for Fingers, the rhino is holding a newspaper with a photograph of the masked rodent on the front page. The rhinoceros orders Fingers to stop but he escapes on his trusty yellow scooter. The rat and the birds are once again depicted on the recto of this tenth opening; the rat is peering out from a slot in the wall and the birds are sitting on a raised piece of cement peering at a map. Above one of the bird's head is a think bubble with a question mark.

When readers turn the page, text in the verso's upper left-hand corner reveals that it is 5:00 p.m. and time is running out! McGraw's agitation with readers for not whistling is communicated through his words, as well as through the use of a black think cloud above his head. He abandons the scooter and Finger's characteristic dashes reveal how he navigates across the double-page spread in a nonlinear manner. The recto of this double-page spread includes visual depiction of the continuing land journey of the birds and an escape possibility for Fingers. The masked mouse descends into the sewer to avoid the elephant but just as he is about to consume his cheese on the next opening, he is discovered by a long, sniffing snout. Luckily, the proboscis belongs to an anteater and not an elephant. The anteater, a tourist visiting Chicago to view the architecture of Mies van der Rohe (Vere, "e-mail Interview"), is insulted by McGraw's comments about his nose and spews out the mouse. While an airborne projectile on the next double-page spread, McGraw once more expresses his disapproval to readers about their lack of whistling. Serendipitously, Fingers has a balloon with him and subsequently he lands safely on a dome-shaped blue object. With several of the artistic birds above him on clouds, McGraw is finally ready to consume the evidence. However, the subsequent page turn reveals that the blue object he is sitting on is in fact the top of Detective Jumbo Wayne Jr.'s police helmet.

The next double-page spread shows McGraw in a prison cell at 11:00 p.m. Moonlight shining into the dark cell reveals a forlorn-looking masked mouse with a letter of apology to Moo O'Sullivan on his lap. In the letter Fingers expresses regret for his actions and seeks Moo's forgiveness. However, on the subsequent double-page spread, McGraw is using a rope to descend the right-hand side of the prison wall and is once again asking readers to "do me a favour" (unpaginated). Lightning is striking in the background as Detective Jumbo Wayne Jr. peers down with a searchlight from the prison's roof. On the far left of the verso, the rat we have seen before is looking out at readers from behind prison bars. The final opening of the book includes the dedication (presented in a speech bubble by one of the performance artist birds) and copyright information. A movie poster of *The Getaway* conveys some publication information, as does an orange poster displayed on the wall.

The final endpapers are similar in layout to the beginning pages. However, the front-page story of "The Daily Tribune" focuses on the recent capture and escape of Fingers McGraw with a large black-and-white photograph of the bandit mouse on his scooter. Louisa Layne has tracked down Frankie "Spatz da Rat" Capone again and he provides some insightful commentary about the discrepancy between the spacing of the bars in prison cells and a mouse's stature.

METAFICTIVE DEVICES

As is evident in the descriptions above, the endpapers contain numerous intertextual connections, parodic in nature, to people, events, media, other texts, and cultural knowledge. Before the students read the picturebook, I introduced them to several of the specific intertextual connections in the book including Al Capone, Jumbo the elephant, Lois Lane, and *The Maltese Falcon* (Hammett) ("Maltese Stilton" in the newspaper story). I did not explain the St. Valentine's Day Massacre connection ("St. Valentine's Day group escape from the Mouseways high-security prison" [unpaginated]), nor did I mention Harley-Davidson, as I presumed the children would identify the latter (which they did). The intertextual connection to the quote from the movie "To Have and Have Not" (Hawks) about putting their lips together and whistling was not explained to the students until after they had read the book. Some of the more general intertextualities were discussed (e.g., the front-page stories' references to Hartington, UK, and Stilton cheese) but others were not (e.g., the feral cat biker gang and the performing artist birds). I also introduced and/or reviewed some vocabulary (i.e., gorgonzola, feral, heist, and spatz) with the children before they read the picturebook.

As well as the other parodies mentioned above, the newspaper stories and both the wanted and film posters are parodic in nature. The parodic film credits on the poster include information about the "actors," the production company, the type of and location of filming, and the director and writer.

When readers finish the book, they may indeed wonder if they have just watched the movie of *The Getaway* or if they have viewed the actual events from which a movie will be produced.

The pastiche of illustrative styles in *The Getaway* includes photographs of curb-level decrepitude that create a credible underworld atmosphere and contribute to the mood of the setting. The picturebook contains photographs of various locations around London, especially Smithfield Market and Borough Market, as well as one photograph from Bilbao and another from Barcelona's Barrio Gotico (Vere, "e-mail Interview"). The cartoon drawings in the book were completed in pen and paper and then scanned into a computer. The combination of graphic and photographic elements creates a visually distinctive design.

Multiple and varying examples of typographic experimentation are evident in the book as Vere varies the style, size, and arrangement of matter printed from type to communicate meaning. For example, speech bubbles contain black text that appears to be printed by hand and most of the pages also have text that appears to be created by an old typewriter. Except for the letter *i* these text segments are written in uppercase letters. The discourse style of these typed text segments resembles a commentator talking over the events that are occurring on the page. Often these segments appear in the upper right-hand corner of the verso but they are also located at the bottom of some versos and rectos.

Other metafictive devices evident in *The Getaway* include the following: something about the design or layout of the book is new and unusual (e.g., the foldout, the openings where Fingers traverses the double-page spreads in a nontraditional manner); narrators or characters who directly address the readers; multiple narrators or characters telling stories (e.g., the newspaper stories, the text segments that are commentary in nature, Fingers' narration); multiple narratives/stories (e.g., the stories of Fingers, the birds, and the rats, and other stories in the newspapers); stories within stories (e.g., the stories of the birds and rats and the story of Fingers); disruptions of time and space relationships in stories/narratives (e.g., Fingers directly addresses readers and solicits assistance as the story unfolds in front of readers); and indeterminacy (e.g., the future of Fingers, the fate of the rat behind bars in the prison, the success of the birds on their artistic endeavour).

STUDENTS' RESPONSES

The written responses of three Grade 3 and three Grade 4 students (eight- and nine-year-olds; all names are pseudonyms) presented in random order below are representative of the work completed by the seventeen students who wrote responses to *The Getaway* (three children were absent). Spelling and punctuation in the responses have been conventionalized.

Since Fingers McGraw told me to whistle if I saw Jumbo Wayne Jr., I whistled. But even so Fingers blamed me for not whistling. I think that isn't fair because I was trying my best to whistle when I saw Jumbo. I think this book is funny because it has a total parody of criminals and now and then it pulls little jokes or puns. For example when the bird said, "What do you do to get a decent conversation 'round here?" I think probably Fingers would deserve to get out of prison if he promised to give up being a criminal because the world should be criminal free. (Sabrina)

In this book there is a lot of puns and visual puns like one rat is always behind bars. He's behind bars in jail and in the sewer he's behind bars. The birds were a story in their own story like the rabbits were in Short-cut. *There was like a re-zoom in some ways because the animal was zoomed in and then he or she was zoomed out for example the rhino. It zoomed in on his feet and then zoomed out and we could see the entire rhino. Same with the anteater's nose and Jumbo's hat.* (Gerrard)

I like the way Fingers McGraw talks to you because he gets really, really mad at you. This book has a connection to Wolves *because the newspaper is kind of the like the letter. I wonder why Fingers McGraw had to steal cheese . . . maybe it was to make a living. To me, the snails looked like they were wondering why Fingers McGraw was there [in the alley] because they kind of had a worried face on. Maybe the T.V. on the back cover belongs to Fingers McGraw. They are talking about him and maybe he is watching it as they talk about him.* (Mia)

I liked the book because Fingers kept on saying, "Psst, hey kid!" and he talked right to you. Also I liked how they used some real pictures like when he is on his motorbike there's a real background of a street. It was funny because Fingers kept on thinking he saw an elephant but it was always something else like the rhino or the anteater. (Elijah)

The Getaway *had many different stories. Fingers had a story about running away from Detective Jumbo Wayne Jr. The other story was about the little birds who said, "Tweet. Tweet." I have no idea what they were saying but they were probably making fun of Fingers in some way. The other story I noticed was a rat's story. It was like a visual pun of a rat who was always behind bars. Like he was behind the bars in a drain that led to the sewer and behind the bars of a jail cell.* (Isabella)

What I liked about this book is how they put in the newspaper because it was creative. You can actually see the words. But when you go into the book, it's like the newspaper is part of the book. Plus there

are a lot of parodies because they [the characters] are all real people except they are animals. For example, McGraw is not a mouse in real life. And the mouse looks like it's melting when his nose is drooping down and he looks petrified. So the book is very creative. (Anthony)

As is evident by the students' responses, they greatly enjoyed the picturebook. Some of the children, like Gerrard and Mia, made intertextual connections to other picturebooks they had read during the study. Overall, the students found *The Getaway* to be amusing and they identified parodies, jokes, and puns in the book (although the latter were not always labeled accurately). Our initial conversations, beginning with *Willy the Dreamer*, about intertextuality and parody facilitated the students' identification and understanding of the parodies in the picturebook. According to Lukens, "a parody reminds us of something known, then gives fresh pleasure by duplicating form that contrasts to new and humorous meaning" (224). Although writers, illustrators, and artists may create texts that are intertextual and parodic in nature, it is the reader and/or viewer who interpret the texts; further, interpretation of verbal or visual text as intertextual or parodied is dependent on recognition or knowledge of the original text. As explained previously, the children were introduced to several intertextual connections that then facilitated their identification of parodic appropriations in Vere's picturebook.

As well as identifying intertextualities, several students, including Gerrard and Isabella, commented on the multiple stories occurring within the picturebook. The book's peritextual elements (Pantaleo "Godzilla Lives in New York") introduce readers to some of the book's characters as well as foreshadow the nature of the narrative content and illustrative style. Throughout the study the children had been learning about the functional and aesthetic contributions of the publisher's peritext, such as the endpapers, to picturebooks as "unique art objects" (Kiefer 6). I had emphasized the importance of reading the newspaper stories on the endpapers before reading the book. Some children, like Mia and Anthony, commented on the newspapers in their written responses. Also, during their small group discussions the children talked about how the information in the newspapers contributed to understanding the book's multiple narratives. During her group's discussion, Sydney stated that it was important to read the endpapers "Because you wouldn't know what the cats and birds are doing . . . so you wouldn't really understand what has happened and you wouldn't know who the cats were." Elijah replied with, "Yeah, you couldn't really know what's happening if you didn't read this part or any of the stories in the newspaper. Like who McGraw was and why the police are after him."

Not surprisingly, most of the children wrote something about Fingers McGraw. Sabrina was the only student who actually complied with Fingers' request and whistled while reading the book. As the students were

independently reading the picturebook, I heard a very quiet whistling noise. I looked about the room to identify the source of the noise and when I made eye contact with Sabrina, she smiled at me. I went over to her desk and quietly asked Sabrina if she was whistling. She acknowledged that even though she had whistled, Fingers still reprimanded her! Many children enjoyed the obtrusive nature of the masked rodent. Other students commented on Fingers' actions and appearance and some speculated on his future activity.

A few students, like Elijah, wrote something about Vere's pastiche of illustrative style. The children had viewed a similar illustrative style of combining photographs and drawings with *Who's Afraid of the Big Bad Book?* Other children commented about particular illustrations or aspects of the artwork that enhanced the humour of the book. The responses of many students indicated careful viewing of the illustrations as they mentioned specific details (e.g., the rat behind the bars).

The indeterminacy in the book resulted in many students wondering about particular aspects of the plot and characters' actions. Several children, including Isabella and Gerrard, wondered about the single rat that seemed to be following Fingers. As described above, Fingers is depicted as breaking out of prison in the penultimate opening of the book and many students made predictions about the future of Fingers. As part of their responses, Sierra wrote, "I wonder what Fingers is going to do for his next robbery. Maybe he will try a bread factory (munch, munch) because bread will go with cheese!" and Jake wrote, "He will not discontinue trying to steal cheese when he gets out of jail. I think he will steal more cheese because he loves cheese and wants it all the time." In both their responses and during their small group discussions, the children communicated their comfort of and enjoyment with the unresolved ending. During our large group discussion they enthusiastically generated future escapades for the postmodern cheese thief.

FAVOURITE BOOK

As described above, the students were interviewed on two occasions during the research. In the first individual interview, the children were asked to identify their favourite picturebook from the selection of literature they read during the study. Nine girls and eight boys identified one title, and one girl and two boys selected two titles. Seven different books were selected by at least one student as a favourite. Most students, as is evident by the interview excerpts below, provided more than one reason to explain/support their reasons for selecting specific books.

Overall, *The Getaway* was the favourite picturebook of the Grades 3 and 4 students, accounting for over one-third (39.1 percent) of the class's total selections. Five boys and four girls chose *The Getaway* as their

favourite picturebook, although all of the children commented on the difficulty of choosing one book as their favourite (and three children *had* to pick two). Three excerpts from student interviews follow.

> Kelsey: Hmm . . . *The Getaway*. And mainly because it's got like, I like how it's put together, like from the start, sort of like the zoomzag of Fingers' trail and the gatefold.
>
> S: Half a gatefold, right.
>
> Kelsey: Yeah and it's sort of like in the background it looks like they took pictures, and I like the idea of a mystery book sort of. And Fingers.
>
> S: Can you say what about him appealed to you?
>
> Kelsey: Well because he's a mouse and he's got a mask on so he sort of looks like he's one of those normal thieves, but he's not. He's just a mouse stealing cheese, which is funny and it's parodying thieves.
>
> Isabella: I really liked *The Getaway* because they had lots of intertextual connections.
>
> S: Such as?
>
> Isabella: The Harley-Davidson motorcycle and the "I Love New York" hat and stuff.
>
> S: What else about *The Getaway* did you like?
>
> Isabella: I also liked how there's like unusual folds and stuff. And I also liked how there's like a rat and he ended up everywhere. Almost in every couple pages, he was always behind bars. Like one time he was under the sewer, and also like up in a window place, and behind bars in the jail.
>
> S: Yes and you had to look for him, right?
>
> Isabella: Yeah. And Fingers was funny. Because he was like, he gets all mad at you because he didn't hear you whistle.
>
> Mason: Probably *The Getaway*. Because it's funny and humorous and it's very interesting because they copy Fingers McGraw and Al Capone and they talk to you and stuff.
>
> S: Okay you like how Vere did the parody of Al Capone?
>
> Mason: Yeah, and I like when he steals cheese.
>
> S: Why do you like that part?
>
> Mason: Because it's funny and people usually steal money not really cheese. And they make a big deal out of it.

Thus, as is evident by the above interview excerpts, the most frequent reasons given by the students for selecting *The Getaway* as a favourite book were similar to the aspects they wrote about in their written responses:

Vere's illustration style, the character of Fingers McGraw, the layout and design, the intertextual connections and parodies, the actions and appearances of the other characters, and the book's humour.

CONCLUSION

The Getaway, like many other postmodern picturebooks, communicates messages about the nature of stories and their fictionality. Texts with metafictive devices can provide the kinds of reading experiences that develop readers' abilities to critically examine, deconstruct, and construct an array of texts and representational forms that incorporate a range of linguistic, discursive, and semiotic systems (Anstey). The students' responses indicate how developing an understanding of metafictive devices can enrich readers' comprehension of and appreciation about the codes and conventions of literature, about how literature works, and about book elements and design. According to McCallum, metafictive devices contribute to the aesthetic reading experience as "underlying much metafiction for children is a heightened sense of the status of fiction as an elaborate form of play, that it is a game with linguistic and narrative codes and conventions" (398). In *The Getaway*, the obtrusive Fingers, the pastiche illustrative style, as well as the overall book design and layout contribute to the game-playing with codes and conventions, as well as to the explicit revelation of the constructedness of text. The invitation by Fingers to participate in the diegetic, the fictional world in which the events and situations that are narrated occur, reminds readers of the fictional nature of the story, of "the artifice of what they are reading" (Georgakopoulou 6). The numerous metafictive devices in *The Getaway* simultaneously require reader agency, involvement and "critical detachment" (9). Indeed, Vere's playful text, like other postmodern picturebooks with metafictive devices, contributes to readers' visual literacy competence, literary understanding, and literacy development.

WORKS CITED

Anstey, Michèle. "'It's Not All Black and White': Postmodern Picturebooks and New Literacies." *Journal of Adolescent and Adult Literacy* 45.6 (2002): 444–457.

British Columbia Ministry of Education. *BC Performance Standards: Reading Revised Edition*. Victoria, BC: Author, 2002a.

British Columbia Ministry of Education. *BC Performance Standards: Writing Revised Edition*. Victoria, BC: Author, 2002b.

Georgakopoulou, Alexandra. "Discursive Aspects of Metafiction: A Neo-oral Aura?" *Edinburgh Working Papers in Linguistics* 2 (1991): 1–13.

Hammett, Dashiell. *The Maltese Falcon*. London, Pan Books, 1930.

Hawks, Howard. *To Have and Have Not*. Burbank, CA: Warner Brothers, 1945.

Kiefer, Barbara. *The Potential of Picturebooks: From Visual Literacy to Aesthetic Understanding.* Englewood Cliffs, NJ: Prentice-Hall, Inc., 1995.

Kress, Gunther, and Theo van Leeuwen. *Reading Images: The Grammar of Visual Design* 2nd ed. London: Routledge, 2006.

Lukens, Rebecca. *A Critical Handbook of Children's Literature* 6th ed. New York: Addison- Wesley Educational Publishers Inc., 1999.

McCallum, Robyn. "Metafictions and Experimental Work." In *International Companion Encyclopedia of Children's Literature*, edited by Peter Hunt, 397–409. New York: Routledge, 1996.

Pantaleo, Sylvia. "'Everything Comes From Seeing Things': Narrative and Illustrative Play in *Black and White*." *Children's Literature in Education: An International Quarterly* 38.1 (2007): 45–58.

———. "Exploring the Metafictive in Elementary Students' Writing." *Changing English* 14.1 (2007): 61–76.

———. "'Godzilla Lives in New York': Grade 1 Students and the Peritextual Features of Picturebooks." *Journal of Children's Literature* 29.2 (2003): 66–77.

———. "Grade 1 Students Meet David Wiesner's Three Pigs." *Journal of Children's Literature* 28.2 (2002): 72–84.

———. "'How Could That Be?': Reading Banyai's *Zoom* and *Re-zoom*." *Language Arts* 84.3 (2007): 222–223.

———. "The Long, Long Way: Young Children Explore the Fabula and Syuzhet of *Shortcut*." *Children's Literature in Education: An International Quarterly* 35.1 (2004): 1–20.

———. "Readers and Writers as Intertexts: Exploring the Intertextualities in Student Writing." *Australian Journal of Language and Literacy* 29.2 (2006): 163–181.

———. "Scieszka's Subversive Little Red Hen: Aka 'One Annoying Chicken.'" *Journal of Children's Literature* 33.1 (2007): 22–32.

———. "Young Children Interpret the Metafictive in Anthony Browne's *Voices in the Park*." *Journal of Early Childhood Literacy* 4.2 (2004): 211–233.

Vere, Ed. "e-mail Interview." 4 March 2007.

Waugh, Patricia. *Metafiction: The Theory and Practice of Self-conscious Fiction.* New York: Methuen, 1984.

CHILDREN'S LITERATURE CITED

Banyai, Istvan. *Re-zoom*. New York: Puffin Books, 1995.

———. *Zoom*. New York: Puffin Books, 1995.

Browne, Anthony. *Willy the Dreamer*. Cambridge, MA: Candlewick Press, 1997.

———. *Voices in the Park*. London: Picture Corgi Books, 1998.

Child, Lauren. *Beware of the Storybook Wolves*. New York: Scholastic Inc., 2000.

———. *Who's Afraid of the Big Bad Book?* New York: Hyperion Books for Children, 2002.

Gravett, Emily. *Wolves*. London: Macmillan Children's Books, 2005.

Lendler, Ian, and Whitney Martin. *An Undone Fairy Tale*. New York: Simon & Schuster Books for Young Readers, 2005.

Macaulay, David. *Why the Chicken Crossed the Road*. Boston, MA: Houghton Mifflin, 1987.

———. *Black and White*. Boston, MA: Houghton Mifflin, 1990.

———. *Shortcut*. Boston, MA: Houghton Mifflin, 1995.

Scieszka, Jon. *The Stinky Cheese Man and Other Fairly Stupid Tales.* New York: Viking, 1992.
Vere, Ed. *The Getaway.* London, UK: Puffin Books, 2006.
Wiesner, David. *Tuesday.* New York: Clarion Books, 1991.
———. *The Three Pigs.* New York: Clarion Books, 2001.

Contributors

EDITORS

Lawrence R. Sipe is an Associate Professor in the Graduate School of Education of the University of Pennsylvania. He teaches courses in children's literature, ranging from picturebooks to young adult fiction, and his research focuses on the responses of young children to picture storybooks. He is the author of *Storytime: Young Children's Literary Understanding in the Classroom* (2008), and is the North American Editor of *Children's Literature in Education*.

Sylvia Pantaleo is an Associate Professor in the Faculty of Education at the University of Victoria. She teaches undergraduate and graduate courses in language and literacy, and in literature for children and adolescents. Her research has focused on exploring elementary students' understanding, interpretations, and responses to contemporary picturebooks, specifically literature with Radical Change characteristics and metafictive devices. She is author of *Exploring Student Response to Contemporary Picturebooks* (2008).

CONTRIBUTORS

Michèle Anstey has been an Associate Professor at the University of Southern Queensland, Australia; Director of the Literate Futures Project for Education Queensland; and a teacher in various parts of Australia. Her research interests are literacy, pedagogy, and children's literature, particularly picturebooks. She manages ABC Anstey & Bull Consultants in Education and further information about her educational consultancy can be accessed through the following website: (www.ansteybull.com.au).

Evelyn Arizpe is a Lecturer in Children's Literature at the Faculty of Education, University of Glasgow. She is coauthor, with Morag Styles, of *Children Reading Pictures: Interpreting Visual Texts* (2003) and *Reading Lessons from the Eighteenth Century* (2006). Her current research involves immigrant children, picturebooks, literacy, and culture.

Monica Belfatti is a PhD candidate in the Reading/Writing/Literacy program at the Graduate School of Education at the University of Pennsylvania. Monica has taught first through fourth grades in both public and private school settings and currently teaches literacy methods courses to pre-service teachers in Penn's teacher education program.

Karen Coats is an Associate Professor of English at Illinois State University, where she teaches children's and young adult literature. She is the author of *Looking Glasses and Neverlands: Lacan, Desire, and Subjectivity in Children's Literature*, (2004) and coeditor, with Anna Jackson and Roderick McGillis, of *The Gothic in Children's Literature: Haunting the Borders* (2007).

Eliza T. Dresang is the Eliza Atkins Gleason Professor at the Florida State University College of Information, where she teaches graduate students studying children's literature. She is known for Radical Change theory explicated in her *Radical Change: Books for Youth in a Digital Age* (1999) and for other scholarship related to contemporary children's literature. She has chaired the American Library Association's Newbery, Belpré, and Batchelder Children's Book Award Committees.

Maria Ghiso is an EdD candidate in the Reading/Writing/Literacy program at the Graduate School of Education at the University of Pennsylvania. Formerly a dual-language kindergarten teacher in New York City, Maria currently teaches courses at the University of Pennsylvania on children's literature, literacy methods, and addressing the needs of English Language Learners.

Bette Goldstone is a Professor of literacy studies and children's literature at Arcadia University. She works with local school districts and frequently presents at national and international conferences. She has written extensively on postmodern picturebooks.

Christine Hall teaches children's literature in the School of Education at the University of Nottingham in England. A former teacher herself, she is currently director of the University's postgraduate pre-service teacher education courses. Her research interests are in children's literacy and literature, and the teaching of English and the arts in schools. She codirected the *Children's Reading Choices Project*, an investigation into children's voluntary reading (1999).

Barbara Kiefer is the Charlotte Huck Professor of Children's Literature at The Ohio State University. She has written extensively about picture-books and children's responses, including a book, *The Potential of Picturebooks: From Visual Literacy to Aesthetic Understanding* (1995). She also is the principal author of *Charlotte Huck's Children's Literature* (2007), a widely used textbook currently in its ninth edition. She has served on several Caldecott and Newbery Committees.

Susan S. Lehr is a Professor of literature and literacy at Skidmore College. Her books include, *The Child's Developing Sense Of Theme*, and edited volumes *Battling Dragons: Issues And Controversy In Children's Literature* (1995), *Beauty, Brains And Brawn: The Construction Of Gender In Children's Literature* (2001) and *Shattering the Looking Glass: Challenge, Risk and Controversy in Children's Literature* (2008).

Margaret Mackey is a Professor in the School of Library and Information Studies at the University of Alberta. She teaches and writes on the subject of literacies new and old, working with readers of all ages. Her newest book is *Mapping Recreational Literacies: Contemporary Adults at Play* (2007). For eleven years she was North American editor of *Children's Literature in Education*.

Robyn McCallum teaches literature at Macquarie University. Her major focus is on children's and adolescent literature and film, theories of subjectivity, semiotics, and literature and the visual arts. She is author of *Ideologies of Identity in Adolescent Fiction: The Dialogic Construction of Subjectivity* (2007) and *Retelling Stories, Framing Culture: Traditional Story and Metanarratives in Children's Literature* (with John Stephens, 1998).

Caroline McGuire is a PhD candidate in the Reading/Writing/Literacy program at the Graduate School of Education at the University of Pennsylvania. Formerly a coordinator of out-of-school literacy programs, Caroline now teaches children's literature courses to undergraduate and graduate students at Penn.

Maria Nikolajeva is a Professor of comparative literature at Stockholm University. She is the author and editor of several books, among them *How Picturebooks Work*, coauthored with Carole Scott (2001). She was one of the senior editors for *The Oxford Encyclopedia of Children's Literature* and received the International Grimm Award in 2005 for outstanding contribution to children's literature research.

Martin Salisbury studied illustration at Maidstone College of Art in the UK in the 1970s and worked for many years as a freelance illustrator. He now combines illustrating with his permanent post as Reader in Illustration

at Anglia Ruskin University, Cambridge. He has written widely on the practice of illustration and is author of *Illustrating Children's Books* (2004) and *Play Pen: New Children's Book Illustration* (2007).

John Stephens teaches and supervises postgraduate research at Macquarie University. He is the author of several books, including *Language and Ideology in Children's Fiction* (1992), *Retelling Stories, Framing Culture* (with Robyn McCallum, 1998), *Ways of Being Male* (2002), and approximately ninety articles about children's (and other) literature. He was awarded the 11th International Brothers Grimm Award in 2007.

Morag Styles is a Senior Lecturer at the University of Cambridge and Reader in Children's Literature at Homerton College, Cambridge. She has written and lectured widely on children's literature, poetry, visual literacy, and the history of reading.

Index

A

Aakeson, Kim Fupz 72
access 41, 49–51
Adobe Photoshop 25, 30, 32
adults, picturebooks for 15, 16, 32
Alderson, Brian 18
alphabet books 16
ambiguity 5, 44, 51, 198, 202
Andersen, Hans Christian 55, 67
Anstey, Michèle 2, 106
Anton elsker Ymer (Brøgger) 68
Ariès, Phillipe 16, 75
Arisman, Marshall 24
Arizpe, Evelyn 151, 152
Arlene Sardine (Raschka) 82–3, 123
The Arrival (Tan) 20
art 78; citation of works of, in picture-
 books 67–8, 94, 95, 98; illustra-
 tion and 24–5;
picturebooks as 10–11, 36, 37, 56; post-
 modern 79
art schools, study of picturebooks 23,
 24, 25
Australia: picturebooks in 89–90,
 90–101; postmodernism in 89,
 90–2, 93–6, 97, 101
autonomy 77, 78–9, 80, 83, 85

B

back covers 60, 107, 114
Bad Day at Riverbend (Van Allsburg)
 110–11, 120; children's responses
 to 193, 194–7
Bader, Barbara 1, 9
Bak Mumme bor Moni (Dahle) 56, 57,
 73
Bakhtin, Mikhail 234
Baldrick, Chris 108

Banyai, Istvan, 48; *Re-Zoom* 120, 122;
 Zoom 120, 122, 240
Barthes, Roland 205, 235
Bartolin, Hanne 66, 67
Bartram, Simon 208
Bawden, Edward 23, 33
Bech, Bente 66
Beneath the Surface (Crew/Woolman) 91
Beware of the Storybook Wolves (Child)
 175, 181, 187
Bible Pauperum 14
*The Big Ugly Monster and the Little
 Stone Rabbit* (Wormell) 84
bilingual readers, responses to postmod-
 ern picturebooks 213–19, 220
Black and White (Macaulay) 44–5, 120,
 121, 123, 126
Blake, Peter 36
Blake, Quentin 39
body, transmodernism and 81–3, 84–5
book design 17–18, 131, 164, 248;
 digital 42, 44, 46
Book of Kells 13
Book of the Dead 12
Books of Hours 14, 20
borders 64; decorative 12, 20
boundaries, changing 43, 44, 49–50
boundary breaking 2, 3, 44, 72, 119,
 145
Brack, John 95
Brancusi, Constantin
bricolage 44, 178
Bridget and the Gray Wolves (Linden-
 baum) 68
Briggs, Raymond 19
Brøgger, Lilian: *Anton elsker Ymer* 68;
 Historien 70, 71, 72
Bromley, Helen 40

Brooke, Leslie 18
Brown, Habblot (Phiz) 17
Browne, Anthony 33; *Voices in the Park* 165, 197–200
Bull, Geoff 2
Burningham, John 90
Burton, Virginia Lee 19
Buz (Egielski) 119

C

Caldecott, Randolph 18
Calvino, Italo 90
Cambridge School of Art 23
Campbell, Joseph 11
Cannon, Janell 82
Carle, Eric 86
cartoon illustrations 166–7, 167–8, 218, 248
Catalanotto, Peter 122–3
Caxton, William 16
Chamberlin, Helen 161
chapbooks 17
Child, Lauren 79, 86, 175–8: *Beware of the Storybook Wolves* 175, 181, 187; Charlie and Lola books 166–8; Clarice Bean books 168–75; *I am too Absolutely Small for School* 167; *I Will Not Ever NEVER Eat a Tomato* 134–6, 144, 145, 167; *Who's Afraid of the Big Bad Book?* 175, 176–7, 181, 185–6, 187–8, 189 (children's responses to 209–13)
childhood 16, 17; anxieties about 130, 134, 136; vision of 75
children: collaborative sense-making 195–203, 204; development of books for 16–19; portraits of 77; responses to postmodern picturebooks 151–2, 193–4, 203, 207–20, 253; self-fashioning of 76; understanding of postmodern references 30
Chokoladeskapade (Hammann/Gellert) 68
chronotopes 1
Church, and book illustration 13–14
Clarice Bean, Guess Who's Babysitting? (Child) 168
Clarice Bean, That's Me 166, 168, 171–2, *170, 171, 172, 173*
Clark, Emma Chichester 38
Clever Bill (Nicholson) 18
codex 12–13

cognitive dissonance 227–9
Cohen, Izhar 181, 182, 184
Coles, Martin 2
collaborative sense-making 195–203, 204
collage 36, 85–6, 93, 94–5, 100; Child and 165, 166, 173, 175, 189
Collier, Brian 86–7
colour reproduction 18–19
Come Away From the Water, Shirley (Burningham) 90
Comenius, John 16
comic strip format 20
community, and transmodernism 83–4
connectivity 41, 45, 47–9
Crane, Walter 18
Crew, Gary 90–1
Crispin The Pig Who Had It All (Dewan) 131–4, *133,* 144, 145
Cushman, Karen 80
Cushman, Philip 80

D

Dagbok forsvunnet (Ekman) 67
Den dagen det regna Kattunger (Sande) 68
Dahle, Gro 56
A Day at Damp Camp (Catalanotto) 122–3, 126
Dear Diary (Fanelli) 111–12
decoding 127
demand images 132, 134, 182, 184, 241
Det er et hul I himmelen (Karrebæk) 66
Dewan, Ted 131–4
Diaz, David 86
digital art 30, 168
digital design 42, 44, 46
disruptions 220, 241, 248; metaleptic 180–91
The Diverting History of John Gilpin (Caldecott) 18
Don't Let the Pigeon Drive the Bus! (Willems) 46–7
Doonan, Jane 200
Dore, Gustave 184
double spreads 58, 59, 60–5
Dougal's Deep-Sea Diary (Bartram) 208–9
Doyle, Richard 17
drawing 17, 25, 36
Dresang, Eliza (*see also* Radical Change theory) 1
Drysdale, Russell 90–1
Duften I luften (Bech) 66

dust jackets 59–60, 107, 110, 210, 226
Dyson, Anne Haas 216

E
Edwards, Wallace 112–13
Egypt, papyrus scrolls 11–12, 20
Einstein, Albert 125, 127
Ekman, Fam 59, 67, 68
endings, unresolved 5, 50, 251
endpapers, use of 46–7, 60, 110, 114, 250; by Child 168, 169, 171; *The Getaway* 241–2, 247, 250; *Wolves* 107, 140
etchings 17
ethnic minority children, responses to picturebooks 213–19, 220
Evans, Edmund 18
excess 100, 145
The Extinct Files (Edwards) 112–13

F
fairy tales 17, 180; retelling 175–8, 180, 181–91
Fanelli, Sara 111–12
Felix, Monique 126
Festus and Mercury (Nordqvist) 63–4, 67
fictional/real world, blurring of boundaries between 109, 118, 181, 189, 199, 234–5; in *Bad Day at Riverbend* 111, 120, 197; in *Who's Afraid of the Big Bad Book?* 185, 188, 210–11
Flieger, Jerry 1–2
Flotsam (Wiesner) 48–9
folk tales 55, 180–91
font, use of 164, 168, 169, 176, 187, 210, 211
formats 59, 105, 107–8, 112, 155
Forward, Toby 181, 182–4
Four Resource model 154–8, 161
Four Roles of the Reader model 154
fragmentation 3, 44, 92, 94, 97
frame-breaking 64–5, 168, 184, 185, 190, 231, 234
frames/framing 64, 66, 185, 214
Frederick (Lionni) 118
Freebody, Peter 154

G
Gabardi, Wayne 89
Gag, Wanda 18, 19
Gaiman, Neil 50–1

Den Gamle Mannen og Hvalen (Hole) 26, 29, *29*
Garmanns Sommer (Hole) 26, *27–8, 31*
Gellert, Dina 68
Gergen, Kenneth 80
The Getaway (Vere) 238, 242–7, *242–5*, 253; metafictive devices in 241, 247–8, 253; responses to 248–53
glocalization 89, 92, 95–7, 101
Go' morgen frue (Karrebæk) 68
Goldstone, Bette 2, 164, 203
Good Night, Gorilla (Rathman) 119
Granpa (Burningham) 90
graphic design 23
graphic novel format 20, 26
Gravett, Emily 107–10
The Great Escape from City Zoo (Riddle) 97–100, *99*
Greenaway, Kate 18
Greenberg, Clement 78
Gregory, Eve 216
Grey, Mini: *The Pea and the Princess* 214–17; *Traction Man is Here* 40
Grieve, Ann 2

H
Hall, Christine 2
Haller, Bent 56
Hammann, Kirsten 68
Harthan, John 12, 15
Hassan, Ihab 2
Heath, Shirley Brice 214
Henderson, Margaret 89, 91–2
Hey, Al (Yoricks) 119
Higgonet, Anne 75, 77
Hillis, Danny 104
Historien (Brøgger) *70, 71, 72*
Hole, Stian 26–30, 32
Holland, Brad 22, 37
Hopper, Edward 95, 98
Hoved & hale (Jensen) 68
human/animal, blurring of boundaries between 71–2, 198–9
Hurd, Clement 19
Hutcheon, Linda 1
Hutchins, Pat 104, 109
Hva skal vi gjøre med lille Jill? (Ekman) 67
hypertext 4, 51, 126; handheld 42, 44, 45, 51

I
I am too Absolutely Small for School (Child) 167

I Will Not Ever NEVER Eat a Tomato (Child) 134–6, 144, 145, 167
illuminated manuscripts 13–14
illustrated magazines 17
illustration 14–15, 23, 24–5, 155; Graeco-Roman/insular 13; pastiches of styles 241, 248, 251; religious 13–14; of secular texts 14
illustrators 22–3, 24, 25–6; postmodern 117–18, 122, 124
imagination 130, 134, 135–6, 137, 140, 141; effect of new technology on 131; modalities and 142–5
The Incredible Book Eating Boy (Jeffers) 217–19
indeterminacy 2, 73, 94, 145, 203, 241, 251
ink 15
interactivity 41, 45, 119–20, 214, 238; playfulness and 46–7, 67–72; responses to devices of 240–53
intermediality 56–7
Internet 4, 46, 49
intertextuality 3, 5, 90, 234, 240; in *The Getaway* 241, 247, 250; making connections 216–17; parodic 181, 241, 247, 250; and performance 212–13, 217; playfulness and 67–8; Radical Change and 42, 44, 50, 51
The Invention of Hugo Cabret (Selznick) 20
irony 2, 20, 44, 91, 139; children's grasp of 208, 209; humour through 84; in *The Wolf's Story* 182, 183; in *Wolves* 109
Islamic art 13
Ispigen 56–7, 58, 73

J
Jackson, Shelley 86
Jameson, Frederic 91
Jansson, Tove 67
Jeffers, Oliver 217–19
Jenkins, Steve 86
Jensen, Helle Vibeke 68
Jimmy Corrigan: The Smartest Kid on Earth (Ware) 26
Johnson, Steve 4

K
Kanninen, Barbara 47
Karrebæk, Dorte 56, 59, 60, 64, 66
Kattens shrekk (Ekman) 67, 73
Keats, Ezra J. 118
Kendrick, Maureen 214
Kenner, Charmian 216
Kiefer, Barbara 151, 178
The King of the Golden River (Ruskin) 17–18
knowingness 37, 80
Knuffle Bunny (Willems) 119
Kress, Gunther 131, 142–4, 182
Kristeva, Julia 1

L
Langer, Suzanne 10
language 85, 151, 241
LaReau, Karen 83–4
laser printing 19
Latham, Don 44
Law, Roger 23
Lawson, Robert 78
Leaf, Munro 78, 125–6
Lear, Edward 17
learning to read 51, 104–5, 106
Lehman, Barbara 49, 120
Lehr, Susan 174
Lewis, David 1, 2, 145, 203, 204
Lille frøken Buks og de små sejre (Karrebæk) 59
liminal space 223, 229, 232, 235
Lind, Peter 66
Lindenbaum, Pija 68
Lindisfarne Gospels 13
Lionni, Leo 118
Lissiat, Amy 148, 159, 160–1
literacy 153; visual 33, 36, 38
literacy education 106, 115
lithography 17
Little Louie Takes Off (Morison) 32, 33–4, *34, 35*
Locke, John 16–17, 77
The Lost Thing (Tan) 38, 92, 94, 95–7
Lukens, Rebecca 250
Lullabyhullaballoo (Inkpen) 119
Lundgren, Max 29
Lyotard, Jean-Francois 42

M
Macaulay, David: *Black and White* 44–5, 120, 126; *Shortcut* 201–3
McCallum, Robyn 3, 253

McCloskey, Robert 19
McGowan, John 42
McGuire, Caroline 3, 51, 164
McKay, Roberta 214
McKean, Dave 50–1, 79, 80, 83
McNaughton, Colin 181, 184–5
Magritte, René 98, 99
Manolesson, Katherina 40
Marantz, Kenneth 10
Marin, John 125
Martin's Big Words (Rappaport) 86–7
materiality 57–8, 79, 103–4, 105, 107–15, 217
meaning/s 141; examination of 157–8; identifying 156–7; intertextuality and 98; multiple 3, 4, 5, 159; postmodernism and 85, 92, 94, 100, 156, 161; words and pictures used to negotiate 209, 220, 227–8
Meek, Margaret 103–4
Mesterjægeren (Karrebæk) 64
metafiction 3, 5, 90, 238, 241
metafictive devices 2, 43–4, 147–50, 238; in *The Getaway* 241, 247–8, 253; in retelling of fairy tales 180–91; responses to 151–2, 207–20, 253
Middle Ages, book production in 15–16
Mikkelsen, Nina 117
Millions of Cats (Gag) 18
Mines, Heather 216
Minton, John 38
Mirrour of the World (Caxton) 16
modalities 99–100, 110–11, 136, 181; imagination and 142–5; mixed 181–2, 188–9, 190
modernism 81, 83, 84; picturebooks and 78; self and 77–8, 85
Mommy? (Sendak/Yorinks/Reinhart) 50
Mondrian, Piet 98, 100
monsters 49–51
Moomin, Mymble and Little My (Jansson) 67
Morison, Toby 32–4
Morpurgo, Michael 130–1
Munch, Edvard 98
Myers, Christopher 86
Mysterious Thelonious (Raschka) 122, 123, 126

N

När Åkes mamma glom de bort (Lindenbaum) 68–72, 69

narration: hierarchical relationships in 181, 184; ironic 183; multiple narrators 177, 181, 190, 241, 248
narratives: framing devices 210–11; multiple 241, 248; parallel visual 67; reshaping 181, 186
Newbery, John 17
Newton, Eric 30
Nicholson, William 18
Nikolajeva, Maria 9, 151, 212, 214
Nodelman, Perry 9
nonlinearity 2, 3, 42, 48, 51, 114, 123, 201
nonsense literature 68
Nordqvist, Sven 63, 67
Norway, picturebooks from 26, 30, 32
nursery rhymes 18
Den nye leger (Karrebæk) 60, 61, 62, 63 73
Nygren, Tord 66
Nyhus, Svein 56
Nyström, Bente Olesen 66–7

O

Officer Buckle and Gloria (Rathman) 119
offset printing 18–19
Oops (McNaughton) 181, 184–5
Orbis Pictus (Comenius) 16

P

page layout 59, 61–3, 66, 248
Pantaleo, Sylvia 44, 45, 46, 48, 51, 52, 151–2, 193–4, 236n
paper 15
The Paper Bag Princess (Munsch) 4
papyrus scrolls 11–12, 20
paradox 127–8
parchment 13
parody 2, 3, 5, 79, 90, 139, 145; in *The Getaway* 241, 247–8, 250; in *The Stinky Cheese Man* 114; in *Wolves* 109
pastiche 2, 3, 44, 92, 109; of illustrative styles 98, 241, 248, 251
The Pea and the Princess (Grey), children's responses to 214–17
pedagogy 151, 152–3
performance 208–9, 212–13, 220
peritext 58–9, 114, 195, 210; children's responses to 225–6
permeability 118–19, 122

picturebooks (*see also* postmodern picturebooks) 1, 117; academic study of 24, 25, 26, 36; as art form 10–11, 15; changes in 19–20; for children 16–19; definitions of 9–10; history of 11–19; modernism and 78

pictures 10, 50, 113, 211, 215, 218; interaction with text 10, 24, 37–8, 46, 61–2, 164, 166–7, 168 (used to negotiate meaning 209, 220, 227–8; playfulness and 55, 56, 178

Pigen der var go' til mange ting (Karrebæk) 60, 64–5, *65*

playfulness 2, 3, 5, 20, 44, 55, 209, 235; and interactivity 67–72; in layout 66; through materiality 57–60, 111–12; word and image and 55, 56, 64, 178

portraiture 77

postmodern picturebooks 3–5, 79–80, 82–3,119, 147, 149, 165; as artifacts 150–1, 153–4, 161; characteristics of 2–3, 20, 107, 108, 164; interpretation of 193–205, 234

postmodernism 1–2, 42, 78, 79; in Australia 90–2, 93–6, 97, 101; definition of 106, 108;picturebook as 36, 37, 56; Radical Change and 42–4, 45, 52; self and 80, 85

Potter, Beatrix 18

printing press 15

PS. Hils morfar! (Ekman) 59, 67

Punch 17

Pyle, Howard 18

Pynchon, Thomas 96

R

Rackham, Arthur 18

Radical Change theory 1, 41, 167–8, 178; applied to picturebooks 45–51; postmodernism and 42–4, 45, 52

Rainstorm (Lehman) 49

Rappaport, Doreen 86–7

Raschka, Chris: *Arlene Sardine* 82–3; *Mysterious Thelonious* 122

Rathman, Peggy 119

Ravilious, Eric 33

readers (*see also* children) 120, 127; age of 26, 29, 36; agency of 253; challenges for 106, 193, 219; involvement of 164, 177, 182, 187; resistance to stories 234; sense of control for 46–7, 51

The Red Book (Lehman) 49, 120, 122

The Red Thread (Nygren) 66

The Red Tree (Tan) 38

Reed, Lynn 47

references 30, 33–4, 37

Reimer, Mavis 9

Reinhart, Matthew 50

Rejsen (Bartolin) 66, 67

religious manuscripts 13–14

representation 76, 81

Re-Zoom (Banyai) 120, 122

Ricciardi, Alessia 90

Riddle, Tohby 92, 93–4, 97–8

rock paintings 11

Rødhatten og ulven (Ekman) 68

romanticism 29–30, 78, 82, 83

Rosie's Walk (Hutchins) 104, 109

Ross, Phlip 106

running stories 67

Ruskin, John 17–18, 23

S

Sande, Hans 68

Scieszka, Jon 4, 47, 114

Scott, Carole 9, 151, 212, 214

Searle, Ronald 23

self 76; modern to postmodern 76–81

self-referentiality 3, 5, 37, 79, 94, 107–8, 111–13, 184; Child and 164–5

Selznick, Brian 20

semiotic systems 94–5; transmodernism and 84–7

Sendak, Maurice 19, 83; *Mommy?* 50; *Where the Wild Things Are* 50, 83, 118

Senefelder, Aloys 17

Shephard, Ernest 18

The Short and Incredibly Happy Life of Riley (Thompson) 148–50, *148, 149;* testing Four Resource Model 158–61

Shortcut (Macaulay), children's responses to 201–3

Shulevitz, Uri 10

Simms, Eva M. 75

Sipe, Lawrence R. 3, 10, 51, 110, 114, 164, 216

size 59

En sky over Pine-Stine (Ekman) 67

Slobodkina, Esphyr 19
Smart, Jeffery 95
Smith, Jessie Wilcox 18
Smith, Lane 4, 47, 114
Smoky Night (Bunting/Diaz) 86
The Snowy Day (Keats) 118
space, use of 117, 118–25, 125–7, 164;
 fourth and fifth dimensions
 119–20, 122–3, 127; liminal 223,
 229, 232, 235; spatial innovation
 90, 215; Spiro, Rand 236n
Spudvilas, Anne 51
Squire, Kent 115
Stellaluna (Cannon) 82
*The Stinky Cheese Man and Other
 Fairly Stupid Tales (Scieszka/
 Smith)* 4, 47, 114
*The Story of a Little Mouse Trapped in a
 Book* (Felix) 120, 126
The Story of Ferdinand (Leaf) 78, 125–6
A Story with Pictures (Kanninen/Reed)
 47
Styles, Morag 38, 39, 151, 152
surrealism 90, 112

T
taboo topics 19, 165, 167
Tadpole's Promise (Willis) 82
Tan, Shaun 20, 137–8; *The Lost Thing*
 38, 92, 94, 95
Tatar, Maria 183
teachers 224–5; role of in discussing
 books 193–4, 195, 105, 235, 240
teaching reading 151, 152
television cartoon series 167–8
Tenniel, John 17
Thompson, Colin 148, 159, 160–1
The Three Pigs (Wiesner) 119, 120,
 181, 223; children's responses to
 225–36; metaleptic disruptions
 in 189–90; use of space 113–14,
 123
time and space 124–5
The Tip at the End of the Street (Riddle)
 92, 93–4, 97–8, 100
title pages 17–18, 60, 226
Todorov, Tzvetan 137
Traction Man is Here (Grey) 40, 136–9,
 138, *139*, 144, 145
transmodernism 81–3; community and
 83–4; self and 76; semiotic sys-
 tems and 84–7
typography 211–12, 248

U
Ugly Fish (LaReau) 83–4

V
Van Allsburg, Chris 110–11, 120, 193,
 194–7
Van Etten, Ingunn 68
Van Leeuwen, Theo 131, 182
Var är min syster (Nordqvist) 67
Vejen til festen (Nyström) 66–7
Vere, Ed 240, *242–5*
viewpoints 93, 122–3, 208; manipula-
 tion of 182–3
virtual play 130–1
visual literacy 33, 36, 38
visual text 155
Vitz, Paul 76, 81
Voices in the Park (Browne) 165,
 197–200

W
Waddell, Martin 39
Ward, Lyn 19
Ware, Chris 26
Watson, Ken 1, 3
Wait! No Paint! (Whatley) 181, 189–90
The Watertower (Crew/Woolman) 90–1
Waugh, Patricia 2, 241
Weisgard, Leonard 19
*What Planet Are You From, Clarice
 Bean?* (Child) 168, 169, 174
*What Really Happened to Little Red
 Riding Hood: The Wolf's Story*
 (Forward/Cohen) 181, 182–4
Whatley, Bruce 181
Where the Wild Things Are (Sendak) 50,
 83, 118
Who's Afraid of the Big Bad Book?
 (Child) 175, 176–7, 181, 185–6,
 187–8, 189; children's responses
 to 209–13
Wild, Margaret 51
Wiesner, David: *Flotsam* 48–9; *The
 Three Pigs* 5, 113–14, 120
Willems, Mo 46–7, 119
Willis, Jeanne 82
Willy the Dreamer (Browne) 240, 250
Wilson, Jacqueline 130, 145
Wisniewski, David 86
Wolves (Gravett) 107–10, 140–1, *142*,
 144, 145
The Wolves in the Walls (Gaiman/McK-
 ean) 50–1, 79, 80, 83

Woolman, Steven 90–1
Woolvs in the Sitee (Wild/Spudvilas) 51
wordless picturebooks 48, 59, 66–7
words (*see also* pictures, interaction
 with text) 10, 50, 113, 119, 215
Wormell, Chris 84
Wyeth, Newell Convers 18

Y
Yoricks, Arthur 50, 119

Z
Zin! Zin! Zin! A Violin (Moss) 123,
 126
Zoom (Banyai) 120, 122, 240